A History of Latin American Art and Architecture

From Pre-Columbian Times to the Present

A History of Latin American Art and Architecture

From Pre-Columbian Times to the Present

Leopoldo Castedo

TRANSLATED AND EDITED BY PHYLLIS FREEMAN

PALL MALL PRESS • LONDON

To Carmen

Published in Great Britain in 1969 by
The Pall Mall Press, Limited
5, Cromwell Place, London S.W.7
All rights reserved
SBN 269 0252 43
Printed in Austria
by Brüder Rosenbaum, Vienna

Acknowledgments

This book was made possible through the generous cooperation of a large number of institutions and individuals. Among the institutions, the author would particularly like to mention the following: in Mexico, Instituto Nacional de Antropología e Historia and Instituto de Investigaciones Estéticas de la Universidad Nacional Autónoma in Mexico City; in Argentina, Instituto de Arte Americano e Investigaciones Estéticas de la Universidad de Buenos Aires and Centro de Artes Visuales del Instituto Torcuato Di Tella in Buenos Aires; in Brazil, Museu do Ouro in Sabará, Museu de Arte Sacra in Bahia, and Serviço do Patromonio Historico e Artistico in Rio de Janeiro; in Colombia, Biblioteca Luis Angel Arango and Museo del Oro in Bogotá; Centro de Investigaciones Históricas y Estéticas de la Universidad de Venezuela in Caracas; and the Division of Visual Arts of the Pan American Union, Washington, D.C.

The author also offers his warm thanks to the following: in Mexico, to Justino Fernández, Francisco de la Maza, Carmen Barreda, Jorge Gurría Lacroix, Félix Candela, and Mathias Goeritz; in Venezuela, to Graziano Gasparini, Alfredo Armas Alfonzo, and Alfredo Boulton; in Colombia, to Beatriz Caicedo, Luis Barriga, and Gabriel Giraldo Jaramillo; in Ecuador, to Alfredo Pareja Diezcanseco and Father José María Vargas; in Peru, to Jorge C. Muelle and Fernando de Szyszlo; in Bolivia, to Julia Elena Fortún, José de Mesa, and Teresa Gisbert; in Argentina, to Jorge Romero Brest, Carlos Paz, Héctor Schenone, and Mario J. Buschiazzo; in Brazil, to Rodrigo Mello Franco de Andrade, Antonio Joaquim de Almeyda, Dom Clemente Maria da Silva Nigra, Claudio Garcia de Souza, and Gilberto Freyre; and in the United States, to José Gómez-Sicre, Rafael Squirru, Luis Lastra, Ramón

5

G. Osuna, George Kübler, Stanton L. Catlin, and Terence Grieder. He would also like to mention that the statement by Alexander Calder that appears on page 280 was quoted in Sibyl Moholy-Nagy's book *Carlos Raul Villanueva,* on page 113.

Finally, the author expresses his gratitude to Phyllis Freeman for her excellent translation and painstaking editing of the text; to Brenda Gilchrist for her advice and careful preparation of the manuscript for publication; and to Ellyn Childs for her meticulous assistance in collecting and checking new data.

Contents

Part II: The Encounter with Europe

Part III: The Modern Synthesis

Introduction

Despite its heterogeneous climates and terrains, despite its variety of peoples, histories, and origins, Latin America has tenaciously maintained a distinctive aesthetic expression. Since this conglomerate of countries first became part of recorded history, it has been searching for the ways to formulate its collective identity. During this entire period, the only collective process that has not been interrupted by natural or man-made cataclysms has been its aesthetic expression—its graphic, architectural, poetic creations—its manner of representing contemporary ideological and stylistic movements. And it is in its arts that Latin America's essence is to be found.

To understand this phenomenon, it is necessary to assess the diverse factors that have conditioned Latin America's evolution in the past and determined its present. The most obvious and most profound influence is its mixed nature—its *mestizaje*. As we shall see, the relative strength and cohesive power of Latin America's diverse components—the Iberian, the Indian, and the African—have been accurately reflected in its prevailing artistic values.

Another decisive element is the Iberian temperament. The baroque has dominated the art of both Spain and Portugal because of the affinity between the Iberian spirit and the fundamental qualities of this style. During the colonial period, this aspect of the Latin American spirit found a ready counterpart in the flowering of the baroque, but this stylistic preference underlies all the art of these peoples and makes its influence felt today in the painter's awesome vision, the poet's complicated metaphor, the architect's love of the curve, the composer's neo-Bachian expressionism, the sculptor's sinuous forms.

In the history of the visual arts, the Spanish have always had something to say, and it has always been first-rate. This constant—a Latin American fact from the sixteenth century on—has stamped the art of Spanish-Portuguese America and has given the region the best it has.

The history of Latin America is a history not of reasons but of passions. It is, therefore, fruitless to interpret it in a rational manner, wrenching it into the Procrustean patterns of Christian civilization— a tradition to which, nevertheless, it does belong.

Because of this ambiguous relation—as well as the difficulty of compressing three thousand years of rich achievement within the confines of a single volume—we have chosen to focus on the nature of the aesthetic perception in Spanish-Portuguese America during each stylistic period and on its unique contributions to the art of the world.

1

Constants and Variants

In Latin America, artistic expression is at its most distinctive when its links with the ancestral world are closest. It is not surprising, therefore, that the most distinctive aesthetic forms date from the epoch before the Iberian Conquest.

In the two major areas of pre-Columbian culture—in Mesoamerica to the north and in the highlands of Peru to the south (*see map, p. 311*)—stone was the basic material in which the artist worked. In the north, it was employed not only in architecture but also for ornamentation. In the Andes, it was utilized almost exclusively in construction. In coastal Peru, buildings were usually of adobe, and little remains of this perishable material.

The solidity and nobility of pre-Columbian art stems in great measure from the fact that the craftsmen always respected the integrity of the medium. For Henry Moore, who accords the supreme value to "stoniness"—by which he means "truth to the material"—Mexico's pre-Columbian art has been "unsurpassed . . . by any period of stone sculpture." He pays special tribute to "its tremendous power without loss of sensitiveness, its astonishing variety and fertility of form-invention, and its approach to a full three-dimensional conception of form."

This judgment concerning the treatment of the stone is equally applicable to the megalithic art of Alto Peru—the area in the Central Andes that today includes Bolivia's mountain regions. For although it is frequently remarked that the Aztecs placed a high value on craft skills, this is generally true of all the pre-Hispanic peoples. Neither effort, nor technical problems, nor time required was reckoned in producing the incredible works we marvel at today, and it was the Alto-peruvians whose work in stone combined aesthetic achievement with masterful feats of engineering.

Pre-Columbian art is, perhaps to a greater extent than any other art, the product of the plastic, musical, and spatial interpretations of a mythic world that completely dominated the thought and action of man. This art did not seek essences or abstractions as such, because it described what it did in fulfillment of a magico-religious necessity, and the pre-Columbian works that we now call art were originally intended solely to express man's dependent relation with his gods.

Our modern obsession with the search for new ideas or forms played little part in the pre-Columbian imagination. On the contrary, pre-Columbian art is eminently conservative, with an aesthetic in some ways very close to the Oriental. And as in the East, decorative elements are repeated on a vast scale, creating a deliberate rhythm that is one of the essential features of pre-Columbian art.

Although the artist was a highly prized member of these societies, his craft hewed to absolutely unalterable patterns. Freedom of individual expression, as that concept developed in Renaissance Europe, had no force or meaning for him. From this outlook, certain principles derived—"existential" principles, to use contemporary terminology— that are explicitly stated in the ancient Náhuatl poetry of Mexico and the roughly contemporaneous Quechua poetry of Peru.

Theogony in Mesoamerica and theocracy in Peru constituted the two contemporaneous systems by which man was subordinated to his circumstances. In the north, he had to sustain the mythical gods with bodily sacrifice; in the Andes, especially in the Inca period, the god was of flesh and blood and bestowed riches on his flock.

From Mexico to Alto Peru, a representation was not a real or abstract symbolization of the god or his acolytes but was the god or the acolytes themselves. The only reality was the myth; the intention of the carver, the painter, or the goldsmith was to clothe the myth in a physical garb. This outlook was conducive to abstraction, to concentration on generally recognized aspects rather than on individual variations. In consequence, representations—of men, serpents, jaguars, dogs, llamas, fishes—run a gamut extending from exact physical transcription to stylizations that to our eyes often have an extremely remote correspondence to the object depicted.

Over the centuries, this art became progressively more abstract, since it was directed toward initiates and executed by a small caste of artist-priests bent on hiding the significance of the forms from the masses.

In some areas, climate, too, conditioned the style of a people's art. The Mexican scholar Wigberto Jiménez Moreno applied Spengler's

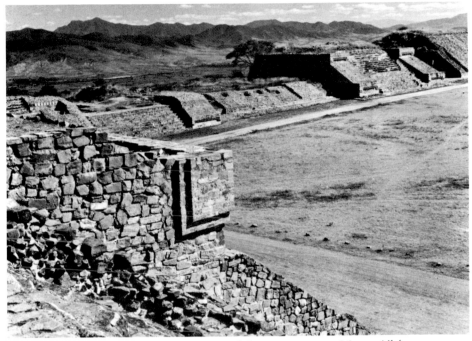

I-1. The horizontality and symmetricality of these structures at Monte Albán underline the classicism of this culture. Here, the southwest group, left to right: the Ball Court, Building "P," the Palace, and Building "Q." Valley of Oaxaca, Mexico.

eternal dualism between the Apollonian and Dionysian concepts of artistic creation to distinguish the plateau cultures of Mesoamerica from those of the tropical lowlands. The arts of the Valley of Mexico, Puebla, and Oaxaca, dating from a few hundred years before the Christian Era to a few hundred years after its start, are generally called "classical" because of their sobriety, balanced proportions, clarity, solemnity, and harmonic rhythm (*Ill. I-1*). In the art of the tropical lowlands, especially on the Gulf coast (*Ill. I-2*), Jiménez Moreno discerned the antithetical baroque concept, evident in the expressive energy, complex forms, gaiety, deliberate disproportion, and predominance of the curve.

In this sense, pre-Columbian art follows a course common to all art; it exhibits the progressive tendency toward baroqueness that Wilhelm Worringer attributes to every stage of intellectual maturation in the evolution of a style. But in Latin American art, there is no direct cor-

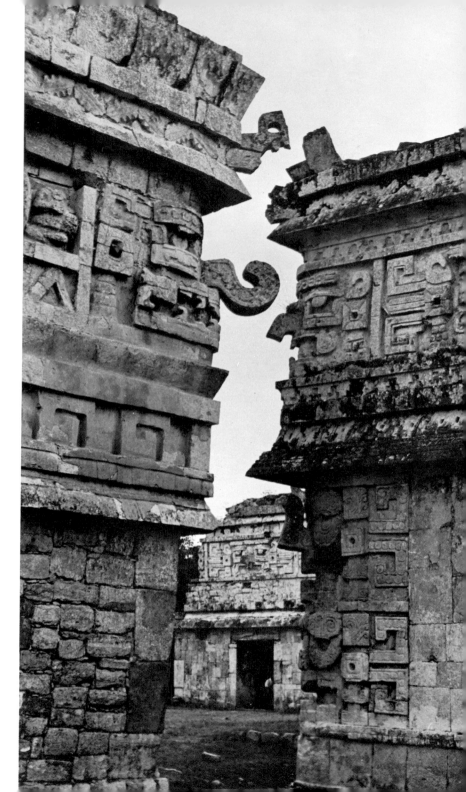

relation between the climate and the inclination toward the baroque or the classical. Of course, throughout the pre-Columbian territories, temperament, collective motivations, the degree to which a people felt impelled to search for infinity in artistic-religious expression conditioned the evolution of a classic feeling into a subsequent baroque reaction. The same process was repeated during the formative stages and the development of art in the colonies. In the colonial period, however, the appearance of baroque richness and of classical austerity ran directly counter to the phenomenon remarked by Jiménez Moreno. Ornamentation became more elaborate as the vice-royalties and captaincies were established farther and farther from the tropical regions. In the highlands, the baroque was fostered not by a congenial climate but by a congenial indigenous culture distant enough from the coastal ports to challenge the prevailing European styles.

Long before the advent of the Europeans, there was unquestionably communication between the cultures of the north and the south. Peruvian goldwork reached Guatemala and perhaps even Mexico; the artistry of Colombian goldsmiths was admired in Yucatán. The Maya imported ceramics from the regions that are today Nicaragua and Honduras, and the ancestors of the present-day Panamanians carried on active commercial relations with the tribes in Ecuador, who in turn traded with Peruvians.

Naturally, the evidence of these contacts and their influence was more pronounced at close range, or around certain centers, and the variants within and among cultures were often very marked. Nevertheless, a relatively parallel process of maturation can very clearly be traced in all pre-Columbian art, distinguishing it from the equivalent phenomena in other latitudes.

In *The Art of Ancient Mexico,* Paul Westheim acutely points out that if the aim of modern realism is to reproduce the visible, the aim of pre-Columbian realism is to make the invisible visible. Employing these terms, we can say that the supreme achievement of this art is the invention of plastic systems capable of expressing the visionary with real elements.

◀ I-2. Pre-Toltec buildings at Chichén-Itzá—left, the Iglesia (Church); right, the Nunnery Annex; at rear, the end of the façade of the Nunnery—exhibit the baroque aspects of Maya architecture in the Chenes and Puuc periods. Yucatán, Mexico.

2

The Cultures of Western and Central Mexico and the Gulf Coast

For many years, archaeologists have heatedly disputed the identity of the Olmecs. Were they ancestors of the people known to have inhabited the Gulf coast or the lands between the western Sierra Madre and the Pacific centuries later? Or had they actually disappeared from this area, through some disaster or migration? If anyone considers such a dispute a frivolous pedantic indulgence, an inspection of the dazzling works of art the Olmecs have left would surely alter his opinion.

Despite their controversy, most archaeologists support the observation of one of the giants of modern Mexican archaeology, Alfonso Caso, who called the Olmec civilization a "mother culture." There is no question of its role in the development of the arts of the Maya, Zapotecs, and Toltecs, in addition to its influence on the preclassical culture of the Valley of Mexico, especially in Tlatilco, on the outskirts of Mexico City. Nor is there doubt concerning the date of the oldest Olmec pieces found at La Venta or Tres Zapotes; carbon tests have established that they date from 1400 B.C.

Typical Olmec statuary is megalithic, in the shape of an enormous head, such as that in La Venta Park, in Villahermosa. Whoever sculptured this monolith clearly intended to convey an architectonic feeling through the spherical block. The details of the face—eyes, nose, mouth —scarcely stand out from the over-all mass. This sculpture embodies a masculine ideal represented by an elongated head, snub nose, strong jaws, almond-shaped Oriental eyes, and the obligatory trait—the thick-lipped "jaguar" mouth, with its corners turned forcefully downward (*Ill. 1-3*).

The Olmecs have left, besides megalithic statuary, great stone altars and steles with delicately worked bas-reliefs, sculptured axes orna-

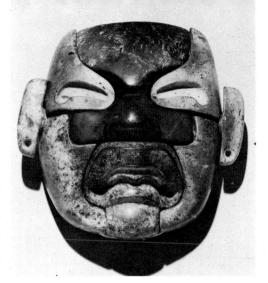

I-3. Olmec mask in serpentine. Its thick lips and an architectonic vision are two of the hallmarks of the Olmec culture, in very small pieces, such as this, as well as in the more familiar basalt monoliths. Tabasco (?), Mexico.

mented with shallow incisions, colonnaded tombs, boxes and mosaics of stone, and elegant jade carvings.

The Olmec style exists as much in the art of contemporaneous cultures as in those that developed after it. Tlatilco, the principal center of Zacatenco culture, overlapped the Olmec civilization in time. It was probably from the Olmecs that Tlatilco ceramicists learned how to fashion hollow pottery, and they clearly borrowed stylistic traits from the Olmecs.

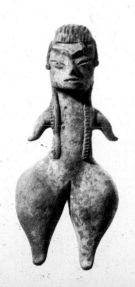

I-4. Fired clay figure from Tlatilco. The elaborately coifed head and bulging thighs are common in this style, which was centered near Mexico City.

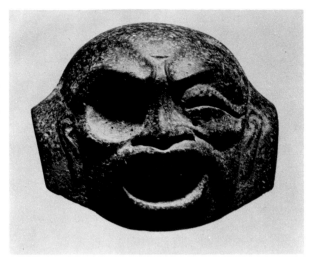

I-5. An ancient representation of the duality between light and shadow, day and night, life and death, expressed within a single face. This theme pervaded all pre-Columbian cultures. Tlatilco, Mexico.

Although Tlatilco ceramics—from cooking utensils to elegant funerary objects in richly varied colors—show skilled artistry (*Ill. I-4*), the distinctive contribution of these potters was the two-headed female figurine, sometimes with features repeated, such as three eyes, two mouths, and two noses. It is an astonishing American coincidence that faces with two conflicting expressions (*Ill. I-5*) are found here, as well as in the distant Chavín region of Peru.

The Western Cultures

Dynamism, caricatural distortion, and expressive energy are the hallmarks of the art of Mexico's west coast, which customarily includes all the cultures from Lower California to the border of Oaxaca. Highly accomplished art has been found in Nayarit, Jalisco, and Colima, as well as among the Tarascans of the lake region and the puzzling people of Guerrero.

Obsession with caricaturing reaches its extreme in the State of Nayarit. Clay statues depict misshapen women, with colossal genitals, ridiculous arms, and long noses weighed down by numerous rings. There are also pairs of sated lovers, women with running pustules giving birth, aggressive warriors, dwarfs, and hunchbacks. In a soberer mood, Nayarit sculptors also portrayed human groups at different tasks, playing ball, dancing, banqueting.

The Jalisco figures have elongated heads, sharp noses, straight lines for eyelids, and a small ball to indicate the eye. They are considered a

transitional form or a link between the savage Nayarit caricatures and the more polished and sophisticated art of Colima.

The people of Colima, living to the west and south of the volcano that gives the region its name, developed another technique of working clay, with an extraordinary variety of themes (*Ill. I-6*). The best-known pieces from Colima are the *techichi,* or *tepescuintli* (hairless dogs). The *techichi* are modeled in every form and posture imaginable— seated, standing, sleeping, in pairs kissing or licking, with an ear of corn in the snout, feet in the air—almost always with absolute naturalism (*see Ill. I-17*).

In the region of the lakes (Pátzcuaro, Cuitzeo, and Chapala), the Tarascan culture survives, widely familiar through the famous butterfly nets of Janitzio, an island in Lake Pátzcuaro. The Tarascans developed a creative, inventive architecture. Their *yácatas* were stepped structures with a T-shaped floor plan. At the end of the stem was a round platform that formed the foundation of the temple, which was also round. It is interesting to note that the volcanic stones of the façade were precisely fitted at the edges, exactly as in Peru. The Tarascans expended great care in working obsidian, as well as copper, and for the latter they developed extremely varied and complicated techniques.

In the present State of Guerrero, along the Mezcala River, craftsmen produced masks, figures, and stylized ornaments in hard stone in the

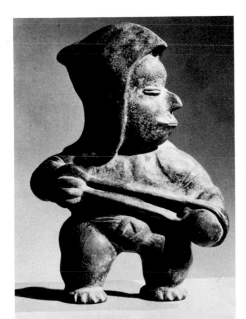

I-6. Colima effigy vessel in hand-modeled fired clay, probably representing a warrior about to release a stone from a slingshot. Western cultures. Mexico.

form of a petal-shaped ax with symmetrically placed elements. Since the forms and symbols of the Guerrero work resemble no other Mesoamerican style, they constitute one of the many enigmas in the study of pre-Columbian art.

Teotihuacán

Since Leopoldo Batres' first systematic excavations, in 1905, Teotihuacán has justly been considered one of the most splendid cities of the ancient world. Around the middle of 1962, an army of archaeologists from the Mexican National Institute of Anthropology and History began to reconstruct the temples that line the Street of the Dead.

The Valley of Teotihuacán is a plain about 9 miles by 4½ miles wide. The city's ceremonial sector covered an area 1½ miles long by ⅔ mile wide—although we see today only what survived the city's widespread destruction more than twelve centuries ago (*Ill. I-7*). Yet the dead city, with its many palaces dominated by the two imposing pyramids, must clearly have been the center of an advanced culture. Each of the buildings is massive. The Pyramid of the Sun rises 210 feet, occupies an area of nearly 60,000 square yards, and has a volume of 1,308,000 cubic yards. The Pyramid of the Moon is 138 feet high;

I-7. Buildings at Teotihuacán: left, the Pyramid of the Ciudadela (Citadel); center, the Pyramid of the Sun; right, the Pyramid of Quetzalcóatl. Valley of Mexico.

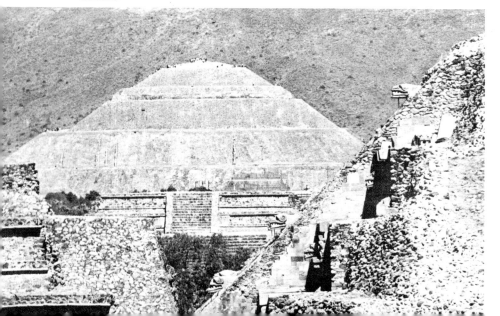

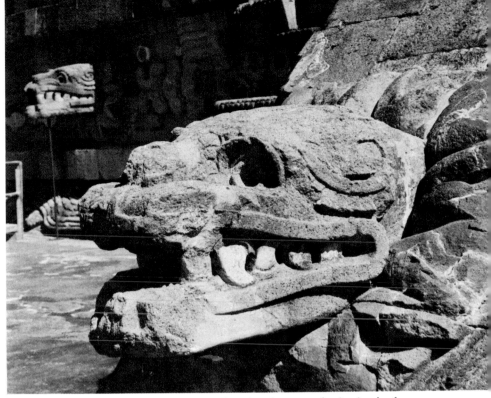

I-8. The Pyramid of Quetzalcóatl, Teotihuacán: foreground, the head of a plumed serpent; left, in shade, a schematic representation of the god Tláloc. Valley of Mexico.

its base measures 387 by 483 feet, excluding the stairway of the façade. A tunnel hollowed out in 1935 to explore the structure of the Pyramid of the Sun showed that it was a solid form, consisting of large bricks covered with clay and stone facings.

Now that the present stage of restoration and clearing of rubble has been completed, the Pyramid of the Moon presides over a vast square into which the Street of the Dead leads. The sides of the square are formed by twelve temples and the façade of the Pyramid itself. These temples, as well as the temples crowning the Pyramids of the Sun and the Moon, had flat crenelated roofs.

On the elaborate Pyramid of Quetzalcóatl (the Plumed Serpent, worshiped for a variety of attributes associated with weather) are marvelous friezes: from a background composed of bodies of serpents, serpent heads protrude, ringed with feathers, rhythmically alternating

with stylized representations of Tláloc, god of rain, depicted as a geometric face with two great symmetrical circles forming the eyes. More serpent heads, also encircled by plumes of the quetzal bird, guard the flanks of the central stairway (*Ill. I-8*).

A distinctive aspect of Teotihuacán culture is its architecture, based on the principle of the *tablero* (vertical panel) and the *talud* (sloping panel), which provided its well-known profile. However, ceramics, woodcarving, decorative work of all kinds, and paintings, as well as sculpture, are also revealing. The sculpture of the oldest period, when the Pyramid of the Sun was being constructed, is, predictably, massive and cyclopean. The colossal monolithic statue of the Goddess of Waters, Chalchihuítlique, weighs more than 22 tons and stands more than 8 feet high. It is a blocklike structure, in which the forms are governed by an architectural concept similar to that of the Olmecs but resembling even more closely work in San Agustín (Colombia) and Tiahuanaco (Bolivia). Still larger is the "Tláloc of Coatlinchan," found near Texcoco, a little south of Teotihuacán. It is so enormous that the sculptured block—more than 13 by 13 feet and nearly 15 feet tall—was too heavy to be moved from its original site when the work was finished.

After the high point of this initial era, customarily called the Teotihuacán I period, came a typical swing toward the baroque, expressed in an art that was abstract, symbolic, and intellectual. From then on, the central hero was the Lord of Rain, Tláloc. The evolution of the Teotihuacán style was a long and laborious process, and although serene, austere, realistic forms persisted, the culmination was reached with increasingly abstract motifs derived from Tláloc's masks and speech, from jaguar claws, and numerical symbols. The forms of the Teotihuacán gods multiplied, especially the incarnations of the Plumed Serpent or Celestial Dragon, of Xipe-Tótec (the god of sacrificial flaying and also of spring), of the Butterfly-Bird, of the Old God of Fire, and, of course, of Tláloc.

Simultaneously, Teotihuacán developed a distinctive style of earthenware decorated with small frescoed friezes. A very similar version of this ornamentation found in Kaminaljuyú, on the outskirts of Guatemala City, indicates the range of Teotihuacán's influence.

Figurines labeled "portrait type" because of their realism were made in interim periods when baroque abstraction was in the descendant, but, toward the end of the Teotihuacán cycle, on the eve of the destruction of the central city (ca. A.D. 700), the elaborate ornamentation and hairdress of the statuettes signal the resurgence of the baroque.

24

The most dazzling paintings of this culture were discovered in the middle of 1963 by Laurette Séjourné at Tetitla, in the residential portion of the Teotihuacán site. Still brilliant in hue, the murals contain thirteen repeated motifs, including fierce-looking orange tigers, but the quetzal bird dominates all. At the center of an area of angry red, the quetzal's head crowns the body of the serpent. The frescoes discovered in 1963–64, especially those in the basement of the Temple of the Plumed Snails, are in the characteristic style; the motifs are outlined in black and then filled in with the appropriate colors (with which, sometimes, the earlier drawing is corrected). Some of the frescoes represent intertwined jaguars similar to those at Tetitla.

Although a great deal is already known of this ancient Mesoamerican culture, Teotihuacán continues to pose complex and inscrutable enigmas, and they will probably remain enigmas forever. Teotihuacán is profound and secretive; it displays much on the surface, but it buries much in the depths of the earth.

The Toltecs

Around the time of the destruction of Teotihuacán, a barbaric people, known generically as Chichimecs (descendants of a dog) were living in the north of the central plateau. Gradually, these barbarians acquired the customs of the older civilized people and became known as Toltecs (citizens of Tollán), after their capital, Tula. They lived in an area comprising roughly the present Mexican State of Hidalgo, which they shared with two other groups, the Olmecs and the Nonoalcas. From the latter, they adopted the cult of Quetzalcóatl (which they subsequently spread throughout Mesoamerica) as the mythical incarnation of their hero and founder, whom they worshiped under this name.

Toltec architecture is majestic; the structures have sustained horizontal lines, stepped profiles, rectangular panels topped by frets. All is governed by geometric, cubic, cylindrical masses. Within these general outlines, the Toltecs developed several distinctive forms: realistic anthropomorphic sculpture; enormous atlantes (at Tula, four-sided columns depicting male warriors); the representation of Chacmool, an unidentified deity shown as a reclining man with his head and knees elevated and holding a bowl on his stomach; carved friezes of eagles devouring hearts; walls adorned with a rhythmic series of skulls, known by the Maya term *tzompantlis;* monsters in the shape of a jaguar with a human head.

At the end of the tenth century A.D., internal wars forced Quetzalcóatl into exile. A branch of the Toltec family then established itself

in the northern part of Yucatán, where they made a decisive impact on the Maya (*see Chapter 3*).

Monte Albán

Let us try to imagine the feelings of Alfonso Caso, in January of 1932, when he discovered Tomb 7 at Monte Albán. Within this sunken chamber, providentially saved from the greedy hands of hunters, traders, and adventurers, lay a treasure of more than 500 objects of gold, silver, jade, turquoise, rock crystal, and pearls, mostly fashioned with filigree work. Subsequent studies by Caso and Ignacio Bernal (between 1932 and 1952)—the most exhaustive carried out in any single area in Latin America—have illuminated numerous facets of the

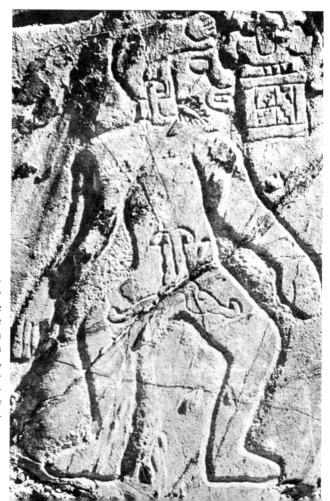

I-9. Figure of a "dancer," the name popularly given to the life-size bas-reliefs at Monte Albán. Dating from the first Monte Albán period, the drawings, incised in stone in a continuous curve, have evident Olmec traits (*see Ill.* I-3). Valley of Oaxaca, Mexico.

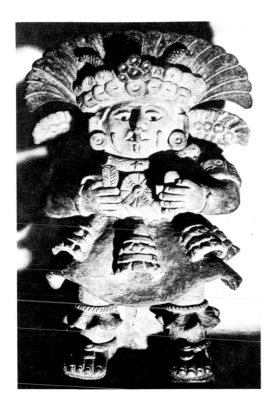

I-10. Zapotec terra-cotta urn, representing an agricultural deity, probably Yopi, the Lord of Flaying, or renewal. Both the fish-scales on the skirt and the ruffled cuffs of skin on the legs refer to the divinity's manifold attributes. Monte Albán III. Valley of Oaxaca, Mexico.

Monte Albán culture, brought to its zenith by the Zapotecs of Oaxaca, in Central Mexico.

During the more than 2,000 years of Monte Albán's history, five consecutive and distinct styles developed. The earliest period, designated Monte Albán I (ca. 700–300 B.C.), produced accomplished ceramics and monumental architecture, faced with singular stone bas-reliefs. These include the series known by the popular and dubious name of "the dancers"—"los danzantes"—(*Ill. I-9*) due to the dynamic movement of the bodies. Dated about the fifth century B.C., these figures have anatomical distortions that indicate Olmec influence: thick lips and noses, flattened chins. Strange flowers and symbolic foliage over or around the sexual organs are among the elements that make these figures—characteristic of an advanced culture—enigmatic. The later periods (Monte Albán II and III A and B) were contemporaneous with the greatest splendor of Teotihuacán, and there is evidence of direct communication between these two cultures.

At Monte Albán, the basic formal characteristics are summarized in the architecture and the funerary urns. These urns (*Ill. I-10*), offered

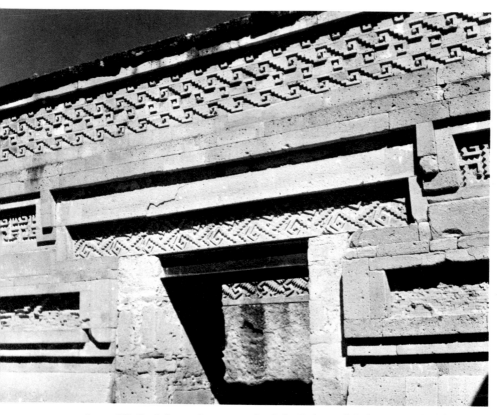

I-11. Wall of the main courtyard of the Palace of Columns, Mitla. The stone frets are meticulously repeated within each panel, but each panel of designs is different. Monte Albán V or Mixtec culture. Valley of Oaxaca, Mexico.

in homage to the dead, depict either Yopi (the Xipe-Tótec of the Teotihuacán hagiology) or Cocijo, Zapotec deity of rain and thunder, adorned with attributes of the jaguar and serpent. The movement toward baroqueness is very apparent in the urns produced over the 2,000 years of the Monte Albán culture; their evolution is marked by the increasing resort to symbolism, ornamentation, and scrollwork, culminating at the end of the Monte Albán III period.

The tombs also exhibit growing structural and ornamental skill. The walls, especially those of Period III, are decorated with frescoes.

A protective god, modeled in clay, guards the door from a central niche.

By the end of Monte Albán III B, the city was abandoned and maintained only as a necropolis where nobles and priests of high rank were buried. The work of this period constitutes Monte Albán IV. Around 800, the Mixtec style began to dominate in the Oaxaca Valley. The architecture, ceramics, and metalwork produced under this influence are now designated Monte Albán V. Evidences of this final Monte Albán style are reflected in Tomb 7 and in the palace at Mitla, about 20 miles southeast of Monte Albán, dedicated to Quetzalcóatl. The stepped spiral, or *xicalcolinhqui*—often aptly compared to the meander, or Greek fret—adorns the surfaces of the walls in a variety of original forms (*Ill. I-11*). Mitla further exhibits structural solutions that made its architecture earthquake-proof.

The Gulf Cultures

Several cultures developed along the Gulf of Mexico at roughly the same period, starting sometime prior to 1000 B.C. Geographically, they fall into three somewhat imprecise zones: (1) El Tajín, between the Cazones and Papaloapan rivers (an area running from north of Mexico City to south of Veracruz); (2) to the north, Huasteca, around the city of Tampico, which displayed a number of independent character-

I-12. Concern with the underlying dualities in the universe permeated pre-Columbian art from the ancient Olmec cultures of Mexico to the distant Chavín in Peru. The theme was often expressed in a sculpture of a face as in *Ill. I-5* and in this El Tajín piece. Mexico.

istics; and (3) the Olmec region, extending south to the first Maya city, Comalcalco, near Villahermosa.

Architecture in El Tajín, especially the Pyramid of the Niches, and the Huastec cities was significant, but the truest expression of these cultures is found in their clay sculpture and stone carving. However, El Tajín's art is permeated with concepts and forms that belong to other contemporaneous Mesoamerican cultures (*Ill. I-12*)—the Olmec, Teotihuacán, Maya, and Monte Albán—and examples of it are found throughout a vast region that extends as far as present-day Honduras. This interplay of ideas is especially manifest in the Cerro de las Mesas (Hill of the Tables), in the center of the State of Veracruz; it is almost a catalogue of eclecticism, with its colossal stone heads, like those of the Olmecs at La Venta; steles and tablets incised with extremely complex bas-reliefs, similar to those of the Maya; and clay sculptures, such as the figure of the famous Old God of Fire, certainly linked with Teotihuacán.

The Gulf cultures also developed several artistic forms of their own, notably the "yokes," "axes," and "palms." Convincing explanations of their use have not yet been produced, but many believe that the "yokes"—U-shaped stones—represent the wide belts used by the ball players in ritual games (*Ill. I-13*). The dimensions of the numerous examples extant are similar: about 18 inches long, with a 12-inch span, enclosing an opening of 6–7 inches. All are covered with filigree carvings, except on the lower surface. In the finest "yokes," the ends have marvelous bas-reliefs, sometimes of human profiles. The "axes"—stylized stone heads whose general contours resemble ax blades—are similarly incised, but the volutes on the axes are even more schematic in design (*Ill. I-14*). On some, there are heads or footprints; on others, helmets in the form of fishes or birds. The "palms"—palm-shaped stones—are very varied in shape (*Ill. I-15*). They, too, are decorated with swirls and original designs: acrobats, elaborately dressed personages, birds, and reptiles. Elegant disk-shaped mirrors, with richly carved backs, were also produced by the Veracruz craftsmen.

Because of the large number of structures still standing at El Tajín —including many temples and no less than six ball courts—it ranks as the most important architectural complex yet unearthed on the Gulf coast. At the center of this politico-religious city, founded in the second century A.D. by the Totonacs, stands a colossal pyramid with six stepped levels. At each level as the staircase ascends, there is a series of niches, 364 in all. The function of the niches has not yet been deter-

I-13. "Yokes" were generally sculptured in basalt or andesite, less frequently in serpentine or, as here, diorite-porphyry. El Tajín culture. Mexico.

I-14. Marble "ax," with a cutout figure that may represent an acrobat. Since the back face of the axes usually was finished with a peg, it is assumed that they were designed to be inserted into a wall. El Tajín culture. Mexico.

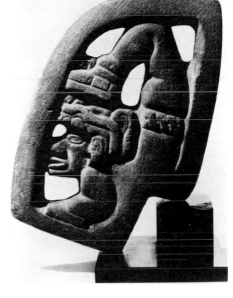

I-15. Stone "palm," probably in imitation of the decorated chest shield worn by ball players. The stones known as "palms" were fashioned into triangular prisms with a hollow at the base, which might have fitted into a belt. El Tajín culture. Mexico.

mined, but they provide a fascinating and unusual decoration with effective contrasts of light and shade.

Among the structural innovations El Tajín exhibits are large open windows and enormous roofs constructed so solidly that, despite their size (one covers an area of more than 95 square yards), they were not supported by columns or, even more surprising, by beams.

The most famous and most sought-after clay sculptures of the Veracruz region are the laughing figurines in the Remojadas style (*Ill. I-16*), named for the place where they have chiefly been found. Seldom have a people so consistently sustained an expressive form that is both realistic and warmly humorous. The flattened triangular faces, the elongated legs and arms, the groups of dancers, of gossips, of houses and farm workers' huts provide a literal portrait of a society that wanted to perpetuate itself in its most genuine attitude—a congenital gaiety.

In the course of its 2,000 years of existence, the Huastec culture has probably displayed more continuity and uniformity than any other in Mesoamerica. Today, in Tancanhuitz, potters still turn out creamy earthenware decorated in black, as did their ancestors centuries ago.

In addition to ceramics, the ancient Huastecs were skilled weavers and worked shell inventively. Their most finished work was limestone

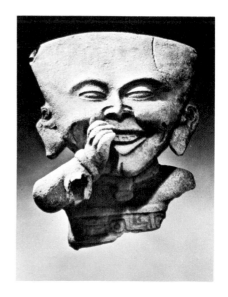

I-16. Unlike most pre-Columbian art, which was essentially religious in function, the art of Remojadas is, as William Spratling observed, "more human than divine." The faces do not merely smile; they laugh frankly. Veracruz, Mexico.

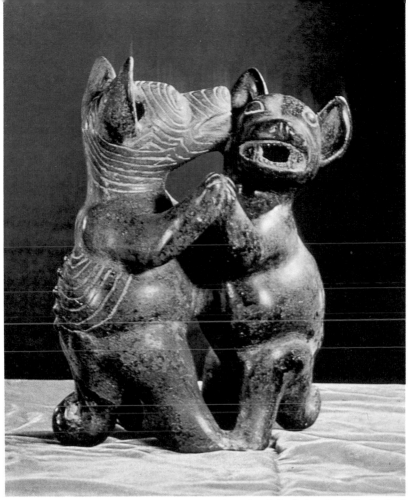

I-17. Dancing Colima *techichi* dogs in hand-modeled fired clay. Both the incised patterning of the figure at left and the smooth surface of the one at right were common ways of handling the red slip among Colima potters. Western cultures. Mexico. (*See p.* 21.)

statuary, in which anatomy is typically rendered in geometric terms, as in the initial Teotihuacán period. Frequently, the figures bear a representation of death on the back. Despite the architectonic implications of their statuary, little has been discovered about their architecture. Among the Huastec structures known today, the finest is the Pyramid of the Flowers (ca. A.D. 700–1000), which has a conical temple on its upper platform.

The Mixtec-Puebla Culture

From the clouds shrouding the Oaxaca mountains, the "people of the rain" derived their name—Nusavi—and they called their land Mixtecapan ("land in the clouds"). Little is known of the origin of the Mixtec culture, but it began to manifest its unique forms in the tenth century, over a vast area that encompassed the center and south of the present State of Veracruz, the states of Puebla and Tlaxcala, and part of the states of Guerrero and Morelos, as well as the Valley of Mexico and the mountains to the east of Oaxaca. Because of the Mixtecs' influence on Puebla, the two cultures are often spoken of jointly.

The delicacy, refinement, and exquisiteness of the Mixtecs' applied arts are notable (*Ill. I-18*). Besides the architecture and sculpture, one can trace the evolution of a whole civilization of excellent craftsmen in the bone and wood carvings, the feather mosaics, the metalwork, stone as finely chased as if it were soft gold, and especially, the ideographic painting in codices, ceramics, and frescoes.

Mixtec ceramicists made notable innovations in form, often incor-

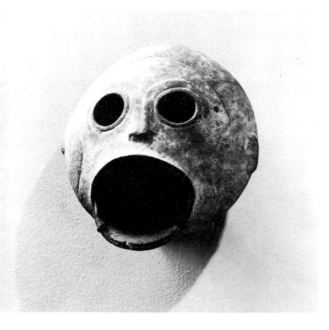

I-18. The head of a monkey in this fired-clay jar displays sophisticated stylization and masterful observation. Monte Albán V or Mixtec culture. Valley of Oaxaca, Mexico.

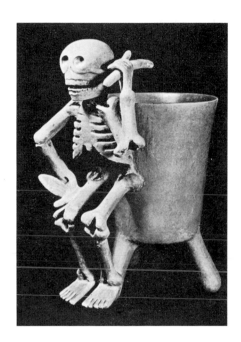

I-19. Mixtec ceramic tripod vase, with a skeleton leaning on it. The theme of death occurs very frequently in Mixtec and Toltec art. Zaachila, Mexico.

porating sculptural elements, as in the famous biconic vessel found in El Volador, near Mexico City, from which a three-dimensional skull projects, and in the tripod vase with a skeleton leaning on it (*Ill. I-19*).

The Mixtecs' skill in carving hard stone was extraordinary. Rock crystal, jadeite, amethyst, opal, obsidian, jet, and agate were fashioned into people with elaborate attire, animals in various attitudes, stylized men. Similar techniques were employed in sculpturing bas-reliefs on ceremonial wood and bone objects, such as the spatulas of jaguar bones found in Tomb 7 at Monte Albán.

One of the most important contributions the Mixtecs made to Mesoamerica was disseminating their masterful techniques for working silver, copper, and gold. They made pectorals (*Ill. I-20*), protective nose shields, masks (*Ills. I-21 and I-22*), pendants, buckles, and numerous other items, either by hammering the metal into the desired shape (the *repoussé* technique) or casting by the lost-wax (cire-perdue) process.

Although the motifs of the bas-reliefs closely resemble those of the codices, it is the latter that are the most revealing of the Mixtec arts.

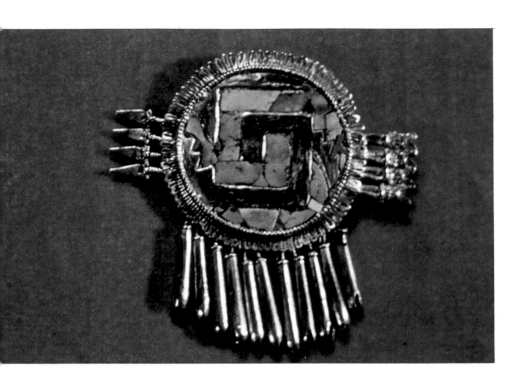

They teem with people, plants, gods, animals, mountains, clouds, wells, aside from countless random elements and symbols that frequently exhibit total and truly plastic stylization.

The Aztecs

The forces harnessed and unharnessed by creation; birth and destruction united in a single being; the beginning and end of all; illumination and death. This is the goddess Coatlicue, who wears a skirt of serpents, which are jets of blood; who consumes filth and impurities, which are her countless sons (*Ill. I-23*). She is the sum of elements, concepts, and ideologies that, in modern terminology, might be called the surrealist aspect of power.

Here must be the key to interpret whatever can be interpreted of Aztec culture and art. This reality of pre-Columbian Mexico might explain many constants persisting in Mexico since. Coatlicue is the quintessence of a mode of expression that the Renaissance Iberian

I-20. Mixtec shield-shaped pectoral pierced by four arrows and decorated with turquoise mosaic and a fringed border, from which bells hang. The Mixtecs introduced metalworking into Mesoamerica and developed it to its highest level. Yanhuitlán, Mexico.

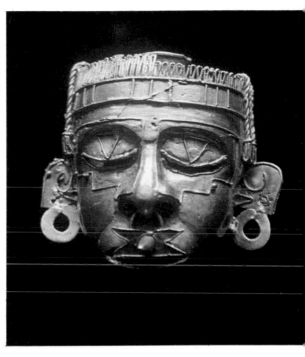

I-21. Gold mask depicting the god Xipe-Tótec, found in Tomb 7, Monte Albán. This is an example of the Mixtecs' skill in casting by the "lost-wax" technique. Mixtec culture. Valley of Oaxaca, Mexico.

conquerors abhorred and tried to stamp out, and with her died the elements of this art that could not be confined within the European framework.

In form, the goddess was a four-sided cyclopean block, with two fronts of similar importance. More than sculpture, her representation

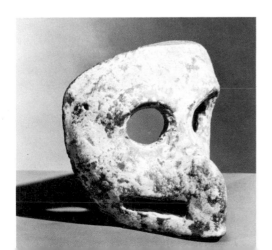

I-22. Mask of a bird god in fired clay. Although its origin is unknown, this piece shows stylistic kinship with the head of a monkey from Monte Albán (see Ill. I-18). Mixtec-Puebla culture (?). Mexico.

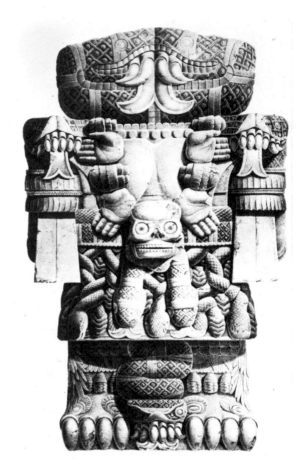

I-23. The Aztec goddess Coatlicue. This dominating deity was the mother of the Gods of War and of the Moon and the Southern stars. She was also the Goddess of the Earth and of Death. Engraving after Karl Nebel. Mexico City.

is an architectural work adapted to a remotely human configuration. Where the waistline should have been, there is a skull. Instead of a face, the goddess has two serpent heads. There are serpents on all sides: in the stumps of the arms, in the hands, on the skirt. On her bosom hangs a necklace of amputated hands and hearts.

Coatlicue was found beneath the Zócalo, the central square of both ancient and colonial Mexico City. Here, many other significant objects were unearthed: the monumental solar stone, usually called the Aztec calendar stone (*Ill. I-24*); the monument to Tizoc, who ruled the city between 1481 and 1486; the stone jaguar where the hearts of sacrificial victims were deposited. These are some of the many indications that this was the site of Tenochtitlán, city of canals, with bridges over Lake Texcoco, zoological gardens, and markets (*see Ill. III-18*). Its nobles were so extraordinarily refined that when they were forced to

come near the Spaniards, they screened their nasal passages with branches of fragrant flowers.

Tenochtitlán, the capital that the Spaniards conquered and destroyed, was the culmination of an imperial metropolitan civilization. It was the Rome of a vast dominion kept subject by terror, by a cult of violence and blood. Consequently, Aztec art was imbued with the dread, drama, and grandeur necessary to dazzle the subject peoples and convey the image of an omnipotent and implacable state.

These effects were achieved through monumentality and flawless techniques (*Ill. I-25*), as well as graphic vigor capable of stylistic contrasts that ranged from objective and austere realism, in representations of men and animals, to abstraction utterly incomprehensible to the common people.

It is not easy to distinguish the elements of this art that are exclusively Aztec. A barbaric and powerful people, the Aztecs conquered first and afterward assimilated the attainments of those they subjugated (*Ill. I-26*). A certain cubist archaism in the form and volume of sculpture, controlled, like that of western Mexico, by an architectonic concept, was the departure point for an art subsequently modified in passing through the hands of the Toltecs of Tenayuca (near Mexico City).

The chief temple of Tenochtitlán was a copy of that in Tenayuca, the center of Toltec culture after the abandonment of Tula, and Aztec

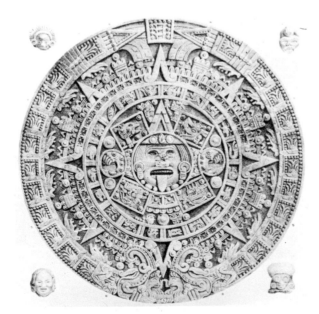

I-24. The Aztec calendar stone, a compendium of contemporary ideas about the universe, was completed after 1502. Engraving after Karl Nebel. Mexico City.

I-25. Plumed serpent with the head ▶ of a warrior. The harmony of proportions and the expressive energy of this Aztec figure justify Henry Moore's enthusiasm for the "stoniness" of Mexican pre-Columbian art. Mexico City.

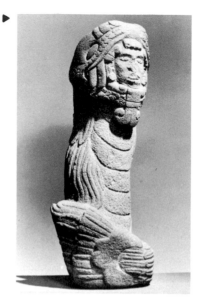

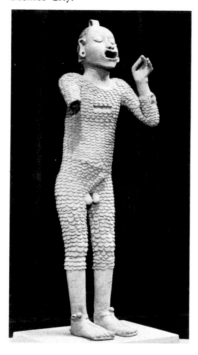

◀ I-26. Xipe-Tótec, who was called "Our Lord of Flaying," because in Mixtec manuscripts and sculpture he is shown clothed in the skin of a human victim. For the Aztecs, Xipe-Tótec was the God of Spring; his skin covering represented the burgeoning shoots of new plants after the spring rain. Aztec culture. Puebla, Mexico.

techniques and themes were similar to those of the Toltecs: eagles devouring hearts, walls of serpents, profiles of skulls in rhythmic series. However, they also incorporated the decorative symbolism of the Mixtec-Puebla culture. Although the Aztecs endowed the motifs of the Mixtec codices with a third dimension, they painted their precise reliefs in Mixtec colors: ocher, black, white, rose, crimson, blue, turquoise, and olive green.

A further consideration in isolating purely Aztec elements is whether the pieces found at Tenochtitlán were sent in payment of tribute to the Aztec rulers or were created by Mixtecs working in the capital. Certain pieces, however, are distinctly Aztec in feeling, because of

40

their subject or the medium employed: the obsidian vessels, the rock-crystal skulls, the jadeite statue of the god Xólotl, brother of Quetzalcóatl, or the famous green aplite figure in the Bliss Collection, at Dumbarton Oaks, in Washington, D.C., which represents the Goddess of the Earth, Tlazoltéotl, giving birth to the God of Corn, Centéotl (*Ill. I-27*).

From the central plateau, through the mountain regions, to the tropical lowlands along the Gulf of Mexico, the art of the pre-Columbian peoples of Mexico exhibits an extremely diverse range of themes and motivations. It is unified, however, by certain common concepts, among them: a similar approach to city planning, and in the major structure, the pyramid, the unquestioned dominance of the sloping *talud* motif, along with the invariable use of stairways and of multilevel stepped profiles. In all these cultures, the plastic arts—sculpture, ceramics, paintings, goldwork—make vigorous, often expressionistic, statements.

Clearly, there is a profound difference between the vision that underlies the objective realism of the cultures of western Mexico, on the one hand, and the vision that issues in the baroque complexity of the Monte Albán urns, on the other. Nevertheless, there is a common spirit, which derived from the forms introduced by the Olmecs and was synthesized by the Aztecs in drawing on the achievements of all of pre-Columbian Mexico.

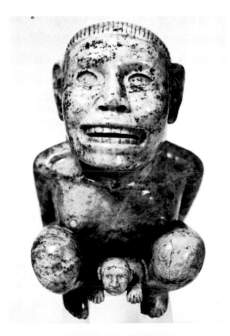

I-27. The Aztec goddess Tlazoltéotl, the "Mother of God," in the act of giving birth to Centéotl, God of Corn. Besides being the "creator" of corn, this goddess had the power to pardon—once in a lifetime—the sins of men. Mexico City (?).

3

The Maya

In his bibliography of works written between 1514 and 1960 on Mexico and the rest of Mesoamerica, the Mexican archaeologist Ignacio Bernal listed an astonishing total of 5,315 works dealing with Maya civilization—in addition to almost 2,000 general items, many of which contain information and studies on the Maya.

This figure is eloquent testimony to the interest aroused by Maya culture, beginning centuries before Alexander von Humboldt's pioneering scientific explorations, in the early nineteenth century. It indicates, as well, the depth and dedication of legions of investigators, who vie with one another in tributes to this civilization of architects, carvers, painters, city planners, and savants. In the field of astronomy alone, the Maya perfected knowledge of the calendar, of the movements of the solar system, of applied mathematics, to a level—at least in the case of the calendar—superior to that of the most advanced European cultures of the time.

The Maya civilization flourished chiefly in hot lowland areas, territories that are today southeast Mexico, British Honduras, Guatemala, half of Honduras, and a strip of El Salvador. Among the Maya, there was an identity of ideas, techniques, and scientific knowledge that gave this culture—despite regional variations—an extraordinary unity in time and space. For example, the development of primitive agriculture stretched over several hundred years (between the eighth and fourth centuries B.C.), known as the Mamom period, during which very simple ceramics were fashioned. Then came a gradual perfecting of decorative forms and themes, in the Chicanel period (between the fourth century B.C. and the fourth century A.D.). It was during this time, in the second century A.D., that the Maya built their first great city, Uaxactún. This city seems to have served as an early model for Maya architecture and city planning. In its ruins, Olmec influences can clearly be discerned—in the fabulous creatures, half dragon and half jaguar, with bulging

eyes, large ears, and ferocious tusks that jut from an enormous mouth. At the same time, structural elements of Maya art can already be distinguished: the stone steles, astronomical observatories, and especially, the corbeled stone vaults resembling a pointed arch—a formal sign of Maya architecture from then on.

Tikal, Copán, Palenque

According to Herbert J. Spinden's chronology (by far the most accurate available), the golden age of Tikal, Copán, and Palenque lasted from the fourth through the eighth centuries A.D.

The art of Tikal displays many elements in common with the overall style of El Petén, the central region of Guatemala, the site of such important cities—besides Tikal—as Uaxactún, Holmul, and Nakum. Because of their proportions and the smallness of the cubicle that served as a sanctuary, the pyramids at Tikal seem less cult temples than strategic forts. Their solid, dense volumes contrast with the audacity of the general outlines. The immense surface is broken and relieved by steps, and both the *talud* and the *tablero* are angled to conform to the slope of the whole structure. Roof combs enhance the freedom and elegance of the pyramids, and the dramatic effect is heightened by grotesque stucco masks. These figures ultimately covered the façades, and because of their dual function as both architecture and ornament, they accelerated the process of stylization, which emerged at the same time as the first pure decoration—representations of Chac, the God of Rain, and of Itzamna, Goddess of the Heavens.

These fabulous creatures also appear on very ancient edifices at Uaxactún, and in time, they proliferated in El Petén and Yucatán, hewing more strictly in each appearance to an axial symmetry. The basic design of these creatures became stereotyped as it was adopted throughout the region, but the elements were combined and recombined in endless variations.

In Tikal, these masks are placed at regular intervals around the upper portions of various buildings. This rhythmic repetition constituted a basic law of Maya ornamentation and over the centuries became the prime characteristic of the Puuc style (named after the Puuc hills of southwestern Yucatán).

The graceful proportions of the buildings contrast with the complex and elaborate designs in the bas-reliefs on the stone steles and on the wood of the interiors. The bas-reliefs in Tikal, Copán, and Palenque are a carved facsimile of the jungle, although with a rightness and

43

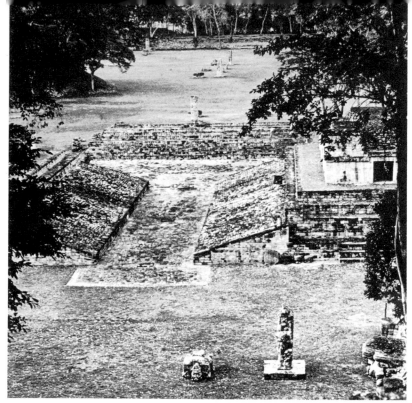

I-28. The Ball Court at Copán: foreground, an altar and Stele D, both dating from A.D. 736. The court as a whole is 78 feet long and 21 feet wide. Maya culture. Honduras.

I-29. Altar G, in the square at Copán, represents à monster with an intricate form. Considered the most recent work at the site, it is dated at A.D. 800. Maya culture. Honduras.

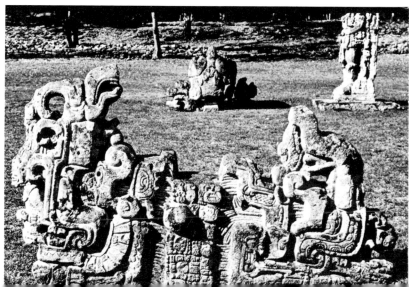

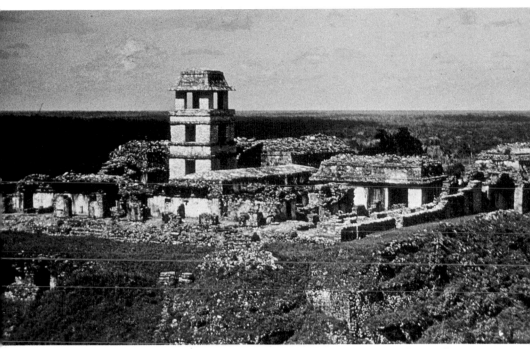

I-30. The Palace at Palenque, consisting of several structures grouped around courtyards and dominated by a square tower 45 feet high. Maya culture. Chiapas, Mexico.

order in the placement of figures, achieved, once more, through increasing stylization. The contradiction between the proliferation of plastic ornamentation in sculpture and painting and the purity of architectural works is characteristic of the entire El Petén region.

Farther south, in present-day Honduras in the basin of the Motagua River, stands the unique city of Copán (*Ill. I-28*). Its most strikingly original creation is a form of high-relief sculpture that today we would call figurative. No other Maya site displays such profuse and skillful integration of statuary within the architectonic whole. The structural blocks of green trachyte are transformed into sculptural figures with no sacrifice of their regularity and function.

In Copán's statuary, its altars (*Ill. I-29*), and high-relief steles, with faces shown frontally, the three-dimensional concept of volume, the complexity of the ornamentation, and the horror vacui reflect a very

45

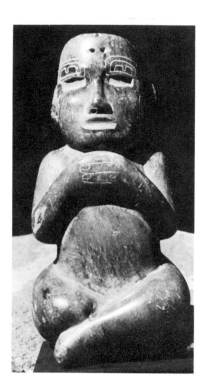

I-31. Jade statuette found in the most ancient part of Uaxactún, in the Petén region of Guatemala. It displays Olmec traits, such as incised eyebrows, thick lips, and the bare head. Maya culture.

different kind of baroqueness from that of the Gulf Coast or central Mexico. These tendencies are even more apparent in Palenque, which typifies the art of the Usumacinta River Basin. Here, the craftsmen utilized another material that was conducive to the full expression of their subtle and elegant baroque sensibility—stucco. The finest works in this medium are the heads in the crypt of the Temple of the Inscriptions, notably, the famous representation of the beheaded warrior. The plasticity of stucco also made possible the elaborate reliefs that adorn the temples and the Palace at Palenque (*Ill. I-30*), which were painted in dazzling colors, to judge from the fragments rescued from the ravages of the jungle, fires, and humidity.

Besides the stucco heads, in different periods, styles, and regions, the Maya developed refined techniques for making objects of jade (*Ill. I-31*), ceramics, and terra cotta, and for stone and wood sculpture. Among the most famous of these pieces are the wooden statue (one of the very few in that material that have survived) in the Museum of

46

I-32. This masterpiece is carved in a hard wood the color of dark coffee. Pieces of red hematite remain in some parts of the figure, suggesting that it was originally incrusted with stones. Maya culture. Tabasco, Mexico.

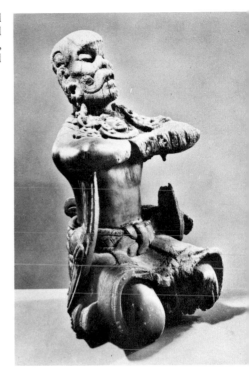

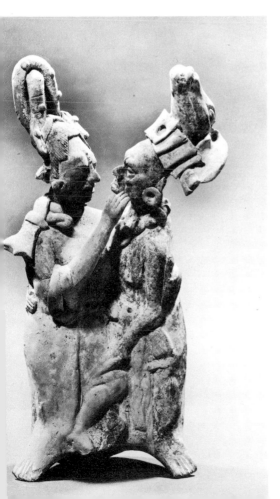

I-33. Whistle in the Jaina style, showing an old man and a young girl embracing. The little island of Jaina, off the coast of Campeche, produced ceramics in a distinctive style that exhibited refinement, elegance, and dynamism. Maya culture. Mexico.

Primitive Art in New York City (*Ill. I-32*) from Tabasco; the realistic and elaborate sculptures from Jaina, a small island in the Gulf of Mexico off the coast of Campeche (*Ill. I-33*); and the jade mask of a Maya prince from Palenque (*Ill. I-34*).

The Río Bec, Chenes, and Puuc Styles

Between the seventh and ninth centuries A.D., new styles emerged on the Yucatán Peninsula. Río Bec borders on central Guatemala, and consequently, the towers found here are similar to those at Tikal. In the false temples that crown the pyramids and especially in the copious decoration that completely covers the façades, the Río Bec style is likewise related to that of the Chenes, which borders it on the north.

To carry out their ornamental aims on a grand scale, the people of the Río Bec region buttressed the fragile stucco with stone supports whose intricately crossing surfaces came to constitute true mosaics. The Chenes artisans indulged their passion for ornaments in a rather more stylized manner than was practiced by their neighbors of Río Bec. As their ornamental vocabulary evolved, the obvious representations of flora and the anthropomorphic or zoomorphic figures were transformed in both styles into extremely varied geometric forms, increas-

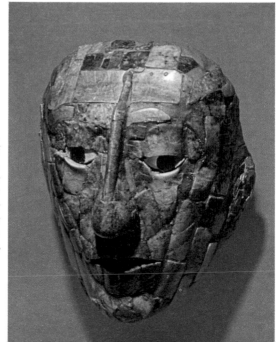

I-34. Jade mosaic mortuary mask, with eyes of shell and obsidian pupils. This mask covered the face of what was probably a prince interred in the crypt of the Temple of the Inscriptions, at Palenque. Maya culture. Chiapas, Mexico.

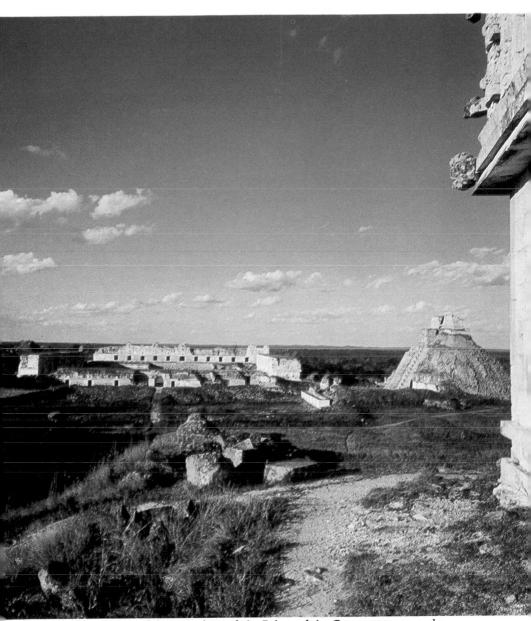

I-35. Uxmal, viewed from the base of the Palace of the Governors; center, the Nunnery Quadrangle; right, the Pyramid of the Magician. Maya culture, Puuc and Chenes styles. Yucatán, Mexico.

ingly abstract and at the same time simpler. This stylistic development must have delighted its originators, for they literally smothered the façades of their buildings with schematic masks of Chac, the God of Rain, coursing in rhythmic patterns.

Chac was transported to the north and incorporated into the Puuc style, but in the north—unlike in the Río Bec and Chenes areas—stone mosaic was not yet in use. The difference can be seen in the west façade of the Pyramid of the Magician at Uxmal (*Ill. I-35*) and the façade of the Annex of the Nunnery in Chichén-Itzá (*see Ill. I-2*). The Puuc walls are plainer, and the decoration is concentrated on the top-most level. When there are bands of vertical ornamentation, a broad molding is placed to link them with the wall. In certain Puuc-style buildings, there are singular carvings consisting of false columns in the form of grouped banisters, for instance, in the Nunnery Quadrangle at Uxmal (*Ill. I-36*), in the Palace at Labná, and in the House of the Turtles at Sayil. Some scholars consider this original design a vestige of wooden construction, a kind of petrified bundle of sticks.

In the Puuc style, the tendency toward stylization is even more pronounced than in the south. The rhythmic repetition of Chac's image reaches its climax in the façade of the Palace at Kabah, which has 250 masks, each composed of 30 elements.

Maya-Toltec Art

Chichén-Itzá embodied the ultimate splendor of the Mayas. Today, the spectacular restored city shows the fusion of two cultures—the ancient

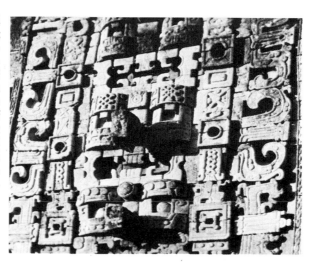

I-36. Detail of the wall of the northern building in the Nunnery Quadrangle, at Uxmal. The ornamentation consists of superimposed masks with teeth and elaborately worked ears. Instead of protruding, the great trunklike noses of the god Chac are enclosed to curl back upon themselves. Maya culture, Puuc style. Yucatán, Mexico.

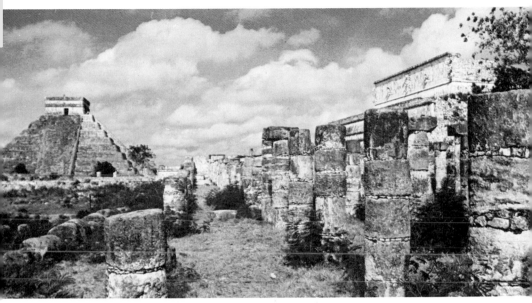

I-37. Chichén-Itzá's newer sector shows clear Toltec influence. In this partial view: right foreground, a portion of the Thousand Columns; behind, the terrace of the Temple of the Warriors; left, the Castillo (Castle). Maya-Toltec culture. Yucatán, Mexico.

Maya and the imposed Toltec—that interpenetrated and complemented each other. In fact, if the old Chichén preserved unmistakable evidences of the Puuc style, the new is astonishing because of the symbiosis between the native art and that of a people who were foreign and, artistically speaking, antagonistic in their essential features.

According to a Maya chronicle, the Books of Chilam Balam, about A.D. 495 a group of strangers from the south called Itzás occupied the old Maya city of Chichén, which they ruled for about 200 years. At the end of the tenth century A.D., allied with a group of Toltecs from Tula (to whom they may have been related), they were again able to occupy Chichén.

At Chichén, the Toltecs had found a developed city, with outstanding structures in the Puuc and Chenes styles and local variants reflecting a curvilinear concept in architecture. Among the most perfect examples at Chichén that are properly Maya in style are the ruins of the Nunnery, its Annex or east wing, the Iglesia (Church), and the Caracol (Snail, a spiral observatory). Besides altering the Caracol

51

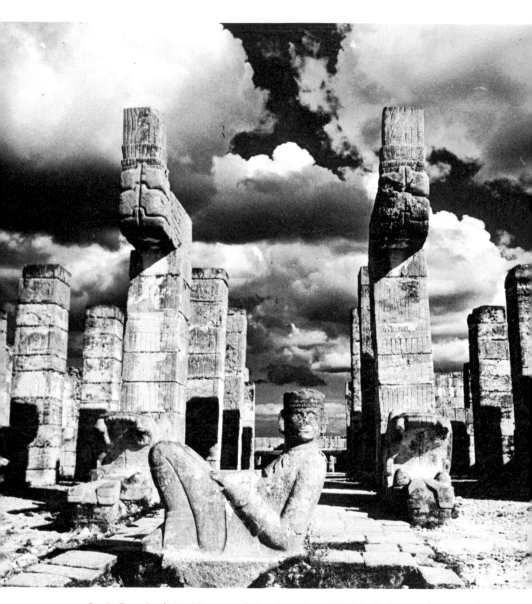

I-38. Portal of the Temple of the Warriors, Chichén-Itzá, presided over by the statue of the Toltec god Chacmool. Originally, the two flanking serpents supported a lintel upon their tails. To the right appears a characteristic Puuc decoration with masks of the Maya rain god, also called Chac, repeated over and over. Maya-Toltec culture. Yucatán, Mexico.

and the east wing of the Nunnery, the Toltec Itzás erected the Castillo (Castle), the Temple of the Warriors, the Courtyard of the Thousand Columns (*Ill. I-37*), the Tzompantli, and the great Ball Court.

The Nunnery has a stepped fretwork of dadoes sculptured with floral elements resting on small columns. The latticework and masks on the so-called Annex of the Nunnery, as well as the symbolic representations of the god Chac, link this building with the Puuc-style structures at Uxmal. On the other hand, the outrageously ornate eastern façade is covered with innumerable masks (of the God of Rain) that reiterate a single concept, as in the Chenes style. The mixture of the Puuc and Chenes styles is even more evident in the Iglesia. The roof combs heighten the decorativeness of the façade and set off the profiles of Chac's nose jutting from the corners.

In the new Maya-Toltec section, the Castillo stands out because of its massiveness; it is a pyramid of nine stepped levels, and on each of the four faces, stairs rise between pairs of serpents. In the interior, there is a smaller but identical pyramid. A spirited Chacmool reposes in the antechamber of this inner temple, and in the sanctuary itself is a red jaguar encrusted with jade spots.

The Ball Court is similarly vast (576 feet long). A carved stone ring projects from both its vertical walls. This was the hole through which the ball had to pass in ritual games. At one end stands the Temple of the Jaguars, with two columns in the form of a serpent.

The Temple of the Warriors exhibits the happy blend of Toltec and Maya elements, although its structural components are identical to those of a building at Tula. At Chichén, however, functional requirements, arising from the desire to achieve a central focus, led to technical advances in hypostyle halls. In Tula, simple roofings of wood and straw had been used; in Yucatán, a harmonious combination of rows of pillars and columns was obtained by means of the Maya stone vault. On the lower floor of the Temple of the Warriors is a hall with parallel passages and an open façade with a vault that constitutes an extraordinary architectonic feat.

The upper level of the façade is dominated by the Chacmool, flanked by two monumental columns of the plumed serpent (*Ill. I-38*). Their enormous mouths, flush with the floor, extend into their bodies, which form the shafts of the columns. Their tails, bent parallel to their heads, served to support the lintel of the door, which presumably was wood and decayed or burned centuries ago. The motif of the open throat of the serpent is repeated at both the base and the top of the stairs.

I-39. Grotesque carved face in which the artist utilized the natural contours of a seashell in carrying out his whimsical concept. Mayapán culture. Yucatán, Mexico.

Eagles, jaguars, and skulls are depicted in low relief on some of the walls. The pillars of the hypostyle hall are carved with warlike themes and human figures, and small atlantes support the temple altar.

Perfection in hypostyle construction was attained in the Thousand Columns, which originally covered more than 1,500 square yards. The movement from pillar to column permitted passage in all directions, and immeasurably heightened the sense of freedom.

The Itzás maintained their power and their new Maya-Toltec style of architecture for about two hundred years. Then both power and style shifted to Mayapán, a walled city-state west of Chichén-Itzá. Although the art of Mayapán is generally considered "decadent," it was there that the most baroque and most elaborate of all Maya ceramics and carvings were produced (*Ill. I-39*).

The cenote has played a decisive role in the history of Yucatán and in Maya civilization. This geologic phenomenon is thought to be formed when a limestone crust collapses at ground level, revealing a large underground reservoir. Cenotes are the prime source of water for many towns of the peninsula, but their sacred function has been even more significant. Early in the sixteenth century, Diego Landa, Bishop of Yucatán, described the rites of human sacrifice practiced by the Maya, especially the hurling of victims with their jewels into

the Cenote Sagrado (Sacred Well). Three hundred years later, a shrewd North American, Edward S. Thompson, who knew Bishop Landa's descriptions, bought the Chichén-Itzá property. More a treasure hunter than an archaeologist, Thompson dug through the ten feet of mud that covered the cenote to extract enormous numbers of objects of jadeite, ceramic, alabaster, copper, and gold, which he sold to the Peabody Museum, at Harvard. In 1952 Samuel K. Lothrop published a detailed study of the finds.

Of the varied objects recovered from the Cenote Sagrado, two main groups are particularly noteworthy: first, the series of gold disks that depict combats between the Maya of Yucatán and their Toltec conquerors, human sacrifices, combats between gods and monsters. Almost all of these are profusely embossed with skillful *repoussé* work. The second group provides proof of an inter-American commercial interchange, at least in goldwork and personal adornments: pieces with anthropomorphic crocodiles and polychromed ceramics from Coclé in Panama, pendants in the fashion of the Quimbayas of Colombia.

The fascination that Chichén-Itzá and its cenote exercised over the Toltecs and the Maya takes new forms today. For the twentieth century, the awesome magic cannot be recaptured, but Chichén remains unique for its fusion of the most important structural, formal, and ornamental elements of pre-Columbian art and architecture in Mesoamerica.

Bonampak

Among the "survivals of a magic world" (to borrow a term Laurette Séjourné used in another context), none is so spectacular as Diego Rivera's intuitive re-creation of the life of pre-Columbian Mexico in his murals. Rivera had started his chronicle murals before the discovery, in 1947, of the paintings at Bonampak, which, particularly in composition, uncannily resembled his work—not only in the points he had been able to research, but in spirit as well.

Although Bonampak lies in the jungle lands of the Usumacinta River, south of Palenque, it seems miraculously to have withstood the assaults of heat and humidity for more than ten centuries. The treasures of Bonampak lie in a building about 53 feet long, with three high-ceilinged chambers. Their walls are completely covered with mural paintings that are the culmination of this form of expression among the Maya. Ceremonial life is faithfully pictured in horizontal

bands around the hall. The murals in Chambers Two and Three have similar layouts. The scenes cover almost all the wall surfaces and are surmounted by a frieze, also painted. In the first chamber, the frieze is divided into two levels. At the left side of the lower frieze, an entire orchestra appears (*Ill. I-40*). The upper frieze is composed of masks of Chac. Between these two is a larger panel showing a child being offered to a group of priests. In Chamber Two, we are made to feel the tensions of a great battle in the middle of the jungle. The third hall depicts the triumphant warriors celebrating their victory. In addition to organizing the composition on the planes of the four walls and steeply sloping ceilings, the ninth-century artists of Bonampak complicated their problem by splitting the planes into four horizontal levels, each devoted to a different scene.

The Bonampak murals are a dazzling example of conscious artistry in composition and of dynamism controlled by clear logic in balancing masses. The inventiveness in color is also striking; at the base, intense orange and brilliant turquoise; in the figures, siennas, ochers, and coffee colors; in the clothing, yellows, blues, roses, greens, and reds. As many as thirteen colors, and combinations of them, can be distinguished. The richness of this range is even more impressive in view of the technique employed: colors were applied to the pure lime walls without any medium. Bonampak's splendors have rightly been acclaimed one of the classic treasures of universal mural art.

Despite the many undecipherable mysteries of Maya culture, a common bond of forms and concepts can be discovered within it. El Petén, in Guatemala, is the point of origin. Here, in the city of Uaxactún, exist almost all the formal elements that were maintained, with regional variations, for more than eleven centuries. The extension of El Petén influence toward the Usumacinta River Basin culminated in Palenque, where stucco, because of its plasticity, permitted the development of a baroque style that dominated the culture from then on. To the south, in Copán, the Maya stele, actually a historical chronicle, was elevated beyond its formal role into a monument commemorating important events, recorded every five, ten, or twenty years. To the north, as the structures of El Petén evolved, there was greater utilization of ornamental filigree work, which increasingly displayed rhythmic repetition as it was adopted in successive styles (from south to north: Río Bec, Chenes, and Puuc), achieving its finest expression in the Nunnery Quadrangle at Uxmal.

At the end of the period, the invasion by the Toltecs in the northern

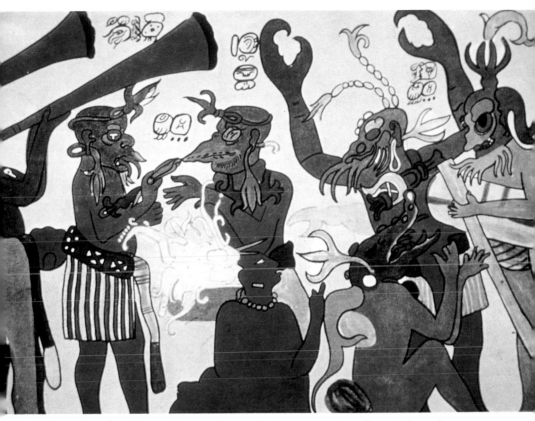

I-40. In a detail from a Bonampak mural (Room 1, north wall), musicians play a variety of instruments, and actors or dancers wearing masks of crabs, iguanas, lizards, and other animals disport themselves. Drawing by Augustín Villagra, using special material to penetrate the deteriorated picture and infrared rays to copy and photograph it. Maya culture. Chiapas, Mexico.

part of Yucatán produced at Chichén-Itzá a synthesis between the technical and spatial solutions of the people of the Valley of Mexico and the structural feats of the ancient Maya. Although much of Maya culture has been destroyed or buried by the jungle, nevertheless, the stele, the intricate stone-mosaic or stucco ornamentation, and most of all, the "false" or corbeled vault, ensure the art and architecture of the Maya a prominent position in the creative history of mankind.

4

The Intermediate Cultures and the Jungle Peoples

For untold centuries before the Spanish Conquest, trade routes from north and south crisscrossed the territories of the present Central American republics. Although this traffic undoubtedly sowed influences from its distant points of origin, Central America developed an art of its own, particularly in ceramics and goldwork. From the objects known and analyzed, it is possible to trace, admittedly imprecisely, the frontiers of this culture: to the south, the Gulf of Nicoya in Costa Rica; to the west, the Maya lands, with which there were unquestionably links; to the east, the northern area of South America.

More important than these obvious influences are the features that are peculiar to the pre-Columbian art of Central America and the area north of the Andes and that set it off from the continental context as a whole. The most significant cultural developments centered around the Güetaros, of Costa Rica, and the Chorotegas, who in-

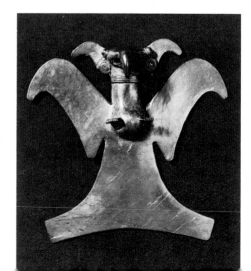

I-41. Cast-gold eagle pendant. Executed in anthropomorphic terms, the figure wears ear spools in its flaring ears, and a gorget adorns its chest. Veraguas culture. Panama.

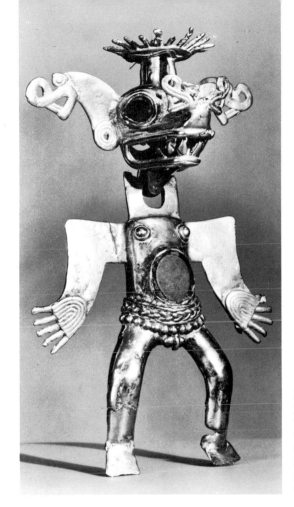

I-42. Gold and pyrite pectoral portraying a man wearing a ritual mask with outsized ears, a jaguar mouth, and a crown incorporating various plant forms. Chiriquí culture. Costa Rica.

habited Nicaragua, part of Honduras, and part of Costa Rica. In addition, in Veraguas (*Ill. I-41*), Coclé, and Chiriquí (*Ill. I-42*), in Panama, various crafts reached a high degree of skill, and the goldwork of the Quimbayas, Muiscas, and Taironas in Colombia was outstanding.

The Chorotega potters of the Nicoya Peninsula achieved great variety and refinement in their forms and decorative techniques. The tripod vessel, produced also in Mexico and, to a lesser extent, in South America, is the most distinctive creation of Chorotega art. A special Chorotega variation is that the feet frequently appear more important than the bowl itself. In ornamenting their ceramics, the Chorotegas employed negative painting, covering the surface of the vessel with

wax and scraping off the areas that were to take dye. During the firing process, the wax remaining on the protected portions melted away.

In the ceramics of the Güetaros, polychrome painting supplemented the contours of the central composition with an endless variety of images; in their purity of line, these designs were more a counterpart of later figurative stylizations than a sign of an immature primitivism.

The ancient settlers on the Pacific coast of Latin America, especially in Nicaragua and Costa Rica, worked stone with great care and skill (*Ill. I-43*). They have left gigantic carvings on monoliths more than 6 feet high; metates to grind corn that evolved in time into ritual elements (*Ill. I-44*); stone mace heads shaped like fierce jaguars.

The ceramics of Coclé and Veraguas are superbly stylized. Samuel K. Lothrop's studies enable us to identify the styles of individual

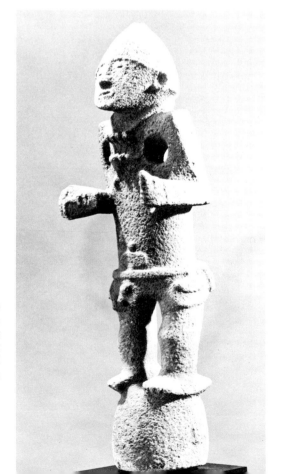

I-43. Despite its small size (less than 3 feet), this figure is similar to the stone giants found on the Pacific coast of Nicaragua and Costa Rica. Reventazón culture. Costa Rica.

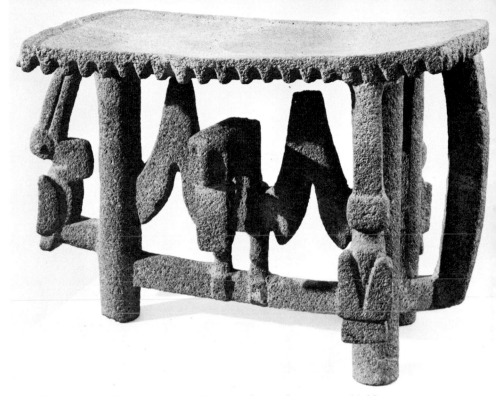

I-44. Stone metate. Metates were used to grind corn, but in time, highly ornamental forms were evolved to fulfill ceremonial purposes. Reventazón culture. Costa Rica.

artists. In one of the pieces he analyzed, parts of an alligator, a man, and a monkey are combined to form a dancing crocodile. In another, a coiled serpent body ends in a human head with the cleft tongue of a lizard shooting from the chin.

From the time of the Conquest, the area now occupied by the Republic of Panama was called "Golden Castile." The discovery in 1930 of the treasure at Coclé must rank with those of the Cenote Sagrado in Chichén-Itzá and of Tomb 7 at Monte Albán. In thematic variety and technical perfection, the Coclé pieces are the equal of the best works of the Mixtec-Puebla culture or of the Colombian styles.

Colombian Goldwork

In the pre-Hispanic goldwork of Colombia, identification of regional styles is far more significant than chronological considerations, both

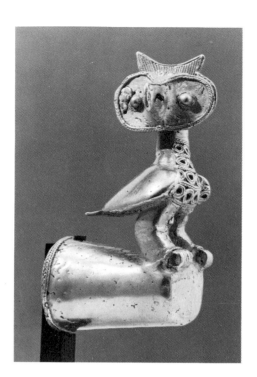

I-45. Gold owl in the predominantly zoomorphic Sinú style. Note the delicacy of the wire filigree cast by the "lost-wax" technique. Colombia.

because each style made valuable contributions and because it is difficult to determine the precise provenance of most of the pieces known. Further, it was in precious metals that the ancient settlers north of the Andes achieved their finest work.

These pieces have erroneously been attributed to a supposed Chibcha culture, but this label is meaningful chiefly in linguistic studies. In fact, seven styles have been distinguished in the goldwork of pre-Hispanic Colombia. These are, from north to south:

The Tairona style (which flourished between the Magdalena River and the Guajira Peninsula) has left few examples, chiefly, nose rings, ellipsoidal earrings, flat anchor-shaped pieces, and anthropomorphic objects.

The Sinú style (centered in the headwater region of the Sinú River) is represented by filigree made of wire cast by the cire-perdue process and formed into pairs of figures and birds with long beaks (*Ill. I-45*).

The Darién style exhibits great skill in engraving, soldering, and the

I-46. Quimbaya gold cup exhibiting the sculptural approach and perfectly balanced masses and volumes typical of this style. Colombia.

cire-perdue technique. The human figure became so highly stylized in Darién work that it is scarcely recognizable. Typically, two large truncated spheres top the body and diagonal sticklike arms on each side reflect a concern for symmetry.

The Muiscas (who lived on the savannas of Bogotá and Cundinamarca) put their unmistakable stamp on many treasures now in modern Bogotá, in the Gold Museum of the Bank of the Republic. Among these pieces, the most original are the *tunjos,* with their extraordinary purity of line. (*Tunjos* are small triangular human figures, generally broader at the head than at the base, their limbs and features defined with cast wire.) The Muiscas also made exquisite openwork plaques, wire reliefs, and various adornments for the body.

The Quimbaya style is marked by a sizable spectrum of techniques, with several frequently employed in a single piece, as well as by realism in representation (*Ill. I-46*).

In Tolima, near the valley of the Saldaña River, many vast objects have been found, worked with different techniques but all strongly

I-47. Tolima-style gold pectoral from the Shrine of the Dragon. In this stylized anthropomorphic figure, the openwork follows a rigidly geometric rhythm. Colombia.

I-48. Gold pectoral, with a central ▶ mask in high relief. Huge cuplike ear spools dominate the face and are echoed by the curves of the piece as a whole. The border consists of stylized birds. Calima style. Colombia.

expressing geometric ideas of absolute symmetry and of balance in proportions. Openwork and filigree hew to a parallel rhythm (*Ill. I-47*). The stylized human figures often resemble a kind of anchor, which strengthens the balance of proportions already noted.

The last of these Colombian goldwork styles, that of Calima, takes its name from the river of the region. The Calima pieces in the Gold Museum in Bogotá constitute its most complete and valuable group. Diadems with long antennas and other hair ornaments; objects in the shape of bats, crocodiles, birds, and snails; pendants with anthropomorphic figures; mythical beings similar to those of the Tolima style; varied pectorals (*Ill. I-48*); funerary masks—all these testify to the diversity of plastic concepts and the rich imagination of this culture, which shows obvious links with the mysterious monoliths of San Agustín.

The San Agustín Culture

Few cultures of the Old or New World have kindled as much wild theorizing as that of San Agustín, the work of unknown craftsmen at the headwaters of the Magdalena River. Attempts have been made to

glorify it as the "mother culture" of all the Andean peoples, including even the Tiahuanacans, more than 1,300 miles to the south.

Although the San Agustín culture appears to be extremely ancient, present archaeological information is too limited to permit any secure estimate of its age. We shall, therefore, consider only its singular formal features.

The San Agustín monoliths—human, semihuman, and nonhuman beings carved in volcanic stone—display a tremendous range of ideas. The eyes are, at times, almond-shaped, at other times, round or semicircular, at still others, rectangular; the noses are broad and the mouths often sprout fierce tusks (*Ill. I-49*) curiously like those on the heads at Chavín, in Peru; in the human figures, the head usually occupies half of the total mass—this in statues that are sometimes more than 13 feet tall.

The similarity in form between the megalithic statuary of this culture and the goldwork of Calima has already been mentioned. In fact, many figures from San Agustín wear pendants, nose rings, and necklaces. In Calima pieces, even the mouth may be fashioned in a rectangular shape, just as in the stone statues of the Upper Magdalena.

In their sculpture, the San Agustín carvers, like those of the ancient

Olmecs, Aztecs, and Tiahuanacans, clearly displayed an architectonic feeling dominated by geometric concepts. And as in Mesoamerica and the Central Andes, the basic material of the San Agustín culture is stone.

Pre-Hispanic Ecuador, Amazonia, and Venezuela

In the matter of the interrelations among the diverse cultures of the pre-Columbian world, the San Agustín culture is not the only fascinating enigma. It is equally challenging to try to illuminate the unknowns concerning apparent or certain links among the arts of Mexico, Central America, and the coast of Ecuador. In the province of Esmeraldas and around Tumaco, respectively in present-day Ecuador and Colombia, clay figurines have been found of consummate perfection, and in the mountain region of the Ancasmayo River, which forms the frontier between Ecuador and Colombia, deep sepulchers have yielded up ceramics with excellent negative painting.

Difficulties of every kind, arising especially out of the hostility and harshness of jungle life, have hampered systematic studies of the ancient cultures that must have developed to the east of the Andes. Since 1956, two U.S. archaeologists, Clifford Evans and Betty J. Meggers, have been carrying out excavations on the Isle of Marajó (at the mouth of the Amazon) and around the Napo River, a tributary of the Amazon flowing through Ecuador and Peru. Their discoveries have made it possible to establish relationships in form between the

I-49. Stone figure from San Agustín, Colombia, with two pairs of jaguar tusks that are similar to those seen in almost all the sculpture of Chavín, in Peru, and in some Olmec figures from Mexico.

Marajó ceramics and those produced more than 2,500 miles in the interior, which could demonstrate some consistency in the development of jungle cultures from very remote times. Anthropomorphic urns, glass beads, and other articles might likewise prove an identity extending as far as the Orinoco Basin, in Venezuela.

The so-called Marajó ceramics (*Ill. I-50*) have very precise, carefully worked ornamentation, in which coarse and fine lines alternate in arabesques and frets very different from those of the high lands previously analyzed. Incising and painting were the techniques used in decoration, often both being applied on a single object. Because of the quality of their design, the decorations employing alligators demand notice: in some, sculptural realism is evident; in others, the figure is stylized.

Elsewhere in Amazonia, especially where the Tapajós River joins the Amazon, at Santarém, another type of ceramic developed, with schematic linear ornamentation or with animals and human heads appliquéd profusely on the surface.

Within the area that is today Venezuela and adjacent Colombia, it has not yet been possible to establish a classification of regional styles. In the ceramic work, however, there is an absolutely unique style of anthropomorphic figurines, with disproportionately large heads, oblong or square, and great wide-open eyes that at times are reduced to two elongated parallel lines.

No comparative study has been made among the forms and expressions in the art of the intermediate cultures, which have usually been

I-50. Ceramic jar from Marajó Island with characteristic incised decoration. The arrows are stylized representations of serpents. Brazil.

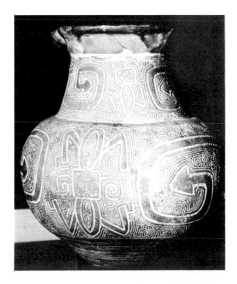

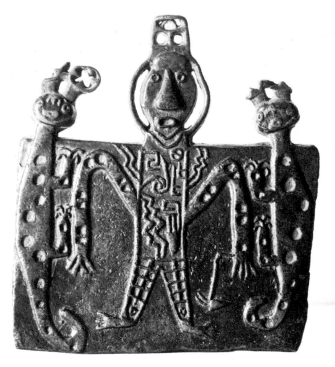

I-51. Cast-bronze plaque, possibly of the Aguada culture, in northwestern Argentina, depicting an anthropomorphic figure guarded by two animals with human faces. Extremely interesting metalwork, especially in copper, was produced in this area between the eighth and eleventh centuries A.D.

overshadowed by those of Mesoamerica and the Andes. From an analysis of the similarities, for example, between the elongated heads of Venezuela and Colombia and some broad heads with prominent eyes typical of the Aguada culture (*Ill. I-51*), in Argentina, it would be possible to determine the extent of convergence in ideas—perhaps more than of hypothetical influences—illustrative of the parallelism in the successive stages in the evolution of these cultures.

Such a parallelism probably underlies the no less surprising similarity between the broad trends of most pre-Columbian art and outstanding examples of Oriental art. Without minimizing the value of studies that try to demonstrate actual contact and an interplay of influences, let us be aware of another enigmatic truth: the environment, the motivations, the thought, and the relations of men with men and of men with gods create the conditions for these evolutionary stages to emerge in similar forms across time and distance.

5

The Pre-Inca Cultures

Among the constants of pre-Columbian art, there are also distinctive trends that must be attributed to artistic concepts peculiar to a specific time or place. In the various Mesoamerican regions, works produced contemporaneously do not necessarily share similar characteristics. In Peru, however, the play of common influences and motivations within the "cultural horizons" results in a high degree of identity among the arts of a given period. This phenomenon is very evident in the three principal "horizons" of the Andean and Pacific cultures: the Chavín, Tiahuanaco, and Inca.

The Chavín Horizon

Chavín de Huántar is a small village squeezed into the valley of the Monza River, high in the mountains of northern Peru. In 1873, among the ruins of a great temple, the Italian naturalist and geographer Antonio Raimondi discovered the stele that bears his name and, with it, rediscovered a forgotten culture.

The temple ruins at Chavín cover 35,000 square yards, and have a base nearly 6 feet high, which supports another level, with, in turn, several structures—the whole in the shape of a truncated pyramid. The temple's floor plan—actually on the subterranean level—is extremely complex. There are countless stairways, compartments, and crisscrossing tunnels. Numerous sculptures, in niches and on walls, are integrated into the structure and unify it. The walls display the remains of wide cornices, from which enormous gargoyle-like heads spring. Among the sculptures of idols, serpent heads, condors, pumas, and on steles—notably, the Raimondi Stone, the Tello Obelisk, and the so-called Great Image—there is a clearly consistent style and the imprint of a very advanced culture.

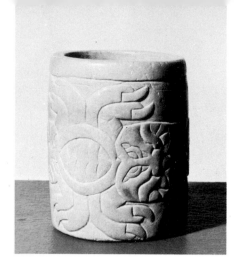

I-52. Steatite cup with a pair of fantastic crabs, equipped with double tails and feline heads instead of pincers. Cupisnique culture (Coastal Chavín). Peru.

The dating of the Chavín works has been and continues to be a controversial matter, and the stonework, which combines figurative representation with abstractions and stylizations of every kind (*Ill. I-52*), still poses riddles for archaeologists and historians. Most of the reliefs bear the image of a divinity in human form, with elements of a jaguar, serpent, and—most extraordinary of all—a bird. To be sure, it is not the Mesoamerican quetzal, but the Andean condor, which in Chavín combines elements of the puma and the South American jaguar.

In the Callejón de Huaylas, evidences of the typical architecture survive: stepped and truncated pyramids, whose exterior stairways, unlike those of Mesoamerica, have no landings. It is a work of megalithic engineering, employing carefully polished stones with special detailing on the monoliths at the corners. The horizontal rows are positioned in layers that form a rhythmic pattern, and the vertical joinings meet exactly.

The Paracas Culture

On Peru's southern coast, in the Nazca and Ica valleys and on the Paracas Peninsula, about four centuries before Christ a culture flourished that was very different from anything before it. But the Paracas culture has been associated with the Chavín horizon because of the close similarity in designs of fierce-looking mythological beings.

In the ruins at Cerro Colorado, near Pisco, another facet of the Paracas culture was unearthed: strange subterranean structures con-

sisting of rooms ranged in a straight line, corridors, and large funerary chambers with adobe walls and roofs constructed with a mortar of mud, whalebone, and lime. Here, too, in 1925, the Peruvian archaeologist Julio C. Tello, noted especially for his work at Chavín, discovered a burial site with more than 400 mummies wrapped in exquisite fabrics. They belong to what Tello called the "Necropolis" period, as distinguished from the earlier epoch, to which he gave the name "Cavernas." The Cerro Colorado caverns—actually pits sometimes 23 feet deep—terminated at the bottom in circular funerary chambers.

In the evolution of the Paracas culture, both epochs made important contributions. In the Cavernas phase, excellent ceramics were produced. The later phase is notable for the high quality and technical perfection of its weavers.

In the Cavernas ceramics, the complex polychrome work is especially fine. Bottles with slender necks have been found, jars with two spouts joined by a bridge, dishes with heads of humans or of animals on the interiors. The outlines of the designs are accentuated by heavy lines emphasized by means of incising. Sometimes geometric forms appear, in negative painting (*Ill. I-53*).

Although its potters were highly skilled, the Paracas culture was, in essence, centered on weaving. The astonishingly wide winding sheets found on mummies are evidence of a technique in the warp and woof and dyeing so perfect that they have survived for 2,000 years,

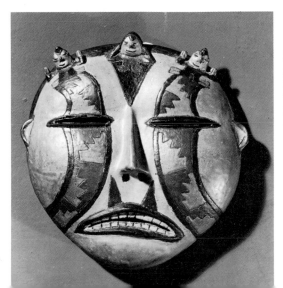

I-53. Ceramic mask with post-fired resin paint dating from about the sixth to the fourth centuries B.C. It has the heavy incised outlines and extreme stylization—slits for eyes and curving bands through the eyes and cheeks—characteristic of the Paracas Cavernas style. Peru.

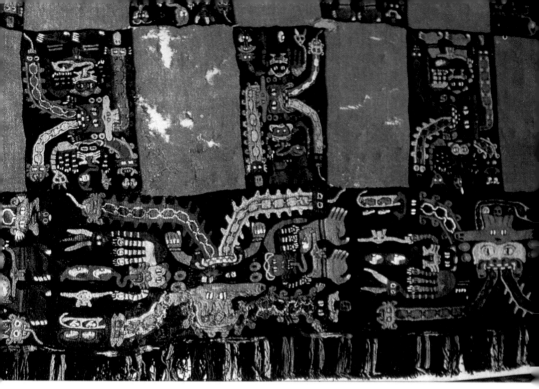

I-54. Detail of a poncho with serpent deities. The similarity and repetition of the designs contrast with the profuse variety in the colors used. Paracas Necropolis style. Peru.

although the dryness of the climate has undoubtedly been a factor in their preservation. The motifs are extremely varied and imaginative: monsters, warriors, mythological beings, dancers bearing heads as trophies of war, birds (real and fantastic), fishes or amphibious beasts, crowned flying demons that spit serpents or carry feathered fans, maces, or knives.

The fine wool generally used in these fabrics was spun on the hand spindles devised for cotton or for wool from the long-haired beasts of the Andes—the llama, alpaca, guanaco, vicuña. Despite the intricacy and wealth of their designs, perhaps the most marvelous aspect of these works of art is the richness and harmony of their colors (*Ill. I-54*). In a single mantle, 190 gradations of color and 22 different hues have been distinguished.

The Chavín horizon also extended toward the north coast of Peru,

showing its influence here especially in ceramics. Between 1933 and 1939, Rafael Larco Hoyle carried out several excavations in the Chicama Valley. He gave the name Cupisnique (after the tiny valley where he first found examples) to a monochromatic ceramic, usually sienna or black, often with background ornamentation resembling pebbles. Schematic figures of jaguars are also common, and the characteristic form is the stirrup spout (*Ill. I-55*).

During the period customarily termed "formative," other varieties of ceramics were produced in Salinar (in Chicama) and in Gallinazo (in the Virú Valley). The Salinar work is an early version of a style that reached full development later, in the Mochica period. It is simply decorated, in white on red. The Gallinazo vessels display fine negative painting. In the Santa Valley, another style has been identified, known as the Recuay or Callejón de Huaylas (*Ill. I-56*) style (after the particular spot and the region, respectively). The architecture of the Callejón de Huaylas, as we know, shows the imprint of the Chavín horizon. The same is true in ceramics, but Recuay pottery is distinctive for its use of the tripod jar, produced here for the first time in Peru.

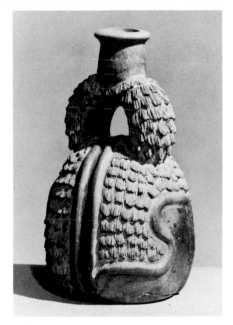

I-55. Clay jar with the stirrup spout typical of the northern coast of Peru. The high-relief decorations are also common in this region. Cupisnique culture (Coastal Chavín). Peru.

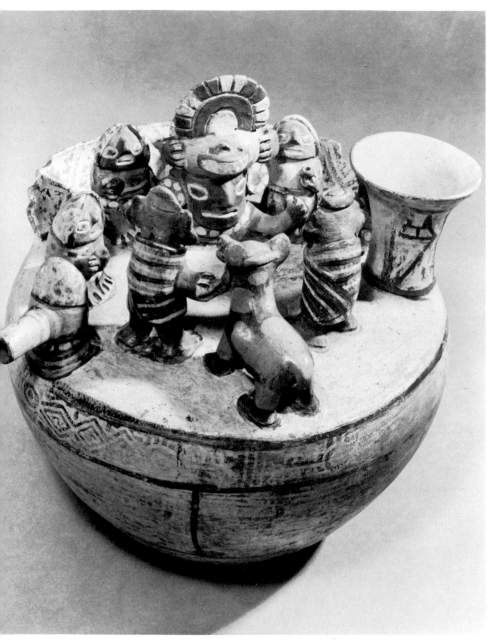

I-56. Like the ceramic sculptors of western Mexico, the artists of the Callejón de Huaylas and of the northern coast of Peru described incidents of daily life—here a court scene—in pottery. Recuay style.

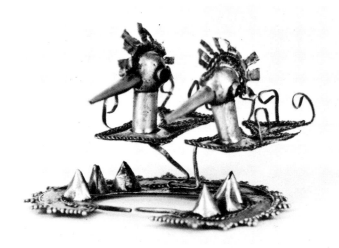

I-57. Two birds, with long beaks, alight on a nose ring of sheet gold decorated with gold threads. Late Vicú culture. Peru.

The Chavín horizon is likewise apparent in the goldwork of Lambayeque, which is estimated to date from at least five centuries before any in Mesoamerica. The hallmark of the Lambayeque gold figures is their almond-shaped eyes tilting up at the corners.

The Chavín horizon influenced the ancient local culture of the Vicús, as well. The Vicús flourished before and in the same region as the Mochica culture. Vicú work was marked by a high degree of realism, which probably derived from Colombian models (*Ill. I-57*).

The Mochica Culture

Around the fourth or fifth century A.D., two parallel cultures flourished in Peru—the Mochica and the Nazca—which, for about 500 years, retained enduring and ineradicable features.

At the edge of the Moche Valley, in northern Peru, near Trujillo, the ruins of the shrines of the sun and of the moon indicate the existence of a monumental architecture. The base of the Pyramid of the Sun is a rectangle about 250 yards long by 150 yards wide, and the structure rises to a height of almost 110 yards. The vestiges of this architecture, inherently perishable because adobe was its basic material, are too scant to permit even an imaginative reconstruction of its

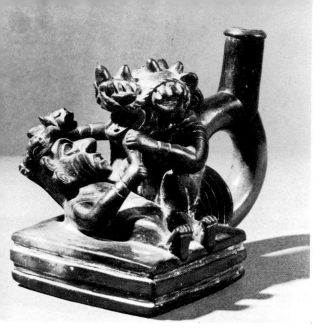

I-58. Despite the fearsome appearance of the main figure, this Mochica effigy vessel depicts a monster comforting a fallen warrior. Peru.

colossal design, but the pyramid form is duplicated in the Chicama Valley. On the other hand, the contents of numerous tombs have revealed a varied and unusual art: vessels of many shapes, stirrup-spout jars, large spherical bottles, enormous trays, clay sculptures of animals, fruits, men, and gods (*Ill. I-58*). Mochica artistry in goldwork —mosaics of turquoise encrusted with gold, medallions with human faces, necklaces—was excellent, and their craftsmen had mastered the techniques of soldering gold and silver and alloying copper and gold.

Mochica ceramics are celebrated for the incomparable realism of their portraiture (*Ill. I-59*). In fact, many of the Mochica jars depict

I-59. Mochica jar portraying a one-eyed man. The representation of the hollow left by the missing eye is startlingly realistic. Peru.

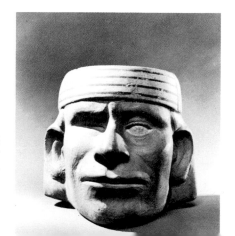

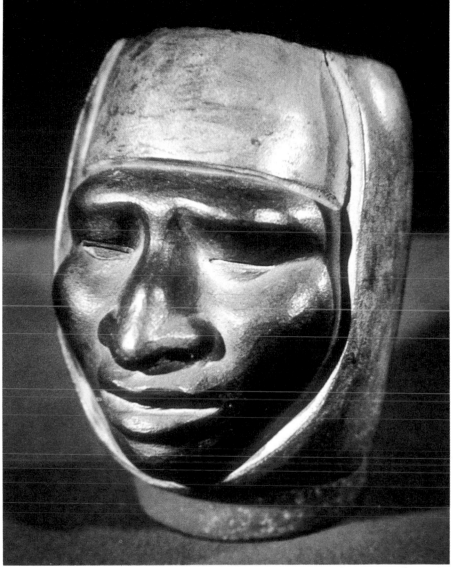

I-60. This funerary vase, probably made somewhere on the northern coast of Peru, displays the "photographic" quality of Mochica portraiture.

persons who can easily be identified by checking them against portraits of the same individual made in distant localities. The Mochica portrait does not coldly reproduce the subject's facial features. There is an unmistakable attempt to reflect his psychological attitudes—disdain, happiness, fatigue, sexual desire—through his eyes, mouth, eyebrows, and nostrils (*Ill. I-60*).

Although Mochica ceramics are essentially sculptural, they are expertly painted with fine brushes, in a sienna that often borders on red, against a background of yellows. In contrast, the Mochicas used color more profusely and freely in the few murals known.

In keeping with their strongly sculptural outlook, the Mochicas displayed a lively interest in landscapes; many jars simulate hills with rough, irregular contours, the sea with symmetrical waves, and plants and animals with precisely rendered details. A similar alternation between objective realism and complicated stylization is seen in the painted motifs of the jars, with ideographic abstractions especially common in representations of divinities.

The erotic symbolism of Mochica artifacts and drawings deserves particular mention. Erotic ceramics have been found chiefly in Chiclama and Lambayeque. They reveal a pervasive obsession with the caustic manifestations of love. Along with normal scenes of the fertility cult are depictions of a large catalogue of perversions: pederasty, sodomy, impotence, sexual satiation. Hunchbacked, blind, and crippled figures are portrayed in scenes of lovemaking suffused by death; cadavers continue onanism after dying. An extensive collection of Mochica erotic ceramics can be seen in the Larco Herrera Museum, in Lima, in a large, inaccurately labeled hall.

Nazca Art

Around the fourth century A.D., an art contemporary with the Mochica, but with very different characteristics, began to flourish in the Nazca and Ica valleys.

Nazca art, part of a late Paracas culture, has left superb textiles, although the Nazcas never equaled the Paracas weavers in quality. Despite the pre-eminence of weaving in the Nazca culture—and despite the fact that textile ornamentation supplied the design vocabulary of the other arts—the Nazca stylistic evolution can be observed more clearly in the curved lines of ceramics than in the necessarily geometric motifs of fabric.

Nazca ceramics evolved through various processes until the middle of the ninth century, when they yielded to the incursion of the spirit of Tiahuanaco. Early pieces were painted after they had been fired. In time, they perfected the technique of using resinous materials to fix the painting before firing, but throughout, the richness and variety in the coloring of Nazca ceramics contrast with the two-tone

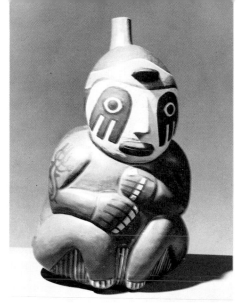

I-61. Like almost all the anthropomorphic ceramics made by the Nazcas, this effigy vessel dates from the final period of their culture (which ended about the ninth century A.D.). As the forms became more stylized, the potters abandoned their earlier rich polychromy for a more limited palette. Peru.

palette of the northern ceramics. In modeling their pieces, the Nazca potters hewed to the ancestral system of using spiral coils of clay that were later smoothed out. Nazca ceramics are identifiable, not only by the skillfulness of their painting, but also by the perfection of their forms. Besides the two-spouted jars with a handle in the middle, they made wide goblets, deep bowls, trays, and vessels with human faces (*Ill. I-61*).

The broad spectrum of colors in the Paracas textiles is evident also in the Nazca fabrics, which contain as many as 100 different tones. Harmony and balance are achieved by muting the brilliance of the colors. The Nazcas used chiefly the ochers, from orange to pale yellowish; various reds, from the color of wine sediment to brick; an intense violet; and ivory tones in the clear background.

In the placement of forms and figures, there is always an ornamental concern. Vegetable motifs—corn, chilis, kidney beans—and animals, especially birds, are represented. As in the Paracas textiles, diabolic figures abound: felines with human feet and hands and various other human attributes. The most famous of these is the "demon of the cactuses."

Among the Nazca, the progression toward more and more marked use of baroque forms took a route similar to that we have encountered in other pre-Columbian cultures. The stylizations of the early period

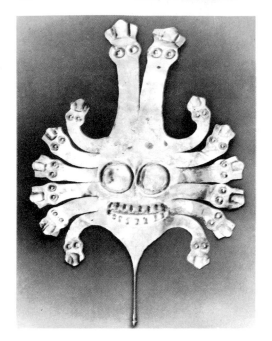

I-62. Nazca ornament for a headdress, in sheet gold, representing a stylized face with six serpents on each side and two above. Peru.

became more and more complicated (*Ill. I-62*). At the end of the process, the "demon of the cactuses" is represented with spirals and rays that only the initiated would associate with this figure.

Nazca architecture was, like that of the entire Peruvian coast, perishable because it depended on the only available material—adobe. Some scholars consider the Pachacamac ruins—very badly reconstructed—a pattern of this architecture. A sacred city erected on a hill facing the sea near Lima, Pachacamac reached its prime on the eve of Inca domination. Its buildings were constructed with small adobe bricks in trapezoidal frames following the natural slope of the walls. Also on the outskirts of Lima, the Juliana and La Laguna shrines—especially the latter—retain surfaces with ornamentation so elaborate that it may be called a transposition of the Nazca fabrics.

The Tiahuanaco Horizon

On the south shore of Lake Titicaca, 13,000 feet up in the Bolivian Altiplano, stand the remains of a city that is thought to have been the original and chief center of the Tiahuanacan culture. Around the middle of the sixteenth century, the Spanish chronicler Pedro de Cieza de León—who, according to his own words, "when the other soldiers

were resting, tired myself out writing"—described the ruins of lofty ramparts and monumental structures.

On Acapana Hill, in Tiahuanaco, there was an enormous fortified platform surrounded by a stone rampart. Today we can still see the stairway, formed by six immense monoliths and framed by two pillars, that leads to the sanctuary of Calasasaya, which extends over an area of more than 19,000 square yards. Behind the stairway rose the terraces of the Temple of the Sun and, on four more large platforms, the Tunca Punco, the Palace of the Ten Gates.

Today, all that remains of these marvelous structures are enormous fallen blocks, some weighing more than 150 tons; others, still standing, show vestiges of crenelated galleries and give clues to the monolithic portals of the Temple of the Sun and the Pantheon.

The most significant construction preserved is the Gate of the Sun, hewed of a single block of volcanic rock 10 feet high and 12½ feet wide (*Ill. I-63*). Over the lintel is a frieze sculptured in the manner of tapestry. On the central axis, a god, shown full face, holds a scepter in each hand. Shrunken heads adorn his vestments. A diadem with rays surrounds his head. Toward him, from left and right, three lines of winged beings advance, with crowns on their heads and scepters in their hands. Those on the middle level have condor heads; the upper and lower groups have human heads. Throughout the Tia-

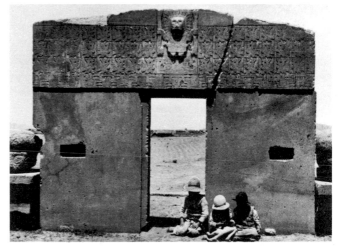

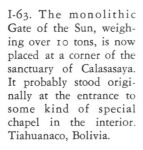

I-63. The monolithic Gate of the Sun, weighing over 10 tons, is now placed at a corner of the sanctuary of Calasasaya. It probably stood originally at the entrance to some kind of special chapel in the interior. Tiahuanaco, Bolivia.

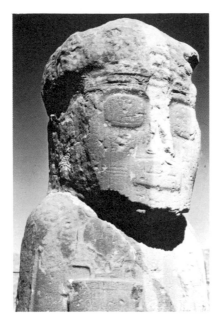

I-64. The upper part of the gigantic statue at Tiahuanaco popularly known as "El Fraile" ("The Friar"). Bolivia.

huanaco horizon, these figures on the Gate of the Sun are repeated, with local variations, in ceramics and textiles.

The back of the gate is no less interesting than the front. The rear opening is flanked by two niches hollowed in the monolith itself, and a series of moldings serves to support the two blind windows.

The La Paz Museum contains the largest monolithic statue found in Tiahuanaco. Still in its original site is another huge figure (*Ill. I-64*), known popularly as "El Fraile" ("The Friar")—one of those that led Thor Heyerdahl to the notion of a link between these monoliths and the giant *moais* of Easter Island. In the town of Tiahuanaco, two smaller statues flank the entrance of the church, built in the Spanish period. Like the great statuary of Mesoamerica, and of the San Agustín culture, the Tiahuanaco monoliths are dominated by an architectonic feeling; the human figure is adapted to the shape of the stone block (*Ill. I-65*).

The general label of "Tiahuanaco horizon" has been applied to a series of creative manifestations that share common features, despite considerable local differences that make it questionable whether the

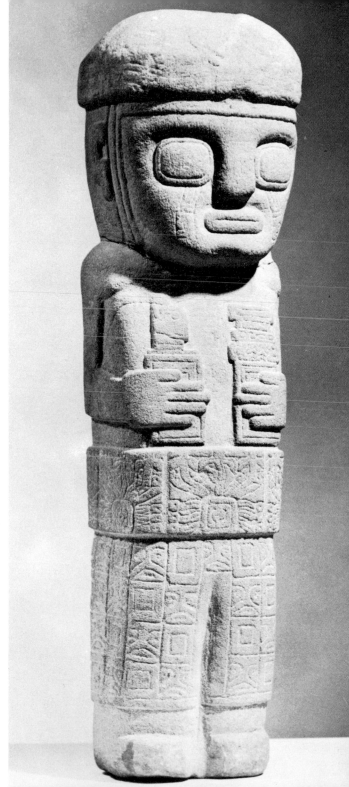

I-65. Although this stone figure is only 18⅜ inches high, it faithfully embodies the architectonic concept of monumental Tiahuanaco sculpture. Bolivia.

original center of this culture was Acapana Hill. In Huari, near Ayacucho, Peru, stone statues have been found that bear some relationship to the monoliths at Tiahuanaco. The Huari ceramics are clearly related to Nazca work. Also, in Pucara, in the Peruvian Sierra, ceramics were made similar to those of Titicaca.

In the ruins of Tiahuanaco, very fine ceramics have been unearthed that make it possible to trace a marked evolution from simple forms to extremely complex abstractions. Fluted monochrome censers have been found, as well as vessels with scalloped rims, bichrome decorations, and animal heads. Other censers, probably later, have more luxuriant coloring, on a yellowish or dun background, against which the outlines stand out in gray, yellow, or chestnut brown. White outlines—sometimes dark—define figures of pumas and condors and human heads. In the course of time, the abstraction and schematic symbolism increased and became more complicated. Clay sculpture reached perfection in hybrid animals with bells on their necks and symbols painted on their bodies. In formal achievements, Tiahuanaco ceramics are especially noted for their *keros,* beakers of painted earthenware flaring at the mouth (*Ill. I-66*).

The influence of the Tiahuanaco horizon endured for a long period and extended over a vast area—from northern Chile and northwestern Argentina to northern Peru (*Ill. I-67*). It is hence often referred to

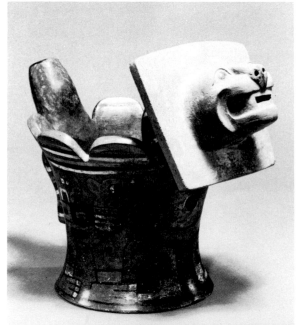

I-66. Tiahuanacan potters developed this hollow-sided form of bowl called a *kero* very early. It remained popular well into the Expansive (Coastal) period. The large feline head on the rim serves as a spout. Bolivia.

as the Tiahuanaco Expansive, although some archaeologists call it the Huari—or Wari—culture. The iconography thus far analyzed indicates that, throughout this entire territory, the same religion was practiced. The impress of this style continued well into the eleventh century A.D.

The Chimú and Chancay Cultures

Strictly speaking, the double recessed border that surrounds the opening in the Gate of the Sun at Tiahuanaco does not actually represent the technique of chiseling out stone. Although a monolithic block was in fact employed, an attempt was made to simulate the construction of narrow lintels on thick mud walls that were shaved down to the thinness of the lintels. This formal sign links the architecture of Tiahuanaco, in the Altiplano, with that of the cities, fortresses, and

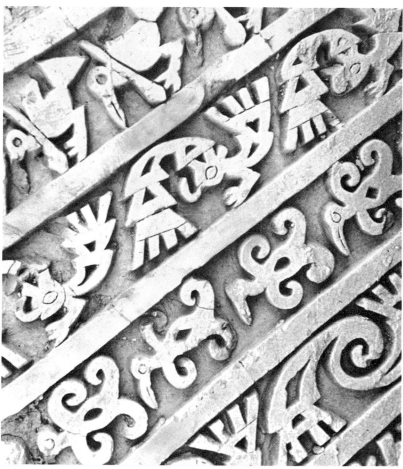

I-68. Bas-relief on a wall of the fortress at Chanchán, capital of the Chimú Kingdom, the largest city in the pre-Columbian world. The figures were modeled in mud to resemble a textile design. Peru.

temples on the coast. As these coastal settlements yielded to the mythico-religious influence of Tiahuanaco, the local powers became united into confederations. Ultimately, weakened by rivalries, one after another surrendered to the military might of the Incas.

These confederations extended far to the north of Tiahuanaco, beyond the Moche Valley. Their cities and fortifications stretched along almost the entire coastal region of present-day Peru. To the north, the

Chimús built the city of Chanchán and the fortress of Paramonga. In the center, in the valleys of Lima and Lurín, the Cuismancu confederation constructed the platforms of Pachacamac and the walls of Cajamarquilla. In the valleys of Chincha, the Chuquimancu confederation built the *pucaras,* fortresses strategically placed on the crests of hills. Farther south, in the ancient Nazca region, the Chincha confederation also erected fortresses and palaces.

The most splendid of the confederation cities was the Chimús' Chanchán. Seen from the sea, it must have presented a magnificent spectacle. The vertical silhouettes of the shrines—some, like that of the Bishop, more than 250 feet high—contrasted sharply against sturdy buildings painted in vivid colors, with gracious porticoes crowning vast stepped terraces and fertile gardens everywhere. Thick sloping ramparts on broad horizontal bases must have given this architecture an unmistakable aura of luxury. Some walls retain a tapestry-like clay frieze with birds, monkeys, and plants, stylized fishes, rhombuses and other geometric forms—all with the angular shapes characteristic of textiles (*Ill. I-68*). In the fortress of Paramonga, which guarded the Chimú kingdom on the south, ramparts and bulwarks testify·to an advanced state of military engineering.

Chimú goldwork was similarly rich and sophisticated. Even before the Chimús had reached their full flowering, metalworking had had a long history in Peru. The goldsmiths of the Chavín, Paracas, and Nazca periods were masters of the *repoussé* technique. Although it has not been possible to discover where pre-Columbian goldworking originated, technical and stylistic similarities among objects from Costa Rica, Panama, Colombia, Ecuador, and Peru indicate that they constituted a cultural unit.

Soldering and cire-perdue, which postdate the beaten-gold method, were first developed in Colombia. The Mochicas succeeded in alloying copper with precious metals, and this skill appeared again in the same northern section of Peru during the Chimú period (*Ills. I-69 and I-70*). Beginning about 1200, a great range of metallurgical methods was employed with a high degree of skill: soldering, gilding, casting, alloying, embossing, hollow casting by the cire-perdue system, beading, etc.

Between the Chancay and Rímac valleys, near the present site of Lima, unique artistic forms developed. In Cajamarquilla, in the spurs of the Andes, a labyrinthine city was constructed with *adobón* walls. In this technique, *tapias,* adobe bricks measuring nearly 2 cubic yards,

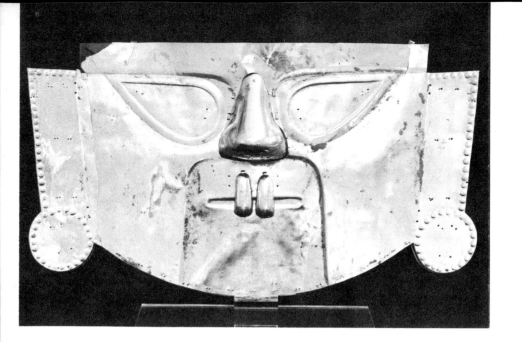

were laid and later plastered over to form a uniform surface. Adaptation to the available materials continued during the colonial period and is evident even in our day.

In recent times, there has been growing appreciation of the primitive enchantment of the Chancay clay figures, which depict human beings with flattened heads, foreshortened arms, open hands, and frequently, a kind of spectacles (*Ill. I-71*). There has also been great

I-70. Gold ear spool with *repoussé* designs. The border depicts a sequence of a hunter with arrows tracking (or being tracked by) a bird. Chimú culture. Peru.

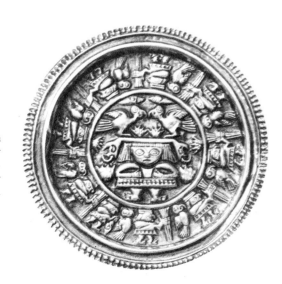

I-69. Gold funerary mask with *repoussé* decoration on the ears and ear spools. Both the nose and the danglers over the mouth were formed of separate pieces of sheet gold. Chimú culture. Peru.

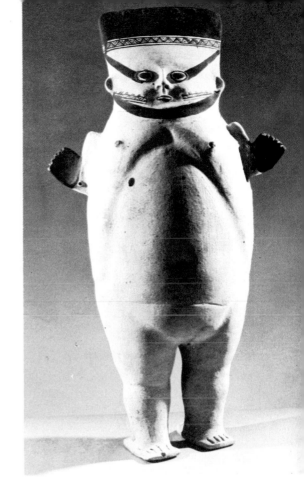

I-71. Hollow ceramic anthropomorphic figures from Chancay, with the typical oval form and red-and-cream coloring. Even after the Incas had established their political and stylistic domination, the Chancay potters retained their own designs with only slight modifications. Peru.

interest in the oval pitchers whose necks have stylized human faces. Chancay ceramics have very simple, vigorous decorations on a dull whitish background.

Although later cultures have contributed their own regional modifications, pre-Inca art has transmitted various qualities that assure it a place in the history of art: the skill of its potters and weavers; an utterly original sense of color; the incorporation of forms, techniques, and concepts into the medium; the balance of proportions in both masses and decoration. The Peruvian architectural historian Héctor Velarde has acutely crystallized the genius of the pre-Inca peoples: the land gave them the sense of form and volume; weaving taught them the value of texture and decoration.

6

The Incas

"Nowhere in the kingdom of Peru was there a city with the air of nobility that Cuzco possessed. . . . those who founded it must have been people of great worth." With this very justified acclaim, Pedro de Cieza de León reflected the admiration of a sensitive European before the spectacle of the capital of the Tahuantinsuyo, the Inca Empire.

The Inca was an omnipotent divinity, tyrannical and paternal, absolute master of an organization that has frequently been termed socialist because it was based on the immutable principles of blind obedience and of obtaining the material welfare of its subjects. In the Inca dominions, to an even greater degree than in Mesoamerica, the social structure and the body of ideas derived from it conditioned the development of art throughout the Empire, and in the reign of Tupac Yupanqui (ca. 1471–93), the Inca Empire stretched from Ecuador to the Maule River, in Chile.

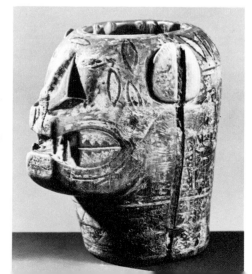

I-72. This wooden Inca *kero* unquestionably lacks the delicacy of Tiahuanaco Expansive, drawing on a more brutal and elemental vocabulary in representing the ferociousness of the jaguar. Peru.

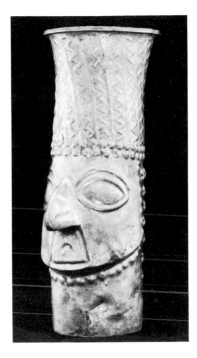

I-73. Before and during the Inca domination, this kind of silver beaker in the form of a human head with an imposing headdress and aquiline nose was made on the northern coast of Peru. This dates from the Inca period.

Like the art of the Aztecs, Inca art was nourished by the experiences and contributions of its ancestors (*Ill. I-72*). On the Island of the Sun in Lake Titicaca, there is evidence of the fusion between Tiahuanacan sources and the functional engineering of the Incas. As in Tenochtitlán, with its craftsmen from the far corners of Mexico, in Cuzco there were many districts inhabited only by artists brought from distant parts of the Empire. And again like the Aztecs, the Inca conquerors made their basic contribution in the adaptation of acquired techniques (*Ill. I-73*), while simultaneously developing specific expressions of their own.

These are especially apparent in architecture and city planning, activities particularly suitable to the prevailing social structure and collective motivations. The Incas—perhaps because their evolutionary cycle was interrupted by the European Conquest—did not attain the splendor of the Maya façades or the perfection of the sculpture of the other great pre-Hispanic cultures.

The varied and relatively free pre-Inca architecture was revamped during the Empire to accommodate new concepts stemming from the

I-74. Using the cyclopean ramparts of the Incas as a base, the Spaniards constructed their adobe walls. Here is one of many such hybrids still visible in Cuzco, Peru.

I-75. Lower part of the ▶ main wall of the Inca fortress of Sacsahuaman. The blocks of stone used weigh as much as 60 tons. Peru.

use of smaller, beautifully polished blocks of stone (*Ill. I-74*). The ideology became standardized in solemn and cold forms; the stone was viewed in purely geometric terms. The virtues of Inca architecture, therefore, are its sense of pattern and its compact and stable volumes. It is a sober architecture.

Every step—the dressing of the cyclopean stones for the walls, the laying of the blocks, the exact joining of corners and sides—was adjusted to the building as if each act were a logical, ineluctable necessity conditioned by the requirements of the site, the circumstance, and the specific function of each structure. It is a deliberately thought-out architecture, thought out without haste. It is, essentially, an architecture conceived for stringent city planning.

Architecture in Peru was calm and static, with level surfaces—char-

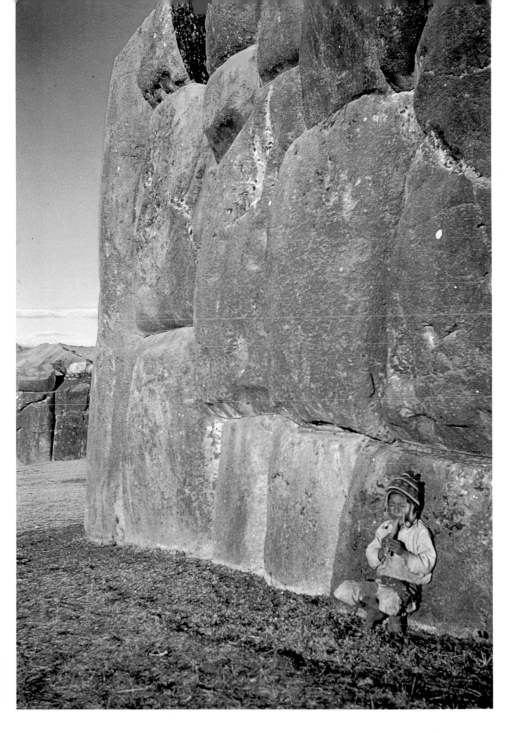

acteristics found also in Teotihuacán. However, Mesoamerican architecture, especially Maya, derives from, and depends on, an integrated plastic system. It is fundamentally dynamic; it seeks to express infinity in loftiness and verticality; contrast and shadow animate its surfaces; the sculptural third dimension strives for and achieves a dramatic tension—the antithesis of the tranquil and unshakable objectivity of the Tahuantinsuyo.

In Inca construction, the earlier moldings and carvings that resembled tapestry gave way to unadorned, strictly functional stone. A discipline that became virtually innate was reflected in the standardization of forms and styles. Cuzco, center of the Empire, created the patterns (as did Rome), which represented the culmination of an urban concept in the sense in which we use it today.

Cuzco was a microcosm of the Empire. Quarters in Cuzco for the people of each region were arranged in a geographic relationship that paralleled the location of their home territories. The main square was reserved for religious, military, and political ceremonies. Four other squares prevented congestion among a population thought to have reached 200,000 at the end of the fifteenth century—a figure that very few cities in Europe could match at that time. (It is estimated that in the reign of Tupac Yupanqui the Empire had a population of 12 million.) Bridges, stairways, squares, ramparts, and long narrow streets were adapted to the topography in an extraordinarily natural way. The same harmony governed the choice of sites for temples, religious houses, oratories, palaces, workshops, barracks, and homes.

Directly to the north, a hill dominates Cuzco. On it, the fortress of Sacsahuaman was constructed to defend the capital. The first line of ramparts was 1,300 feet long. It consisted of gigantic granite blocks, placed in zigzag lines. Each rock was fitted perfectly to its neighbors, and the exteriors were painstakingly polished to form a smooth convex curve (*Ill. I-75*).

The Incas gave the Temple of the Sun in Cuzco the name Coricancha, which in Quechua signifies "fence of gold," because of the treasures it guarded. Imagine the effect of the sun rising over the enormous disk that dominated the temple chapel and that, at daybreak, illuminated it completely with its reflections. The temple complex was a truly self-sufficient entity enclosed by a rampart. The principal chapel was situated on the upper platform of the temple. Around a central courtyard were the chapels of the Stars, the Lightning, the Moon, the Thunder, and the Rainbow. On lower floors were the rooms for the priests and

94

functionaries and the gardens. At one corner of the building, there was a conical tower, much of it still standing, and, like the rest of the ruins, displaying remarkable skill in hewing, dressing, and fitting the stones.

Ajllahuasi, the House of the Virgins of the Sun, lodged about 1,500 women. The most beautiful were dedicated to the sun cult; others were servants of the Inca and charged with perpetuating his lineage; still others were artists who fashioned ritual and ceremonial ornaments. Like the other palaces, Ajllahuasi was surrounded by a wall.

Some walls of the Palace of Manco Capac (the first Inca) have survived, as well as a portal of the Palace of Huayna Capac (the father of the two last Incas). This portal has a lintel on a reinforced base— actually a stone beam thicker at the ends than at the center, with a carved serpent occupying its entire length. This is typical of ornamentation in Inca architecture, always sparse, cold, and austere.

Other ruins in Cuzco consist of the Sunturhuasi (a kind of capitol building); the Sancacancha (the prison); and the Llachaimasi (the university), shrine of knowledge and gathering place for the *amautas,* outstanding men who taught and studied the sciences.

To the east of Cuzco, in the valleys of the Urubamba River, which empties into the Amazon Basin, the remains of a string of cities can be seen today; Huamanmarca, Patallajta, Winayhuayna, Puyo Botamarca, Loyamarca, Pisaj, Ollantaitambo, Machu Picchu.

A river gully, terraced from its bed to the peaks of the hills on either side, dominates the city of Pisaj, which, like Machu Picchu, rests on a ridge between two hills of unequal size. The base of its temple is literally hewed out of living rock and follows its contours.

Ollantaitambo, viewed as a whole, resembles one vast edifice, from its base near the river to a small plateau where the defensive ramparts stand. On the highest ground is the city proper, with the Oratory of the Ten Windows. On the peak is the watchtower, constructed of enormous blocks of red porphyry. Because of their vast size and weight, these porphyry monoliths could not be joined precisely, and the crevices between them were filled with smaller chunks of the same material. This was an extremely old technique that the Inca architects retained in their repertory and utilized when the circumstance required it. It has been suggested that the stepped design of the watchtower blocks, whose meaning is not known, demonstrates the survival of Tiahuanacan traditions. Such a link would signify an astoundingly durable influence, because Ollantaitambo was one of the last cities

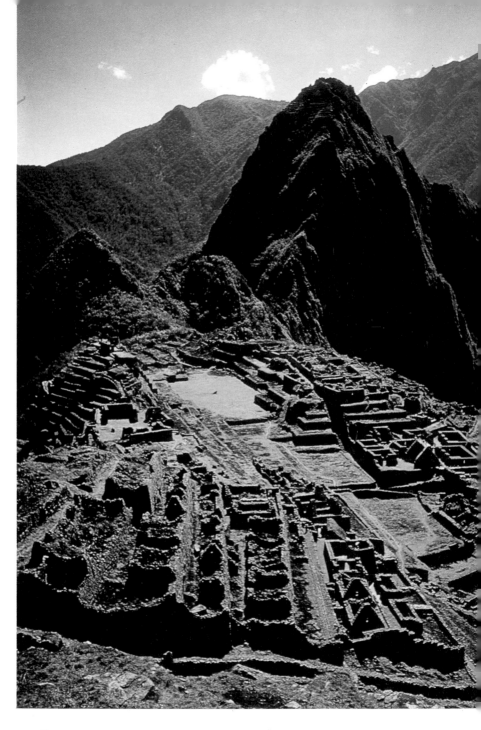

built under the Incas, a millennium after the Tiahuanaco horizon held sway.

In Ollantaitambo, perhaps more clearly than in other Peruvian ruins, curious knobs can be discerned in the exterior faces of many of the blocks. It has been surmised that they were symbols, or else related to the engineering problems: guides for grooving the stones, or hooks to fasten the rigging used to transport them, or fulcrums on which to raise and position the beams that supported the roofs.

Machu Picchu

Accompanied only by a guide and a Peruvian Army sergeant, Professor Hiram Bingham of Yale discovered the "lost city of the Incas" on July 24, 1911. In April, 1913, *The National Geographic Magazine* disclosed this marvel to a world that had not known of its existence, since no Spanish conquistadors had ever recorded it.

Today, one no longer reaches Machu Picchu by the original access road, which provided a panoramic view of the city. To obtain this perspective, the traveler must go down the steep slopes of one of the two mountains that form the axis of the city: Machu Picchu (Old Peak) and Huayna Picchu (Young Peak), half the height of Machu (*Ill. I-76*). Higher than either, the snow-covered teeth of the lofty Andes loom on all sides. On the slopes of the peaks cling the farmers' plots—more than 3,000 in all. Below, in the abyss between, the city lies, presenting an infinity of planes. The first impression is that the entire complex was built without interruption, dominated by the idea of creating a single great unity. And the unity extends to the remarkable integration of the city into the landscape—perhaps the most unique and indisputable achievement of Machu Picchu.

In the center of the city, palaces and houses surround the great square. In one of the best preserved, the Palace of the Ñusta (Royal Mausoleum), a trapezoidal window is evidence of the pervasive Inca architectural strictures. A stairway carved in the rock leads to a palace terrace that commands a view of the cordillera landscape. From

◀ I-76. General view of Machu Picchu, from the higher peak, Machu. In the distance, the lower Huayna Picchu marks the opposite limit of the city. The streets and dwellings were laid out around the central square, with the Palace of the Ñusta and the Sunturhuasi seen to the left. Peru.

it can be seen a total of sixteen troughs, each with its own well, to convey water from terrace to terrace. The palace terrace opens into an isolated tower, the Sunturhuasi, with conical walls around the base that later uncoil to form another courtyard on the second floor of the Palace of the Ñusta.

On one side of the central square stands the Principal Temple, an open structure with three walls and the altar at the back. On the upper parts of the walls, which rest on twelve-ton blocks, rhythmically spaced niches compose a frieze. Next to the Principal Temple is the Temple of the Three Windows, whose bays frame the countryside on the east.

Everywhere there are gabled houses with roofs of varying slopes, and everywhere there is the impress of a clear, logical organization of parts. The sectors devoted to agriculture or to higher or lower classes were defined by structure and elevation, and they formed independent units. But all had ready access to other sectors of the city by an intricate network of stairways and streets. Machu Picchu remains today a source book for city planners.

But it is much more. From the summit of Machu Picchu, with the city below, the Huayna in the background, and the endless wonder of the Andes chain all around, the spectator experiences—perhaps more strongly than anywhere else in Latin America—the unfathomable feeling that sustains what is most genuine in American art.

When the ultimate stages of these refined, lapidary pre-Columbian cultures, untarnished by foreign incursions, encountered the mystical barbarity of the European, a struggle to the death was inevitable. But the outcome was not death; there was, instead, a momentary catalepsy. For the magnificent ancient soil survived and survives. And in it, feeding on the mestizo (of mixed European and native parentage) forms that dominated and subdued the invading European transplants, grew the capacity for expressing the essence of a true American culture.

After one has contemplated the welter of values that together define the genius of the pre-Columbian world, Pablo Neruda's exhortation on Machu Picchu becomes more and more compelling: *"Sube conmigo, amor americano"* ("Come up with me, American love").

7

Constants and Variants

A comprehensive theory of Latin American colonial art could be constructed solely by exploring how forms imported from Europe were transmuted by historical and environmental forces into distinctively American breeds. Latin America's geography is marked by extreme contrasts, which, in turn, give rise to extremely varied artistic forms. The availability of materials conditions not only the structure but also the appearance of an architectural work. Thus, astonishingly but logically, in Paraguay and the tropical regions of Bolivia, construction of churches began with the roof. On the other hand, where stone was used, it is nevertheless easy, for example, to distinguish between a church in Zacatecas and one in Arequipa since local stone is tan in the north of Mexico and white in this southern area of Peru. Another clue to identification is provided by the unrelenting humidity in Central America and Venezuela, which rapidly stains the stucco.

Similarly, color is conditioned by altitude and temperature. In the tropics, where nature showers man with violent hues, white is the predominant color. In the arid, monotone plateau and the barren Andean Altiplano, where natural color is absent, it is audaciously invented.

Latin America's contact with the outside world necessarily came by way of the sea. As a result, there was a close tie between the coastal towns and the mother country and an increasingly mestizo tone the farther a town lay in the interior—with the sole exception of Quito, which remained a strongly Spanish enclave within the interior. But the most profoundly Spanish art is found in Lima; the most mixed in the high, remote areas bordering Lake Titicaca. Portuguese influence is most apparent in the port cities of Brazil, notably Pernambuco and Bahia; the most resolutely Brazilian art developed in Minas Gerais, far inland.

Geography also plays a major role in linking baroque splendor and mining. Great artistic centers frequently arose around the mines: in Zacatecas, Guanajuato, and Taxco, in Mexico; Potosí and its environs, in Bolivia; and Ouro Preto, in Brazil.

Despite its relative homogeneity, Latin American art reflects the discrepancies between the Spanish and Portuguese temperaments. These divergences were made more evident by the architects and artists from outside the Iberian Peninsula who put their stamp on Portuguese art of the seventeenth and eighteenth centuries. A degree of German influence is observed in Spanish South America, but it suffuses most of the baroque of the Brazilian Northeast, where a peculiar sensuality is also prevalent.

Among other temperamental and environmental circumstances that produced stylistic variants within colonial art, Church attitudes and activities were often decisive. The New World offered the clergy new challenges and new opportunities: on the one hand, distance from the European continent conferred a degree of freedom; but on the other hand, considerable adaptations in religious art were necessary because of the lack of craftsmen trained in the skills and traditions of the Old World. In addition to the competition among the orders to erect the richest and most ostentatious structures, differences in outlook arose between the regular clergy and the secular clergy, which often performed missionary tasks, as in the curious lay confraternities in the interior of Brazil. As a result, apparently antithetical styles existed simultaneously; the regular clergy built many of the great cathedrals in a predominantly sober style; the seculars, less doctrinaire in their standards of work and styles, often permitted their structures a veritable orgy of baroque ornamentation.

Constant substantive departures from the practices of the old country were required, ranging from legal codes regulating conduct to modifications in the thickness of walls (in order to make them earthquake-resistant) and in the techniques of ventilation (to suit the tropical climate), as well as in the selection of substitutes when familiar materials were scarce.

For many of the Iberians who came to the Indies, there was a goal as least as important as amassing riches or enjoying power: the conquest of souls. In one phrase, Miguel de Unamuno summed up this entire historical process: *"España conquistó América a cristazos"* ("Spain conquered America with blows of the crucifix"). The catechism, backed by political domination and great wealth, swiftly suc-

ceeded in replacing the concreteness and drama of the Indians' pagan rites with the abstractions of Christianity. Physically, this objective could be achieved only by razing the sacred teocallis and erecting churches on their sites. The native soul was won by this action rather than by philosophical conviction.

Although it is possible to dispute the extent to which pre-Columbian artistic values survived the Iberian Conquest, there can be no doubt that an atavistic instinct persisted, side by side and simultaneously with the European forms. (Of course, the intensity of this atavism varied according to the strength of the indigenous roots in a given place.) From the sixteenth century on, the laborers employed in constructing public works were mainly indigenous or mestizo in Mesoamerica and the Andes; later, in Brazil, chiefly Negro or mulatto. Many Indian carvers, from the Zapotecs to the Aymaras, had an ancient heritage of fine craftsmanship. The impress of their style and the cross-culturation of forms and symbols, far from interfering with the missionary's proselytizing, helped him to convert—when they did not subvert— such symbols and forms to his cause. Frequently, indigenous flora and fauna were carved on façades and interiors of churches.

The pre-Columbian ornamental structural sense, which favored single-plane composition, found a natural ally in a kind of Spanish atavism that harked back to Romanesque principles. In combination, these two approaches reinforced the effects of solemnity each produced. In this respect, American baroque differs sharply from European, which indulged the passion for enveloping space by utilizing the third dimension. In Spanish-American colonial art, a curved ground plan is noteworthy precisely because it is unusual.

Often local parishioners provided models for church artists. The anonymous Mexicans of Tonantzintla carved a veritable celestial court composed wholly of Indians, and the Evangelists created by the Brazilian mulatto artists Manuel da Costa Ataíde and Aleijadinho in Ouro Preto are, naturally, mulattoes. This is what most radically differentiated the arts of the New and the Old Worlds. If European art of the sixteenth to eighteenth centuries was an aristocratic art, created by elegant artists attuned to the temper of wealthy nobles, ecclesiastics of pomp and fortune, and royal courts that monopolized power, riches, and standards of taste, in the Latin American colonies, art became more and more popularly based as the Church succeeded in penetrating into the souls of its parishioners, without distinction because of race or social condition.

8

American Plateresque and the Late Renaissance

Early Architecture

"*Plateros de yeso*" ("silversmiths in plaster") Lope de Vega called the Spanish artisans who created the exquisite filigree work that covers buildings and walls of the sixteenth century. With this metaphor, the "Phoenix of Wits" coined—or confirmed—an exceptionally apt label, "plateresque."

Taste in Spain in the period after the death of Queen Isabella was sharply divided as a reaction set in against the excessive ornamentation of the Isabelline style—a flamboyant Gothic mixed with Italian Renaissance that retained elements of Arabic decoration. At one extreme was the exuberant ornamentation cherished by the secular clergy, and at the other extreme was the restraint urged by the political powers and by the regular clergy. In this polarization, the plateresque provided in Spain, like the Manueline style in Portugal during the previous century, a vehicle for the transition from Gothic to baroque—although some historians attribute an important role in this process to Mannerism.

Its overly cunning chasing of plaster and painstaking carving of stone—its extreme elegance of detail—made the plateresque a minor style (also the fate of the rococo in its reaction against baroque excess), with limited scope and constricted volume. It was fittingly compared to the meticulous and small-scale work of the silversmith.

These formal and structural characteristics were becoming prevalent in Spain as ideas and institutions were being transported to the New World. Therefore, the first colonial art, on the island of Santo Domingo (called Hispaniola today and divided between the Dominican Republic and Haiti), echoed these Iberian models.

The oldest plateresque building in Latin America is the Cathedral

II-1. Main façade of the Cathedral of Santo Domingo, the first cathedral built in the New World. Without denying his Iberian origins, the designer utilized original ideas to emphasize perspective. Dominican Republic.

of Santo Domingo (*Ill. II-1*), the first cathedral in America, begun in 1512. The ground plan is typical of Late Spanish Gothic, a style especially notable for its forthright interior structures and for its pointed ribs. The façade, a beautiful example of Spanish plateresque, is attributed to Rodrigo Gil de Liendo, who also designed Santo Domingo's Monastery of Las Mercedes and Monastery and Church of San Francisco, today in ruins (*Ill. II-2*). On the gate adjoining the ruins of the Monastery of San Francisco, a handsome Franciscan-cord decoration in stone can still be seen.

II-2. Ruins of the Church of the Third Order of San Francisco, Santo Domingo. The church had a single nave supported by Gothic arches. Dominican Republic.

Santo Domingo contains other superb vestiges of the earliest Spanish structures in the New World, among them the church of the Hospital of San Nicolás de Bari. Its cruciform ground plan was repeated throughout all Spanish America.

In the Palace of Admiral Diego Columbus, occupied by the explorer's brother from 1514, segmental and Isabelline basket-handle arches have survived to show the Spanish taste of the period, and in what was the Captaincy building, with its windows terminating in ogee arches framed by an *alfiz*—a heavily patterned Moorish-style spandrel.

The first substantial modifications in Spanish plateresque were made in Mexico. In order to provide shelter in time of danger for the sizable number of Indians and mestizos in a *pueblo* (village), a structure of considerable proportions was needed. The early Conquistadors accordingly revived a system used on the Iberian Peninsula in medieval times—the combination fortress-church. The dimensions of such an

edifice were more suited to the grandiose concepts of Gothic architecture than to the small-scale plateresque, which in the mother country could adorn the entire façade. There was also a return to the lofty Gothic nave, supported by the characteristic network of ribs. Consequently, both aesthetic and functional considerations combined to perpetuate the Gothic style in the New World long after it had been abandoned in Europe.

Another functional requirement altered the plateresque in Mexico. The Indians were so numerous that, however great the capacity of any church, they could not attend Mass simultaneously. The solution was the *capilla abierta* (open chapel), usually set against the wall leading from the church to the courtyard. From here, hundreds of the faithful could partake in the rites in the open air. Alternatively, broad chapels with several parallel open naves were linked at one end that opened into the courtyard. In other. cases, a tremendous arch, as in Actopan, sheltered the presbytery, from which the Indians were ministered to.

Another feature of the Mexican plateresque is the *posa,* a small, square open chapel in each of the four corners of the large walled courtyard, used especially during Holy Week services. Both the *capilla abierta* and the *posa* originated in Europe, but nowhere were they employed as extensively as in Mexico.

The vast monasteries built in Mexico during the sixteenth century adhere to certain general outlines prescribed by the first Viceroy, Don Antonio Mendoza. These include a large front courtyard, enclosed by high crenelated walls with three doors on the axes. At the rear of the courtyard, the church rises imposingly, with an open chapel in most cases and arches at the entrance to the monastery.

The church always has a single nave, usually surmounted by a Gothic vault with prominent ribs. The main retable (or altarpiece) is of carved and gilded wood, with oil paintings, polychrome ornamentation, and painted, gilded sculptures. The monastery is built around a cloister, two stories high, generally with vaults on both floors.

The Franciscans' vow of poverty, as reflected during the sixteenth century in their churches, set them in marked contrast to the Augustinians of the period, who concentrated on ornate, colossal feats of engineering, mirroring the transition from Gothic to baroque.

Of the twenty-one Augustinian buildings that survive today in Mexico, the largest and most splendid are at Acolman, Actopan (*Ill. II-3*), and Cuitzeo. The façade of the Church of San Agustín

II-3. Church and cloister of the Augustinian monastery. The first-floor arcade retains the pointed arch and Gothic ribbing, in contrast to the semicircular arches on the second floor. In the background, the crenelated tower of the church. Actopan, Mexico.

Acolman (*Ill. II-4*) is one of the most graceful examples of Mexican plateresque. In the monastery as a whole, the technical perfection of the stonework is on a par with the best carving Europe produced in the heyday of Gothic architecture.

In their enormous monasteries at Oaxtepec, Tepotzlán, Oaxaca, and Yanhuitlán, the Dominicans tried to emulate the Augustinians. They began to use the transept, which became standard in the following century, as in the church at Oaxtepec, which also has ribbed vaults and pointed arches. On the façade of Tepotzlán, medieval reminiscences are evident, and the solidity of the cloister, crowned by crenelations, expresses the religio-military purpose of the building. Yanhuitlán, too, has the typical attributes of the fortress-church.

Elsewhere in Latin America, plateresque architecture did not attain the splendor and variety it exhibited in Mexico and Santo Domingo. There are vestiges of it in Colombia, and clear traces in some churches in Peru show that the plateresque style penetrated to even the most remote parts of the newly colonized lands. For instance, in Ayacucho, in the Andes, about equidistant from Cuzco and Lima, many plater-

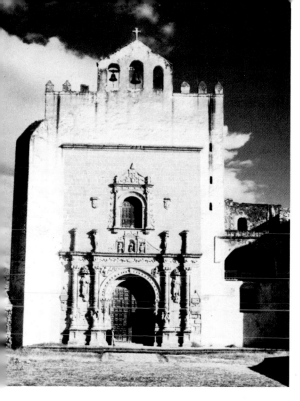

II-4. Façade of the Church of San Agustín Acolman, 1560. Unlike Spanish plateresque façades, this façade had filigreework rather sparingly placed over only part of its surface. Mexico.

esque details can be seen: the arches of the central door, flanked by Corinthian columns; the façades of La Merced and of San Francisco, as well as the carved ceiling of the Sanctuary of Santa Clara, with the ribs forming elaborate moldings of florets and foliage in the Moorish-Christian style known in Spain as Mudejar, mixed with pure Renaissance touches. Lima's Santo Domingo has bossed vaults that are plateresque, as do several ruined churches in Peru. Open chapels and *posas* also developed in Alto Peru, but were never as numerous as in Mexico.

The Great Cathedrals

The plateresque was not introduced in Spain (or later in Latin America) without a struggle. To prove this, one need only compare the plan and appearance of the first great cathedrals built by the bishops with the stylistic defiance represented by the religious orders' introduction of baroque elements. During the second half of the sixteenth century, Philip II's stern tastes led to guidelines for Spanish and Indian art, which the architect Francisco Becerra was charged with

107

bringing to the New World. Among the buildings started under this edict was the present Cathedral of Mexico City (*Ill. II-5*). Work was begun in 1563 and continued for almost 250 years, an unusually long time among Spanish American churches.

The interior plan was drafted by Claudio de Arciniega, and the elevation was the work of Juan Miguel de Agüero. Arciniega's plan bestowed a majestic sweep, with three longitudinal naves, two naves with deep chapels, nine transverse naves, and the transept. Just as their pointed bossing gives plateresque churches their familiar interior aspect, so in the Cathedral of Mexico City—except for the sacristy and presbytery—there are an enormous uninterrupted barrel vault and aisles roofed by quadripartite vaults, both typical of the Renaissance.

The cathedral exacted a substantial quota of innovations to suit unfamiliar environmental conditions. Besides the special foundations required by Mexico City's swampy subsoil, the problem of providing light for such a wide edifice necessitated an original solution, which would be repeated elsewhere in Latin America: The central nave was elevated above the laterals, and the laterals above the chapels.

Most of the façade was carved well within the seventeenth century, but its baroqueness is obviously checked by another stylistic concept. This heightens the contrast between the façade of the cathedral itself and that of the adjacent Sagrario (Sacristy), a separate chapel. The cathedral dome was reconstructed by the greatest exponent of neo-classicism in Mexico, the Spaniard Manuel Tolsá, a circumstance that explains why the exterior has elements of both the Late Renaissance and neoclassicism, although the rigidity of the latter could never be imposed without concessions to the baroque Latin American temper.

The cathedral in Mérida, on the Yucatán Peninsula, demonstrates even more fully the coincidence of outlook and time in the Renaissance restraint apparent in its simplicity of line and austerity of plan. Two small towers are incorporated in an enormous simple façade with three portals in the Mannerist style. The Cathedral of Oaxaca clearly exemplifies the significance of the modifications imposed by the American environment. The need to protect the structure against earthquakes gave it a broad, squat appearance, which is reinforced by the two small towers and the enormous buttresses that support the lateral walls.

In its unmodified elements, the Cathedral of Tunja symbolizes the conflict of styles in Colombia. On the Corinthian capitals of the portal, by Bartolomé Carrión, the stems of the leaves end in birds, in the plateresque manner, and the upper pyramids end in balls, an unmis-

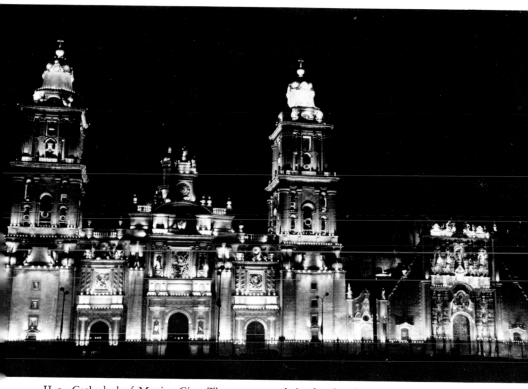

II-5. Cathedral of Mexico City. The towers and the façade of the main section (with sculptures by Miguel and Nicholás Jiménez, dating from 1687) were finished by a Mexican architect, José Damián Ortiz de Castro, around 1790. At the right, the façade of the Sagrario Chapel (*see Ill. II-13*).

takable stamp of the style of Juan de Herrera, the second architect of El Escorial, Philip II's austere palace.

The model that best conforms to the ideals Philip supported in Spain was the Cathedral of Jaén, begun in 1540 according to a plan by Andrés de Vandelvira. In a ground plan that later was called "hall church," the spatial concept of a six-sided rectangular form expressed a severity as much at odds with the plateresque as with the baroque. This was the plan followed in America (except for the modifications concerning the greater height of the central nave, which produced the prism form).

The Cathedral of Puebla, in Mexico (*Ill. II-6*), begun probably by Arciniega in 1575 and modified by Becerra, has a plan very similar to that of the Cathedral of Mexico City; but it differs from the earlier building in, among other things, the height of the towers, so lofty and massive in Puebla that their volume makes them compete with the façade for dominance.

Becerra had arrived in Mexico in 1573, with Viceroy Martín Enríquez de Almansa. When Enríquez was transferred to Lima in 1581, he brought his favorite architect with him. There, Becerra drew up the plans for the two most important cathedrals in South America: in Lima (*Ill. II-7*) and in Cuzco (*see Ill. II-52*).

Becerra's two Peruvian cathedrals have three naves with two rows of deep chapels. The placement of the armless transept almost in the center, along with the lack of an apse, apse aisle, and dome, gives the exterior of both structures the form of a perfect cube.

Construction on both cathedrals was fairly advanced when Becerra died, in 1605. In Lima, successive modifications, carried out at the wish of the authorities or imposed by the need to rebuild after earthquakes, resulted in the present hybrid structure, particularly marred

II-6. Main façade of the Cathedral of Puebla. Dedicated in 1649, it has greater stylistic unity than the Cathedral of Mexico City. The sober façade is framed by high towers. Mexico.

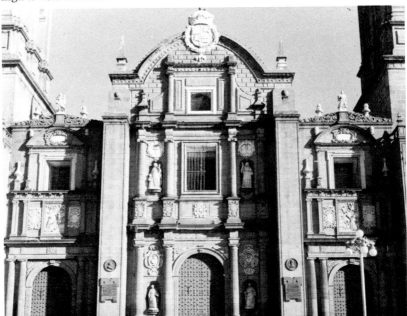

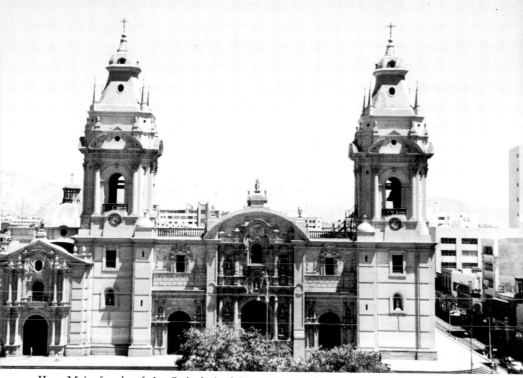

II-7. Main façade of the Cathedral of Lima. Begun about 1572, the cathedral was almost finished at the start of the seventeenth century. This façade was completed in the first third of the eighteenth century. Peru.

by the anachronistic towers. In Cuzco, on the other hand, Becerra's final plans (drafted in 1598) and his architectural ideas have survived. In both, the dominating style is the Spanish hall church, with the interior space large and horizontal and the horizontal vista emphasized by the treatment of vaulting and ribs.

Sculpture and Painting

From the sixteenth century onward, a communal approach, rooted not only in the art brought from Europe but also in pre-Columbian practice, subordinated colonial sculpture and painting to the architectonic design of the whole. In the great cathedrals, in the monasteries, in the churches dedicated to a particular saint, the artist—whether mestizo or Spanish—tried to fulfill as closely as possible the ideals of the mother country (*Ill. II-8*).

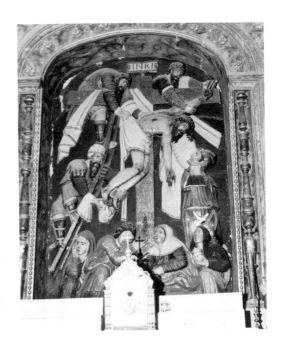

II-8. The Descent from the
Cross. Polychrome bas-re-
lief (ca. 1575). Chapel of
the Sagrario of the Domin-
ican convent of Yanhuit-
lán, following an etching
by Marcantonio Raimondi.
Mexico.

During the Third Mexican Church Council (1585), there was strong
orthodox sentiment favoring the iconographic pronouncements of the
mid-sixteenth-century Council of Trent. However, the Mexicans re-
ceiving religious instruction seem to have evaded the Counterreforma-
tion strictures against Renaissance nudity and other "pagan" approaches
to religious subjects. As a result, from the sixteenth to the eighteenth
centuries, colonists from both countries of the Iberian Peninsula
watched disapprovingly as a popular sentiment found release in sculp-
ture. However, except in Quito and Lima, native ancestral values were
less prevalent in painting than in sculpture. The mestizo and Indian
carvers bore in their blood a tradition based on the use of relief decora-
tion, a tradition comprehensible to the European eye. But anyone who
wished to become a painter was forced to assimilate European tech-
niques totally different from those he had inherited and, moreover, to
achieve objective representations copied from reality. Therefore, in
colonial art, sculpture is more free and original than painting. It is,
above all, more American.

In Cholula, in Mexico, there is a thoroughly Aztec frieze that was carved after the Spanish Conquest, and in the Augustinian monastery in Acolman, also in Mexico, there is a Virgin that could be considered a sister of the terrible Aztec goddess Coatlicue. The façade of Acolman is, undoubtedly, the most European in Mexico. However, on the inner curve of the arch of the doorway, there are local fruits, in addition to the purely Aztec glyphs that separate the shields of Castile and León.

Naturally, as the plateresque style developed, the most clearly Mexican impress appears where carving has given new applications to functional structures or, at least, was used in wholly native profusion. The *posas* and the crosses in the walled outer courtyards ·of the churches are particularly rich in such carving.

The four *posas* in Huejotzingo show an inventive use of this novelty. There, the angels on the *alfiz* bearing the attributes of the Passion have legs stylized in a nonacademic way to give the effect of flight. Among the open chapels, one of the most outstanding for its carving is in Tlalmanalco, in the Monastery of San Luis Obispo, where the plateresque abundance of ornament is united with a puzzling mélange of ideas: the angels have monkeys' faces.

Popular imagery in the form of statuettes was so skillful and splendid in Guatemala that beginning in the sixteenth century, it was exported in large quantities, particularly to Mexico. The Guatemalan images are European (especially Spanish) and Christian in spirit. One cannot find in them traces or reminiscences of a pre-Hispanic past, despite the fact that they were made in the very region where one of the great centers of Maya civilization had been situated. The value of these carvings resides in the finished technique of their craftsmen, several of whom have been identified. Among those most highly esteemed were Juan de Aguirre and Quirio Cataño. It has not been possible to make positive identification of any of the works attributed to Aguirre, who was active during the last thirty years of the sixteenth century. Cataño, however, is known to have created the famous *Christ of Esquipulas* (1595), with its unusual color—bronze, almost black.

In painting, unlike in the other arts, Mexico did not experience the conflict between native and European forces; in painting, the Old World's triumph was absolute. It is revealing to note that the Mexican's own temperament led him to sweeten the Spaniard's awesome and terrible vision. The Mexican versions of this *tremendismo* appear much later, when, according to modern historians, the notion of frustration gained currency. There is also some work that derives from the *tre-*

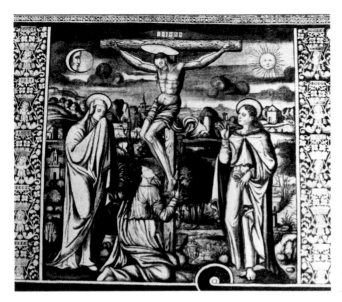

II-9. Calvary. Fresco on the upper part of the main cloister of the Church of San Agustín Acolman. The colors are chiefly in the gray range, with the hair being ocher. Mexico.

mendismo of Valdés Leal, the celebrated Spanish painter of cadavers.

Engravings of famous European works arrived in the American colonies continually. The models were excellent, and though they were copied, they were copied well. What was imitated was, of course, the composition, for working from black-and-white versions, the copyist had to devise the color scheme for himself.

The first Spanish painter to arrive in Mexico came as part of the retinue of Hernán Cortés, whom he painted in the act of praying. This pose is symbolic of the predominance of European values over mestizo in painting during the Viceroyalty. Admittedly, the painting of this period was marginal and undistinguished, but it represented the artists' and patrons' attempt to re-create their own poetic world with the resources within reach.

Alonso Vázquez and Andrés de la Concha, two Spaniards, began easel painting in Mexico at the height of the plateresque vogue, but the true expression of the period lies in the monastery frescoes, mostly in white on black. The finest of these are at San Agustín in Acolman (*Ill. II-9*), Huejotzingo, Tepeaca, and Actopan.

The arrival of the Flemish painter Simon Pereyns in Mexico in 1566

launched the development of important easel painting, notably on the retables in Cuernavaca, Malinalco, and Huejotzingo.

Fresco paintings similar to those of the Mexican plateresque monasteries have been preserved in the city of Santo Domingo. In the rest of the Antilles, and in Central and South America, the majority of paintings known to date from the sixteenth century are imported. During the second half of the sixteenth century, European artists reached these areas. Like Pereyns in Mexico, they must have established schools and influenced the Creole painters. Around the middle of the century, a painter born near Seville, Alonso de Narváez, was working in Bogotá, and from 1587 on, a Roman, Angelino Medoro, painted in Tunja, before settling in Lima.

In 1534, the year the city of Quito was founded, Franciscans established there the first school in South America to teach arts and crafts needed by the Church. Two Flemish missionaries, Friar Pedro Gosseal and Friar Jodoco Ricke, trained bricklayers, carpenters, blacksmiths, stonecutters, painters, and musicians. They also brought artisans from Peru and Flanders, who worked on the construction and decoration of the Monastery and Church of San Francisco.

Friar Pedro Bedón, born in Quito in 1556, represented the Roman school in this region and began a kind of local painting that in time became known as the Quito School.

During the second half of the sixteenth century, several Spanish image-makers, among them, Diego de Robles and Luis de Ribera, arrived in Quito. They opened workshops and created patterns adopted, if not because of their quality, at least because they satisfied widely cherished ideals. Most of the image-makers in Quito who gained fame in the following century were Indians or mestizos, although their works do not give any hint that the artists were natives.

In Peru, the zeal and the faith of an Indian noble produced the first mestizo sculpture. In 1583, Don Francisco Titu Yupanqui, a descendant of the Incas, finished a statuette of the celebrated *Virgin of Copacabana,* influenced by the Spanish masters from whom he sought support and instruction. This work, as well as the replicas made subsequently by Titu Yupanqui himself, constitutes an exception to the prevailing demand for Spanish sculptures, which had been much sought after in Lima for most of the sixteenth century.

Similarly, the Peruvians imported Italian, Flemish, and Spanish paintings on wood or canvas in large numbers from the middle of the sixteenth century.

9

The Baroque in Mexico

In seeking the essence of Mexican baroque, one can scarcely over-estimate the importance of the delight in color. All the materials of Mexican baroque architecture, and its adornments, demonstrate this national passion. The stones used in building offer dramatic contrasts: "Tezontle" is a volcanic stone of such an intense red that it looks almost artificial. To the touch and sight, it has the texture of coarse fabric, an effect that is heightened by its porousness. "Chiluca" is a whitish limestone that lends itself easily to carving.

A further element of architecture also involved rich use of color: polychrome plasterwork, which was adopted in Mexico just as it reached its flowering in Andalusia, but the form as well as the orna-mental function were different on each side of the Atlantic. In Spain, the scrolls retained the traditional role of an accessory ornament. In Mexico, especially in Puebla, the scrolls are elongated and attenuated until they become delicate plaster darts. Crossings and coilings reach the most exaggerated extremes, which underline and emphasize the polychrome work. Plasterwork, moreover, makes it possible to develop a form of organic sensuality, and some scholars find in this aspect direct relationships with pre-Cortesian ornamentation.

Polychrome plasterwork is a cheap form of ornamentation, easy to work and affording unlimited possibilities for the free play of the imagination. It was very conducive to the search for effects, novelties, and surprises so dear to the spirit of the baroque and to the Mexicans' delight in adornment. Even softer than wood, it is like wood in tol-erating polychrome carried to extremes. The art of polychrome plaster-work reached its height in Puebla, but it is seen in all the adjacent territories as a distinctive formal element of Mexican baroque.

Glazed tilework, originating as a Mozarabic craft, also had a long tradition in both Spain and Portugal. In Mexico, the centuries-old heritage of excellent craftsmanship crystallized in genuine local schools.

The Puebla school was important enough to stamp the style of its whole region, and its influence extended far to the north and south. Ranging beyond the technique of the noted Spanish tile-making town of Talavera de la Reina, Puebla craftsmen utilized ceramic and crockery in many additional ways. An original kind of arabesqued tile was employed on domes and, sometimes, on entire façades in audacious harmonies of reds, blues, and yellows.

In Mexican colonial art, color was a fundamental element in a particular style's process of differentiation; it is the exact expression of a consistent development that originated in pre-Cortesian paintings and culminated in the plastic creation of the twentieth century.

Another formal sign of the Mexican baroque is the use of mixtilineal shapes, mingling curved and straight forms—a characteristic in which some critics have seen a convergence of two sources: the pre-Cortesian tradition and the contribution of Mozarabic concepts, present from the plateresque. This obsession with the use of mixtilineal elements achieves amazing originality in the lanterns surmounting the churches and in the forms of arches. Three-lobed and semihexagonal arches were elaborated into incredibly imaginative combinations.

Besides these distinctive features, a form was created that became an unmistakable sign of Mexican baroque: the *estípite,* a pilaster in the shape of a truncated pyramid inverted to rest on the smaller base. The general concept of the *estípite* can be traced back as far as Mycenae and Crete. It developed somewhat further during the Renaissance in Europe. In Mexico, it was adopted so widely that it became as much a distinguishing mark in interiors as the "retable-façade" on exteriors. The retable-façade was so named because its carving in stone rivaled that on the ornate wooden altarpieces that graced baroque churches.

In harmony with the baroque predilection for utilizing extremely heterogeneous elements, the Mexican façade became more and more complicated. Onto the traditional features, sculpture of various kinds was grafted—foliage, scrolls, conical protuberances. Local craftsmen even went so far as to develop a double *estípite,* with the center of the shaft a tangle of sculpture from which a pair of symmetrical designs spring, one snaking upward, the other downward, sometimes so overburdened with ornamentation that it is impossible to discern the original basic structure.

Architecture

The aesthetic divergence between European and Creole currents reflected a growing differentiation in the social structure of the colonies.

This phenomenon is common to most of Latin America, but in Mexico, it crystallized more definitely than in the south. The Spaniards, living in the major cities, were driven by nostalgia to try to recall the image of their distant homeland. On the other hand, the heirs of the conquistadors constituted a plutocratic aristocracy of landowners and mine owners anxious to preserve their forebears' memory with imposing and enduring architectural works. Each of these contradictory impulses found a means of architectural expression, with the uprooted urban Spaniards preferring strict adherence to European models and the Creole aristocracy of the smaller towns more receptive to mestizo forms incorporating indigenous concepts.

The Church of San Sebastián y Santa Prisca (*Ill. II-10*), in Taxco, symbolizes the Creole side of this phenomenon. Don José de la Borda, owner of a very extensive silver lode, devoted much of his fortune to the erection of the church and numerous other public structures. Diego Durán Berruecos built Santa Prisca between 1751 and 1758. The highly ornamented, elegant façade is framed by twin towers that balance the masses to achieve a very pleasing baroque verticality. In ornamentation, however, there is total confusion. Although the *estípites* here are unusually discreet, classical columns are topped by twisted varieties; fillets, brackets, scrolls, niches with sculpture, foliage—all rush reck-

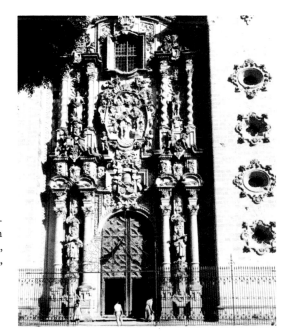

II-10. Detail of the façade of the Church of San Sebastián y Santa Prisca, begun in 1751. Taxco, Mexico.

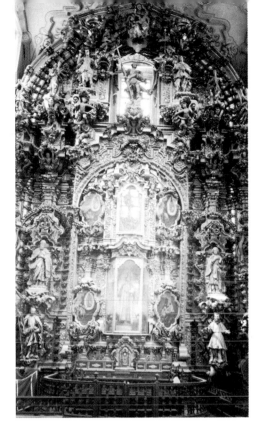

II-11. Side altar of the Church of La Valenciana, built between 1765 and 1788. Its retables are choked by a veritable orgy of ornaments, foliage, angels, and saints. Guanajuato, Mexico.

lessly over a façade that offers no rest to the eye. On either side, elaborately bordered windows interrupt the relative continuity of the wall. An octagonal drum supports the dome, which is faced with multicolored Puebla tiles. Inside, the theatricality is heightened by rusticated bands and diamond points carved in stone.

Santa Prisca's retable-façade framed by panels supporting the towers was a form widely used throughout Latin America. North of Taxco, near Guanajuato, another typical church, La Valenciana, shows slight variations from the earlier model. The church was built next to the mine of that name, which was discovered in 1760 by Antonio Obregón, and the minerals themselves helped Obregón to finance construction of the church (1765–88).

The façade of La Valenciana employs patterns that were now national trademarks: the *estípites* are the predominant element, but they are more elegant than heretofore and serve to frame the niches between them. The splendor of the interior (*Ill. II-11*) is enhanced

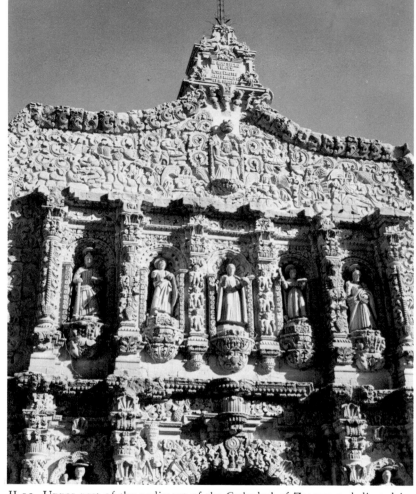

II-12. Upper part of the pediment of the Cathedral of Zacatecas, dedicated in 1752 but finished only in 1761. The horror vacui, typical of Spanish-American baroque, made it necessary to cover every inch of the façade with ornaments. Mexico.

by the bossage on arches and pilasters, and in the vaults there is sumptuous mixtilineal ribbing with unquestionably Gothic roots.

Farther north, the Cathedral of Zacatecas (*Ill. II-12*) exhibits another original Mexican variation that distinguishes it from both local and European baroque. It has rightly been observed that this cathedral's magnificent decorative extravagance makes it the finest baroque church in Mexico. The formal elements of the true European baroque (the horizontality of the entablature, its regularity between the vertical

members, the restraint in the foliage on the twisted columns) are smothered in the façade of the Cathedral of Zacatecas. Shock and surprise are generated by the frame that surrounds the entire façade, by the novelty of omitting the flanking panels, and above all, by a continuous hierarchical ascension that culminates in the representation of the Eternal Father surrounded by eight angelic musicians, in a style that mingles Romanesque origins with the indigenous planar composition.

Lorenzo Rodríguez is usually considered the most outstanding of the creators of a Mexican architecture. Rodríguez, born in Spain around 1704, was a man who assimilated and identified with American taste. In 1749, he embarked on his most renowned work, the Sagrario Chapel next to the Cathedral of Mexico City. On its two façades, employing the *estípite* as the basic ornamental motif, he brought the retable-façade to its apotheosis (*Ill. II-13*). Instead of the retable's wood, he carved the façade in clear whitish chiluca stone, with the walls of

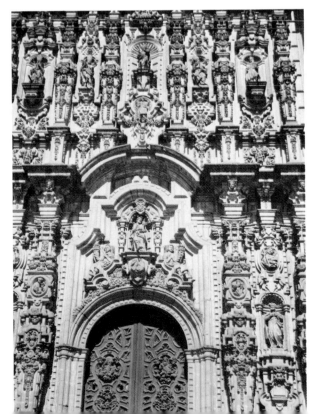

II-13. Detail of the façade of the Sagrario Chapel adjacent to the Cathedral of Mexico City, executed by Lorenzo Rodríguez between 1749 and 1760. This side faces the Zócalo, or main square.

red tezontle. Rodríguez took advantage of the disparity in height between the lofty central axis of the façade and the lower supporting masses to devise sloping walls, inclined like flying buttresses, and outlined the profiles in a variety of curves and finials.

The retable-façade of the Jesuit Church of San Martín Tepotzotlán (*Ill. II-14*) is another catalogue of the profuse ornamentation and heterogeneous forms of which Mexican baroque was capable. In this instance, which is more traditional in the European sense, the carving on the white façade harmonizes with and flows into the single tower. Inside, standing on the axis of the main altar, one seems to be within a radiant grotto; ornamentation covers the side walls completely and dominates the transept.

Like Tepotzotlán, the interiors of Santa Rosa and Santa Clara, in Querétaro, are manifestly designed to dazzle the worshipers, but they do so by means antithetical to those of Tepotzotlán. In Santa Clara, one is astonished not so much by the florid carving along the lateral walls and the grandiose retables as by the imaginativeness of the choir screen (*Ill. II-15*). Constructed in three parts, the screen has a heavy grille with three large medallions on the lowest portion. A light grille forms the second level. Capping both is an airy filigree as delicate as the artistry on a tortoise-shell comb.

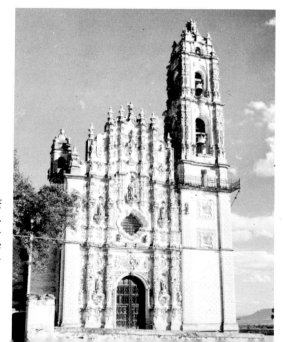

II-14. Jesuit Church of San Martín Tepotzotlán. The decoration of the retable-façade achieves here the effect of a true tapestry of foliage. Mexico.

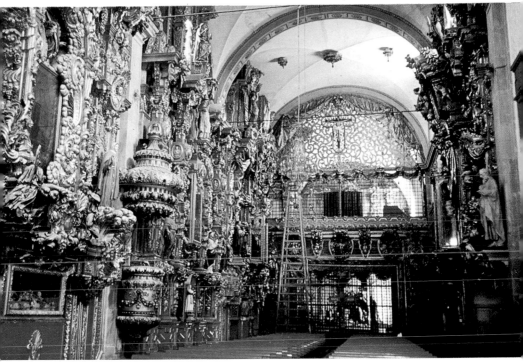

II-15. Nave of the Church of Santa Clara seen from the main altar, looking toward the choir. The church was completed in 1633, but the interior decorations, attributed to Mariano de las Casas, date from the eighteenth century. Querétaro, Mexico.

Another example of the inexhaustible variety of Mexican baroque is the Collegiate Church of Ocotlán, in the State of Tlaxcala, also in the central part of the country (*Ill. II-16*). Little is known of its designer, identified in local records merely as the "Indian Francisco Miguel." But this obscure draftsman conceived a façade in the shape of a shell, which is wholly Mexican yet is more plastic than the several shell façades elsewhere in the country. The conceptual unity of the towers and façade of Ocotlán is enhanced by the verticals that support the towers. Everything, in this model church, is subordinated to a deliberate intent to achieve the exaltation of slender grace. Small hexagonal red tiles highlight the whiteness of the stone on the façade, with its deep chiaroscuros and reliefs, centered around a window in a fanciful star shape. Since the members that support the towers

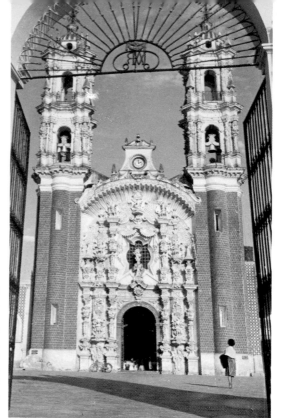

II-16. Principal façade of the Collegiate Church of Ocotlán. The interplay of volumes between the supports of the towers, the adornments on their pinnacles, and the façade enhance the sensation of instability typical of the baroque. Mexico.

are also covered with these deceptive red tiles, which make a surface that resembles a snakeskin, the viewer thinks that the supports have less volume than the towers themselves and consequently experiences the sensation of disequilibrium that the baroque architect seldom achieved so surely as at Ocotlán.

A few more examples, equally striking, will serve to show the symbiosis between Creole baroque, with its overpowering structural and ornamental lavishness, and the clearly mestizo elements in popular Mexican religious art.

The most perfect embodiment of this is the Pocito Chapel, near the shrine of Guadalupe, a short distance from Mexico City. The chapel was built between 1777 and 1791 by Francisco Guerrero y Torres, a Guadalupe architect, to shelter a well with miraculous waters. Guerrero's originality does not lie in the ground plan, which consists of a circular entrance hall, an oval central area, and the sacristy, forming an octagon

with four straight and four curved sides. This plan derives from a drawing of a Roman structure that appeared in Sebastiano Serlio's *Architettura* in the sixteenth century. Although Guerrero modified Serlio considerably, his great contribution is the front elevation of the building. Each of the three parts is a different height and is crowned by a dome of different size and form, which rests on a drum that is, likewise, different. All the domes are faced with blue and white bands of Puebla tile arranged in a zigzag pattern. The contrast of these bands with the red tezontle of the walls and the whiteness of the chiluca stone of the lanterns and portals intensifies the astonishing effect of this small church, which would have dazzled Borromini himself.

The so-called Tepalcingo style recently identified in several churches of the region (Santa María Jolalpan, San Lucas Tzicatlán, and Santa María Tlancualpicán), not far from Mexico City, is characterized by an exaltation—one might venture to call it a surrealist exaltation—of Christian symbolism that, although it has direct iconographic roots in medieval Europe, is enriched with mestizo contributions with an Oriental flavor.

On the façade of Jolalpan (*Ill. II-17*), the columns of intertwined serpents, the stone curtains that disclose exotic birds, the *estípites* in human form, the symbols of the sun and moon are mingled in an incredible potpourri. This is the acme of Mexican mestizo expression of plastic feeling that begins with the grotesque in Gothic and reaches the fantastic fusions of Art Nouveau.

The plasterwork in the Church of Santo Domingo in Oaxaca, dating from the start of the eighteenth century (almost a hundred years after the completion of the building), seems to belong to a magnificent Italian palace rather than to a church. Nevertheless, the peasant-style polychrome plaster gives the central nave, the choir vault, and the Rosary Chapel (*Ill. II-18*) an unmistakably Mexican flavor. The genealogical tree of Jesse on the choir vault is usually considered the most original feature of this church, but the entire structure is alive with that fantastic world that could be expressed only in polychrome plaster.

In the inventiveness of its interior ornamentation, the Rosary Chapel of Santo Domingo in Puebla, finished in 1690, is beyond imagination. It could have been achieved only because of the ease with which plaster can be worked. The interior of the Chapel of the Holy Christ in Tlacolula, in the State of Oaxaca, reproduces in miniature this Rosary Chapel in Puebla.

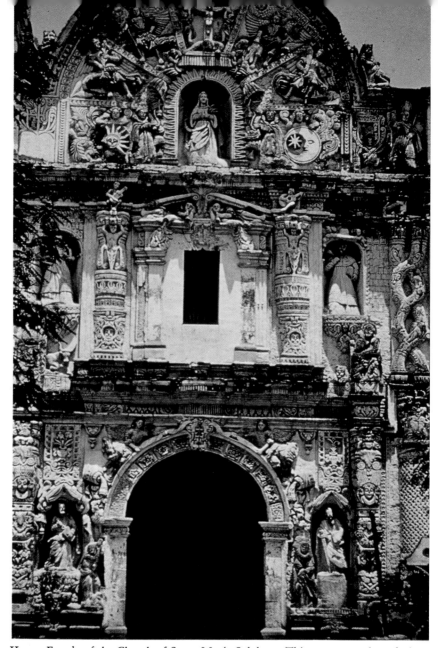

II-17. Façade of the Church of Santa María Jolalpan. This represents the culmination of the Tepalcingo style, characterized by the use of traditional inconographic elements, but arranged with an absolutely original sense of composition. Mexico.

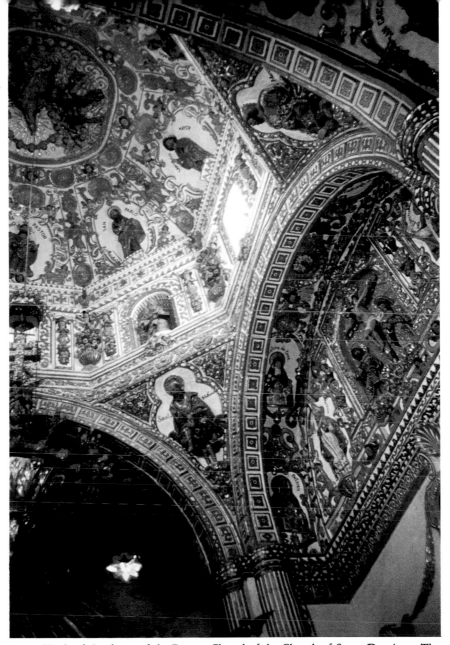

II-18. Vault of the dome of the Rosary Chapel of the Church of Santo Domingo. The chapel was added between 1722 and 1729 to the main body of the church, which dated from the late sixteenth and seventeenth centuries, but the style of polychromed stucco was retained. Oaxaca, Mexico.

It is impossible to establish a dividing line between this major art, getting its impetus from and paid for by wealthy Creoles—giving vent to nationalism in the arts long before they did so in politics—and the clearly popular manifestations of the same phenomenon. But perhaps it is in this form of aesthetic expression that the mestizo people of Latin America, too, made their most original impact.

Popular Mexican baroque, although it never surpassed the achievement of Puebla, erupted the length and breadth of the land. The Sanctuary of Atotonilco, in Guanajuato, was built about the middle of the eighteenth century. Its parishioners, however, expressed their continuing devotion with the progressive addition of new chapels, appended to the central structure, until six were completed besides the sacristy and the *camarín,* which housed the image of the patron saint behind the altar. These additions resulted in an unusually fragmented façade, as well as an enormous variety in the structures, concepts, and interior ornamentations. The altar of the Rosary Chapel is adorned with paintings on mirrors, and in the Chapel of the Holy Sepulcher, along with three sculpture groups that are excellent examples of native religious art, there is an ingenious popular variety of baroque spatial envelopment created by a lattice interposed in the center of the nave.

The *camarín*—a chapel or niche behind the altar usually displaying the image of the Virgin—clearly provided an outlet for the mestizo to express himself freely. In the *camarín* in the Sanctuary of Ocotlán, the

II-19. Vault of the *camarín* of the Santa Casa de Loreto, in the Church of San Martín Tepotzotlán. The *camarín*—built between 1679 and 1680—shows in its vault, with its crossed ribs, the survival of Mudejar influence on structure. Mexico.

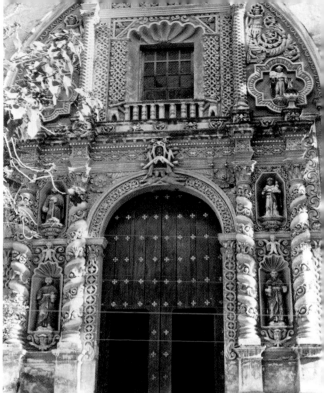

II-20. Façade and lantern of the Church of San Martín Texmelucan. The decorative tapestry is highlighted by the immaculate white of the stucco. Mexico.

II-21. Detail of the façade of the Church of the Third Order of San Francisco. The mestizo character of this popular façade is evident in the strange framing of the Supreme Being, the mermaids with their vegetal tails, and the adaptation of the gargoyles. Atlixco, Mexico.

twisted column dominates a tangle of ornamentation. In Tepotzotlán, the *camarín* of the Santa Casa de Loreto exhibits Mudejar reminiscences in the structure of the vault (*Ill. II-19*). Surprising hybrids are produced, and if there is a European air to the four dynamic angels that spring from the cells between the ribs, the figures that rest on the low parts of the same ribs have native features and dark complexions, and each is flanked by twelve small faces, also of natives, but with blond hair.

The façade of the Church of San Martín Texmelucan (*Ill. II-20*) is a veritable tapestry in keeping with the single-plane decorative sense; the cupolas and the lantern overshadow the perfection of the facing of Puebla tiles. The façade of the small Church of the Third Order of San Francisco in Atlixco, in the State of Puebla (*Ill. II-21*), presents an

II-22. Detail of the upper part of the façade of the Church of San Francisco Acatepec. This is an outstanding example of the use of Puebla tiles, which here follow the involutions of the complicated decoration. Mexico.

II-23. Vault of the Church of Santa Mariá Tonantzintla, a high point in the ▶ interior decoration in the Mexican mestizo baroque style. Mexico.

ingenious thesaurus of different imported formal elements: the coiling columns with lush stylized foliage; the mixtilineal rosettes, which here serve as niches to hold saints' images carved with a touching primitivism; the Mozarabic echoes in the rigidly patterned plaster foliage in an obviously disparate style. Twin mermaids, with leafy tails, complete the pediment. In the center, supported by two native angels and encircled by fanciful cabalistic forms, there is a face with enormous mustaches that must represent the Supreme Being—naturally Mexican.

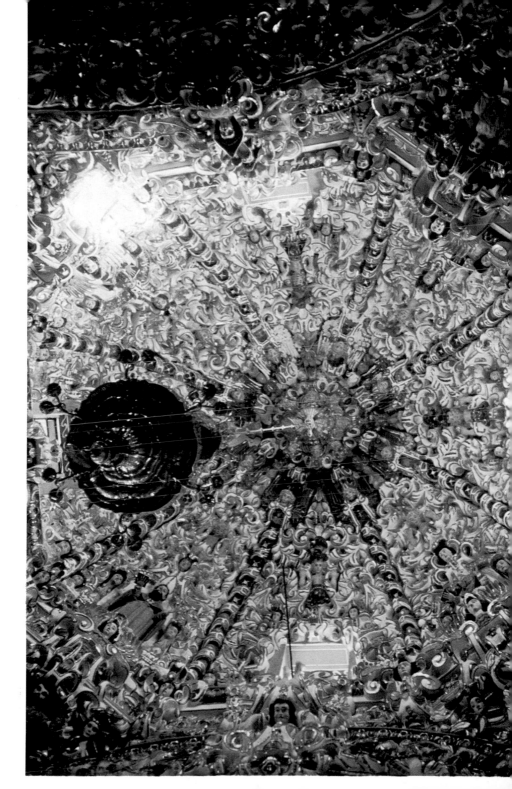

The culmination of the native Puebla style is to be found in the exterior of San Francisco Acatepec and the interior of Santa María Tonantzintla. The façade and towers of San Francisco Acatepec (*Ill. II-22*) are entirely modeled in tile, predominantly blue and yellow. By "modeled" we mean not that the tile was applied over a basic structure of decorative twists and turns, but that the decoration was conceived and executed through the tile itself. The pieces of ceramic that make up the façade were actually fashioned into capitals, moldings, volutes, *estípites,* stars, and foils. The slight concavity of the façade as a whole enhances the evident baroque dynamism here expressed in a popular adaptation.

In Santa María Tonantzintla, decoration based on the masterly use of polychrome plaster reaches the sublime. The interior is truly an enchanted grotto. On the three sections of the ceiling, red and yellow plasterwork glows against a green background. Over the choir, angelic musicians, the color of roast meat, contrast with the more pallid figures of the dome, where, among the moldings that conceal the pendentives, a swarm of heads is mingled with the carved foliage (*Ill. II-23*). On the chancel arch, totally covered with plasterwork, more heads stand out, and the arch itself displays new motifs—among them, crowned devils spewing forth tropical fruits and Indiatids (the New World's counterpart of Greek caryatids) with Roman-style plumed military headdresses. We are in the presence of an innumerable celestial court. And, because of the identity of its anonymous artists, the court is Indian.

Sculpture and Painting

The opposition between European and Creole tastes is also apparent in Mexican baroque sculpture. It can be seen, not in outright controversy, but in the line dividing the two worlds, which could be fused only in popular expression.

Since the sixteenth century, "cultivated" sculpture had been employed in the architecture and solemn statuary of façades and on retables. It flourished, in extremely varied forms, from Chihuahua in the north to Oaxaca in the south. All critics agree that its dominating figure is Jerónimo Balbás, who arrived in Mexico at the beginning of the eighteenth century decked in the laurels he had won for his main retable in the Sagrario Chapel of the Cathedral of Seville. Balbás' greatest work in Mexico was the *Retable of the Kings* in the Cathedral of Mexico City (*Ill. II-24*). The noted Mexican scholar Justino Fernández subtitled his book on this piece "Estética del Arte de la Nueva

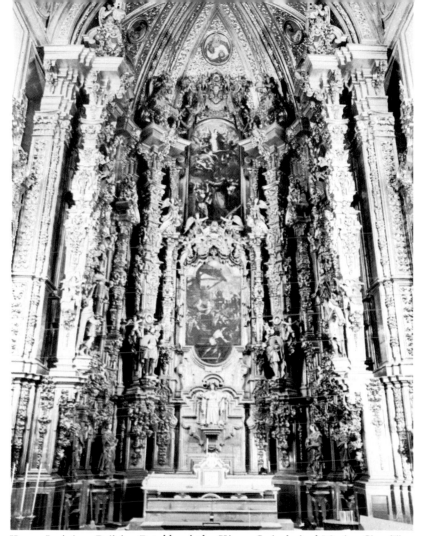

II-24. Jerónimo Balbás: *Retable of the Kings*. Cathedral of Mexico City. The work (begun in 1718 and finished in 1737) is the finest Mexican example of the Spanish baroque retable.

España" ("Aesthetic of the Art of New Spain"), thus indicating both its quality and its archetypal position in Mexico. Balbás' *Kings* was the most influential and important retable throughout New Spain. It was also the most costly aesthetically. If it did not introduce the "formal sign of the baroque"—the *estípite*—it was the source for its widespread proliferation.

The exhaustive study now under way of "cultivated" (and, significantly, signed) religious statues—especially of the Puebla and Querétaro schools—will probably disclose their similarity to contemporary models favored in Europe (in Spain, the works by Juan Martínez Montañés in Seville and Pedro de Mena in several Andalusian cities and Toledo).

A distinctively Mexican sculptural style found expression not only in religious statuary, but also in peasant retables. And the Birth of the Virgin in the Rosary Chapel of Santo Domingo in Puebla is an archetype of the numerous bas-reliefs in which fervent native craftsmen gave vent to a real feeling of intimacy with the divine. In the Puebla work, St. Anne's bed, instead of being placed in the traditional horizontal position, is inclined, perhaps to give the composition a personal touch. The women around her, portrayed in varying sizes, rather than being drawn from the Holy Scriptures, seem to be Puebla neighbors helping to care for the newborn daughter of the one they cherish most.

Popular religious images fill the churches of Mexico from one end

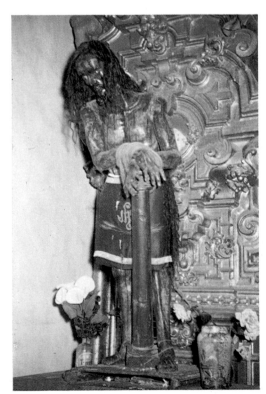

II-25. Christ at the Column. Church of San Sebastián y Santa Prisca. This flayed, emaciated figure symbolizes grief as expressed in the *tremendismo* —the vision of terrible and awesome events—common to both the Mexican and the Spanish minds. Taxco, Mexico.

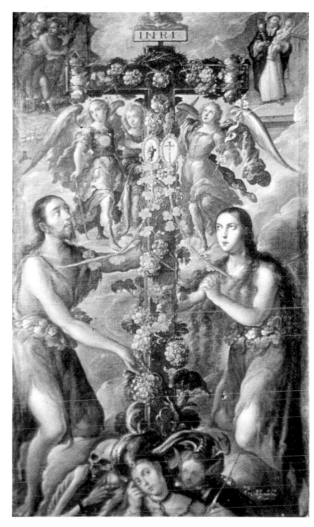

II-26. Cristóbal de Villalpando: *Adam and Eve Before the Cross*. Franciscan Monastery of Guadalupe. The iconography follows Spanish models. Zacatecas, Mexico.

of the country to the other. And over and over, the primitive imagination produces sublime innovations, such as the crucifixes made of corn husks. There were also primitive interpretations of traditional Spanish modes, dramatically seen in the expressive realism of the Christ at the Column, in Taxco, where the flagellation is rendered with genuine physical pain, blood, and terror (*Ill. II-25*).

The Flemish painter Pereyns produced good disciples in Mexico. Despite the influence of his Flemish master, Baltasar de Echave Orio

(Echave the Older) painted in Mexico from 1580 to 1620 with a Spanish flavor. His Mexican-born son Baltasar de Echave Ibía expressed himself in blues, the blues of the heavens as well as of the landscapes. Another disciple of Pereyns, also born in Mexico, Luis Juárez, brought the native sweetness mentioned earlier to his blond angels, with their ecstatic eyes and joyous colors. José Juárez, son of Luis, abandoned the sweetness of his father, and a third Echave, Baltasar de Echave Rioja, combined the conflicting influences of Murillo and Rubens. This mingling of styles and ideas is even more astonishing in the career of Pedro Ramírez, who imitated, successively, José Juárez, Ribera, and Rubens.

The Europeanized painting of the first baroque period in Mexico culminated in the work of Cristóbal de Villalpando (*Ill. II-26*), who died in 1714, and Juan Correa, who continued to paint well into the eighteenth century. Both were prolific painters and, perhaps for this very reason, inconstant in their styles, both alternating between a somber, ecstatic mood, with dark tones, and a contrasting use of dynamic figures and clear tones.

By the mid-eighteenth century, two painters of very different character emerged. José de Ibarra, born in Guadalajara, was called the "Mexican Murillo," as much for his ability to copy the master as for his physical resemblance to him. In his bombastic canvases, Ibarra pursued baroque emotion, but he seldom penetrated beyond the periphery. Miguel Cabrera, a proud and argumentative individual, was highly acclaimed in his lifetime, but today many consider his merits doubtful. He was a good portraitist, known especially for his painting of Sister Juana Inés de la Cruz, painted over an earlier one of poor quality.

The history of Mexican painting until the break with Spain, and even after, is almost wholly a history of European influences. So strong was this dominance that it did not permit any mestizo school, parallel to those in Cuzco and Potosí. In Mexico, true mestizo expression must be sought in architecture and its ornamentation.

10

The Baroque in Central America and the Caribbean

Central America

Some of the constants in Mexican baroque are also encountered in the baroque of Guatemala and other parts of Central America, but they always occur with a difference. Although plasterwork was widely used in both Central America and Mexico, the Central Americans seldom applied the polychrome embellishments popular in Mexico. Although in Puebla, white stucco was commonly used, in Guatemala, the plaster has an immaculate whiteness that makes the buildings appear to be spun out of sugar. Some curious alchemy seems to have transmuted the wealth derived from sugar cane—the region's chief economic resource—into these spun-sugar marvels.

The *estípite,* too, is seen on some retable-façades in Venezuela, Central America, and the Antilles, although in proportions and variety, it is very inferior to the Mexican version. The Central American *estípite* tended to have curved sides, and the double *estípite* with a central rosette, almost always hexagonal in shape, was particularly favored. On the façade of the Church of Santa Clara in Antigua Guatemala, there is a typical example (*Ill. II-27*).

The formal sign of all the architecture of Central America, as well as of the Caribbean coasts of Venezuela and Colombia, is a variety of ogee arches, an Isabelline echo here given a peculiar variation: the apex was sliced off horizontally.

In façade ornamentation, the distinctive formal sign is the rusticated (or bolstered) pilaster, whose alternate projecting and recessed horizontal bands need no additional decoration to produce an effect of great richness. This may be why in the use of foliage carved in stone, baroque in Central America was infinitely more restrained than in

II-27. Façade detail of the Church of Santa Clara. The evolution of the double *estípite,* with its baluster-like rim, increased the ornamental complexity of this style. Antigua, Guatemala.

Mexico, Quito, or Peru. Rarely so ubiquitous elsewhere in Latin America, the rusticated pilaster took various forms in Central America, and its angular profile even became stylized into a sinuous line, with indentations at regular intervals the only reminder of its origin. By coincidence (or perhaps through a direct influence), the deeply recessed *oeil-de-boeuf* window, a characteristic feature of the Lima-style church, was enthusiastically adopted in Guatemala.

Throughout the region, the excellent quality of local timber facilitated the development of wooden architecture, using rafter-and-beam framing, on high uprights that terminate in braces to support the tie beams. This is an architecture suited to a hot climate; the height and openness permitted breezes to circulate and countered the accumulation of stagnant, humid air. Timbered buildings were relatively uniform throughout Paraguay and the Moxos and Chiquitos provinces of Bolivia, but, in Central America, regional variations developed.

The peculiar character of wooden architecture was heightened because of the ease with which it could incorporate the unrestrained Mudejar style, which is very obvious in the tracery of florets and arabesques on the double tie beams. On the other hand, more than

superficial design was involved in the choice of wood; wooden structures withstood earthquakes much better than those of brick or stone. In fact, despite the importance of other regional influences, the earthquake was the chief factor in shaping colonial architecture in Central America, particularly in Guatemala. This phenomenon curses all the areas of Latin America caught in the folding and sinking of the earth's crust along the west coast, from the Andes to the Pacific. However, in South America, attempts were made to find structural forms and earthquake-resistant materials that would not make it necessary to alter the existing stylistic vocabulary. In Central America, the seismic jolts were so severe during the eighteenth century that architects seized on the first formula within reach: the construction of thick walls; stubby, very wide towers that at times, as in Esquipulas (a Guatemalan shrine for pilgrims), were in themselves equal to the entire volume of the façade.

The finest examples of Central American baroque are to be found in a city in ruins—Antigua Guatemala, the original Guatemala City, repeatedly the victim of terrible earthquakes. The disaster of 1717 necessitated reconstruction of the entire city on more solid foundations. These measures were not enough, however, to withstand the quake of 1751. The city was rebuilt once again, but another cataclysm, in 1773, was so devastating that the site had to be abandoned, and the seat of the Captaincy General was transferred to the area today occupied by Guatemala City.

Since then, the ruined city has been called Antigua Guatemala, Old Guatemala, and in time, the name was shortened to the adjective alone —Antigua. Before the earthquake of 1773, Antigua's architectural splendor rivaled that of Mexico City, Lima, Cuzco, Potosí, Ouro Preto, and Bahia.

The Cathedral of Antigua, begun in 1669, and continued later according to a plan by Martín de Andújar under the direction of José de Porras, was finished in eleven years. Either because of the taste of the patrons and architects or because of alterations made during the reign of neoclassicism, the Cathedral of Antigua is the clearest example in Central America of Peninsular influence. This is especially apparent in the quadripartite vaults and in the profusely decorated soffits of the arches. The façade has the sobriety of the Escorial style, with smooth, flat columns, and unemphatic niches, pediments, and tympanums—an approach that is repeated in Santa Teresa and several other churches in Antigua.

II-28. Main façade of the Church of San Francisco, begun in 1675 and finished at the start of the eighteenth century. It discreetly foreshadows what will later become baroque complications. Antigua, Guatemala.

As early as the seventeenth century, the increasing magnetism of the baroque had manifested itself in the construction of San Francisco, in which the influence of the cathedral's façade is discernible, but the columns have become twisted and the second-story arches are polygonal (*Ill. II-28*).

II-29. Partial view from the courtyard of the University of Antigua. Dating from about 1763, it is today the Colonial Museum. Designed by a local architect, José Manuel Ramírez, it has intricate convolutions in its arches, an elegant reminder of Moorish heritage. Guatemala.

II-30. Main façade of the Cathedral of Tegucigalpa. The rustication of the pilasters is the dominant feature, and it is continued up to the top of the second story. Honduras.

The façade of La Merced celebrates the triumph of the popular delight in ornamentation, although it is imposed on classical structures. The native origin is revealed in the grooved decorative work. The extension of the foliage to cover the entire surface and the unusual rhythm of the volutes has been thought to express a "sister sensibility" to that of the Maya structures of the Petén style.

Civil architecture in Antigua is handsomely represented, not only by numerous one-story houses, but also by three palaces that survived the earthquakes: the Ayuntamiento (City Hall), the Captaincy General, and the University. The most original of these is the University, the work of a mestizo architect, José Manuel Ramírez. He resolved the problem of weightiness and solidity characteristic of other Guatemalan colonial architecture by multiplying the proliferation of curves. This is particularly noticeable in the arcade of the cloister (*Ill. II-29*).

Honduras and Nicaragua offer the most typical examples of buildings in the regional style just defined. In El Salvador, a country also lashed by earthquakes, the extremely interesting Church of El Pilar, in San Vicente, has been preserved. It has very thick pillars and walls and a façade without bays. In this church, the architect has obtained surprising and ingenious solutions. The ringed half-columns of the façade are concave, but from a distance, one thinks them convex.

The Cathedral of Tegucigalpa, begun in 1756 by Gregorio Nacianceno Quiroz, is obviously closely related to the Antigua style. Rusticated (or "beaded") pilasters make the façade distinctive (*Ill. II-30*), and on the side portal that leads to the garden, two examples of American iconography give an unmistakably popular flavor: one is a bas-relief, showing St. Joseph and St. Anne, and from their chests sprout the stems of a flower on which the Virgin rests. The other is a pair of mermaids who support two small rusticated columns that frame the group.

The rusticated pilaster is the hallmark of church style in Honduras. It is used in the Cathedral of Tegucigalpa, and found in modified form in the churches of Los Dolores and Comayagüela, also in Tegucigalpa, in Sabana Grande, and other places. But the most superb building in Honduras is the Cathedral of Comayagua.

The decorative buoyancy here succeeds in giving the symbols of the Conception a tropical American significance, apparent in the palm leaves that fill the first level of the façade, as well as in the hybrid stylizations of flowers that terminate in ears of corn and sprout from climbing plants that flank the arch of the door and frame two primitive angels that crown the portal, and in the exotic trees that spring from the pilasters supporting this arch.

In the cities of León and Granada, in Nicaragua, the ogee arch appears everywhere. The best embodiment of baroque church architecture in León is the Church of La Merced, built by Pascual de Somarriva. The cathedral, the work of Diego de Porras, an architect from Antigua, was modified during the neoclassic period. The finest churches in Granada were destroyed by the North American adventurer William Walker, who for a brief period in the 1850's was the self-proclaimed President of Nicaragua. Nevertheless, interesting examples of wooden architecture remain in Granada.

There is an obvious kinship among the forms and styles of the various Caribbean countries. In the seventeenth century, the original Panama City prided itself on its cruciform cathedral, of rubblework and dressed stones, with heavily carved cedar woodwork. All that re-

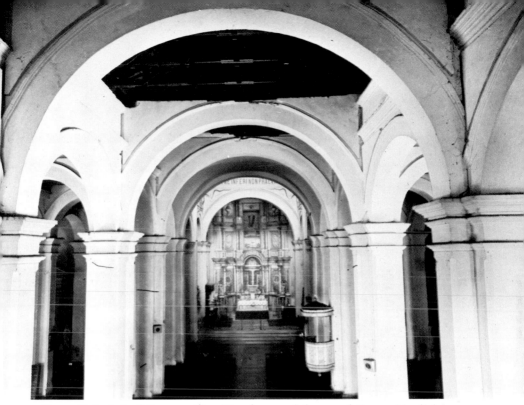

II-31. Cathedral of Panama City. The five arcaded naves follow, with slight changes, a plan dating from 1749, more than a half century after construction had started.

mains of this is the four-story tower and some ramparts. There was also the ambitious Church of San José, as well as a number of other religious and secular buildings. The pirate Henry Morgan destroyed them all in a raid in 1671.

Once the city was moved to its present location, outstanding structures were erected—dating from the end of the seventeenth century. The new cathedral was begun in 1690 and took a century to complete— a span that explains the anachronisms of the façade. The most interesting aspects are the ground plan and the arcade in which the five naves terminate (*Ill. II-31*). The Church of Santa Ana, also in Panama City, resembles many in Venezuela and Colombia; cylindrical columns separate the three naves, and two lateral chapels form a cross, a posteriori, so to speak. The swelling columns are also regional relatives of those in Venezuela.

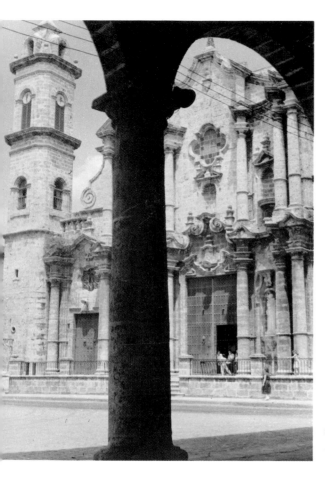

II-32. Cathedral of Havana, detail of the façade from the arcades of the square. Its design is attributed to Pedro de Medina and Antonio Fernández Trevejos. The façade was finished in 1777. Cuba.

Cuba

After the flowering of the plateresque and the Late Gothic on the island of Santo Domingo and to a lesser extent in Cuba and Puerto Rico, Santo Domingo lost its post as the American custodian of European culture. It was supplanted by cities on the mainland, and construction on Santo Domingo stagnated.

From the beginning, Cuban colonial art was permeated by Mudejar traits, in religious buildings as well as in palaces and smaller dwellings. Furthermore, conditions in Cuba were never favorable for the devel-

opment of a mestizo art. Besides the lack of a labor force with a craft tradition and the difficult properties of the local stone, which was porous and incrusted with sea fossils, there was another obstacle: the religious orders, which elsewhere tolerated or encouraged the contributions of native artisans, had too little influence in Cuba to shake the prevailing aesthetics. In consequence, Cuban baroque is much more restrained than that of the rest of Latin America, a fact that links it to the art of the Caribbean.

Two buildings in Havana exemplify this characteristic. The Church of the Franciscan Monastery, finished in 1738, has a high central tower over its façade, which displays the simplicity of the Escorial style, by that time an anachronism. Pedro de Medina, an Andalusian, and Antonio Fernández Trevejos, a Cuban, collaborated on the design and construction of the Cathedral of Havana. The building is noted for its vaulting, with wooden ribs over its three naves. The façade has a slight undulating movement pleasing to the baroque eye and sharply defined columns and entablatures (*Ill. II-32*). The right tower is double the width of the left one, and this discrepancy gives the building a curious distinction. Although begun as a relatively modest church for the Jesuits, the finished cathedral shows clear reliance on the cathedrals of Guadix and Cádiz, in Spain. Unfortunately, a badly executed restoration in 1945 eradicated several of the structure's finest features.

Venezuela and Colombia

The meager economic development of the province of Venezuela contributed, no doubt, to the characteristic sobriety of its colonial art. The typical church ground plans are modeled after the Cathedral of Coro, on the Caribbean coast, and the Church of La Asunción on Isla Margarita, an island in the Caribbean. Both were completed in 1617, and both have three naves with cylindrical columns, semicircular arches, and wooden roofs—features also of the contemporaneous churches in the Canary Islands, which have always had close ties with Venezuela.

It is relatively clear why La Asunción became an archetype for Venezuelan architects. It blends the formal elements of the Late Renaissance and of a linear plateresque in which ornamentation is reduced to its expressive minimum. And La Asunción's delight in the ogee arch demonstrates once again the similarity in taste between the purest

II-33. Façade of the Church of Cumanacoa, a curious example of stylistic survival: only the first story of its towers and the entrance are colonial. The rest was finished in the latter half of the nineteenth century. Venezuela.

Latin American baroque and the Spanish styles of a century or more earlier.

However, Venezuelan architecture evolved certain unique elements, among them, the lavish use of the swelled column, the repetition of the *estípite* (rare elsewhere in South America), and the exercise of the ornamental impulse in a variety of arches, from the simple basket-handle type to extremely intricate mixtilinear forms (*Ill. II-33*).

In the Antilles, and in Cartagena (in Colombia), the characteristic buildings were those constructed for military purposes, but in Venezuela, energies centered on individual homes, which typically exhibit unbridled imagination in the arches of their front entrances.

Despite the relationships and influences arising from Colombia's administrative role during the colonial Viceroyalty of New Granada—at various times its jurisdiction included the present territory of Panama, much of Venezuela, and part of Ecuador—the art of the Atlantic coast of Colombia is stylistically closer to the Caribbean and Panama than to the Andean countries, although a good part of Colombia itself lies within the Cordillera.

Two structural features of the Cathedral of Cartagena demonstrate the Caribbean influence: the columns with unadorned cylindrical shafts

that rest on square pedestals, and separate the three naves, constitute, as we have noted earlier, a structure characteristic of the Canary Islands; the ground plan and the elevation were copied in various places on the Atlantic and Caribbean coasts, and in Santa Ana in Panama City.

Cartagena is identified, on the one hand, with the rest of Colombian art, and, on the other, with Yucatán, because of the frequent use of bell gables on the façades of its houses of worship, such as the Church of Santo Toribio (completed in 1732) and the Church of the Third Order (completed in 1735). Monumental structures were not built in the fortified city, except for the Church of San Pedro Claver, which was of the Jesuit type based on the Gesù, built for the Society in Rome by Giacomo Barocchio da Vignola. San Pedro, however, exhibits a moderation that contrasts sharply with Jesuit churches in Mexico and the Andes. The finest baroque work in Cartagena is the portal of the Palace of the Inquisition (*Ill. II-34*). This building displays the per-

II-34. Entrance of the Palace of the Inquisition. Finished in 1770, the pediment has a certain resemblance to those of Peruvian homes of the same period. Cartagena, Colombia.

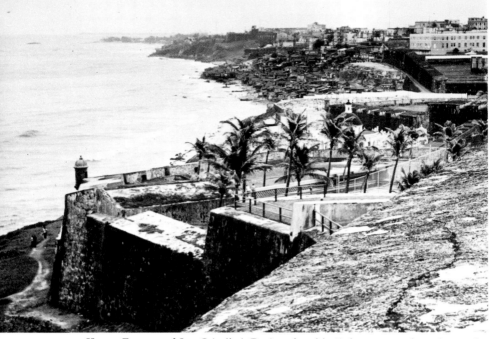

II-35. Fortress of San Cristóbal. Designed and built between 1765 and 1772 by Tomás O'Daly, an engineer, it displays characteristics common to most of the military works built in Latin America during the eighteenth century. San Juan, Puerto Rico.

fection attained in colonial dwellings, which, as in Venezuela, are the most distinctive achievement of Colombia's colonial art.

The curious bell gables used in the northern part of the Yucatán Peninsula complete this panorama of the peculiarities of colonial art in the Caribbean. Ticul, Mani, Valladolid, Izamal, Mérida, and many other places show in their churches and monasteries numerous systems of superimposed arches, in the crests of the façades, in the entrances to the walled courtyards, or in the towers.

Military Architecture

To defend her New World territories against pirate raids, the mother country had to dot the American coasts with forts and citadels, from Florida to the Strait of Magellan.

An idea of the magnitude of this undertaking can be gleaned from the mere enumeration of the works constructed for the defense of

Puerto Rico that remain today: a citadel (the castle of San Felipe del Morro, the Morro Castle), three small forts and six larger ones, two castles—San Cristóbal (*Ill. II-35*) and San Gerónimo—fifteen full bastions and demibastions, eight self-contained gun emplacements, three powder magazines, three defensive lines, almost two and one-half miles of spiked walls, several guardhouses, six porticullises in the walled main enclosure. Add to all this about two miles of subterranean passages, barracks, penal quarters, living quarters—and multiply this up and down the Atlantic coast. The total is staggering.

Philip II had entrusted this colossal task to a militia commander, Juan de Tejeda, and an Italian engineer, Bautista Antonelli. Work started in 1586, in Cartagena, after the city had been sacked by Drake. By the end of the sixteenth century, the city was totally walled, according to Antonelli's plans. The work as a whole was not completed until 1796, under the supervision of Antonio de Arévalo.

Sculpture and Painting

Popular images are Guatemala's crowning achievements in sculpture. During the colonial period, this form of applied craftsmanship became a major art and often surpassed its Spanish models (*Ill. II-36*).

II-36. Guardian Angel. Popular Guatemalan image of wood carved and polychromed according to the technique of *estofado* (picking away overlayers to reveal gold) and *encarnadura* (applying flesh tones). Mid-eighteenth century.

In general, Guatemalan images are small (from about seven to sixteen inches high). The wood used came from roots, cured by a slow process; they were kept under water for four years and then dried in the sun for two years. When the carving was finished, it was covered with plaster, and then given a coating of silver, another of gold, and a third of enamel. Once the desired base had been built up, the artisan proceeded to the meticulous work of picking out the folds of the robes and other details with a pointed tool such as a burin. This highly skilled process was known as *estofado*. The equally demanding work of *encarnadura*, to give flesh color to faces and hands, was produced by a method that was practiced in secret, and it has never been recovered.

Quirio Cataño (*see Chapter 8, p. 113*) was influential in the seventeenth century, until his death in 1622. His gradually evolved baroque style, however, never exhibited the strength of the work of Alonso de la Paz, renowned for his St. Joseph, in the Church of Santo Domingo, in Guatemala. Juan de Chávez represents the tormented dynamism of the Spanish image-makers (especially Juan Martínez Montañés).

During almost the entire baroque period, painting in Central America reflected the unmistakable influence of Zurbarán, through the arrival of his works or, even more, of his disciples. One of his followers, the Guatemalan painter Antonio de Montúfar, left unfinished an excellent series of canvases on the Passion, inspired by the Spanish master.

On March 6, 1797, the Royal Economic Society of Friends of the Country established a School of Drawing in the new Guatemala City. A year later, it had more than seventy graduates. Its historical importance lies not only in the fact that it evidences collective interest and a tradition, but also in the fact that it trained sculptors, painters, and engravers in the full sway of neoclassicism.

11

The Baroque in Quito and the Viceroyalty of New Granada

When the European artists arrived in Mexico, at the time of the Conquest, they had to reckon with a viable tradition with strongly defined characteristics. Consequently, the newcomers could only modify the national vision; they could not impose the European tradition as they might have upon a barren field. The history of the baroque of Quito is exactly the opposite. At the earnest insistence of the religious orders in Quito, administrative and artistic ties with Europe were very close.

Architecture

In the art of Quito in particular, and of New Granada (of which Quito became a part in 1718) in general, it is possible to identify the creators of specific works, and there is evidence that they were esteemed during their lives. This in itself should have countered the city's dependence on European sources, so it is all the more surprising that European dominance persisted despite the fact that many natives designed or supervised the architecture of the period—notably Juan, Carlos, and Antonio Chaquiri; Manuel, Juan, and Diego Criollo; and Antonio Guambactolo. The outstanding figure, despite the difficulty in making positive attributions of his work, is unquestionably Antonio Rodríguez, the *"arquitecto mayor"* ("chief architect"), apparently a native of Quito.

Despite the individuality of each of these architects, there is one formal sign peculiar to the art of Quito that, in our opinion, makes it absolutely distinctive. The chancel arch that separates the transept from the main altar, in the European baroque as well as in the baroque of most of Latin America, serves a purely structural function. In the Old World, it heightens the obsession with enveloping space, the passionate embrace of the third dimension. Except for Quito, in

the rest of Latin America, where this value does not have such great appeal, the function of the chancel arch is almost always limited to supporting the dome, when there is one; or to differentiating the masses, thereby emphasizing its character as an independent entity on the axis of the transept, if it exists; or to separating the central nave from the apse.

In Quito and, no less decisively, in its influence on styles as far north in the Viceroyalty of New Granada as Tunja, Colombia, the chancel arch is indissolubly linked with the main altar. It frames it, seeming to lock the retable within a windowless case, outlines the contours of the altar, and is integrated with it to form a single visual unit.

The emphasis New Granada and Quito gave to the chancel arch, which they almost invariably elevated to the role of a triumphal arch, was a curious transposition of the Mudejar ornamental approach. After being adopted in Quito, Mudejar motifs spread swiftly through a large part of South America, until they reached Chuquisaca (now Sucre, in Bolivia), above all in the carved ceiling beams. But this was not, to be sure, the only lesson of the Mudejar. We see it also in retables, ceilings, and ornamentation on columns, as well as in false columns.

In historical terms, the most important church in Quito is San Francisco (*Ill. II-37*). The façade, finished soon after 1580, is divided into two levels, both containing Tuscan columns. Horizontal and diamond-pointed rustication is employed to frame both levels. Some critics see a direct reflection of the austere spirit of El Escorial in this façade, but it is scarcely evident in the small ball-topped pyramids that form the finials of the second level and adorn the courtyard. It is not Philip's monastery-palace but a determination to restrain the eruption of the baroque with the severity of the Late Renaissance that stamps San Francisco's façade, as well as its interior, with its exquisite choir vault.

The baroque comes to full expression in the Church of the Jesuits, which is wholly dominated by European models. Like San Pedro Claver in Cartagena, the ground plan of the Quito church is an exact copy of Vignola's plan for the Gesù in Rome. The façade, also Italian, was begun in 1722 by Friar Leonhard Deubler and completed in 1765 by Venancio Gandolfi, a Mantuan Jesuit. In contrast, the interior is Mudejar rather than Italianate, with complex geometric decorations in stucco.

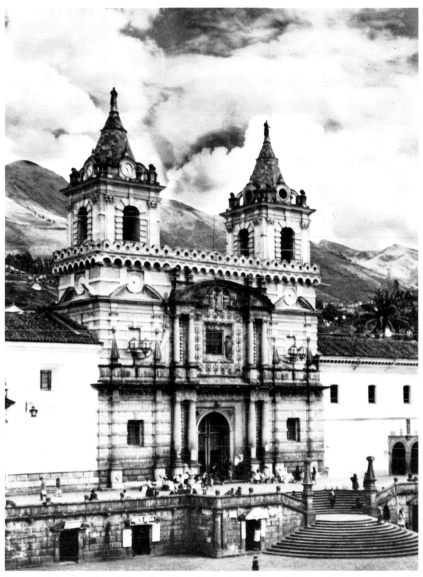

II-37. Main façade of the Church of San Francisco. The earthquake of 1868 destroyed the original towers, and these are of recent construction. The former ones, two stories and higher, enhanced the gracefulness of the structure. Quito, Ecuador.

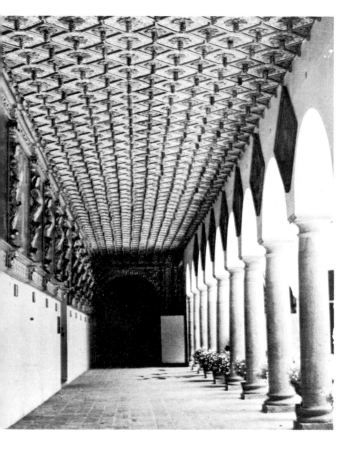

II-38. Ground floor of the main cloister (finished around the mid-seventeenth century) of the Monastery of San Agustín. The series of paintings on the life of St. Augustine were executed by Miguel de Santiago and his students, after engravings by the Flemish artist Schelte à Bolswert. Quito, Ecuador.

The baroque in Quito is distinguished further by the abundance, variety, and richness of the cloisters of its monasteries. The lower galleries of the cloister of the Monastery of San Agustín, completed in about 1660, contain a long series of pictures by Miguel de Santiago. In the square and octagonal coffers are carved ears of corn and flowers (*Ill. II-38*).

The baroque of New Granada reaches its greatest glory in the Rosary Chapel of the Church of Santo Domingo in Tunja. The two sections of the building each have their own attraction. The first is the flat ceiling that rests on four semicircular arches, joined by springy scrolls of foliage in harmony with the exuberant ornamental intent of the whole. The second is the Chapel itself (*Ill. II-39*). It is impossible

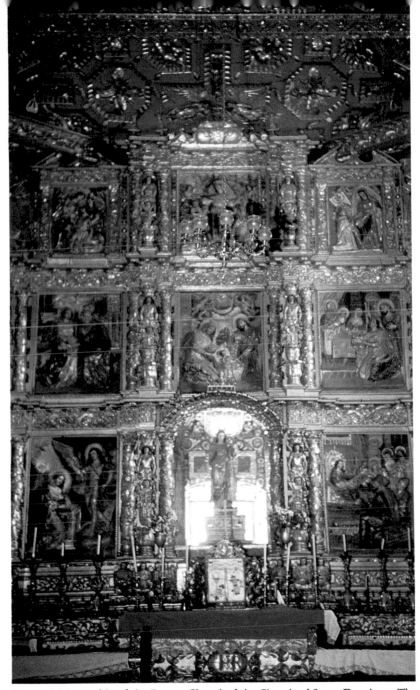

II-39. Main retable of the Rosary Chapel of the Church of Santo Domingo. The piece was the work of José de Sandoval and Lorenzo de Lugo. Tunja, Colombia.

to imagine—much less to describe—the staggering quantity of plateresque ornamentation and baroque intricacy that covers the ceilings and walls. The baroque element lies in the superabundance and exoticism of the adornment. In the case of Tunja, this means the use of tropical flora and fauna in a cool mountain city far from the tropics. The plateresque element is found in the invariable symmetry, enhanced by the geometric formalism of the Mudejar motifs.

The jambs of Santo Domingo's chancel arch embody this American peculiarity. A creature with a clearly Oriental face supports on its head a *petaca*—a basket of this region—containing bananas and avocados around a symbolic pineapple (*Ill. II-40*). Resting on the massive foliage above, another being, clearly an Indian, balances another *petaca* with ears of corn.

In Santa Fe de Bogotá (present-day Bogotá), the bond with Europe is more direct than in Tunja. For the Church of San Ignacio, Juan Bautista Coluccini, an Italian Jesuit, relied on Iberian models. Likewise, the features of the Church of San Francisco (*Ill. II-41*) that are

II-40. This detail of a jamb of the chancel arch of the Church of Santo Domingo, Tunja, is an example of the ornamental exoticism in the colonial art of Colombia.

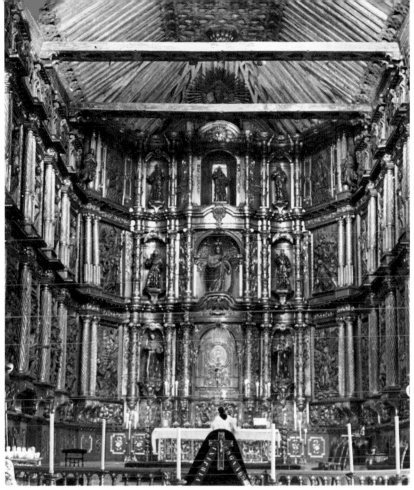

II-41. Main altar of the Church of San Francisco, begun in 1620 under the direction of Ignacio García de Ascucha. The central portion, which is late baroque in style, was reconstructed in 1789. Bogotá, Colombia.

widely admired—its handsome timber framing and exquisite ceiling—are Mudejar in origin. Happily, Domingo de Petrés respected these beauties in reconstructing the church, after much of it was destroyed by the earthquake of 1785.

In Popayán, there are also variations within the New Granada–Quito style—such as in the Jesuit Church, the work of the German Jesuit Simon Schenherr, who relieved the sobriety of the façade with obliquely set concave pilasters; in the Monastery of Santo Domingo,

with its curiously Romanesque portal and deep medallion windows, by Gregorio Causí, a native of Bogotá; in the Church of San Francisco, with its monumental façade of pilasters and panels and curving cornices, built between 1775 and 1795 by the Spaniard Antonio García.

Color constitutes the differentiating sign of a local art in Quito and Colombia, as it does elsewhere in Latin America. With only limited variations, one finds the constant use of gold against a red background in Tunja, Bogotá, Popayán, and Quito itself. Generally, the molding and the relief areas of the wood or plaster ornamentation are gilded, so they shine and stand out against the red background. This form of embellishment is also found in Chuquisaca, surely a reflection of the influence of Quito, and in Mexico as well (e.g., Santa Clara, in Querétaro, *Ill. II-15*). But only in the former Viceroyalty of New Granada is it employed so persistently that it becomes a stylistic trait.

Sculpture and Painting

Quito's superb architecture has been overshadowed by the work of its religious artists. Universal recognition has been accorded not only its well-known painters, but also the host of anonymous masters who at times equaled, and occasionally surpassed, those whose names have survived.

The pre-eminence of Quito's painters dates from the seventeenth century. During the following century, in only eight years (1779–87) of those for which we have figures, more than 260 cases of sculptures and paintings from Quito passed through the port of Guayaquil.

Spanish influence, especially the work of Martínez Montañés, Alonso Cano, and Pedro de Mena, plainly guided the religious artists of Quito, but they ranged further in conception than their mentors. Besides, Quito's work is sometimes tinged with an Oriental tone, undoubtedly as a result of the work and influence of a group of artists that the Franciscans brought from the Far East. Among the innovations are the use of glossy, rather than mat-finished, colors and the development of a whole guild specializing in flesh tones. The colors of vestments were fixed by rigorous codes: the Virgin was dressed in blue and white; St. Joseph in green and ocher; St. John in green and red.

The first native of Quito to win artistic acclaim during his lifetime was Padre Carlos, born at the beginning of the seventeenth century. His works are scattered among several churches in Quito. One of his

II-42. Bernardo Legarda (?): *Virgin Mary*. Legarda chiefly carved Virgins in the rite of the Seventh Seal.

disciples was José Olmos, better known as "Pampite." Perhaps the most dramatic of all the image-makers in Quito, he was noted for his thoroughgoing realism: his Christs in torment are covered with blood. Together with his old master, Pampite worked on the retables for the Jesuit Church.

The most famous was Bernardo Legarda, who had his studio and school opposite the Church of San Francisco. He depicted the Virgin as a young and beautiful woman, who rests one foot on a half-moon, according to the conventional iconography. But then Legarda

II-43. Caspicara: Popular image in the Quito style, representing the Christ Child. Wood, in *encarnadura* and *estofado*.

introduced a novelty: her other foot tramples on a serpent, which is bound with a chain. The Virgin bends her head, looking down (*Ill. II-42*). Legarda's Virgins were much in demand from Popayán to Lima. He also carved retables, the best of which are on the main altars of the Cantuña and the presbytery of La Merced, as well as in several Jesuit churches.

A curious anomaly in the history of colonial art is the fact that two women were among Quito's religious sculptors in the mid-eighteenth century. Sisters in the Church and by birth, Sister María Estefanía de San José and Sister Magdalena carved important statues in the Carmen Moderno and other churches in Quito.

The second half of the century is dominated by the work of another native artist, Manuel Chili, better known as "Caspicara" ("Pockmarked"). Although his outlook was thoroughly European, he conplemented the customary Spanish sources with Italian models. He executed sculpture groups, such as *The Assumption of the Virgin*, in the Church of San Francisco, and *The Descent from the Cross*, in

II-44. Caspicara: *Virgin Mary*. In this late-eighteenth-century piece, the wooden figure is garbed in real clothing rather than a wooden simulation.

the cathedral, as well as individual figures (*Ills. II-43 and II-44*). Spiritually allied with the Italianate dynamism of the designers of the Church of the Jesuits, Caspicara carried the serpentine figure to the extreme, notably in *The Redeemer,* in the Museum of Colonial Art in Quito.

The strange figure that serves as a newel for the pulpit stairway in San Francisco, in Popayán (*Ill. II-45*), combines American Indian traits and an Oriental aura. (The figure holds a pineapple in one hand and with the other supports on its head a straw basket overflowing with fruits of the region.)

As in Quito, in the rest of New Granada, much popular imagery was carved by anonymous artists, who indulged their self-expressive impulses without restraint (*Ill. II-46*). Among countless works by anonymous artists, perhaps the most enchanting are the miniatures in wood and marble, some only a few inches high. Another kind of painting, not parallel in quality, but parallel in its contemporary popularity, flourished in Quito during the seventeenth and eighteenth

II-45. Access stairway to the pulpit of the Church of San Francisco, another example of the ornamental exoticism of the baroque in New Granada. Popayán, Colombia.

II-47. Miguel de Santiago: *Winter*. This painting is thought to have been done in the artist's youth and it is one of the few examples of work with a secular theme in colonial painting in Quito. ▶

centuries. This painting, also Spanish in origin, relied not only on imported engravings but on imported paintings, as well.

Friar Pedro Bedón, a mestizo born in Quito, is usually considered the first of a series of notable artists of this tendency. Another mestizo, Miguel de Santiago, shares with his nephew and disciple Nicolás Javier de Goríbar the summit of the so-called School of Quito. Miguel de

II-46. Popular image in the New Granada style. The eloquent position of Christ's arms emphasizes the baroque dynamism in its most cherished expression. Church of San José. Popayán, Colombia.

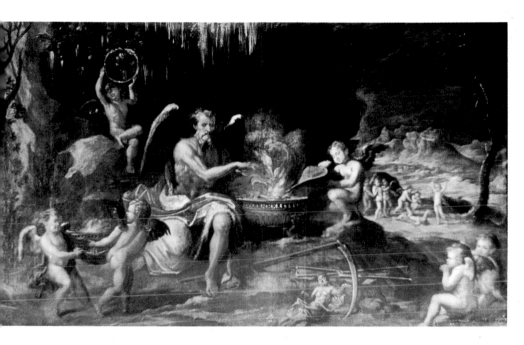

Santiago's many works—chiefly in the Monastery of San Agustín and in the Shrine of Guápulo—are infused with the ideas and forms of Murillo and Zurbarán, especially the latter. His dark tones give his canvases a shadowiness that provides a dramatic setting for the high-lighted areas (*Ill. II-47*). In contrast to his master's *tenebrismo* (the Spanish style of painting characterized by a somber and morbid tone), Goríbar tries to find a baroque expression in the dynamism of his robust figures, of which *The Prophets,* in the Jesuit Church in Quito, is his finest example.

In the eighteenth century, Manuel Samaniego is among the out-standing miniaturists of Quito. His output was scanty, perhaps because he asked such high prices for his work.

The glory that Miguel de Santiago and Goríbar enjoyed in Quito belonged in Bogotá to a native son; Gregorio Vázquez de Arce y Ceballos was much ahead of his time, in the mid-seventeenth century, in seeking a daring realism at odds with the mannerist daubing that proved to be so pleasing to the public. Had his patrons exercised the same criteria as their counterparts in Europe, Vázquez would probably have been judged the most important painter in colonial America.

12

Peruvian Baroque and the Colonial Period in Argentina and Chile

The essence of Peruvian baroque lies in two characteristics that set it off from the baroque in the regions to the north: first are the functional modifications necessary in that environment and in that land racked by earthquakes. Second is the intermingling of European and native elements in art, with the latter becoming progressively dominant in direct ratio to the distance from the coast.

We have already mentioned that Gothic construction was revived in Latin America, because it was better fitted than barrel vaulting to withstand earthquakes. In Lima, a different system of roofing known as the *quincha* was developed, and it proved extremely effective. It consisted of canes or reeds and wood woven together and covered with plaster or stucco.

The first to utilize the *quincha* system was the Portuguese architect Constantino de Vasconcelos, who began to erect a new Church of San Francisco over the ruins left by the earthquake of 1656. In the retable-façade, however, Vasconcelos revealed his European preoccupation with the third dimension. The entire façade is conceived in depth; the columns are placed on clearly distinct planes, with deep niches and pediments at the top. As in Lima's other beautifully constructed churches, all the walls, even those of the towers and interiors, have horizontal rustication. Another feature peculiar to architecture in Lima is a prominent stringcourse that extends around the entire perimeter of the building.

Despite the lapse of nearly a century between the building of the San Francisco in Quito and the San Francisco in Lima, a stylistic link is evident, for instance, in their cloisters. Both employ the Augustinian monastery feature of alternating large and small arches. The monastery in Lima was the first in the Viceroyalty of Peru to have a

II-48. Torre Tagle Palace. Mixed-form arches of the main courtyard, seen through the grillwork of a hall. The palace was originally the residence of the Marquises of Torre Tagle. Today it houses the Ministry of Foreign Relations. Lima, Peru.

hemispherical arcade in the lower gallery, and over this, another arcade with a smaller radius and unusually wide bays perforated with oval *oeils-de-boeuf*. In the main cloister of La Merced, the plan is the same, but the baroque elaborations increase; the arches become foliated, with obvious Mudejar echoes. The movement toward high baroque culminates in the main courtyard of the Torre Tagle Palace (*Ill. II-48*). This palace is perhaps the most graceful example of colonial civic architecture in South America. Two sturdy balconies, with a pronounced Moorish flavor, flank the stone doorway. The doorway itself has two levels and displays an attribute characteristic of Peruvian architecture: a window inserted between the volutes of a

broken pediment and framed by two columns supported by corbels.

The finest retable-façades in Lima are those of La Merced and San Agustín. On La Merced's façade (*Ill. II-49*), dating from the end of the seventeenth century or the beginning of the eighteenth, the twisted column is the basic form. The columns are placed on three levels, and the shell-shaped arch sets up an ascending rhythm that rises to the cornice, which is broken in a thoroughly original stepped design. But the façade of San Agustín, executed in 1720, is even more magnificent. It is somewhat similar in design to the San Francisco in Lima, but San Agustín has an incomparable ornamental sumptuousness. Despite much in the sculpture and ornamentation of the façade that is standard for the period, the totality constitutes an ageless baroque triumph that reaches its climax in the sculptural composition of the niche that shelters the patron saint of the church, St. Augustine (*Ill. II-50*).

Perhaps it is in the interiors that Lima's architectural ties with Europe are most apparent—especially in the many main altars that convey a true sense of profundity that is also evoked by the finest altars in the Andalusian churches of the time.

Architecture in Cuzco

The native substratum in the art and life of Cuzco survived by means of a process of layering. After the Conquest, the entire city was conceived on two levels, figuratively, in its spirit, and actually, in its

II-49. Upper portion of the façade of the Church of La Merced. Covered during the nineteenth century by a mass of stucco, the façade was salvaged and restored by Emillo Harth-Terré in 1939–41. Lima, Peru.

II-50. Detail of the central niche of the façade of the Church of San Agustín, finished in 1720. The four heads of the figures at the foot of the patron saint are surely the most penetrating examples of baroque expressionism in South America. Lima, Peru.

architecture. Frequently, a superbly fashioned Inca wall formed the base for a Spanish house, with aggressively white stucco walls, topped by the drab brownish-orange roof tiling that pervades the old cityscapes of Spanish America.

In Cuzco, native influences played less of a role than they did on the shores of Lake Titicaca or in Arequipa, because in Cuzco, the capital of the Tahuantinsuyo (the Inca Empire), the Spaniards recognized the symbolic significance of implanting new formulas. To serve

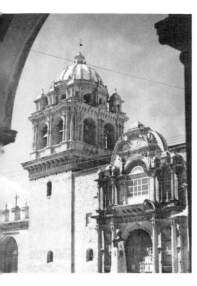

II-51. Side entrance and tower of the Church of La Merced. The seventeenth-century façade retains characteristics typical of the Late Renaissance. The tower, finished about 1675, is the most original in Alto Peru. At the left, the entrance to the monastery. Cuzco, Peru.

II-52. The main square of Cuzco. At the left, the Cathe- ▶ dral, whose façade was carved between 1651 and 1654. At the right, the Jesuit Church (1651–68), with the adjacent former Jesuit University. Peru.

this end, instruction was carried out more by force than by persuasion. The façade of La Merced provides a clear example (*Ill. II-51*).

Despite this incipient intermingling of cultures (or, rather, resistance to it), the baroque in Cuzco developed certain characteristics that give it the stature of a regional style within the over-all Alto-peruvian context. It is especially marked by the use of Inca structures, already mentioned, the best-known and most important example of this practice being the apse of the Church of Santo Domingo. Other traits typical of the Cuzco baroque are the heaviness and solidity of the buildings, the dark andesite stone used, the hemispherical lanterns topping the towers, and the Mudejar engraving on the rectangular panel that frequently projects from the arches in cloisters.

In the main square of Cuzco (*Ill. II-52*), there are evidences of daring sabotage of the Spanish cultural crusade. On the façade of the former Jesuit University, the spandrels of the central arch shelter two curious figures wrapped in the shrouds of Indian mummies.

But the building next to the former university, the Jesuit Church, presents an even more audacious challenge. It challenges the dominance of the cathedral, across the square, and triumphs as the finest

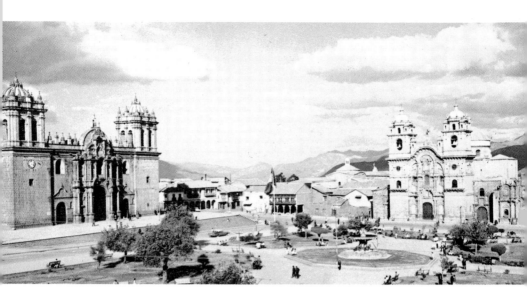

achievement of Cuzco baroque. Its construction is attributed to the
Flemish Jesuit Juan Bautista Gill, known after he became Spanish—
or American—as Egidiano. The ground plan employs the typical
Jesuit single-nave layout, but despite its creditable interior, the unique
position of the church stems from its retable-façade, the work of
Diego Martínez de Oviedo. In contrast to the horizontal cathedral—
and like a demonstration of the creative competition between the
regular clergy and the orders—the Jesuits' church soars to a height
that is double its width. As in most of the churches in Lima, its gable
is compressed between the towers so that it will be more resistant to
earthquakes. The connection between the façade and the towers is
accentuated by the cornice that forms the base of the lowest section
of the towers and, at the same time, edges the crest of the façade gable.

Architecture in Arequipa

The earliest fusion between the indigenous artistic foundation and
the Spanish passion for the baroque was centered in Arequipa. The
formal qualities of colonial art in this city, midway between the

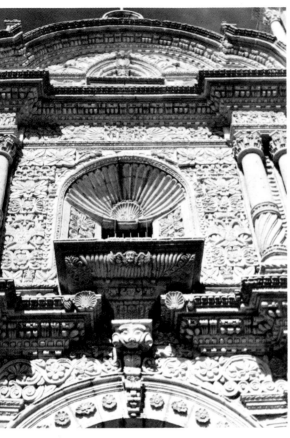

II-53. Central detail of the façade of the Jesuit Church. Finished in 1698, it constitutes one of the most brilliant examples of mestizo baroque in Latin America. Arequipa, Peru.

II-54. Vault of the dome of the ▶ Church of Santiago. Symbol of the adaptation of European schemes to the indigenous American formal ideology. Pomata, Peru.

Pacific coast and the lofty Altiplano, distinguish it not only from all other colonial art, but also from other Peruvian art as a whole. First, the materials are different. In Arequipa, the churches and the façades of houses were constructed from the stone left by the lava from Misti, the volcano that dominates the city. This stone is porous, very white, and most important, very easy to carve, a factor that permitted Arequipa's craftsmen to indulge in an unbridled frenzy of ornamentation.

In structure, the typical Arequipa church is also unique in colonial Latin America. Here, as in Guatemala, protection against earthquakes was sought by thickening the walls and reinforcing them with power-

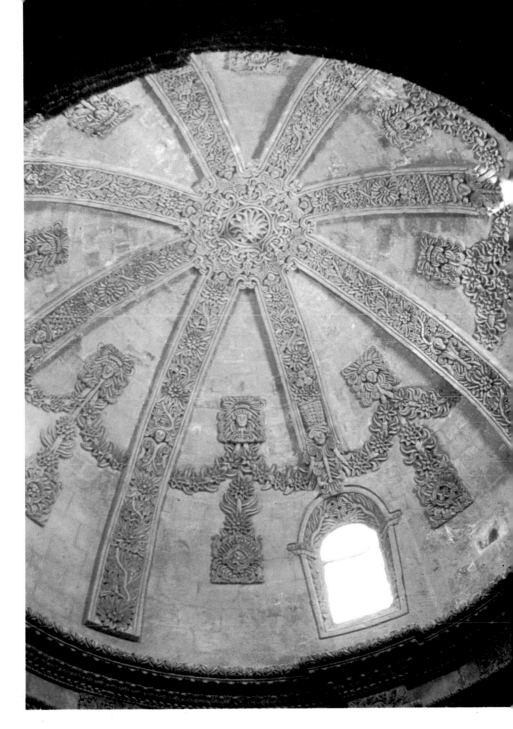

ful stepped buttresses. The Arequipa dwelling also has an unmistakable stamp: sculptured rectangular panels over the windows and a wide curvilinear pediment crowning the door.

The Arequipa style cast its shadow as far as the highlands of Titicaca, and in the remoteness of Potosí, it definitely won out over the pre-Hispanic. Its church architecture is marked by a feature that, although found in Europe and elsewhere in Latin America, nowhere was so generally adopted as in Titicaca and the Altiplano. This is the prolongation of the uninterrupted barrel vault outside of the church, until it becomes a nichelike form that shelters the façade.

Indian and mestizo ornamentation produced a jungle of formal elements: birds, Indian heads, braids, ears of corn, and confused motifs revived from pre-Hispanic mythology, like the many-footed tiger cat that lived, according to the legend, on the shores of Lake Titicaca. All these elements are especially apparent on the façade of the Jesuit Church (*Ill. II-53*), finished in 1698 and, to a lesser degree, on the façade of San Agustín, where the background was painted to highlight the reliefs and to deepen the effect of the shadows.

The most perfect examples of indigenous ornamentation are found in the churches in Zepita, Ilave, Juliaca, Acora, Juli, Puno, and Pomata. Almost all the stone in the Church of Santiago in Pomata is carved, inside and outside. The lunettes of the vault reveal native faces entangled in lianas, fruits, and other tropical vegetation. On the pendentives, vegetation sprouts from vases held by Indian angels. The vault of the dome (*Ill. II-54*) is a sublime expression of this style. Four broad bands link the central rosette with the cornice on which the drum of the dome rests. Four shorter bands terminate over the arched windows. In the intervals are eight figures, each a stylized embodiment of ideas rooted deep in the pre-Hispanic world. Masses at the top and bottom of each figure are balanced in turn by a continuous band of twined arms, symbolically represented.

On the façade of the Church of San Francisco in La Paz, we again find ears of corn, pineapples, Dianthuses, faces of Indians, other natives squatting, and a new subject, the *alkumari,* a strange-looking bird of prey.

Among the many churches in Potosí, San Lorenzo most eloquently displays the fusion between the New and the Old Worlds, the *mestizaje.* Its façade (*Ill. II-55*) is enclosed by a huge semicircular arch that joins the two towers. The archivolt of the door rests on nude

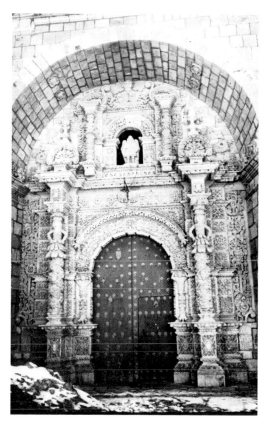

II-55. Central doorway of
the façade of the Church of
San Lorenzo. In the tech-
nique of stonecarving, the
geometric stylization of the
Indian cutters seeps through
irrepressibly. Potosí, Bolivia.

Indiatids, with the lower parts of their bodies covered with scales, who
support the impost with their hands and heads. On the sides of the
Indiatids are twisted columns whose shafts are two Indian women,
larger than the Indiatids, with arms akimbo and wearing dancers'
skirts. Also on this section of the façade, there is a niche with a winged
St. Michael, whose only "imported" feature is his sword. For the rest,
he is an Indian with pre-Columbian features. At the sides of the niche,
two mermaids play the *charango*, a Bolivian mestizo instrument like
a small guitar, with the soundboard made from a *quirquincho* (arma-
dillo). To preserve the symmetry, the mermaid on the right strums
with her left hand.

173

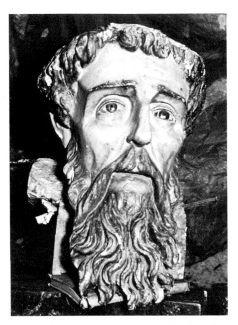

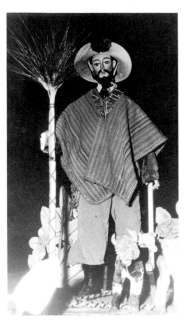

II-56. Popular wooden image in the Alto-peruvian style, representing St. Jerome. It is not certain when this was carved and painted since Bolivian religious sculptors continued the colonial tradition into the nineteenth century. Church of Sicasica, Bolivia.

II-57. Popular image in the Altoperuvian style, representing St. Isidore the Farmer. Carved, painted wood. The clothing is typical of mestizo and Indian garb. Church of Andahuaylillas, Peru.

Sculpture and Painting

The beginning of the seventeenth century brought a veritable exodus of sculptors and carvers from Seville to Lima. The religious imagery made in the capital of the Viceroyalty of Peru is Spanish, and its historical importance is precisely that it confirms the extreme Europeanism of the capital cities (*Ill. II-56*), in contrast to the *mestizaje* of those deep in the interior. Images by Martínez Montañés are plentiful in Lima, with which Seville's great religious craftsman maintained profitable commercial relations.

The finest carved works in colonial Peru are the choir stalls. Mestizo artists certainly worked on them, but they are as European in spirit as the painting and sculpture. Strictly speaking, the choir stalls should

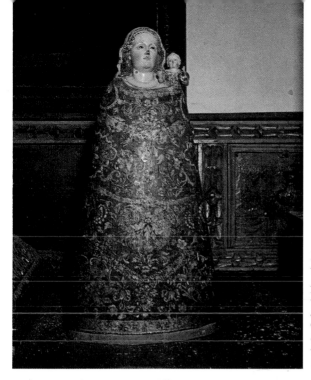

II-58. Popular image in the Altoperuvian style, representing the Virgin Mary with the Infant Jesus. These figures were carved in wood, with *encarnadura* and *estófado* techniques. Cathedral of Sucre, Bolivia.

II-59. Melchor Perez Holguín: *St. Luke the Evangelist* (detail). Probably relying on engravings by Marten de Vos, Holguín painted the Four Evangelists in 1724.

be studied, from the formal and stylistic point of view, as part of Spanish art.

On the other hand, in Chuquisaca and Potosí, in Alto Peru, two surprisingly individual mestizo forms took shape. One, frequently displaying first-class workmanship, centered on the popular saints, dressed in the clothing that their makers derived from the social hierarchy they knew. The Apostle James often wears the garb of a judge or other important personage; female saints of distinguished lineage are dressed like ladies of the Viceregal Court; others, more humble, such as the Castilian peasant venerated as St. Isidore (*Ill. II-57*), are clothed in native ponchos, and, to remove all doubt, they are further identified by a pair of farm oxen, generally tiny.

The other, even more interesting, local form developed from the ancestral concept of composition on one plane. When this approach is transferred to an object in the round, it expresses itself in the cone, since this is the most contained shape by which a human body can be represented. A brilliant example is the Virgin in the Cathedral of Sucre (*Ill. II-58*). And even when images were carved with an Iberian air to acquiesce to foreign taste, they were embellished with vibrant colors that conveyed a gaiety scarcely appropriate to the asceticism of the patron saints.

Just as the image-makers maintained active contacts between Europe and Lima, the painters had a similar relationship on both sides of the ocean. When Angelino Medoro, a "Roman painter," as he came to be called, arrived in Lima in 1600, Mateo Pérez de Alesio, also a Roman, had already painted a portrait of the Viceroy, the Marquis of Cañete. From the beginning of the seventeenth century, artists and pictures were consigned to Lima. The Creole painters imitated the masters, especially, to avoid breaking the rule, Murillo and Zurbarán. Several works by the latter remain in Lima.

The soaring talent of one Altoperuvian painter shows a capacity for expression beyond the ideas copied from the mother country. Melchor Pérez Holguín, born in Cochabamba around 1660, ranks along with Miguel de Santiago and Gregorio Vázquez to compose a brilliant trinity that embraced Potosí, Quito, and Bogotá, respectively. Although his fascination with chiaroscuro obviously reflects the influence of Zurbarán, on the other hand, employing the constants of Spanish iconography, Holguín created a singular physiognomy; his subjects are always rendered with prominent cheekbones and sunken cheeks.

The series of the Four Evangelists (*Ill. II-59*) in the Museum of the Mint, in Potosí, is the work of a great painter. Holguín was, moreover, a graphic chronicler. He enjoyed painting monumental works, such as the *Triumph of the Church,* in San Lorenzo, in Potosí, and the *Entry of Archbishop Morcillo into Potosí* (in the Museum of America in Madrid), which describes in detail life at the end of the seventeenth century in the Villa Imperial, as the city was called in the colonial epoch.

In Cuzco, Latin American painting came into its own as a school with its own style. Because most of its painters were anonymous, the Cuzco School has the quality of corporate art. The themes, naturally, are Christian, but the technique is a Peruvian modification of Andalusian practices, with strong roots in the past. Saints and personages of note, scenes of the Holy Family, and historical themes are depicted in flat hues on gold backgrounds, without modeling (*Ill. II-60*).

Planar composition is not the only ancestral trait that shaped the Cuzco School; conservatism of spirit also played a role. Once the successful expression of a style with an assured demand had been found, the distinctive features of Cuzco painting remained almost unaltered for more than two centuries. The iconography and technique also remained the same. The Holy Trinity was the most common theme, even after an ecclesiastical decree that forbade its representation as three equal personages, according to mestizo style. It is also characteristic to dress the Virgin and the saints, as well as the Christ child, in native finery.

Even the artists closest in spirit to the European models, or those who, such as Diego Quispe Tito, made exact copies of the engravings most popular among their clientele, showed the unmistakable imprint of the Cuzco School. The identity between painters and image-makers culminated in a two-dimensional version of the very painting technique used on wooden sculpture.

There is a close similarity in themes and techniques among Cuzco, Chuquisaca, and Potosí—from the allegories crammed with historical detail especially popular in Bolivia (*Ill. II-61*), to the Christ child wrapped in the swaddling clothes of Quechua babies. It is likely that the Cuzco style was transmitted by some masters brought from Cuzco to the Villa Imperial, Potosí, which was the center of the economic life of South America for two centuries and the most densely populated city in the Spanish Empire.

II-60. Painting of the Cuzco School, representing the Holy Family. The blondness of the figures testifies to the survival of European inconography. The brocade (gilded on the surface) does not follow the folds of the garments, thereby increasing the planar quality of the figures.

Chile

To the south, both the impact and the acceptance of baroque architecture were less complete than in the ancient seats of the pre-Columbian cultures. In Chile, the poverty of the kingdom, the centuries of warfare between the Araucanians and the Spanish, and above all, the earthquakes delayed the flowering of its architecture until the neoclassic epoch, at the end of the eighteenth century. Then the Italian architect Joaquín Toesca dominated the scene. There was one church of relatively original design: the seventeenth-century Jesuit Church in Santiago, which was destroyed in a fire in 1863. The history of colonial architecture in Chile is a history of memories of vanished structures.

II-61. Popular painting in the Altoperuvian style, representing the Virgin of Potosí. The Potosí School differs from the Cuzcan in its more marked primitivism, the rigidity of the figures, and the abundance of "narrative pictures."

Argentina

Argentina did not have the same ill luck. Apart from their historical interest, several colonial churches in Buenos Aires have notable aesthetic qualities. San Ignacio, with its marked Bavarian flavor, did not set a style, but the Church and Monastery of El Pilar, the work of Andrés Blanqui, an Italian Jesuit, influenced many others in the capital of the Viceroyalty of the Río de la Plata.

Córdoba had the first university in Argentina and was, in addition, an important Jesuit center. It has justly been asserted that the dome of the Jesuit Church in Córdoba is a unique monument in the history of architecture. The dome and its vaulting, designed by a Belgian Jesuit, Philippe Lemer, present original solutions, derived perhaps

II-62. Tower dome of the Cathedral of Córdoba. Although the dome, designed by Friar Vicente Muñoz, dates from the mid-eighteenth century, it is an echo of Romanesque forms and a perfect expression of baroque dynamism. Argentina.

from Lemer's knowledge of naval architecture. The construction, entirely of wood, consists of panels set with the faces and sides alternating, secured by pegs and pared into a circular arch. Recently, a fire defaced part of the vaulting, but most of the upper section and the dome were saved.

The façade of the Cathedral of Córdoba was also executed by Blanqui, but the most distinctive feature is the dome (*Ill. II-62*), the work of an architect from Seville, Friar Vicente Muñoz. It is a curious baroque translation of elements characteristic of Spanish Romanesque, such as the four turrets designed to counteract the thrust of the dome. Another peculiarity of the dome is the contrast between the sluggish weight of the basic structure and the dynamism of the ribs and volutes.

13

Brazilian Baroque

Of course, several constants of Spanish American colonial art obtain in Brazilian colonial art, as well: the radical structural and formal modifications in the inland cities; the direct link with European models in the coastal cities; the creative competition among the religious orders (or, in Minas Gerais, among lay confraternities); the correspondence between significant expressiveness and the extent to which art is rooted in the people.

However, there are numerous differentiating elements in the colonial art of Brazil: the sensuality, undoubtedly the contribution of mulatto values, which are an inextricable part of Brazilian art; the audacity in the search for new forms, a tendency that will reach its climax in twentieth-century architecture; the grace and frivolity, probably deriving jointly from African sources and from the overrefined Imperial Court, a trait that some scholars view as typically rococo.

In colonial Brazil, a high baroque coincided in time and place with a temperamental predisposition toward the key attributes of such a style. This conjunction made it possible for Brazil's colonial art to express the genuine national essence—above all, in the art of the interior.

Unlike the Spaniards in Mexico and Peru, the Portuguese colonists in Brazil did not find an indigenous labor force with an artistic tradition. Unquestionably, this is the most important difference between Spanish and Portuguese colonial arts, because in Brazil, the forms transplanted from Europe did not collide with existing forms and did not, consequently, have to undergo initial modifications. Although the link with the ideology of the mother country—especially in ground plans and façades—was maintained on the coast during the entire colonial period, art and architecture nevertheless developed distinctive features, especially in the interior (Minas Gerais).

Architecture

Nothing remains of the first colonial structures, consisting of mud over simple wooden frameworks. The earliest examples extant are those of the Jesuits, who had brought the architectural thinking of the Counterreformation, controlled by a sobriety that contrasts markedly with the later obsession with ornamentation. The Jesuits' model was the Church of São Roque, in Lisbon, which was simplified in Brazil into a single-nave layout, generally without side chapels or a transept and only rarely with a dome. The nave and the presbytery were covered with a wooden ceiling or vault.

The development of a regional architecture was interrupted between 1624 and 1654 by the Dutch occupation of, first, Bahia and then, more lastingly, Pernambuco. After the ouster of the Dutch, architectural design advanced. In churches, lateral chapels appeared and were connected, making room for corridors or narrow naves. The sacristy became very large, generally occupying the entire width of the church behind the presbytery. Often, a chapel was constructed on each side of the presbytery.

At this time, two renowned architects were giving religious buildings in Portugal a strange cast: Johann Friedrich Ludwig, a German better known later as Ludovice, and Niccolò Nasoni, an Italian. Ludwig, designer of the famous Mafra palace, which has been compared to El Escorial because of its ambitious dimensions, achieved in Portugal a synthesis of Italianate concepts (derived from Borromini), in his enveloping forms, with Germanic concepts, in the solidity of his structures. The monumental stairways, the bulbous domes, the windows in fantastic shapes were elements typical of Nasoni's work in Portugal that were imitated in Brazil, with the sole colonial modification being that the ornamental aspects were exaggerated further.

The rectangular ground plan adopted by the Jesuits was not the invariable rule in coastal baroque architecture in Brazil. Among the outstanding exceptions are the ground plans of the churches of São Pedro dos Clérigos, in Recife, and of Nossa Senhora da Gloria do Outeiro, in Rio de Janeiro. In 1728, Manuel Ferreira Jácome completed his design for São Pedro, incorporating a twelve-sided interior area within a four-sided exterior (*Ill. II-63*). The proportions and dimensions of the walls give the building a monumental aspect. Nossa Senhora da Gloria do Outeiro's single tower on the central axis enhances the grace of its silhouette. Its nave has an irregular octagonal form, as does the sacristy, which surrounds the presbytery.

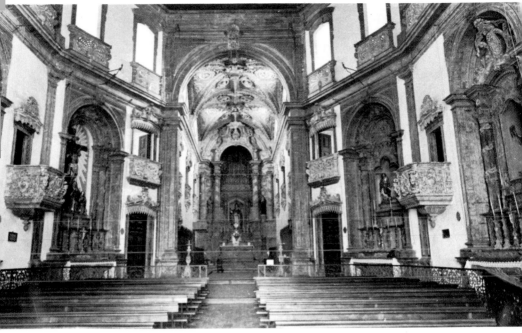

II-63. Church of São Pedro dos Clérigos, designed in 1728 by Manuel Ferreira Jácome. An octagonal nave with the presbytery at the rear. The plan has similarities to that of the church of the same name in Oporto, Portugal, designed by Niccolò Nasoni (or Nazzoni). Recife, Brazil.

The façades of the coastal churches exhibit a notable similarity, and are directly modeled after Portuguese structures. Sometimes, arches, portals, and even virtually whole churches were brought from Europe. Typically, twin towers crowned by pyramids frame the façade, which is divided into two orders of Doric design, as in the Cathedral of Bahia, the former Jesuit Collegiate Church. Massive volutes, with projecting profiles, customarily top the pediments to form a characteristic baroque pattern.

In some cases, Italianate elements are intermingled, as in Nossa Senhora da Conceição da Praia, in Bahia, attributed to the Portuguese architect Manuel Cardoso de Saldanha (*Ill. II-64*). Here, a generous triangular pediment with finials, towers placed on the diagonal, and other details used by Ludwig in the palace-monastery at Mafra and in the main chapel of the Cathedral of Evora demonstrate how Portugal transmitted the influence of Italy.

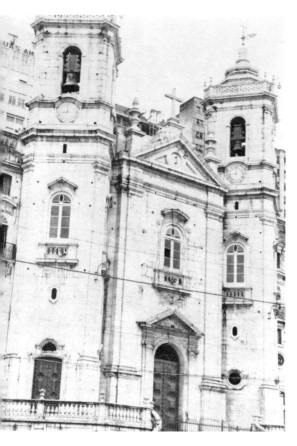

II-64. Church of Nossa Senhora da Conceição da Praia. Stylistically and structurally one of the Brazilian churches most directly linked to Portugal, it is attributed to the Portuguese architect Manuel Cardoso de Saldanha. Bahia, Brazil.

The sole exception to the uniform sobriety of the coastal façades is found in the Church of the Third Order of São Francisco da Penitência, in Bahia (*Ill. II-65*). This surprisingly complex façade could well be classed as a retable-façade although there is no evidence that its designer ever was in Spanish America or had seen even an etching of this typically Spanish-American baroque feature. Nevertheless, Manuel Gabriel Ribeiro, born in Bahia, treated the stone as if it were wood and incorporated a vast repertory of baroque motifs: acanthus friezes, crowns, heads of fauns, anthropomorphic capitals, and arabesques.

Behind their grave façades, the coastal churches conceal splendidly flamboyant interiors. Here, the structural and ornamental elements imported from Portugal were "tropicalized," especially in Bahia and

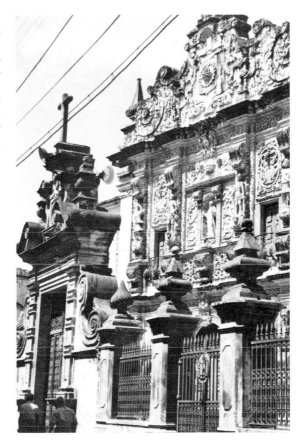

II-65. Walled courtyard and façade of the Church of the Third Order of São Francisco da Penitência. The construction was carried out according to a design by Manuel Gabriel Ribeiro. The church was consecrated in 1703. Bahia, Brazil.

Pernambuco. Ornamentation was permitted to run riot to an extent that would have made the most florid European artist of the time appear inhibited and timid.

The so-called Pernambuco School culminates in the magnificence of the Golden Chapel of the Church of the Third Order of São Francisco da Penitência, in Recife. Although this is the ultimate expression —qualitatively if not chronologically—of the Pernambuco style of ornamental exuberance, there are other buildings of comparable importance: the Chapel of the Third Order of the Carmelites, in João Pessoa (in the neighboring state of Paraíba); the small Chapel of the Engenho Bonito, near Recife; and the Chapel of Nossa Senhora da Conceição dos Militares, also in Recife.

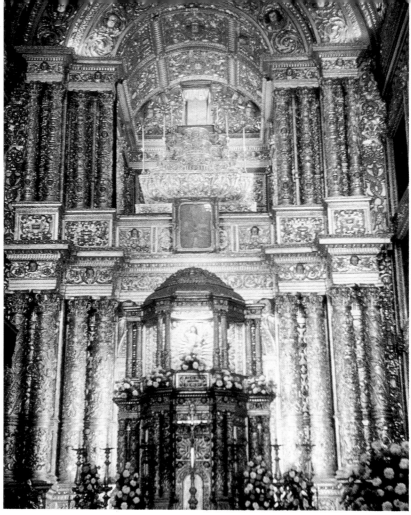

II-66. Main altar of the Cathedral of Bahia, Brazil. The structure was begun in 1657 as the Jesuit Collegiate Church. The sanctuary and the main altar were constructed between 1665 and 1670. All the carvers and painters who worked on the project were Jesuits.

During the eighteenth century, ornamental enthusiasm infected the entire coast, from Belém do Pará in the north to Rio de Janeiro, whose Church of the Benedictine Monastery is a superb achievement. Because Bahia was until 1763 the capital of the Portuguese colony, it was natural that the most brilliant and sumptuous churches were built there. The former Jesuit Collegiate Church, today the cathedral, exhibits this dazzling richness in its gilded lateral altars and in the main

II-67. Two androgynous atlantes support on their shoulders the altar of Nossa Senhora da Glória in the transept of the Church of São Francisco. Bahia, Brazil.

altar, a typical example of classical-style entablature literally covered with gilded foliage (*Ill. II-66*). The interior of the Church of São Francisco outdoes even this extravagance in its transept and main altar, which sustain a dizzying quantity of elements—saints, angels, profane allusions, twisted columns coated with foliage, exotic animals, garlands (*Ill. II-67*). In São Francisco, the dynamism of baroque orna-

II-68. Female angel on the balustrade of the central nave of the Church of São Francisco. The carving on the balustrade is attributed to the Bahian artist Friar Luis de Jesus, known under the nickname of O Torneiro. Bahia, Brazil.

II-69. The small Church of Nossa Senhora do O (Nossa Senhora da Expectação do Parto). Begun in 1717, it was restored in 1955. The campanile was placed in its present position at the end of the eighteenth century. Sabará, Minas Gerais, Brazil.

mentation combines sublimely with an undisguised sensuality in carvings of seductive angels possessing the most unmistakably feminine attributes and ogled by fauns with unequivocal expressions (*Ill. II-68*).

The settlement and frenetic economic development of the *planalto* (plateau) that today forms the State of Minas Gerais dates from the discovery of an extremely rich vein of gold in 1693. First, small chapels were erected, many of them by artisans brought from Portugal's possessions in India and China. An enchanting example of such workmanship is the Church of Nossa Senhora do O, in Sabará (*Ill. II-69*), whose decoration is obviously Oriental in flavor.

As mining operations expanded, the chapels were replaced by vast churches, which at first followed the models of the mother country.

However, a regional style soon developed marked by the widespread use of round or octagonal towers and increasing dynamism in chamfers, pediments, and moldings.

The use of cylindrical towers—a regular feature of Minas Gerais churches—accentuates the curvature of the façades, and the pediments were elaborately decorated, increasingly veering away from the sobriety of the façades on the coast. Further, the integration of forms and ornaments subordinated the architectonic lines to the requirements of new spaces created by the presence of medallion windows, *oeils-de-boeuf,* and even the very chamfers made necessary by the protrusion of the massive cylindrical towers. This mounting dynamism finally led to oblong ground plans, often presenting highly original solutions.

Manuel Francisco de Araújo drafted the plans for São Pedro, in Mariana, and for Nossa Senhora do Rosário do Barro, in Ouro Preto. For the latter, he devised an extremely unusual façade employing an elliptical transverse portico, with a triple arcade, surmounted by a convex pediment. The curvature is repeated in the round towers (*Ill. II-70*) and in the ellipses of the principal nave and the main chapel. In the Rosário, this scheme of undulating walls, in the style of Bor-

II-70. View of the Church of Nossa Senhora do Rosário do Barro. The unusual plan of this church is generally attributed to Manuel Francisco de Araújo or to an assistant, António Pereira de Sousa Calheiros. Ouro Preto, Minas Gerais, Brazil.

romini, reaches a point where it should properly be considered a molded form. This is the first time in Brazilian art that the concepts of architecture and sculpture fuse, and it is a harbinger of the enduring national style.

Sculpture and Painting

Unlike sculpture in colonial Brazil, the painting of this period cannot easily be classified into schools or groups. On the other hand, because of the development of polychrome religious imagery, the master painter frequently shared the execution of a work with the carver. Often, the work depended as much on sculptural as on pictorial means, for example, the painting done by Manuel da Costa Ataíde on the figures of the Passion carved by Aleijadinho in Congonhas do Campo.

Another example of interdependence between two arts is found in the work of João de Deus Sepúlveda, born in Olinda, in the State of Pernambuco. He is especially noted for his frescoes—of *The Life of the Virgin* and of *The Life of Jesus,* in Nossa Senhora de Conceição dos Militares, in Recife, and above all, for the gigantic ceiling fresco of *St. Peter Blessing the Catholic World,* in the Church of São Pedro dos Clérigos, also in Recife.

In Bahia, José Joaquim da Rocha did an excellent painting of *The Visitation* for the main altar of the Church of the Santa Casa da Misericórdia; Verisimo de Souza Freitas painted the spacious ceiling of the nave of Nossa Senhora de Lapa; António Joaquim Franco Velasco and Friar José Téofilo de Jesus, the latter responsible for the ceiling of Nossa Senhora do Pilar, comprise the outstanding baroque painters in Bahia.

In Rio de Janeiro, Friar Ricardo do Pilar, a humble Benedictine born in the colony, decorated the choir of São Bento with a series of canvases with a marked Germanic air. His student, José de Oliveira, painted several canvases for the churches of São Bento and São Francisco da Penitência. In the latter, there is a notable ceiling in perspective, painted by Caetano Costa Coelho.

Painting in Minas Gerais reached its highest expression in the work of the mulatto Manuel da Costa Ataíde. His talent far exceeds that of the other artists of his region, such as José Soares de Araújo, who painted the much-praised *Elias* in O Carmo in Diamantina. Maestro Ataíde brought to his plastic perception a religious iconography in

II-71. Ceiling of the central part of the nave of the Church of the Third Order of São Francisco de Assis da Penitência. The artist depicts the Immaculate Conception with Negro and mulatto figures. Ouro Preto, Minas Gerais, Brazil.

which the basic figures were Negroes or mulattoes. His vast body of work includes the design for the main altar of the Church of Nossa Senhora do Carmo, the excellent painting on the ceiling of the nave in São Francisco de Assis in Ouro Preto (*Ill. II-71*), the polychrome work of the figures of the Stations of the Cross in Congonhas, culminating in the paintings in the Church of Santo Antônio, in Santa Bárbara, Minas Gerais. His *Ascension,* in the main chapel, and the *Assumption,* in the nave, are justly acclaimed as the most original and most valuable colonial paintings in Brazil.

The integration of visual and spatial arts, a fundamental attribute of the baroque, was at its height in Brazil at the beginning of the first half of the eighteenth century. Painters, sculptors, and even architects often subordinated their work to the harmony of the whole. Therefore, the history of colonial sculpture in Brazil concerns in good part the

II-72. Popular image representing Christ, with an obvious Oriental influence. Head and hands of carved and painted wood, tunic of silk. Church of the Third Order of Carmelites, Cachoeira do Campo, Brazil.

carving of the interiors of the churches, frequently the work of anonymous artists.

However, their memory endures among admirers yesterday and today. Superb examples of the art of woodcarving are found in the churches of São Francisco in Bahia, the Third Order of Carmelites in Cachoeira do Campo (*Ill. II-72*), and in the Church of the Benedictine Monastery in Rio. There are numerous makers of religious images and carvers in Bahia about whom we have reliable documentation, among them Maestro Chagas (or Cabra), and Friar Antônio da Encarnação, who created the statues of *St. Dominic, St. Anthony of*

II-73. Popular Bahian image representing Christ carrying the cross. Face and hands of carved and painted wood, clothing of red linen. Brazil.

II-74. Friar Agostinho da Piedade: *St. Peter Repentant*. This terra-cotta figure constitutes the culminating work of baroque expressionism on the northern coast of Brazil. Church of Nossa Senhora de Montserrate. Bahia, Brazil.

Padua, and *The Virgin* in the Monastery of São Francisco in Bahia. The Bahia sculptors worked in wood, often polychroming it and painting the flesh tones themselves or, as in Quito, entrusting this critical task to specialists (*Ill. II-73*).

Terra-cotta sculpture has maintained a continuous tradition in Brazil since the seventeenth century. In the colonial period, two Dominicans had a commanding position in this medium. Signed sculptures by Friar Agostinho da Piedade, a native of Portugal who was ordained in Bahia, have been preserved in the Museum of Sacred Art in Bahia. In our judgment, his masterpiece is the *St. Peter Repentant* (*Ill. II-74*)

in the Church of Nossa Senhora de Montserrate, also in Bahia. This is a superb example of baroque expressionism. In addition to capturing the terrible drama of the anguished face, Friar Agostinho has utilized anatomical exaggerations to reinforce the dynamic angles of the figure.

A disciple of this master, Friar Agostinho de Jesus, born in Rio de Janeiro, is more advanced in technique, although less expressive. The school of Rio is represented by another artist of the first rank, Friar Domingos da Conceição da Silva, born in Matozinhos, Portugal, around 1643. Master of an elegant realism, he did several works for the Church of São Bento, in Rio, among them carvings for the main retable and his finest work, the *Dead Lord*.

As the colonial epoch came to an end, Maestro Valentim da Fonseca e Silva, like Maestro Ataíde a mulatto and like him born in Minas Gerais, serves as a bridge to neoclassicism, the tendency that dominates his mature work, particularly in the *St. Matthew* and in the *St. John the Evangelist,* in the Historical Museum in Rio de Janeiro.

Aleijadinho

Brazilian baroque reaches its sublime hour in the figure and work of an extraordinary person, a man of genius matched by few, a phenomenon in the history of art. Antônio Francisco Lisboa was born in Ouro Preto August 9, 1738, of a Portuguese father and a Negro slave named Isabel. On his baptism, Antônio Francisco was given his freedom by his father. Virtually all our information about him is based on the biography written by Rodrigo José Ferreira Bretas, which is not a firsthand work but an account and collection of traditions preserved by a daughter-in-law of the artist and related to Bretas several years after Antônio Francisco's death.

From the material recorded by Bretas, it appears that even as a youth, Antônio Francisco enjoyed such renown that he eclipsed his own father, an excellent architect in his own right. At the age of thirty-nine, Antônio Francisco contracted a disease that, legend says, made him lose the use of his hands. It was then, moved by the spectacle of the cripple who feverishly carved stone without hands, that the people of Ouro Preto gave him the affectionate nickname of "Aleijadinho," the "Little Cripple." Apart from the legend that the supposed or actual loss of his hands has raised to the level of heroism, it is interesting from the critical point of view to realize that Aleijadinho's important work was achieved during his maturity and the finest dates from his old age.

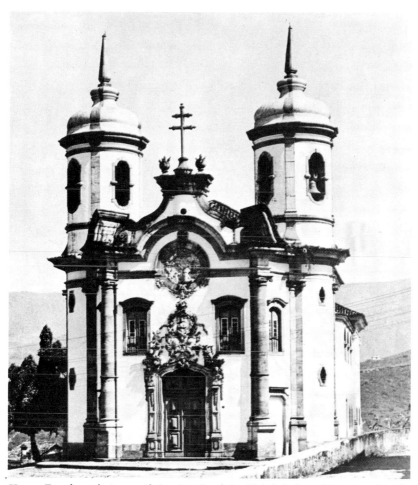

II-75. Façade and towers of the church of the Third Order of São Francisco de Assis da Penitência. The plan, elevation, façade, and most of the exterior and interior carving were the work of Aleijadinho. Ouro Preto, Minas Gerais, Brazil.

As an architect, Aleijadinho's most enduring works are the pediments of the Carmelite churches in Sabará and Ouro Preto and of the parish churches in Tiradentes and Morro Grande, and, above all, the plans and the façade of São Francisco de Assis da Penitência in Ouro Preto (*Ill. II-75*).

II-76. Aleijadinho: *The Prophet Jeremiah* (detail). Soapstone. Sanctuary of the Bom Jesus de Matozhinhos. Congonhas do Campo, Minas Gerais, Brazil.

Aleijadinho's crowning achievement is his work at the Sanctuary of the Bom Jesus de Matozinhos in Congonhas do Campo. This work has two aspects: the stone statuary that extends the entire length of the walled courtyard of the church and the scenes of the Passion in the six small chapels that flank the approach to the Morro do Maranhão, the steep hill on which the church is built.

The twelve statues of the Prophets, carved in soapstone, a soft steatite that fosters abandonment to the curve and facilitates the expression of emotional traits, constitute a veritable "ballet in stone." The choreographic intent of the work is immediately noticeable when one stands on the central axis and observes the deliberate disruption of the symmetry produced by the balusters of the stairway on which the statues are placed. The balusters are divided into three levels. On the first, Isaiah and Jeremiah (*Ill. II-76*) face each other. On the second, sheltered in an esplanade, are Baruch and Ezekiel. On the last, at the same height as the base of the church, the eight remaining statues rise. Amos and Obadiah on one side, Nahum and Habakkuk on the other, on the highest part of the parapet; at the rear, still on the same plane, Jonah and Joel, with their bodies in a sense opposed to the composition, looking outward; Daniel (*Ill. II-77*) and Hoséa flank the top of the stair in its central approach.

II-77. Aleijadinho: *The Prophet Daniel.* At the left, *The Prophet Baruch.* Soapstone. Sanctuary of the Bom Jesus de Matozinhos. Congonhas do Campo, Minas Gerais, Brazil.

Each of the statues bears a cartouche with the Biblical text related to his prophecy. In their faces, hands, gestures, and attitudes, Aleijadinho reflects the significance of the prophecy. Seldom has a sculptor displayed more keen and articulate psychological penetration. Amos is the seraphic shepherd who did not wish to be a prophet; Daniel is the sweet soul who tames lions by faith; Isaiah is wrathful; Joel, apocalyp-

II-78. Aleijadinho: Head of Christ in the tableau of the Road to Calvary. Carved wood, painted by Ataíde. Sanctuary of the Bom Jesus de Matozinhos. Congonhas do Campo, Minas Gerais, Brazil.

tic; Ezekiel, the symbol of the movement of the awesome wheels; Jonah, the despairing; Hosea, the resigned noble who accepts the "wife of whoredom."

Formal, aesthetic, and historical analysis of the courtyard of Congonhas has been exhaustive. It is sufficient to underline here the importance of a choreographic sense in Aleijadinho's concept, conscious or not, shown in the placement of the feet in what in ballet terminology is called the "third position," as well as in the enveloping rhythm of the robes, the ability to compose the ensemble of twelve statues as such, and the virtuoso organization of the group so that the contemplation of two, three, or four together confers on these partial compositions an independent value, without any forfeit of their integration in the total work.

In climbing the Morro do Maranhão, the pilgrim passes the Stations of the Cross, exemplified in seven scenes housed in six small chapels on either side of the road. Altogether, there are sixty-seven statues carved in wood and polychromed. In 1957, a group of restorers from the National Historical and Artistic Patrimony Service carried out a veritable "reconquest of Congonhas," returning this group of images to their original state, after discovering their actual quality under successive layers of paint.

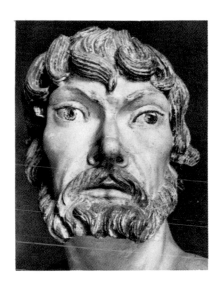

II-79. Aleijadinho: Head of Dysmas in the tableau of the Crucifixion. Carved wood, painted by Ataíde. Sanctuary of the Bom Jesus de Matozhinhos. Congonhas do Campo, Minas Gerais, Brazil.

The Stations of the Cross at Congonhas follow the traditional Gospel sequence. The first chapel houses fifteen figures that represent the Last Supper, and in each statue, there is unquestionably an attempt at individualization. At the center, Jesus supports His favorite, John, the youngest of the Apostles, on His shoulder. Around Him, ten Apostles proclaim their loyalty to the Master. On one side, Judas, smaller, shows his conflict and burden. Two servants complete the semicircle, and the hands of all fly about, forming a Grecian fret.

Immediately after this comes the scene of the Agony in the Garden. Christ is in ecstasy; three Apostles sleep. The angel offers the chalice.

In the next scene, the Prison, Christ's face now evidences a transmutation from innocence to astonishment. A single chapel contains both the Scourging and the Crowning. Here the caricaturing of the Roman soldiers is exaggerated to an extreme. In the Road to Calvary (*Ill. II-78*), the iconographic representation reaches its climax in originality and popular feeling, in a form that we have come to call "the intimacy with the divine." Finally, in the Crucifixion, the anecdotal elements are placed on independent planes, but all the figures are united around the center: the anguished Christ, the Magdalene with open arms, the penitent thief *Dysmas* (*Ill. II-79*), perhaps the most perfect sculpture in the whole series.

Spanish-American colonial art found its most genuine expression in the process of transformation, imposed by the environment, the temperament, and historical tradition, of the forms derived from the European baroque. Controversy still rages ardently today over whether this art should be labeled "imported," imitative, and second-class, in contrast to an original, distinctive, "mestizo" art. In the light of the analyses that we have made, substantiated in photographs, it is clear that both forms coexisted during three centuries, adapting to the demands of the *ambiance* and the taste of the faithful for whom churches were built, images were carved, and religious subjects were painted.

The true stylistic and ideological battle lines were drawn with the irruption of the new neoclassical ideals of the last third of the eighteenth century and the beginning of the nineteenth. Colonial art lost then its capacity for self-affirmation, as it came increasingly under the dominance of the French style. But the people maintained their identity with the baroque spirit, hidden in a marginal art, opposed to official art, and distant from the cultural centers, an attitude that would be revived, in highly intellectualized forms, well into the twentieth century.

14

Constants and Variants

When Latin America wrested independence from its European sovereigns, it paid an awesome price. For the ties that were ruptured were cultural as well as political. The cultural break meant a denial not only of the Iberian past but of Latin America's innermost being. The consequence was that Latin American "cultivated" art in the nineteenth century was wholly imitative. The model, of course, was no longer Spain or Portugal; now it was France that dominated official taste nearly everywhere. Despite this loss of creative initiative, there was no loss of craftsmanship, because this tradition was very firmly embedded.

The tradition was to a great extent preserved by the people. In most areas, they did not participate in the independence struggle as a defined group with defined aims. It was the landholding Creole aristocracy that was the real victor in the struggle, and it was this group that ordained the people's position in the hierarchy. For many years, there was no channel through which this forgotten class could express itself. When its artistic impulses did come to the surface, they took forms peculiar to the "primitive" craftsman: devotional art, revival of the imagery of the patron saint, reversion (especially in Brazil) to a domestic architecture intimately related to native sources. Because the baroque was the style of the final epoch of Bourbon Spain, patriotism demanded that it be rejected by the newly independent Americas. To replace it, Europe provided neoclassicism.

The neoclassic trend reached its height in Brazil and Mexico, but it had profound ramifications throughout all of Latin America. Except for the cities that had attained their splendor during the baroque period and those that had recently been rebuilt, the spirit and shape of the neoclassic nineteenth-century house endured everywhere in Spanish and Portuguese America, from Chihuahua to Valparaíso and from Guayaquil to Bahia.

15

The Nineteenth Century: From Neoclassicism to Impressionism

Neoclassical Architecture

On November 4, 1785, the Royal Academy of Fine Arts in Mexico City opened its doors. Its professors were all Spaniards trained in the San Fernando Academy of Fine Arts in Madrid: Manuel Tolsá taught sculpture; Rafael Jimeno y Planes, painting; Antonio González Velázquez, architecture; Jerónimo Antonio Gil, and later José Joaquín Fabregat, engraving. They had an extraordinary group spirit and a complete identity in stylistic concepts.

The newly imported neoclassic style soon captured the Creole artist. Neoclassic architecture in Mexico began and culminated in the work of two Mexicans: José Damián Ortiz de Castro, of Jalapa, who designed the final alterations and towers of the façade of the Cathedral of Mexico City, and Francisco Eduardo Tresguerras, an aggressive dissenter, a tremendously vital, Renaissance man—poet, painter, engraver, sculptor, musician, and architect. Reckless in his passions, Tresguerras attacked the baroque, but he could never free himself from its spell. The Church of El Carmen, in Celaya, was his masterpiece. To a lesser degree, José Manso, designer of the four-part main altar in the cathedral of his native Puebla, also symbolizes the iconoclastic fervor of the epoch.

The figure of the sculptor and architect Manuel Tolsá, born in Valencia, Spain, dominates the period. It is as a sculptor that Tolsá has gained immortality, especially for his equestrian statue of Charles IV, today on the Paseo de la Reforma, in Mexico City. As an architect, he left evidence of his wide-ranging talent in the dome of the Cathedral of Mexico City—for which he designed the lanterns, the crowning balustrades, the upper façade and its sculptures. His finest architectural work was the School of Mines, a short distance from the cathedral.

III-1. Rafael Jimeno y Planes: Painting on the ceiling of the dome of the Cathedral of Mexico City, an example of the neoclassic style introduced in Mexico by a group of Spanish artists at the end of the eighteenth century.

The interior of Tolsá's dome for the cathedral was painted by Rafael Jimeno y Planes, in a parallel neoclassic style (*Ill. III-1*). Jimeno's mural in the chapel of the School of Mines, celebrating the Miracle of the Pocito—the appearance of the Virgin of Guadalupe—was the first instance of neoclassic painting based on a Mexican theme.

An Indian disciple of Tolsá, Pedro Patiño Ixtolinque, exemplifies the conflict between the imposed neoclassic mode and the strength of the Mexican baroque roots, apparent in his most outstanding work—the retable and main altar of the Sagrario adjoining the Cathedral of Mexico City.

In Brazil, there was less resistance to the incursions of neoclassicism, because the process of Frenchification was absolute, at least in the monumental art ordered by the displaced Portuguese court.

In fact, in 1816, hardly eight years after Dom João VI had fled Portugal and established his court in Rio de Janeiro, the Frenchman Joachim Lebreton—famous in Europe for, in addition to his talent, his battles with the painter David—was hired to command a small army of architects, painters, and sculptors, all French, who were charged with the staggering task of "civilizing" Creole taste.

The first to hold the title of Professor of Architecture in the new Imperial Academy was another Frenchman, Auguste-Henri-Victor Grandjean de Montigny, who exerted a decisive influence on Brazilian art for the entire century. Grandjean de Montigny was the architect not only of official buildings, but of private residences, as well; a city planner; a landscape painter; a projector of vast schemes; a writer; and a painter with great prestige among the court nobility in Rio. He built a considerable number of structures; the most notable still standing are the Imperial Academy of Fine Arts, the Market, and the Customhouse, all in Rio de Janeiro.

The division in Brazilian society in matters of taste and patronage soon hardened into a rigid polarization that cast its shadow over the full course of the nineteenth century: on one side, the architecture and plastic arts devoted to the service of officialdom; on the other, age-old but still vital, the art of masons and less socially prominent architects, who maintained the colonial tradition in constructing private dwellings.

In the face of the conflicting tendencies of a period that did not produce an architectural style of its own, Brazilian imperial art ranged over a broad spectrum, including the typical neo-Gothic motifs beloved by the romantics; a modest "Tuscan style," to which the followers of Grandjean de Montigny were predisposed; and an ambiguous "Moorish art," with confused sources. However, French neoclassicism underwent changes imposed by the tropical environment: open spaces to provide ventilation, arcaded corridors to block the sun and admit air, and especially, the use of traditional tiles, the *azulejos*. Finally, architecture emerged from these fogs and squarely confronted its past, through the unexpected vehicle of Art Nouveau, also imported by a Frenchman, Victor Dubugras.

The introduction of neoclassicism aroused much less conflict in the region of the Río de la Plata (Argentina and Uruguay), Chile, and

Paraguay. In Buenos Aires, the example of Andrés Blanqui's sober designs of the late eighteenth century provided a bridge to the ready acceptance of neoclassicism, almost without a break in the continuity of stylistic evolution. The triumph of neoclassicism was symbolized in the façade of the new cathedral, which had been started in 1754. The façade was completed in 1823 by a Frenchman, Prosper Catelin, obviously inspired by the Madeleine and the Palais Bourbon in Paris.

The Argentine architectural historian Mario Buschiazzo has acutely observed that the great rambling mansions of the haciendas and the suburban villas display "the most authentic values of our native architecture." Buenos Aires' monumental urban architecture reflects the tremendous wealth created in the economic boom at the turn of the nineteenth century. In an obvious return to clearly European baroque concepts, Alejandro Christophersen eloquently expressed the atmosphere of Buenos Aires at its height, especially in his San Martín Palace. The same spirit pervades the Teatro Colón (1905-8), the work of Julio Dormal. Today, Buenos Aires lives amid remembered glories now half a century in the past.

On a smaller scale, smaller Spanish-American cities exhibit the phenomenon of French supremacy in architectural styles. And as in

III-2. Main façade of the Palace of the Mint, Santiago, facing north (1788–99). The Santiago Mint, designed by the Italian architect Joaquín Toesca, is one of the most characteristic civic buildings of the latter part of the colonial period. Chile.

Buenos Aires, lack of a local baroque tradition facilitated this process in Montevideo, Caracas, and Santiago de Chile.

At the end of the eighteenth century, the incipient prosperity arising from a sound administration attracted a first-rate Italian architect, Joaquín Toesca, to Chile. A disciple of the celebrated Francisco Sabatini, who transformed Madrid to suit Bourbon taste, Toesca designed the ground plan and front elevation of the Palace of the Mint, in Santiago (*Ill. III-2*). One of the outstanding buildings of Spanish colonial civil architecture, it is now the executive residence and cabinet building.

A role similar to that of Grandjean de Montigny in Brazil was undertaken in Chile by the French architect François Brunet de Baines, appointed in 1849 to organize the country's first architecture school. And French influence could soon be seen throughout the city. Less elegant than the Paseo de la Reforma in Mexico City and considerably less elegant than the great boulevards laid out in Buenos Aires during the boom, Santiago's Alameda acquired in the mid-nineteenth century the air of a modest French boulevard—and this air remains today. The writer Benjamín Vicuña Mackenna, as superintendent of works, was the Haussmann of Santiago, and since Chile had virtually no native architecture, the beautification of the capital followed, naturally, the French style.

Romantic Painting and Sculpture

Painting (and to a lesser degree, sculpture) was the road through which Latin America sought self-expression during the century of romanticism. This effort extended over a vast gamut, with the Mexican Academy and the freer neoclassicism of South American academies at one extreme, and, at the other, "popular," or "primitive," art and *costumbrista* painting, which documented local customs, costumes, and landscapes.

Many Creole painters drew on European themes at issue in the old continent's struggle between classicists and romantics, and, paradoxically, the Creoles were inclined toward Ingres and David rather than toward Delacroix. For obvious reasons, of politics, environment, and fashion, there was another paradox: they ignored Goya. In contrast, traveling artists who arrived from Europe—some men of exceptional ability—were dazzled by American themes, ideas, and attitudes. The

III-3. Johann Moritz Rugendas: *Country Scene* (ca. 1836). Rugendas, a Bavarian, lived in Chile from 1834 to 1840. During this period, he produced an extraordinary number of oils and drawings that accurately describe the country's customs. He also lived and worked in Brazil and Mexico.

work of Johann Moritz Rugendas is unquestionably the most varied and important (*Ill. III-3*), but there were many other painters who went beyond the seductiveness of *l'exotisme américain* to plumb the American *ambiance* and terrain.

At the farthest reaches of the Latin American world—Mexico and Argentina—however, a relatively individualistic art developed, with the simultaneous emergence of Creole painters and popular painters, terms that, without being exclusive, indicate two divergent streams. Literal copying of the European model was the practice imposed in Mexico by Pelegrín Clavé, a Catalan imported by General Santa Anna in 1846 to reorganize instruction at the Academy of Fine Arts. One of Clavé's followers—as well as rival—Juan Cordero, sought to deal occasionally with Mexican reality as is obvious in the mestizo lines of his *Portrait of the Sculptors Pérez and Valero*.

III-4. José María Velasco: *The Valley of Mexico Seen from the Hill of Guadelupe* (1894). This canvas is Velasco's crowning achievement as a landscapist, though he painted this scene many times after.

Diego Rivera extolled the work of his teacher, José María Velasco, in a grandiose image: "He made and unmade and played with the mountains, like the hero of the *Popol Vuh*" (the Maya equivalent of the Book of Genesis). Rivera viewed his master's career as falling into three periods, but neither the academic-Europeanized nor the impressionist won Rivera's supreme accolade. This he reserved for the final, most Mexican, period, when Velasco's "creative capacity surpassed any [foreign] influence." Velasco's finished technique gave maturity to his landscapes—vigorous depictions of distinctive locales, ruins, and contemporary events, such as his *Bridge of Metlac* (1881), with a railroad train under full steam, or his series of paintings, eight in all, of the Valley of Mexico (*Ill. III-4*).

The two poles of academic and *costumbrista* painting were embodied

in Venezuela by the Paris-trained neoclassicist Martín Tovar y Tovar, who glorified patriotic themes in his *Battle of Carabobo* and *Signing of the Declaration of Independence,* and by Carmelo Fernández, an acute observer of the customs of Venezuela, as well as of Colombia. In Colombia, together with the Italian Agustín Codazzi, Fernández participated in the ambitious work of the Comisión Corográfica. This commission was set up in 1850 under the guidance of Codazzi, who recruited a half-dozen artists, scientists, and writers to map the country and the ways its people lived.

Venezuelan painting scaled the heights of romanticism in the work of Cristóbal Rojas and Arturo Michelena. Rojas handled chiaroscuro skillfully in paintings on social themes, such as *Poverty* and *The Debt.* However, he renounced this palette when he adopted the impressionist creed, shortly before he died, at the age of thirty-two. Michelena's similarly brief life (only three years longer) was devoted to exploring the effects of light and shadow, evident in his celebrated painting of *Miranda in La Carraca Prison.*

In Colombia, shortly after Independence had been secured, a naturalistic school developed. There were clear historical reasons for this trend: the relatively minor inroads of neoclassicism, the solidity of a *costumbrista* literary movement, the persistent interest in the research of the eighteenth-century Spanish botanist José Celestino Mutis, who spent much of his life in Colombia. The leading naturalistic artist was Ramón Torres Méndez, a draftsman, portraitist, *costumbrista* painter,

III-5. José Gil de Castro: *Portrait of Bolívar* (1823). Renowned for his portraits, "El Mulato Gil" provided the basic documents for the pictorial history of Latin American independence. In addition to this of Bolívar, he also did celebrated portraits of the Chilean and Argentinian heroes Bernardo O'Higgins and José de San Martín.

III-6. Pancho Fierro: *Juanita Breña.* The social criticism of this Peruvian water-colorist has rightly been compared with that of the more sophisticated Peruvian writer Ricardo Palma in his *Tradiciones Peruanas.* He here portrays a noted female bullfighter, painted in the mid-nineteenth century.

and miniaturist. The popularity of the miniature, especially for portraits, was one of the oddities of Colombian art in the nineteenth century. However, Torres' finest works were his representations of popular life, stamped with his original vision of the Colombian land and its people.

A group of Ecuadorian painters, related in style, were related in theme, as well—seeking national expression in their canvases. Rafael Salas began to depict the landscape, and Rafael Troya followed his lead. Joaquín Pinto tried to find the roots of an Ecuadorian naturalism or *costumbrismo* in the painting of the Indians and their way of living.

Immediately after Independence, Peruvian art was well-nigh monopolized by the mulatto José Gil de Castro, who turned out large quantities of standardized neoclassic portraits of heroes and eminent persons (*Ill. III-5*). For the rest of the century, the figure and the work of Pancho Fierro were dominant. Also a mulatto, Fierro devoted him-

III-7. Melchor María Mercado: Untitled watercolor depicting magicians. This is a curious surrealist anticipation (painted in 1868) by the perpetuator of the descriptive work in Alto Peru (Bolivia) begun by Alcide d'Orbigny, a French scientist, artist, and explorer, during the first third of the nineteenth century.

self to impaling the aristocracy in satiric watercolors. In depictions of popular figures, his primitive style emphasized his spontaneity and placed him in direct opposition to academicism (*Ill. III-6*). He voiced the reaction of a man of the people before a society that he viewed as arthritic and reduced to the refuge of its memories of past and vanished splendors. At the turn of the century, Teófilo Castillo tried to evoke pre-Columbian roots, anticipating the extensive Peruvian *indigenista* movement launched by José Sabogal in the 1920's.

Because of a curious stylistic lag, in Bolivia the spirit of Altoperuvian baroque painting survived for much of the nineteenth century. Portraiture, especially of heroes, was also important. An extremely interesting and almost unknown figure, who in several respects resembled Pancho Fierro, was Melchor María Mercado (*Ill. III-7*). He depicted popular life in ingenuous watercolors—especially the vivid expressions of a folklore of raw vigor, with its dances, costumes, rituals, and magic.

In Chile, Manuel Antonio Caro launched a discreet *costumbrismo,* and in producing his fine portraits, Francisco Mandiola applied the teachings of Raymond Quinsac Monvoisin, a neoclassic follower of David whose sixteen years in Latin America uncovered a vein of romanticism in him. The impact of the conflict in France between classicism and romanticism was evident in two painters who were close relatives: Alfredo Valenzuela Puelma, an admirer of Ingres, and Alberto Valenzuela Llanos, a romantic, resembling in his landscapes the *plein-air* approach of the impressionists.

In the Río de la Plata region, the treatment of Creole themes, extensively exploited by itinerant artists, culminated—if not in quality, at least in breadth and fidelity—in the work of Carlos Enrique Pellegrini, a native of Savoy. In a parallel way, painters born and educated in Argentina heightened the national flavor through their descriptive painting. Carlos Morel celebrated the life of the gaucho, and Prilidiano Pueyrredón left in his canvases a complete description of the society of the Río de la Plata at the middle of the century (*Ill. III-8*). Pueyrredón was wholly free of the influence of any school, but from his time on, French influence had to compete with Italian in Argentina, until the triumph of impressionism, shortly after the nineteenth century ended.

On the other bank of the Río de la Plata, in Uruguay, Juan Manuel Blanes, a painter with infallible aesthetic instincts, fulfilled the varied functions of chronicler of the struggle for independence, portraitist,

III-8. Prilidiano Pueyrredón: *San Isidro* (1867). A practicing architect as well as a painter, Pueyrredón described the life of the gaucho and the landholder within the framework of the immensity of the Argentine pampas.

and *costumbrista* artist (*Ill. III-9*). Blanes rendered his gauchos on canvases often only 6 inches high, but instead of resorting to the miniaturist's constricted techniques, he employed free, extremely graceful brush strokes. Blanes, along with the Mexican Velasco and the Argentinian Pueyrredón, completes the trinity of the greatest Spanish-American painters of the nineteenth century.

During his five years in Brazil as a member of the Lebreton Mission, Nicolas-Antoine Taunay, another disciple of David, saw his work gain the stature of a school; local themes treated in the French style became a hallmark of the nation's painters. The best-known member of this school is Vitor Meireles de Lima. After studying in Rome and Paris, he returned to paint the *Celebration of the First Mass in Brazil* and *The Second Battle of Guararapes,* both showing the influence of Delacroix—though somewhat adulterated. His triumphs were challenged by Pedro Américo, in his early days a student of Ingres and Hippolyte Flandrin. However, Américo's *Battle of Avachy* is even more romantic and obscure than Meireles' compositions.

III-9. Juan Manuel Blanes: *Knucklebones* (ca. 1885). The founder of Uruguayan painting, Blanes exemplifies perfectly the masterful application of international techniques (he studied in Florence, Venice, and Paris) to the faithful description of Creole themes. In addition, he was the graphic chronicler of the history of the Río de la Plata region.

III-10. Juan Francisco Gonzáles: *Flowers* (ca. 1900). A painter of flowers and landscapes, in addition to portraits, González is considered by critics the outstanding Latin American impressionist.

Impressionism

The eruption of impressionism in Latin America came about through indirect means, that is, not through traveling exhibits of the French masters, but through the enthusiasm of Latin American painters studying in Europe.

Joaquín Clausell bathed his Mexican landscapes in a transparent, luminous atmosphere that was a distillation of the light of his native land. Also in Mexico, Francisco Romano Guillermín adopted the then revolutionary pointillism of Seurat.

After his study in Munich with the German naturalist master Heinrich Zügel, it is not surprising that Fernando Fader's Germanism

III-11. Pedro Figari: *Sharp Tongue* (ca. 1934). A teacher, lawyer, member of the Chamber of Deputies, philosopher, writer, and painter, Figari did not devote himself wholly to painting until he reached the age of sixty. His most fruitful creative period spanned the last seven of his seventy-seven years, ending with his death in 1938.

was evident in his harsh treatment of textures and surfaces. The Argentinian had so much success that painting à la Fader still is a living tradition in the Río de la Plata.

The Venezuelan Emilio Boggio, a friend of Sisley, Pissarro, and Monet, honored along with Renoir by the posthumous homage of the Salon d'Automne, evolved from a mediocre impressionism to a pointillism and neo-impressionism of top rank. Though Boggio painted in France for most of his life, his *Red Roofs of Caracas* (1919) is clearly a European translation of his Venezuelan homeland.

After studying in Europe, Andrés de Santa María remained only a few years in his native Bogotá as Director of the School of Fine Arts. He exhibited his impressionist canvases in Bogotá in 1904, without success. Rejected by a local *ambiance* in which he felt alien, Santa María returned to the Old World and never again set foot in Colombia.

Juan Francisco González managed to give a Chilean stamp to his loose, painterly "impressions," full of nostalgia for colonial survivals around the city of La Serena, and full of the beauty of the flowers of its landscape (*Ill. III-10*).

Pedro Figari (*Ill. III-11*), on the other hand, was most definitely not an impressionist. He began along the general lines of Bonnard and Vuillard, as a colorist. In time, he achieved a personal tone in his work, in his *Death of Facundo Quiroga* and, even more, in the lively, picturesque records of the popular customs of the gauchos and of the boisterous *candombé* danced in Montevideo. A many-sided man and a towering figure in Latin America during the impressionist period, Figari practiced criminal law with great skill and in 1917 published a monumental work, *El Arte, la Estética y el Ideal* (*Art, Aesthetics, and the Ideal*), which had great influence in the countries around the Río de la Plata.

16

"Primitive" Painting

The underlying aesthetic quality of Latin America's encounter with its essence emerged in the kind of painting known as "popular," or "primitive."

In Mexico, anti-academic and popular tendencies were nourished in the outlying provinces. Naturally, the names of most "popular" painters are not known. Among folk artists who have been identified, José María Estrada, who was born in Guadalajara and painted between 1830 and 1860, exhibits all the earmarks of an honest autodidact in his portraiture. His figures are rigid, serenely elegant, wearing elaborate ornaments and fine laces. His portraits of children are his best work (*Ill. III-12*).

III-12. José María Estrada: *The Boy Jesús Miguel Arochi y Baeza.* Painted around 1840, this work must be ranked among the most successful of the host of portraits of the aristocratic bourgeoisie of Jalisco, and churchmen, monks, and soldiers that Estrada painted between 1830 and 1860.

Hermenegildo Bustos had a more "academic" flavor; he was a good draftsman and knew how to delineate the psychological traits of his subjects, sometimes causticly, as in the portrait of his wife.

The portrait was the dominant form in the colonial tradition, but the Mexican "primitives" also depicted historical and devotional themes, local customs, and still lifes. In many ways remarkably similar to primitive works in Peru and Bolivia, the Mexican painting was done on retables or ex-votos, canvases, plates, or panels executed at the request of the faithful.

Although "primitive" painting is rooted in the past, it makes itself felt in our day. Asilia Guillén, a Nicaraguan who died as recently as 1964, concocted embroideries that the common people esteemed extravagantly. When Guillén turned seventy, her friends urged her to express on canvas the ideas she had executed in fabric. Only days before her death, she painted one of her best works: *The Founders of the Americas Meet at Lake Granada,* a delightful archipelago with twenty islands enchantingly crammed with people, vegetation, and houses. In the better-known *Rafaela Herrera Defends the Castle Against the Pirates (Ill. III-13),* now in Washington, D.C., her technique is similar.

José Antonio Velásquez was first a telegrapher and then a barber and mayor of the village of San Antonio de Oriente in Honduras. The

III-13. Asilia Guillén: *Rafaela Herrera Defends the Castle Against the Pirates* (ca. 1960). As in the pre-Columbian ceramics of Paracas, her painting seems to transfer to the canvas the detailed technique of embroidery.

III-14. José Antonio Velásquez: *A Sunday* (1957). Like all Velásquez' other "naïve" paintings, this, representing the parishioners' arrival for mass, is set in his native village of San Antonio de Oriente, Honduras.

minute and detailed workmanship in each of his paintings is astonishing in its precision, richness of color, and spontaneity (*Ill. III-14*).

To a greater or lesser extent, "naïve" painting is pursued in all the Latin American countries. In Brazil, conventional forms with certain intellectual departures are generally employed. In Chile, Luis Herrera Guevara most fully embodied the innocence and sincerity of this school (*Ill. III-15*). But it was in Haiti that "naïve" painting truly achieved the status of a national school. Haitian painting made an international

III-15. Luis Herrera Guevara: *Plaza Bulnes, Santiago* (1941). In all his ingenuous descriptive work, Herrera displays his two-dimensional vision and disregard for perspective.

III-16. Hector Hyppolite: *Voodoo Personage* (ca. 1946). Hyppolite was apprenticed to a shoemaker, a voodoo priest, a house painter, and a furniture painter. He is considered the outstanding figure of the Haitian school.

impact with the work of Pétion Savaín, who has been compared (with some exaggeration) with Henri Rousseau. Around 1945, artistic activity in Haiti intensified, thanks in good part to the proselytizing of a U.S. painter, DeWitt Peters, who in 1944 organized the Centre d'Art gallery, in Port-au-Prince.

The Haitian primitive painter is above all a narrator less concerned with reproducing his vision of the world than with evoking an event by means of concrete symbols. The number of artists in Haiti, professionals in the strict sense, is enormous, and their styles can readily be identified, from the psychological expressiveness of René Vincent to the hieratism of Rigaud Benoit, from the childishness of Philomé Obin to the geometry of Préfète Duffaut, from the baroque lushness of Enguerrand Gourgue's jungles to the balanced symmetry of Toussaint Auguste.

The greatest Haitian primitive painters are Hector Hyppolite and Wilson Bigaud. In his perfectly detailed vegetation, in the horror vacui that impels him to fill his canvases to overflowing, in the massiveness of his volumes, Bigaud undoubtedly resembles the Douanier more closely than any other Haitian, especially in *Earthly Paradise* and *Murder in the Jungle*. Hector Hyppolite is astonishing because of his compositional sense and the inventiveness of his colors (*Ill. III-16*). In his delightful "histories," each detail fulfills an intuited or known function, despite the simplicity of the figurative elements.

In the mid-nineteenth century, advances in lithography, engraving,

and printing opened hitherto unsuspected possibilities to the Latin American artist, especially in Mexico. Caricatures and popular prints were eagerly sought by the masses. From this development emerged one of the great figures of Latin American art, José Guadalupe Posada.

Like many other Mexican artists, Posada was not, nor did he ever claim to be, more than a craftsman, who despite his tremendous popularity retained loyalty to his class and a touching modesty. His publisher, Antonio Vanegas Arroyo, made incredible profits by employing itinerant vendors at fairs or ranches, and on city street corners, to peddle millions of lives of the saints; stories of crimes and miracles; legends, folk songs, jokes, ballads, love letters, caricatures, scandal sheets, and, of course, horoscopes. Vanegas Arroyo gave Posada a lifetime contract to illustrate these texts. They were all written to be recited aloud rather than read by an individual, for more than 80 per cent of the Mexican people were then illiterate. Posada's prints, consequently, had to (and certainly did) translate into recognizable images—simple, objective, and above all, realistic—the words that the buyer had heard and could not read (*Ill. III-17*).

Posada was the first artist whom the Mexican people made their own. Jean Charlot, a fine "Mexicanized" French painter, observed accurately that Posada "functions in the history of Mexican art like the narrow neck of an hourglass, where the past is metamorphosed grain by grain into the future." The impact of Posada's genius paralleled the revolutionary awakening that would transform Mexican art and enable Latin America to present to the world the most genuine image of an inner essence that modern art history records.

III-17. José Guadelupe Posada: *Don Quixote* (ca. 1905). Posada divided his creative life into two sections: satire of contemporary figures, especially politicans; and translation of legendary figures into a world of skeletons and skulls.

17

The Twentieth Century: The Coming of Age

The Mexicans' self-affirmation in terms of their native roots was a logical artistic reflection of the political and social Revolution that began in 1910. In the rest of Latin America, a little later, there were also transformations stemming from the decisive force exerted by a growing middle class. The rumblings that resulted were all animated by a common desire to break away from academic rigidity and the dictates of the European schools and to forge a national expression that would harmonize traditions, social needs, and even political formulas geared to the twentieth century.

In Brazil, the reform impulse led to the Semana de Arte Moderna (Modern Art Week)—an exhibition, conclave, and series of dance spectacles and concerts by avant-gardists in all the arts held in São Paulo in 1922—and to Gilberto Freyre's "Manifesto Regionalista" ("Regionalist Manifesto"), issued in Recife four years later, in which he proposed a position both traditional and contemporary for the nation's new artistic and intellectual manifestations. In Cuba, a parallel movement took shape in 1924, when the painter Víctor Manuel organized a rebellion against the Academy of San Alejandro, Havana's venerable school of fine arts. In addition, Manuel's fiery Havana group was moved by blind admiration for Diego Rivera's celebrations of his nation's past. The collective attitude found its outlet in the *Revista de Avance,* an avant-garde magazine founded in 1927 by Jorge Mañach and other poets. In Venezuela, somewhat later, the abundant national wealth supported an ambitious development of architecture led by Carlos Raúl Villanueva. In Uruguay, in 1934, Joaquín Torres García set up a workshop through which he tried to practice the desideratum he enunciated in his many writings—most definitively in his monumental book: *Universalismo constructivo, contribución a la unificación del arte y de la cultura en América (Constructive Uni-*

versalism, Contribution to the Unification of Art and Culture in America), published in 1944. The eagerness of Argentine artists to synchronize their own individual expression with the contemporary pendulum swings of style is best exemplified in the work of Emilio Pettoruti, Lino Spilimbergo, and Raquel Forner—who retained strong traces of their study in Europe—and in the architectural movement known as "Will and Action," composed principally of direct disciples of Le Corbusier, which was launched on the eve of World War II.

Several other factors spurred architectural advances, notably: an economic boom, more apparent than real; the interest of public— and some private—agencies in the new forms of artistic expression; the ferment touched off by Le Corbusier's visits to Brazil, Uruguay, and Argentina in the 1920's and 1930's; the increasing numbers of artists attracted to university teaching; the dazzling achievements of U.S. architecture between the wars, especially the buildings by Gropius, Mies van der Rohe, Frank Lloyd Wright, and most important of all, Skidmore, Owings & Merrill.

The consequences were quickly apparent in the action and reaction vis-à-vis functionalism, the uncertainty, the trial and error, and the criticism attendant on the hunt for historical sources, and in the achievement of a Latin American vision in the integration of architecture, painting, and sculpture, as well as in urban solutions of a magnitude and audacity unparalleled in the contemporary world.

As we shall see, Mexican muralism was the most important development in Latin American painting. It was also a closed cycle, with an initial explosion, a tormented and triumphant maturity, and finally extinction after the death of two of its most dynamic figures, Rivera and Orozco. Its repercussions were profound, for good and for evil, because the reactions it generated from groups, schools, and individuals created two clear camps that henceforth defined Latin American painting: on one side, the participation and full-fledged competition in international arenas (notably Paris and New York), ignoring local traditions, stories, and customs; on the other side, the search, conscious or otherwise, for the essential and distinctive root of Latin Americanism, in form, landscape, man, or spirit, without hindering its best artists from employing contemporary techniques and concepts.

Inevitably, these activities were most intense in the countries where *mestizaje* was strongest. Because the nature of the mixture varied from country to country, the search for new expressions often led to widely differing results—from the revolution muralism achieved in Mexico,

to Villanueva's integration of the arts in Venezuela, Niemeyer's plastic architecture in Brazil, or Candela's bold structures in Mexico. But whatever the form it took, Latin American art finally became a force to contend with in the international lists.

Mexican Muralism

The most powerful and distinctive phenomenon in Mexican art was born, lived, and matured simultaneously with the agrarian Revolution of 1910. Although several heroes of the popular revolt claim a place in Mexico's political history, it is to the genius, passion, and fire of one man that the birth and consolidation of the artistic revolt must be credited. Gerardo Murillo began by symbolically repudiating the past, changing his Spanish name to Atl, which means "water" in the Náhuatl tongue. A paradoxical man if there ever was one, in the Europe of 1900, he split his political passions between the antagonistic principles of Marxism and anarchism. In 1903, he returned to Mexico with his eyes full of the monumental images of the Renaissance, yearning to express them in fauvist language and new techniques. It was then that he invented the "Atl colors," composed of wax, resin, and oil, and with them, he painted fiery volcanoes and scandalous bacchanals. His first dissident exhibition, organized in September, 1910, with the help of Joaquín Clausell and José Clemente Orozco, displayed about fifty painters and ten sculptors. Its success was thunderous. A little later, on November 20, the Revolution broke out.

The movement Dr. Atl had launched in the Artistic Center was encouraged by two events decisive for the beginning of Mexican muralism: First, in 1921, the philosopher José Vasconcelos, then Minister of Education, invited young painters to cover the walls of the venerable National Preparatory School, in Mexico City, with paintings depicting the theme of the national will. Second, the aesthetic ideology first formulated by Rivera, Jean Charlot, Carlos Mérida, Xavier Guerrero, and other artists was enunciated by David Alfaro Siqueiros in a manifesto entitled "Social, Political, and Aesthetic Declaration," issued in 1922 by the aggressive syndicate of technical and graphic workers (i.e., painters, sculptors, and engravers).

Advancing a program to make art the property of all levels of society, the manifesto repudiated easel painting and all the products of aristocratically oriented intellectuals. It found justification only for the creation of monumental works for the Mexican people, whose art "is the highest and greatest spiritual expression of the world-tradition."

Until this time, only one artist—Francisco Goitia—had employed the Revolution as a theme. Goitia had fought in the struggle in his native Zacatecas, where he painted *Dance of the Revolution* (1916) and *The Hanged Man* (1917). He soon embarked on a lifelong cultural mission, a quest for the indigenous essence of his country. His finest work is *Tata Jesucristo (Daddy Jesus,* 1927), where he gives shattering expression to a sorrow of centuries.

Siqueiros' 1922 manifesto had set forth the basic aesthetic of the muralists: grandiose painting, the bigger the better; absolute realism, without concessions of any kind to lyrical relief; new techniques that would make pictorial history more alive and attractive to the people; individual freedom in the treatment of subjects—grief, martyrs plowed up like manure through the overoptimism of the new builders. The encouragement of freedom for each artist also meant a license for unrestrained reciprocal criticism, which proved to be so savage as a rule that it finally led to the disintegration of the group and the end of the era of historical art.

But, as Orozco observed, in 1922, with these preconditions and Vasconcelos' offer of the walls in the National Preparatory School, "the table was set for mural painting."

The first great Mexican artist to take advantage of Vasconcelos' invitation was Diego Rivera. Although his theme was the Revolution, as a muralist, he turned out academic and conservative works, realistic down to the smallest detail. He never took any idea for granted nor permitted his audience—illiterate for the most part—any freedom of interpretation. His dramas reiterate an invariable dialectic in which evil is the enslaving Spaniards and good the downtrodden Indians. Rivera the muralist is a narrator, a historian who recounts to his fellow citizens the gestation, development, and hopes of Mexico from its earliest origins. His greatest work—the mural sequence in the National Palace in Mexico City—deals with precisely that theme (*Ill. III-18*). Begun in 1929 and interrupted several times until 1945, when Rivera last worked on it, it was left unfinished at his death.

Rivera's folkloric easel painting and his sculptural efforts are generally not as esteemed as his murals for the National Palace. But any historical evaluation of Rivera must necessarily take into consideration his importance in Mexico's cultural evolution, his prestige, and the prestige he brought his country.

In 1919, shortly before Rivera left Europe to become a prime mover in what has aptly been called "the Mexican mural renaissance," he met a young countryman in Paris—David Alfaro Siqueiros. After fighting

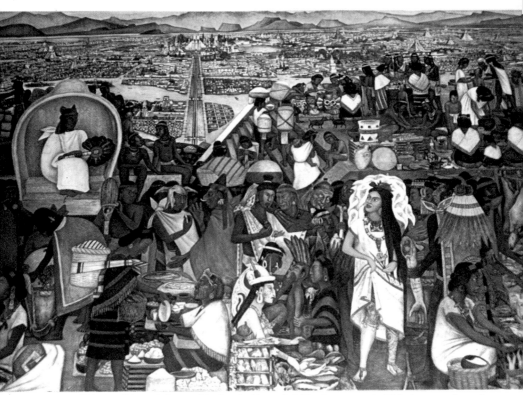

III-18. Diego Rivera: *Market in Tenochtitlán* (1929–45). This is a portion of Rivera's entire mural depicting life in ancient Mexico. It is a thoroughly documented and accurate reconstruction of the Aztec world in the capital of the Empire. National Palace, Mexico City.

in the Revolution, Siqueiros had come to Europe as a military attaché at the Mexican Embassy in Madrid. This encounter was decisive, for Siqueiros absorbed—and has retained—Rivera's enthusiasms. Marxism dominated Rivera's intellectual outlook, and the Mexican Revolution obsessed him emotionally. He returned to Mexico in 1921, while Siqueiros was organizing a Communist movement in Barcelona with his "Three Timely Appeals to Painters and Sculptors of the New American Generation."

Like Dr. Atl, Siqueiros embodies a great many contradictions. A perennial nonconformist, Siqueiros, despite his nationalism, has been imprisoned by his country and exiled from it several times. His profession of an orthodox and irrevocable political commitment has been no obstacle to his ceaseless search for new techniques, instruments, and

materials in his art. Tormented by his failure to meet his exacting standards, he has left a good part of his work unfinished. Still, his *Tropical America,* painted for the Plaza Art Center in Los Angeles, California (and subsequently painted out by the outraged sponsors); the *Portrait of the Bourgeoisie,* in the Mexican Electricians' Union Building; and *For Total Security for All Mexicans,* in the Main Social Security Hospital, establish Siqueiros' place as the great innovator in contemporary mural painting. In our judgment, however, he is a past master in his easel works (*Ill. III-19*), especially those that strive for greater aesthetic freedom, from his searing *Proletarian Mother* to *Our Present Image* and his abstractions.

In 1935, when he carried on an impassioned debate with Rivera, Siqueiros' declarations constituted actually an enumeration of his successes and failures. (Rivera took exactly the opposite tack.) But Siqueiros acquired his knowledge laboriously and has continually amplified his colossal talents with bold—although sometimes fruitless —experimentation.

The third of the three giants of Mexican mural painting is José Clemente Orozco. Initially, Orozco concentrated almost exclusively on political caricature. In 1916, his first one-man exhibition was devoted to his current preoccupation—putrefying Mexican society, with its deformed creatures, prostitutes, and stunted fetuses. After proving the existence of that loathsome world, he went on to transform its people into the archetypal heroes of the Revolution, in a 1923 mural in the National Preparatory School. But taking the violent exhortations of Siqueiros' manifesto literally, he destroyed most of his academic early murals, although he retained their theme in later versions.

III-19. David Alfaro Siqueiros: *Siqueiros by "The Great Colonel"* (1945). Siqueiros' valor in the field won him the rank of lieutenant colonel in the Republican Army during the Spanish Civil War. This period provided him with the nickname "El Coronelazo," "The Great Colonel."

Orozco's drastic attitude cannot be explained as mere rebelliousness. What concerned him was to avoid imitating, to do his work sincerely, according to his own methods and his own ideas. His rigorous self-discipline is mirrored in his direct and precise style.

Orozco was an iconoclast who did not choose his targets according to the guidelines of an orthodox, programmatic scheme, as did Rivera and Siqueiros. Moreover, in Orozco, there was no cleavage between the work of art and its content. Although Rivera's work frequently has the realism of a photograph, in Orozco the touch of the spirit is always present. Even when he depicts a historical event, the spectator is aware that, besides the narrative content, the painting is always there, as painting.

Orozco's central theme is a lamentation that is virtually always delivered in a shout. Whatever the specific story or actual occurrence he paints, he always describes an unlimited, transcendent potency.

Between 1922 and 1927, Orozco painted a group of frescoes in the National Preparatory School: *The Trench,* as well as *The Destruction of the Old Order, The Strike, The (Revolutionary) Trinity: Peasant, Worker, and Soldier.* Between 1927 and 1934, he painted in the United States: the tremendous *Prometheus* at Pomona College, in California, and a group centering on *The Table of Universal Brotherhood,* at the New School for Social Research, in New York City, a table that unites representatives of all the peoples of the earth, presided over by a Negro. At Dartmouth College, in New Hampshire, Orozco again turned to the past, summarizing the development of America in a mural sequence that concludes with his dramatic *Christ Burning His Cross* before a flood of cannons puts an end to civilization.

Beginning in 1934, the year Orozco returned to Mexico, his criticism of contemporary society became increasingly bitter. A mural in the Palace of Fine Arts, *The Catharsis* (1934), in which cynical prostitutes laugh before an avalanche of men and arms, marks the highest peak of tension that Orozco expressed, and which he strove to maintain until his last works, despite his diminishing vigor.

Like Rivera and Siqueiros, Orozco was essentially a muralist. His

III-20. José Clemente Orozco: *Crucifixion* (1942). This dynamic work has a ▶ strong feeling of distortion—an aspect of Orozco's continuous preoccupation with humanizing the figure of Christ.

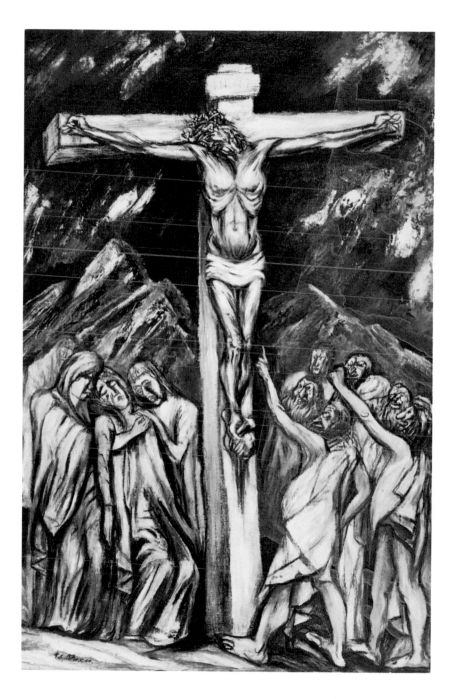

awesome and terrible vision—his *tremendismo*—is also evident in his graphics and canvases. Like most of the revolutionaries in this period, Orozco was a mystic. This explains why he devoted so many canvases to the theme of Christ—Christ as a revolutionary (*Ill. III-20*). Orozco could not conceive of calm or relax his tension. The only calm in Orozco is the calm of death.

Indigenism: A National or a Pseudo-national Art?

In South America, the explosion of Mexico's national spirit in the painting of the great trinity—and their universal success—generated an "indigenist" wave that seemed to engulf academies, schools, and independent artists.

José Sabogal introduced the doctrine of aesthetic nationalism to Peru, upon his return from Mexico, in 1923. As Director of Lima's School of Fine Arts, a post he assumed in 1933, he notably influenced the search for a genuinely Peruvian form of expression through his own work and that of his fellow professors—Julia Codesido, Camilo Blas, Teresa Carvallo, Ricardo Flores, and others. But the theme of the Peruvian Indian was treated in a circumscribed *ambiance,* with European or, at best, Mexican techniques.

Indigenismo in Bolivia was even more dependent on Mexico, through the influence that Siqueiros exerted directly on the painter Roberto Berdecio. Cecilio Guzmán de Rojas encouraged artists in Bolivia to explore Indian subjects and styles, as Sabogal had done in Peru.

In Ecuador, as in Mexico, *indigenismo* emerged out of a rebellion, the May Salon of the Syndicate of Ecuadorian Artists and Writers (1939). Among the painters influenced, Eduardo Kingman Riofrío tried to apply Rivera's successful tricks, Manuel Rendón used French techniques to depict the characteristic figures of the mountain city of Cuenca, and Diógenes Paredes focused on the tragic life of the Indian. Perhaps the most authentic painter of this generation is the "primitive" Luis Alberto Heredia.

In Colombia, Luis Alberto Acuña established the indigenist link with Mexico, where he lived for three years. At the opposite reach of the Andes, Chile experienced the Mexican influence filtered through the work of José Venturelli, as much in his themes as in his espousal of an ideology along the lines of "socialist realism."

In Venezuela, Armando Reverón led the search for a national expres-

III-21. Armando Reverón: *Landscape*. Painted in 1929 near his humble cabin in Macuto (on the Venezuelan coast), this painting demonstrates Reverón's determination to show "light as an object, and light at the expense of the object."

sion into unexpected paths. Reverón made real a desideratum seldom grasped by those who try to capture the tropics on canvas. In Macuto, a village on the Venezuelan coast, he achieved the synthesis of colors—returning the spectrum to its true origin, the absence of color, which is the sum of all colors and the perfect way to paint blinding light seen by a blinded eye (*Ill. III-21*). Reverón's attempt to transpose the wealth of colors that engulfed him terminated finally in the blurred and pure whites of his last canvases.

18

After Muralism

Except for the work of a few internationally recognized or internationally touted figures, Latin American visual art of the last few decades has not yet become part of art history. Judging it is, therefore, a matter for the critic and not for the historian. For this reason, as well as because of the very richness and dynamism of the recent modern period, a comprehensive treatment is impossible in the present study. And for the same reason, this chapter includes the work of artists mostly born before 1920.

It is not difficult to discern a coherent pattern in the evolution of Latin American painting, deriving, on the one hand, from the reaction against the indigenism fostered by Mexican muralism and, on the other hand, from the yearning for self-affirmation and full competition in the international arena. Latin American painting in the middle of our century is both homogeneous and varied at the same time. The unhappy isolation that endured throughout the nineteenth century has been overcome as a result of the São Paulo Biennials (begun in 1951), later imitated by other countries. Much credit is also due to the Pan American Union's Division of Visual Arts, which has been instrumental in "discovering" and giving recognition to Latin America's artists. In addition, one must credit the expanding activities of the Di Tella Foundation in Buenos Aires, the Luis Angel Arango Library in Bogotá, the Museum of Contemporary Art in Santiago, Chile, and many other institutions.

The United States has come to know and acclaim Latin American art, not only through the efforts of the Pan American Union, but also through various conferences, symposiums, and exhibitions. Two landmark exhibitions were "The Emergent Decade," presented by the Guggenheim Museum, in New York, in 1956, and "Art of Latin

America since Independence," organized in 1966 by Stanton L. Catlin and sponsored by Yale University and the University of Texas.

Foreign recognition is belatedly but surely coming to Latin American artists because of their ability to bring universal values to contemporary expression.

Painting in Mexico

Although all Mexican painting is rooted deep in its native soil, since the Revolution painters have taken two not merely different, but antagonistic, routes: the nationalistic, which claimed to perpetuate the realism of the three giants—Rivera, Orozco, and Siqueiros—and the eclectic, which cherished painting for its own sake, without denying its Mexican heritage.

The group that we shall provisionally call neorealistic was formed around 1928 from a group of painters and writers who banded together to fight against "the academics, the clerks, the robbers in public posts, and every variety of intellectual drone and vermin." The Liga de Escritores y Artistas Revolucionarios (League of Revolutionary Writers and Artists) announced that it would concentrate, in politics, on combating fascism; in art, on the continuity of the plastic language created by the three giants. Its members included several excellent artists, but from the first, Juan O'Gorman stood out as the leader of an ultranationalist movement with an obsessional archaeologism. Of O'Gorman's extensive mural work, the best known is the monumental natural-stone mosaic that covers the four sides of the Central Library of the University City, in Mexico City (*see Ill. III-54*). Employing a medium frequently used by Rivera, O'Gorman here intermingled symbols of Western culture with imitations of the pre-Hispanic codices.

Challenging the Liga, Manuel Rodríguez Lozano also sought the Mexican image, but without using narrative or objective event. For him, what essentially distinguishes Mexico is its light, its blinding light, and to reach its source, Rodríguez need only live in a geological environment radically different from Europe's (*Ill. III-22*).

Although Julio Castellanos can best be described as a neorealist, his vision has little of the starkness commonly associated with this term. Rather, Castellanos—as well as his disciples Celia Calderón and to a greater degree Jesús Guerrero Galván—retains a measure of tenderness throughout his work.

Alfredo Zalce, one of the present generation of muralists, repeats the historical themes exhaustively treated by Rivera, and Raúl Anguiano skillfully applies the techniques of the three founding giants. José Chávez Morado lacks the temperament of the typical muralist; rather than proclaiming unshakable conviction, Chávez is both skeptical and insecure. Nevertheless, he executed vast mosaic murals in the University City, using glass and natural stones and a mixture of the two. His greatest work within the mural tradition is *The Abolition of Slavery* (1955), in the Grain Exchange (Granaditas). Miguel Prieto, a Spanish Loyalist *émigré,* created several enduring works and toiled passionately to win recognition for Mexican art.

Frida Kahlo, for twenty-five years the wife of Diego Rivera, cultivated a surrealism with Mexican themes. While her recurrent descriptions of the subconscious are infused with Freudian allusions, her vision is more romantic than aggressive.

Carlos Orozco Romero also employs motifs drawn from an interior world—primeval simian forms, isolated, expressionless, as if in an incoherent fantasy. In these aspects, his imagery resembles that of Rufino Tamayo, the towering figure of Mexican painting today.

III-22. Manuel Rodríguez Lozano: *Piety* (1945). The painter makes use of the landing of a stairway in a Mexico City house to express his passion for the curve and typically uses light as an integral element of his design.

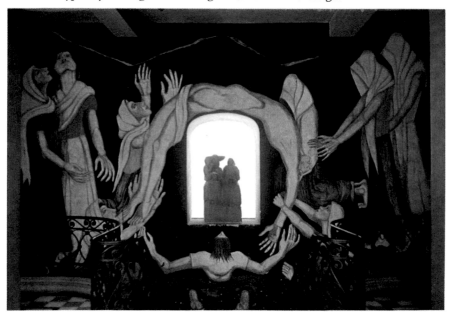

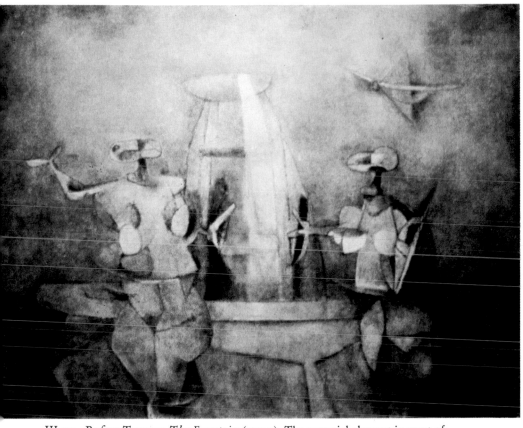

III-23. Rufino Tamayo: *The Fountain* (1951). The essential element in most of Tamayo's work is man, man at one with his environment, integral and eternal.

The current encounter with America in its purest and most distinctive sources reaches its summit in Rufino Tamayo. His formal differences with the three giants of Mexico are profound. For him, renewal must encompass form and content, and his ideas cannot be expressed through the means and systems of the past; he must employ a language that is universal and, above all, contemporary. He rejects historicism, archaeologism, and realistic representation. As a Mexican, he is racked by unrest and anguish, two national characteristics according to Leopoldo Zea. As a twentieth-century man, he is part of his epoch.

Therefore, Tamayo expresses his anguish in terms that, although Mexican, are universal (*Ill. III-23*). Like his Zapotec ancestors, his figures belong also to the heavenly bodies, which still govern the intense enigmas of Mexico. His *Lovers Contemplating the Moon,* his *Man Contemplating the Firmament* are as frightened as their forebears, but with today's fears. Occasionally, his people play the flute to conquer their disquiet. At other times, the musicians die sleeping. Sometimes, there is laughter and dancing. Almost always, the laughter is a rictus of the tormented or the hopeless.

Therefore, from the beginning, Tamayo has opposed illustration and local allusions in art, however skillful it may be, in favor of a subjective rendering of the historical spirit. For Tamayo, this spirit cannot be captured by a cold, rational analysis; for him, the extensive literature of introspection demonstrates, the more it accumulates, that the marrow can be uncovered only by unusual and personal means. Undeviatingly, Tamayo has probed for that intense vision of the Mexican essence, from his early figurative works to the siennas of the earth and the dust of Mexico that make up his latest abstractions.

He is not a painter "arrested" by the discovery of a style. He set out, around 1926 (his first period), fleeing the grandiloquent use of blacks. On the contrary, he immediately displayed a knowledge of the violence of siennas, blues, reds, yellows. Two years later (his second period), his figures were distinctly Mexican, and in his still lifes (his third period), he increasingly employed abstract forms. His fourth period was signaled by gloomy ideas about humanity and his fifth by a continuity with its predecessor, but now Tamayo permitted himself a peculiar surrender to the visual delights of color.

These are what could be called the formative stages. What follows will be an ever-new maturity in the use of age-old forms and colors, as Tamayo painfully pursues a synthesis that will ultimately be summed up in the simple abstract boundaries of the earth.

Painting in Central America and the Caribbean

Central American painting has shown an increasing tendency toward abstraction, though it retains, as well, a devotion to its pre-Columbian roots. Most of the young painters follow a course of subjective abstraction that ignores natural light in search of a tropical synthesis through white.

Chronologically, the rediscovery of the American heritage had be-

gun with Carlos Mérida's historic missionary work. In Mexico, his Guatemalan roots found a soil conducive to their development. Through triangular shapes, Mérida translated the plastic ideology of pre-Columbian art into contemporary terminology. His style took an unmistakable line, which finally culminated in his gigantic mural for the Municipal Building in Guatemala City (*Ill. III-24*). His seminal school retains an influence today in Guatemala.

Cuban painting, for the most part, has moved from exuberant representational abstractions of its tropical flora and African rites toward nonobjective abstractions, a trend evident as early as the 1940's, in the murals of Amelia Peláez and Wifredo Lam in the Cuban Oil Institute Building, in Havana, and in Peláez' mural for the Tribunal de Cuentas, or Comptroller's Office (1954).

Mario Carreño, a Cuban who has been an active member of the Chilean art world since 1958, has remained a geometric abstractionist in both his easel painting and his murals. His chromatic sense gives validity to the decisive jagged staccatos of his triangles. This characteristic integration of form and color functions superbly in his mural for the San Ignacio School, in Santiago, Chile. In recent years, Carreño has once again shifted his subjects and style. Now he depicts textures tortured by atomic disintegration (*Ill. III-25*).

Together with Carlos Mérida and Rufino Tamayo, Wifredo Lam is one of the great figures of twentieth-century Latin American painting. His effort has been to create an international language that would adequately represent his land, its people, and its spirit. He has evolved from immature expressionism to a consuming surrealism, which issued in the illustrations for André Breton's *Fata Morgana* (1942). After a long residence in Spain (from 1925 to almost the end of the Civil War, 1938), Lam became identified with the symbols of Picasso's *Guernica* period. And indeed, Picasso was a generous artistic godfather to Lam. Soon after, Lam developed his distinctive dark style, predominantly baroque in feeling, as befitted his Cuban temperament. *The Jungle* (1943), in the Museum of Modern Art, in New York, is a fine example of this style. His self-exploration is perfectly exemplified in the multiple persons who compose his *Figures in Black and White* (1954; *Ill. III-26*).

In optical art, Venezuela and Argentina were both leaders. The school captivated the Venezuelans, as can be seen in the art works that give a matchless extra dimension to the University City in Caracas. This trend is seen at its most masterful in Alejandro Otero, who

237

III-24. Carlos Mérida: *The Mestizo Race of Guatemala* (1956). Part of a mosaic mural in the Municipal Building in Guatemala City, this is an example of the revival of a Maya form of expression executed with triangular geometric elements.

III-25. Mario Carreño: *Love* (1964). After having tried many different roads, Carreño now works in a "petrified world," in which he examines the organic disintegration produced by the atomic bomb.

238

III-26. Wifredo Lam: *Figures in Black and White* (1954). In this work, Lam shows his thoroughgoing involvement in exploring the subconscious.

has eliminated color, subject, and form from his pictorial conception. Taking an opposite tack, he found solutions similar to Kandinsky's "improvisations," culminating in his invention of "colorhythms," painted in brilliant hues of Duco on severely rectangular planes (*Ill. III-27*)—as he continues to strive for a sensation of the infinite. Jesús Rafael Soto also experimented with multidimensional space until he finally created his changing and startling kinetic "vibrations"—as much sculpture as painting.

III-27. Alejandro Otero: *Colo-rhythm No. 10* (1956). Otero's "colo-rhythms" (1950–69) are the Vene-zuelan's best-known works. They consist of color forms rhythmically organized in parallel vertical lines.

Painting in the South

In the last few years, Colombia has emerged with unexpected per-sonality as an important artistic center within the Latin American context. Colombia's painters use universal figurative language to de-scribe opposing facets of the nation's reality.

Until a few years ago, the Colombian Alejandro Obregón was known as the gloomy painter of his native Barranquilla. He chronicled past epochs and occasionally essayed a descriptive canvas (*Ill. III-28*). Oblivious of day-to-day events, Obregón traveled unhesitatingly to-ward the glorification of his persistent motifs: condors, volcanoes, sea-coasts, lizards. But he now intellectualizes them in increasingly more abstract allusions that may enable him to forge a truly individual style.

Eduardo Ramírez represents the geometric outlook in Colombia, in painting as well as in sculpture. During a prolonged period of purification, he worked out his striving for pure form without color. From this derived his white reliefs in wholly sculptural terms (*Ill. III-29*).

Oswaldo Guayasamín is one of the most controversial Latin American painters. He is either loved or loathed; there is nothing in between. His admirers see in him a link between the vein of suffering in Spanish colonial art and modern expressionism. His detractors charge that he utilized a limited Picassian vocabulary to revive *indigenismo* in his native Ecuador (*Ill. III-30*).

The American volcano, the fire of the third day of Creation, are

III-28. Alejandro Obregón: *The Wake* (1956). Winner of the Guggenheim International Award for 1958, this canvas belongs to the brilliant period when Obregón was interested in the human figure surrounded by elements characteristic of the still life.

◀ III-29. Eduardo Ramírez: Model for *Column* (1966). Ramírez employs smooth surfaces, without color, to heighten his reliefs. His search for purity of forms makes his work especially suitable for an architectural setting, as seen in this model for his *Column* in the American Bank and Trust building (redesigned by Damaz & Weigel, Architects) in New York City. The *Column* itself, a twenty-two-foot-high steel structure, was installed in 1967.

III-30. Oswaldo Guayasamín: *The Cry* (1951). The social protest themes employed by this Ecuadorian figurative painter reflect the influence wielded in the Andean countries by the Mexican muralists, especially Orozco.

III-31. Fernando de Szyszlo: *The Myth of Inkarri* (1968). Szyszlo is obsessed with abstract representation of the magic world of pre-Columbian Peru and with the untamable strength of the high cordillera of the Andes.

fundamental themes of the work of the Peruvian Fernando de Szyszlo, who swiftly won international recognition for his abstract canvases that are a pure crucible of color without form (*Ill. III-31*). His eternal fires and his blue shadows are a graphic counterpart of the impalpable halo Neruda describes in his poem on Machu Picchu.

Since the Bolivian painter María Luisa Pacheco found the way to her "pre-Columbian idols," she has ceaselessly worked to perfect this theme, in the series called "Stoic Figures," until she discovered unmistakably American attributes in her latest "compositions," rendered in a language wholly and quintessentially abstract (*Ill. III-32*).

The contemporary spirit of rebellion was expressed in Chile in the form of an almost total worship of France and things French. In 1928, the Grupo Montparnasse (Montparnassians) was formed by Camilo Mori, who worked in various styles from cubism to abstraction; Luis Vargas Rosas, who created baroque arabesques in the shape of fishes, vines, leaves, always with dynamic curves; José Perotti, who, in addition to painting, made sculptures, ceramics, and engravings; the Ortiz de Zárate brothers, Julio and Manuel, the latter a close friend of Modigliani and a member of the large group of foreigners who launched the School of Paris.

The mentor and guide of the Grupo Montparnasse was Pablo Bur-

chard G. In the modest Chilean *ambiance* of that period, Burchard spearheaded the liberation from impressionism to something approaching fauvism. It was the next generation—the Generation of 1940, Israel Roa, Carlos Pedraza, and Sergio Montecino, among others—that espoused fauvism wholeheartedly. But Chile did not attain international recognition until the advent of Roberto Matta. A thoroughly original painter, in open reaction against the influence of the Montparnassians and the Generation of 1940, Matta gave concrete expression to an obsessive pursuit of the cosmic, to extraterrestrial forms. His very singular and distinctive surrealism seems to have stamped Chilean painting ever since.

Of all the contemporary Latin American painters, it is Roberto Matta who is most concerned with achieving a graphic expression of our time, actually outstripping the mechanics of the space age. This is the source of his importance historically, as well as of his obvious limitations. Unlike most other major twentieth-century artists, Matta has attained an equilibrium and always moves within its orbit.

Highly inventive, Matta has discovered how to paint the absence of dimension. This has nothing to do with the two fundamental dimensions of the canvas, or with the imaginary addition of a third; it is the product of all the dimensions raised to the infinite power. Therefore, and despite his unmistakably Chilean character, Matta is clearly a baroque painter, because he is devoted to the search for infinity.

It has been perceptively remarked that in Matta, there is a permanent conflict: between the organic and the mechanistic and, at the same time, between the cosmic extension of the universe and the microcosmic extension of embryonic beings. (He is obsessed with the act of generation.) Matta's canvases owe much to radiography; he X-rays what is thick and opaque and makes it transparent (*Ill. III-33*).

During his "metaphysical" surrealist period (1935 to the mid-1940's), Matta played a fundamental role in the creation and organization of the New York School. (From 1938 to 1948, he lived in New York. Since 1954, he has lived in Paris.) He himself considers the label of "surrealist" inaccurate. He calls himself a *"realista del sur,"* punning on the Spanish word *"sur,"* which means "south," for his native Chile is at the foot of the continent.

Enrique Zañartu, also a Chilean, defines himself as a realist—"a realist according to my own way of seeing things, a realist for whom reality is what I feel within myself." This introspective analysis is wholly in keeping with Zañartu's work. But he is actually more an

III-32. María Luisa Pacheco: *Totem* (1967). Totemic forms from Tiahuanaco stamp María Luisa Pacheco's most recent compositions. She uses oil and wood on canvas to achieve the formal integration of the architectonic sense of pre-Columbian visual arts.

abstractionist than a realist, because he succeeds in giving concrete form to the subconscious. However, his forms are difficult to interpret; they are often exotic and even more often unfinished (*Ill. III-34*).

A paradox pervades the work of Nemesio Antúnez. On the one hand, he exercises minute care in the modulation of the smooth, subtle tones that pattern his "tablecloths." On the other hand, he represents the fiery and terrible power of the Chilean Andes. In his recent

III-33. Roberto Matta: *The Birth of America* (1957). From a nonfigurative metaphysical attitude linked to surrealism, the Chilean master evolved toward a violent expressionism to terminate, in his own words, with the representation of a "nonanthropomorphic" man.

III-34. Enrique Zañartu: *Beachcomber III* (1955). Unlike the pure surrealists, Zañartu describes subconscious phenomena with amorphous and deliberately imprecise elements.

III-35. Nemesio Antúnez: *The Heart* ▶ *of the Andes* (1966). This phosphorescent oil mural in the United Nations Building, in New York City, shows Antúnez' ability to express the earth force of the Andes chain.

abstractions, he seems always to suggest the presence of a flaming volcano. He is most celebrated for his undulating red-and-black checkerboards that symbolize the earth of his native land rent by earthquakes. He has now abandoned this style, but *The Heart of the Andes* (*Ill. III-35*), in the United Nations Building, in New York, attests to his attachment to American themes.

During his second stay in Paris, from 1924 to 1932, Joaquín Torres García, born of a Catalan father and a Uruguayan mother, founded the magazine *Cercle et Carré,* together with Michel Seuphor. He also organized a revolutionary exhibition of abstractions, including works by Kandinsky, Mondrian, Arp, Sophie Taeuber, Pevsner, Léger, and Le Corbusier. In 1932, he returned to his birthplace, Montevideo, forever. He painted, wrote, publicized. He set himself up as the champion of constructivism and rediscovered his America in its pre-Hispanic roots. The personal meaning of this discovery was made clear less in the 1,000 pages of his *Universalismo constructivo* than in his *La Tradición del hombre abstracto* (*The Tradition of the Abstract Man*). It is in the latter that he says: "Everything is one and diverse. Normal vision of things: counter the out-of-focus vision of the eyes with inner vision. . . ."

Guillermo de Torre, the Spanish-Argentine critic, described Torres García's major contribution to contemporary art as painting by ruler and compass, following in the furrow plowed by Cézanne. And in

III-36. Joaquín Torres García: *Constructive City with Universal Man* (1942). This influential Uruguayan painter abandoned imitation of nature, perspective, and chiaroscuro in seeking the basic principles of his "constructive universalism."

imposing geometry on fancy, logic on the dream, Torres García demolished the bases of surrealism, then in vogue (*Ill. III-36*).

Torres García's influence in Latin America was and is enormous. Especially in Uruguay, a large group of constructivists continues to work within the framework of his theories.

Simultaneously with a promising economic boom, bolstered by the judicious administration of President Marcelo Torcuato de Alvear, Buenos Aires began around 1924 to establish itself as a major art center. It has maintained this position to the present, despite the exodus of its artists, which has been extremely large in recent years. European acclaim for Figari's canvases as well as direct contacts with Europe, spurred a true artistic revolution in Argentina. Most instrumental of all was the founding, in February of 1924, of the magazine *Martín Fierro,* named after the gaucho of the pampas in the epic that bears his name. Martín's long suffering and eventual triumph made him a national hero. Similarly, Argentina's belated assertion of nationality led to its participation in international movements and its eventual acceptance as a full-fledged member. In the fourth issue of the magazine, a manifesto appeared that, paradoxically, rejected the nation's

Creole and conservative tradition, propounding instead new international heroes—Apollinaire, Picasso, and Schoenberg.

The ground had been prepared by the first exhibit of the work of Emilio Pettoruti, in 1924. Pettoruti was then a captive of cubism, although it was already somewhat outmoded in Europe. He has remained faithful to this course ever since and continues to employ flat, geometric planes, upon which the colors harmonize in tranquil rhythms (*Ill. III-37*).

Lino Eneas Spilimbergo also followed the constructivist lead and the creative impulse of the *Martín Fierro* group, although by a different path. Ultimately, he drifted toward a realistic classicism with carefully balanced, precise form and exquisite draftsmanship.

The last of the major figures in the Argentine movement is Raquel Forner, who in her mature period has been oppressed by the calamities of war and reactionary powers. In Raquel Forner, tension issues in a shout, in a searing rupture, in protest. Her nightmares are always horrifying; her apocalyptic agony finds no surcease (*Ill. III-38*).

As in other countries in Latin America, Argentina's painters were much concerned with social conditions. The towering figure in political art in Argentina is Antonio Berni, partisan of the far left. After five years of study in Europe, he returned to Argentina, in 1932, and thereupon embarked on diatribes through brash and impudent caricatures in collage. He has invented two characters—the "young boy"

III-37. Emilio Pettoruti: *Pears and Apples* (1932). Since his first trip to Europe, in 1913, and his friendship with Juan Gris, Pettoruti has been a member of the cubist movement and has never altered his style.

III-38. Raquel Forner: *Moon Landing on Mount Taurus* (1964). In her series entitled "Those Who Saw the Moon," Raquel Forner invents mysterious, weightless personages, symbols of the figurative expressionism she has made her own.

Juanito Laguna and the courtesan Ramona Montiel (*Ill. III-39*)—who enable him to retain an aggressive realism even in his most abstract and insolent constructions.

Today, thirty years after Berni created his genre of figurative irreverence, a large new crop of neofigurative painters has returned to the mainstream of the Argentine tradition. Another group best described by the ambiguous label "abstract" is now acquiring mounting importance. Among its widely disparate members are a husband and wife, José Antonio Fernández-Muro and Sarah Grilo.

However, the first school in Argentina to assert its own values was concretism, which developed a little after 1940. From it derived a sizable and talented group of op painters, liberated from direct European influences and linked in a search for free expression through geometric-abstract means. Luis Tomasello pursues this search with sculptural forms in his "reflections" of polyhedrons.

In 1913, a heated controversy erupted in Brazil because of an exhibit of paintings by a young Lithuanian, Lasar Segall—already allied with the German expressionist movement Die Brücke. In 1923, Segall settled in Brazil and some years later became a citizen. Through his personality and influence, he made his adopted countrymen strongly interested in German expressionism. By this unexpected means, Brazil built a historical bridge over the Francophilia of the nineteenth century and revived the tie with Germany that had been latent in its baroque colonial traditions. The First São Paulo Biennial, in 1951, paid homage to Lasar Segall in a retrospective exhibit, placing him, along with

Cândido Portinari and Emiliano Di Cavalcanti, at the summit of contemporary Brazilian painting.

The national rebellion against academicism, stimulated by the new element of German expressionism that Segall embodied, began to take shape with the first exhibit of Anita Malfatti's paintings, in 1917, and the highly original Tarsila do Amaral, who sought in the sincerity of primitivism justification for her break with rigid entrenched standards. The rebellion culminated in the Semana de Arte Moderna in 1922, in São Paulo. A little later, a futurist movement, admittedly far different from Marinetti's, tried to incorporate the latest trends. Through some exaggeration, an "anthropophagous" movement was formed, and another, "Pau-Brasil" (named after "Brazilwood," used in cabinetmaking), which claimed roots in the indigenous world before the Conquest.

One of the reformers, Emiliano Di Cavalcanti, found his outlet in a sensual, hedonistic painting that delighted in violent color and enthusiasm for the joyous earthly pleasures of a people happy with itself. However, as he himself has sometimes warned, in his young people of Bahia overflowing with carnality, in his cynical courtesans, in his ridiculous hats, there is much of disintegration and defeat (*Ill. III-40*).

Cândido Portinari abandoned the influence of Paris and devoted himself to the task of explaining the mystery and attraction of the forgotten masses and to leaving on his canvases, murals, and tile walls a moving history of Brazil. Portinari embodied the antithesis of trop-

III-39. Antonio Berni: *Ramona's Kiss* (1964). One of Berni's experiments in the use of xylo-collage in relief, employing his favorite character, the courtesan Ramona Montiel.

ical carnival festivities. His career was marked by a constant purging, a simplification of expressive means that led him to use soft colors and subtle tones. Constantly sought after by planners and architects, he attuned his spirit to the new Brazilian architecture, and his work was invoked as a corrective to Mexican muralism. His tile murals in the Ministry of Education and Public Health Building, in Rio; the frescoes for the Hispanic Foundation, in the Library of Congress, in Washington (*Ill. III-41*); the decorations, also in tile, for Oscar Niemeyer's Church of São Francisco de Assis, in Pampulha; and the great canvases on *War* and *Peace* in the United Nations Building, in New York, show successive stages of both his exacting standards and his unending self-purification.

Geometric abstraction has made a stunning impact on new Latin American painting; in the numbers of its adherents and the extent of its influence, it outstrips the angular, schematic vision of Mondrian, the complexities of the Franco-Cuban Picabia, or the philosophical architecture of Kupka.

Chronologically, the first to plunge into the new current was the

III-40. Emiliano Di Cavalcanti: Untitled lithograph (1953). One of Di Cavalcanti's favorite themes is the life and lore of the Bahian Negroes, depicted not only in his brilliantly colored canvases, but also in his dynamic sketches, etchings, and lithographs.

III-41. Cândido Portinari: *The Teaching of the Indians* (1941). Mural in the Hall of the Hispanic Foundation of the Library of Congress, Washington, D.C.

veteran Brazilian Alfredo Volpi. In his youth, a stonecutter, carpenter, and house painter, Volpi, since his debut in São Paulo, in 1924, has endlessly renewed his elemental forms, evolving toward outlines of geometric figures on large bland canvases.

There are many other geometric abstractionists in Brazil, encouraged by the Atelier Abstração (Abstract Atelier) that Sanson Flexor has directed in São Paulo since 1957. From the Third São Paulo Biennial, in 1955, a "nationalization" of concepts has been evident in the work of this movement, with architectural values clearly dominant over purely visual. This trend culminates in the architect-painter Firminio Fernandes Saldanha, especially in his mural for the dining room of the Palace of the Planalto (Plateau), in Brasília.

Although Portinari and Di Cavalcanti strove to define the essence of Brazil through figurative descriptions, it emerges as clearly, or more clearly, in Roberto Burle Marx's mixed mediums. Burle Marx, musician, painter, and architect of both buildings and gardens, believes that his landscape work lies wholly within the scope of the arts: "It seems to me that the principles on which I base the structure and arrangement of my gardens are in many respects identical with those at the root of any other means of artistic expression, whether the idiom used

be music, painting, sculpture or the written or spoken word." Burle Marx designs his gardens as if they were abstract paintings, utilizing existing natural elements, different levels, walks, running water or reflecting pools, potpourris of diverse textures, emphasizing the contrasts of color and volume among the plants. Frequently, he supplements his landscape conception with large murals painted or designed by himself, often in ceramic tile (*Ill. III-42*). In recent years, Burle Marx has experimented with three-dimensional values to link the architecture of the building with that of the garden.

Totemic Sculpture

Critics and analysts perversely insist that in contemporary Latin American art, sculpture is the poor stepsister of a family well-endowed qualitatively and quantitatively in painting and architecture.

Of course, problems of market, demand, and available materials have decisively hampered the development of sculpture in the twentieth century. This is proved by the exodus of many Latin American sculptors to Europe or the United States. On the whole, however, Latin American sculpture has won esteem in contemporary art, not only because of the degree to which it has achieved integration with architecture, but also because of individual works.

III-42. Roberto Burle Marx: Tile mural in the garden of the Arnaldo Aizin residence, 1953, Rio de Janeiro.

III-43. Mathias Goeritz: *Towers Without Function* (1957–58). As the name indicates, this structure in the Satellite City, Mexico City, launches a bold attempt at fusion between sculpture and architecture.

For some years, sculpture, as well as painting, reflected the figurative indigenism that hoped to capitalize on the success of the Mexican muralists. But sculpture passed more quickly through the picturesque and imitative stages to the use of so-called totemic forms, which stress geometric shapes with a vertical thrust and approach the architectonic concept of pre-Columbian stone sculpture.

The Europeanizing process encouraged by the academies embraced sculpture as well as painting. In the early decades of this century, the Mexican Ignacio Asúnsolo tried—successfully—to fuse the Hellenic tradition with Maillol's spatial conceptions, within a Mexican repre-

sentational background. Asúnsolo now utilizes his mastery of the tools of the traditional school to delve into the pre-Columbian past.

Pre-Hispanic or Creole themes, as well as a very genuine "popularism," continue to attract a significant number of sculptors in Mexico. The influence of pre-Columbian architectonic concepts is obvious in the work of Germán Cueto. After his apprenticeship in Paris (1926–32), he played with dynamic hoops as supports for masses, "games," he explains, "with which I continue studying possibilities of forms and adaptations of forms." The indigenist outlook pervades the most fruitful period in the career of Luis Ortiz Monasterio, also a Mexican—from the 1920's to the 1940's. His most individual works were polychromed terra cottas that alternated between Picasso-like anatomical displacement and the terminology of an intellectualized popular tradition. Recently, Ortiz has moved into pure abstraction. The course of the Colombian Arenas Betancourt is similar, from his massive bronzes and polychromed terra cottas to his later figurative abstractions.

Excellent terra-cotta pieces were also made in modern Mexico by Geles Cabrera, who seeks a figurative revival rooted in the pre-Hispanic cultures of western Mexico. With maturity, her primary concept has evolved in stone toward a very tender feminine exaltation.

One of the most extraordinary figures in the Mexican art world is Mathias Goeritz—architect, painter, sculptor, critic, poet, and man of action. Born in Danzig, he was influenced in his youth by the heritage of the Brücke movement. In the period between the two World Wars, Jean Arp and Paul Klee became his aesthetic mentors. Since 1949, he has lived in Mexico. There, despite the opposition of "the giants" Siqueiros and Rivera, who accused him of infecting Mexico with dadaist decadence, Goeritz has had an enormous impact as a catalyst, particularly by introducing the young generation to German expressionism. His own work expresses the ideals of purism (*Ill. III-43*).

The artists of Central America and the Caribbean are linked to their Mexican colleagues by obvious similarities in their approach. Francisco Zúñiga, a Costa Rican living in Mexico, carves weighty, monumental statuary. In all his work, the robust figures, with their slanted eyes and aquiline noses, testify to their creator's *indigenismo*.

Georges Liautaud's sculpture belongs to the great period of "primitive" painting in Haiti. By trade an ironworker, Liautaud began by making crude plows and farm implements. When commissioned, he also made crosses for cemeteries, which he delighted in ornamenting with themes from voodoo mythology. Liautaud was "discovered" in

1953, and his career was capped by his success in the Fifth São Paulo Biennial, in 1959. His sculptures, always in metal, possess an incomparable directness that alternates between tragedy and humor. Valentim, a modest bricklayer; Jasmin Joseph, a self-taught ceramicist; and Odilon Duperier, a carpenter with basic plastic ideas, represent much the same values in primitive Haitian sculpture. In André Dimanche, the Christian-voodoo synthesis is achieved in a very disciplined fashion.

The favorite pupil of the French sculptor Antoine Bourdelle, Juan José Sicre ensconced himself in the Academy of San Alejandro, upon his return to Havana. From this lofty post, he preached the importance of technical mastery, which dominated Cuban sculpture until a school of rebels crystallized to form the Grupo de los Once (The Eleven). A leading member of this group (which was active from 1953 to 1956) was Roberto Estopiñán, who freed himself of academicism to employ massive iron forms bristling with spiny protuberances. His abstractions veer between protozoan creatures and fantastic predatory animals.

After its mounting recognition within the nation and beyond, Venezuelan painting took various courses. Sculpture, however, was centered until the 1940's in the person of Francisco Narváez, who had guided the School of Visual Arts since 1935. But when Carlos Raúl Villanueva commissioned works for the University City in Caracas—by Jean Arp, Antoine Pevsner, Alexander Calder, Henri Laurens, and Balthazar Lobo (*see Ill. III-60*)—Venezuela's sculptors eagerly followed their lead and found their own paths. Narváez, too, was evolving. His bronze for the University Library marked a definitive step toward abandonment of the figurative, a development that soon culminated in simple, pure forms, worked in rare woods. About 1960, the English sculptor Kenneth Armitage settled in Caracas, and thanks to his teaching and counsel, a group of young sculptors have produced remarkable works there.

The case of Edgar Negret is a typical example of how talent can triumph over a hostile environment. First his rebellion took the form of subjective reactions to the problems that were convulsing his native Colombia around 1945. Then he began to search for a theme that would reflect the contemporary world in the aesthetic of the machine and in the abstract geometry of scientific invention—all this seasoned with an aura of timelessness or of distant times. Like Roberto Matta, like Tamayo, Negret has found a personal style. He constantly returns to the revitalizing interplay of geometrical figures that represent or suggest wheels, levers, screws, nuts, coils, and curved plates. The

harmony of his work is reinforced by a color scheme that is generally limited to red, blue, and black. His esoterically interlaced tubes imply the absolute indifference and inadequacy of the mechanistic soul (*Ill. III-44*). What is surprising is that his censure (or celebration) of tubes and plates conveys, by some magic, a poetic vision.

Today a new generation of Colombians, many concerned to translate orthodox ideas of angels and animals into pure abstractions, has already thrust far beyond Negret and his demons. In Peru, however, he has a kindred spirit; this is Joaquín Roca Rey, who like Negret found a personal style. Peru did not experience the indigenist crisis in sculpture, either because of a lack of important sculptors or because Roca Rey, from his youth, directed his talents toward international movements, stimulated particularly by Henry Moore's experiments in space, volume, and dynamism. The project he submitted to the international competition for the monument of *The Unknown Political Prisoner* today forms part of the frieze of the memorial erected in Panama City, in 1956, in honor of José Antonio Remón Cantera, the Panamanian President assassinated the year before (*Ill. III-45*). Another of Roca Rey's great works poises airborne figures on the portico of the Cemetery of the Angel in Lima. In addition, one cannot underestimate his seminal influence as a teacher of Fine Arts in Peru.

The values amassed by Latin American plastic art over untold centuries are revived in the work of Marina Núñez del Prado. From her first efforts, she has focused on the otherworldly qualities symbol-

III-44. Edgar Negret: *Equinoctial Storm* (1959). In his mature style, Negret employs elements from the industrial world, inventing original, and dehumanized, machines.

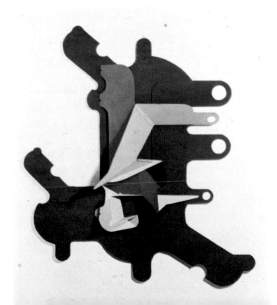

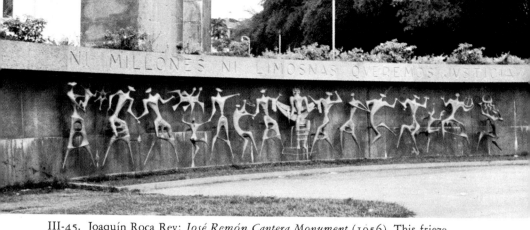

III-45. Joaquín Roca Rey: *José Remón Cantera Monument* (1956). This frieze in Panama City is truly choreographed of human symbols. Roca Rey injected the real world into his procession by means of the legend carved around the top: "We want not millions, not alms, but justice."

ized by the soul and landscape of Bolivia. When she was awarded the Grand International Prize in the Second Biennial in Mexico (1960), Marina had thirty years of uninterrupted self-expression behind her. If her first steps were oriented, predictably, toward a stark realism (notably, *My Mother,* in onyx), from 1934 on, her great yearning was to plumb the hermetic spirit of the Altiplano and capture it in her sculpture. To create *Guacatocoris* and *Condors,* she studied popular music and dance, as Villa-Lobos had done in the Amazon. From music,

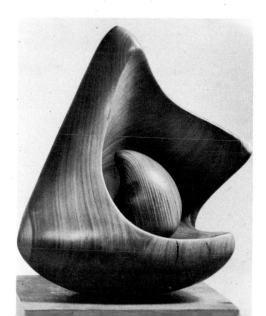

III-46. Marina Núñez del Prado: *Lap* (1943). Marina Núñez' sculpture blends dramatic tension expressive of the strength of the Bolivian countryside and of feminine tenderness.

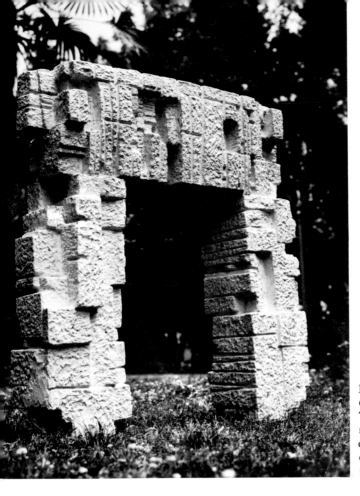

III-47. Marta Colvin: *Gate of the Sun* (1964). This is a deliberate reminiscence of the structural concept of the Tiahuanaco culture of ancient Bolivia (*see Ill. 1-63*).

she moved to social concerns (*The Miners*), and from this, to her enveloping and rugged studies of maternity, evolving from representation to a reduction to essentials (*Ill. III-46*).

Emiliano Luján Sandoval, traveling very different roads, has reached the other summit of contemporary Bolivian art. Predisposed to monumental works, Luján has been responsible for most of his country's modern statuary. His recent monument *The Sacred Heart,* in Santa Cruz, is about 65 feet high. His expressive force refines out any elements of conventionality or sentimentality the commission may entail and then enables form and content to explode boldly.

Paraguayan sculpture is still struggling to free itself from the *indigenismo* skillfully practiced by Julián de la Herrería and José L. Parodi. In time, Parodi, in collaboration with Josefina Pla, moved

toward rhythmic abstraction, already evident in his prize-winning work in the Fourth São Paulo Biennial, in 1957.

In Chile, the school of Nicanor Plaza dominated sculpture until well into the twentieth century. Its conservatism, resting on imitation of the human form, was perpetuated by Tótila Albert and the Chilean disciples of Bourdelle—José Perotti, Lorenzo Domínguez, and Julio Antonio Vázquez. After his trip to Germany in 1938, Samuel Román broke this pattern, and Chilean sculpture began to display its extraordinary richness and vitality. Román unabashedly created monumental statuary, and probably even more decisive, he restored craftsmanship to sculpture through the establishment in 1949 of the Stonecutters' School—the only institution of its kind in Latin America.

Its curious and willful displacements make it apparent that Chilean sculpture, especially the work produced by women, reasserts the structural values of pre-Columbian cultures. This is not so paradoxical as it may at first seem, although in Chile, as in Uruguay, there was no pre-Columbian cultural tradition. For Torres García's constructivism to derive from such a tradition, an act of the intellect was required. Something very similar occurred in Chile, where a pancontinental outlook stimulated the search for pre-Hispanic essences.

When Marta Colvin won the International Sculpture Award at the Eighth São Paulo Biennial, in 1965, it was clear that Chilean sculpture had found its Andean roots. Marta Colvin introduced nonfigurative sculpture in Chile with her monument for the tomb of the dancer Isabel Glatzel. In Paris, she rediscovered her America and, from then on, expressed it in essential structures that at times recall the features of the Gate of the Sun, in Trahuanaco (*Ill. III-47*).

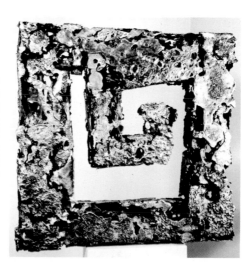

III-48. Lily Garáfulic: *Sign I* (1966). In her movement toward abstract concepts, Lily Garáfulic discovers an unlimited world of new forms dominated by the texture and quality of the materials employed.

Lily Garáfulic's work radiates an intrinsic force that heightens the spatial values proper to sculpture and increases its monumentality. In evolving from figurative realism to abstraction, she has increased the expressive qualities of her materials, exploiting their natural accidental or phenomenal features (*Ill. III-48*), notably in her recent wooden pillars, which are combined with imaginative metal forms.

From the beginning of the century, monumental statuary flourished in Argentina because of the economic boom and the desire for nationalistic assertion. The International Exposition in Buenos Aires, in 1910, coincided with the coming of age of a generation of sculptors who were demonstrating independence of traditional academicism. It is the epoch of commemorative monuments, chiefly the work of José Fioravanti and Alfredo Bigatti, that today give Buenos Aires its style. The apostle of modern sculpture was Antonio Sibellino, an artist whose liberated imagination and rigorous standards of execution led him to break new trails. Sibellino's *Composition of Forms* (1926) has the honor of being the first abstract sculpture created on the South American continent.

However, the ramifications of this liberation were most profoundly seen in the personality and work of Pablo Curatella Manes, who, despite a full career as a diplomat, never abandoned his devotion to sculpture. In his first cubist works, the inspiration of Lipchitz was obvious. But from the time of his *Acrobats,* in 1926, he freed himself of external influences in order to pursue the search for a dynamic expression. Nevertheless, he is racked by a persistent dualism: his "heavy" sculpture remains figurative, while his "airy" sculpture veers toward abstraction (*see Ill. III-65*).

The Argentine version of the search for American roots is exemplified by Sosostris Vitullo. From his first days in Paris, Vitullo was enraptured by Rodin and Bourdelle. Finally, he found his own voice in an intellectualized evocation of his nostalgia for his homeland, which he expressed first in historical works, such as the *Monument to Martín Fierro* (1940–45), and, later, in the interaction of abstract forms in which severely vertical or horizontal planes predominate.

Political tension was basic to the development of Noemí Gerstein, who poured her revulsion against the Perón dictatorship into her project for the monument to *The Unknown Political Prisoner,* which won an award and was exhibited in the Tate Gallery, in London, in 1953. Later, in bronze, iron, and silver, she has created abstractions purged of all descriptive intent until she has arrived at totally hermetic symbols. Libero Badii, born in Italy, also works in a world of abstract

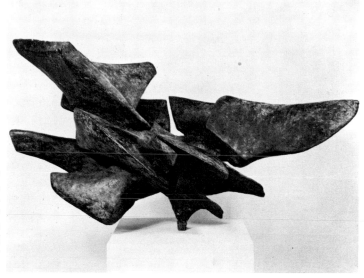

III-49. Alicia Penalba: *Chrysalide* (1961). Alicia Penalba alternates between her search for totemic American forms and abstractions of flowers and plants.

forms, although there are allusions to his experiences in Ecuador, Bolivia, and Peru. Devoted first to constructivism, centering on a symbolic theme of dance, Badii became fascinated with maternal desire and especially the fecundity of the mother. This has swept him, too, toward intellectual abstraction based on fundamental geometric forms.

Some years before her colleagues in Chile, Alicia Penalba explored Latin America's heritage through forms that have come to be called totemic (*Ill. III-49*). This road enabled her to find personal expression in rendering flowers and plants governed by architectonic concepts. Her sculpture groups for children's playgrounds are conceived to delight children with hiding places accessible only through complicated grottoes and labyrinths with varied shapes.

Monumental urban sculpture in contemporary Uruguay is largely the work of Bernabé Michelena, the counterpart on the east bank of the Río de la Plata of Fioravanti and Bigatti. Michelena's expressive independence reflected the extension to sculpture of Torres García's constructive universalism. Germán Cabrera represents the first step in the transition to a modern language, but Eduardo Díaz Yepes, pursuing symbolic abstraction in plants and shellfish, taught Uruguayan sculpture an international language. A political prisoner in 1939, at

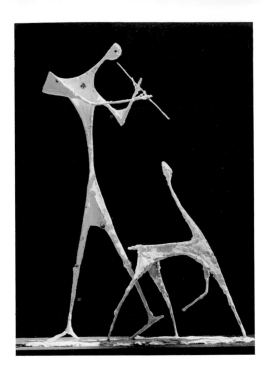

III-50. Bruno Giorgi: *Pastoral* (1959). Essentially a figurative sculptor, Giorgi evolved from thematically independent works to integration of sculpture and architecture.

the end of the Spanish Civil War, Díaz took refuge in Montevideo (and married a daughter of Torres García). His monument in the Ibirapuéra Park in São Paulo is one of his explorations in the world of abstract forms; others cover a vast gamut of experiences, from cubism and expressionism to forms free of any schools or traditions.

We have already seen the impact on Brazilian painting generated by the Semana de Arte Moderna in São Paulo. In sculpture, the assault on conventionality was spearheaded by Vítor Brecheret. In 1922, he had just returned from Paris, captivated by the inventiveness of Mestrovic, which would stamp all his work despite his efforts to purge himself of this influence in favor of abstraction. Of the several distinct approaches Brecheret attempted, historically his most enduring work belongs to the "Pau-Brasil" movement. At this time, he executed primitive carvings and linear compositions drawn from an indigenous art antedating the Conquest. Bruno Giorgi conceives much of his sculpture as an integral element in the thinking of his country's architects, from his *Monument to Youth,* in the garden of the Ministry of Education and Public Health, in Rio de Janeiro, to his *Warriors,* in the Square of the Three Powers, in Brasília. His figurative stylizations are determined by the dominance of composition as an independent value (*Ill.*

264

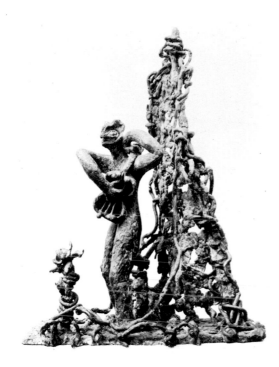

III-51. Maria Martins: *Boto* (1960). The guitar player, a popular figure in the Brazilian countryside, is portrayed here against a backdrop of twisted, luxuriant jungle foliage.

III-50), an attitude shared by Alfred Ceschiatti, who likewise participates in the new architecture—in Ceschiatti's case by adapting figurative forms to architectonic ideas. His *Bronze,* which presides over the main entrance to the Palace of the Alvorada (Dawn), in Brasília, as well as the thoroughly conventional figures in the War Memorial, in Rio de Janeiro, show his skill as a sculptor decorator. His monolithic group for the War Memorial is painfully overshadowed by Julio Catelli Filho's airy abstraction for the same site—a breezy, graceful allusion to a metallic bird.

Another Brazilian who often works within an architectural setting is Maria Martins, creator of the well-known bronze statue facing the rear façade of the Palace of the Alvorada. Maria Martins pours all her vast visual experience into a baroque exuberance with a Brazilian root. The dark sensuality of tropical vegetation dictates the angles and curves of her finely structured pieces (*Ill. III-51*).

Apart from its archaeological revivals and pastiches, Latin American sculpture, like painting, shows the effects of the long search for genuine American roots. This is the source of its markedly architectonic character, apparent even in extremely subjective abstractions. And it also underlies the prevailing emphasis on geometric, especially cubic, forms.

19

The New Architecture

A variety of historical, aesthetic, social, and even political factors have contributed to shaping Latin American architecture along distinctive, often individualistic, lines. Among the historical factors is the deep-rooted and powerful tradition that has served to nourish the process of national self-affirmation, in a struggle against the imposition of ideas, styles, and forms from Europe and, recently, from the United States. Actually, when the Mexicans, Brazilians, and Peruvians felt impelled to work in the idiom of contemporary architecture, they each drew on their own past. The Mexicans had recourse to their pre-Columbian and post-Columbian epochs; the Brazilians to their baroque tradition, and the Peruvians to their Andalusian colonial style.

Social and political factors have also helped to crystallize Latin America's particular style. Much more than the banks, it has been the governments, as sources of state funds, that have given the main impetus to architecture. As a result, there is a tendency to consider the architect a public servant, who is expected to erect public buildings according to aesthetic and nationalistic criteria. However, since 1930, architecture for private dwellings has expanded greatly. In Latin America, perhaps more than anywhere else, architecture has recovered the leading place among the fine arts that it occupied from antiquity to the nineteenth century, when catalepsy overtook its practitioners.

Latin America's architecture, like its other forms of artistic expression, oscillates between an international stance, functional and efficient, and its own stance, national and audacious to the point of extravagance. It will, therefore, be important to observe the dividing line between these two stances in appraising what has been achieved from the 1930's to the present, with the university cities in Mexico City and Caracas virtually completed, the basic nucleus of Brasília planned and constructed, as well as more recent buildings, such as the Bank of London building, in Buenos Aires, and the U.N. Building, in Santiago, Chile.

There is little value in analyzing here the international orientation of Latin American architects. A sizable number have been trained in outstanding U.S. schools and, consequently, have substantial spiritual and formal links with Harvard, Yale, the Illinois Institute of Technology, MIT, Cornell, and Columbia. Nevertheless, one should not be surprised that Frank Lloyd Wright has little appeal for Latin Americans, although they share his passion for the curve (or, perhaps, that is precisely why Wright is neglected). Whatever the reason, the only tie with Wright is in the Uruguayan-Argentinian work in the resort of Punta Ballenas, in Uruguay, and the Peruvian work of the Agrupación Espacio (Space Group), formed in 1947.

Perhaps in compensation for this extensive North American influence, many Latin American architects enthusiastically espoused Le Corbusier, and some even worked directly with him.

In the new Latin American architecture, all that glitters is not gold, especially in comparison with the amazingly durable pre-Columbian and colonial work. Because of lack of foresight, poor-quality materials, or, what is most likely, chronic lack of funds, maintenance of buildings is rarely considered an essential operation. Three or four years after they have been finished, handsome structures begin to show a lamentable degree of deterioration. In this respect, a far from unusual example is Pampulha, a beautiful recreation section in Belo Horizonte, capital of the Brazilian state of Minas Gerais. Here, Oscar Niemeyer erected several buildings, among them the Church of São Francisco (see Ill. III-67). An artificial lake was constructed, which was supposed to be ringed with yacht clubs, restaurants, and other pleasure spots that the lakesite could offer. The damming systems failed, the lake became dry, and the buildings fell into ruin, largely for lack of repairs. In Chile, earthquakes boost the cost of foundations and structures to such an extent that there is seldom any money left in the budget to be spent on a long-wearing surfacing material, much less to preserve the building. Glass or ceramic tile (the latter a providential solution in Brazil) is seldom used, because of its cost, but stucco becomes dripping wet, the cheap paint becomes discolored in a couple of years, and chronic inflation speedily makes havoc of estimates for maintenance, if there are any.

One of the most outstanding features of Latin American architecture is a tendency that has been evident for about ten years: what we would call an obsession with integrating, the harmonious fusion of the visual arts (murals, sculptures, decorated ceramic tiles) with the spatial qualities of architecture. Another characteristic that is almost

equally distinctive is the development, especially in Brazil, of a visual ideology that led to the passion for sculptural architecture.

Consequently, anyone who confines his appraisal of Latin American architecture to its spatial quality would find little to admire. In keeping with a tradition solidly sustained during the pre-Columbian and colonial periods, the distinctive values of Latin American architecture, and those that have given it stature, are not essentially spatial, but formal and structural.

Mexico

In the last half-century, Mexican architecture, like Mexican painting, has been riddled by an antagonism of styles, concepts, and forms that brilliantly synthesize the country's vitality. But there is frequently an element of paradox in the conflict. The men of the Revolution have created a reactionary architecture, because they insist on a nationalistic style literally derived from the structures of the past. In the intellectual and political expression of their nationalism, they may return to pre-Hispanic or even to colonial models—the latter being a survival in itself or a reaction to the Francophilism of the *porfiriato* (the era of President Porfirio Díaz, 1876–1911).

In order to understand this phenomenon, it is essential to consider a fundamental characteristic of Mexican art and architecture that derives from its vitality: once a style has developed, reached its peak, and declined, the cycle is finished. This is especially true of "neocolonialism," "neo-Toltecism," and the obsession with integrating architecture, sculpture, and painting. No one in Mexico today—except those in the tourist industry and the "official" group—is any longer interested in perpetuating such styles.

The rebellion against French domination during the *porfiriato* was brewing well before the end of the nineteenth century. In 1889, the two proposed plans for the Mexican pavilion at the Paris Exposition were indigenist, with pre-Columbian *taluds,* frets, and niches; in the niches, however, neoclassic sculptures were to be installed. Neocolonialism, harking back to the architecture of the eighteenth century, soon degenerated into the "California" (or "Spanish") style, with deplorable results in all the Americas; along with it developed a "neoplateresque" style and, later, a "picturesque," based not on the great religious architecture but on the traditional provincial house.

Through the efforts of José Villagrán García, through his buildings

themselves, his wide influence as a professor, and his recruiting of promising followers, a leading group of Mexican architects adopted the International Style (*Ill. III-52*). With typically Mexican extremism, Villagrán (a professor since 1925) and his disciples—especially Juan Legarreta, Juan O'Gorman, Enrique de la Mora, and Enrique Yáñez— launched a revolt against the pastiches and various "neos" by seizing upon the most dehumanized of Le Corbusier's theories in *Towards a New Architecture.*

The opposition to their stark purism was strong. Arrayed against it was not only the traditional dominance of the baroque, but Mexican official architecture, ,which believed that the means to express the national soul was the integration of the visual and spatial arts. Officialdom was victorious for a long period. Among its products is the University City in the capital, today a tourist attraction and, unquestionably, now past history as architecture. Here aesthetic integration could have free rein, for the enormous walls of the new buildings provided the artists with an ample setting for their "socialist realism."

Three elements indicating the durability of the baroque in Latin American art played a fundamental role in the university's vast plant: the integration among the arts; the obsession with ornamentation; and the generous allotment of open spaces. The university complex in Mexico City was erected at tremendous speed, for it symbolized an extreme access of nationalism. Starting in 1950, its prime—and much-criticized—mover, Carlos Lazo, Jr., mobilized this fever to build one of the most unusual projects in the annals of contemporary architec-

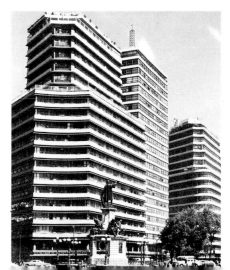

III-52. Ministry of Hydraulic Resources, Mexico City (1950). Mario Pani and Enrique del Moral planned this building on the Paseo de la Reforma for business offices. In opposition to the "Toltecism" of the Mexican architecture of this period, their approach was an adaptation of the International Style not yet widely accepted in Mexico.

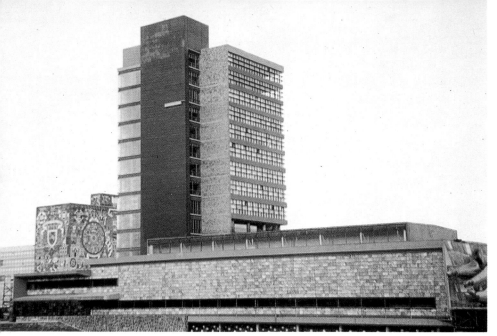

III-53. Central Administration Building, University City, Mexico City (1952–53). At the right of the horizontal section, with its three floors, can be seen part of a three-dimensional mural by Siqueiros. The tower, twelve stories high, is devoted to offices. At the rear, to the left, is the Central Library.

ture. More than 150 young architects, engineers, and technicians, employing an over-all plan drafted by Mario Pani and Enrique del Moral, completed the basic portion of the University City in the incredibly short span of three years.

There are three major groups within the general plan: (1) buildings for instruction and research; (2) recreation and sports areas (the stadium was placed elsewhere so it might also accommodate nonuniversity matches, as it did in the 1968 Olympics); and (3) a residential area, not yet in being.

The axis of the complex is the towering Central Administration Building *(Ill. III-53)*, in which Pani, Del Moral, and Salvador Ortega Flores achieved a harmonic equilibrium of horizontal and vertical masses. On one façade, a projecting panel bears a geometric mural by David Alfaro Siqueiros, which contrasts with another, plastically sculptured, mural also by Siqueiros. The artist conceived the latter so that it could be contemplated from the roadway in an automobile going 60 miles an hour, and perhaps its aerodynamic intent justifies its ugliness.

The Central Library (*Ill. III-54*), by the architects Juan O'Gorman, Gustavo Saavedra, and Juan Martínez de Velasco, masks its rectangular structure under four immense mosaic murals by O'Gorman in polychrome stone, masonry, and onyx. The lower walls that surround a patio-garden are covered with high reliefs, likewise designed by O'Gorman with pre-Hispanic motifs. Together with the Library and the Administration Building, the Humanities Building forms something of a plastic unit. Behind a gigantic horizontal façade extending nearly 1,000 feet, the building houses the departments of philosophy, law, and economics.

To the east of this first group, the buildings for the medical and biological sciences compose a more harmonious and more functional unit. The west façade clearly expresses a plastic intent that is emphasized by black facings on the horizontal wall, which stands on *pilotis* (supporting pillars). To its left, the theme is extended by the mosaic mural by Francisco Eppens.

Both the School of Chemistry and the Geological Institute are composed primarily of cubic forms on *pilotis,* which contrast with the graceful curves of the Pavilion for Cosmic-Ray Research (1951), designed by Jorge González Reyna and built by Félix Candela.

III-54. Central Library, University City, Mexico City (1952–53). The most original structure in the university complex, this building has mosaic murals by Juan O'Gorman on its four sides, each executed in colored stones from the various regions of Mexico. On the first floor, a mural in volcanic stone with reliefs demonstrates Aztec inspiration.

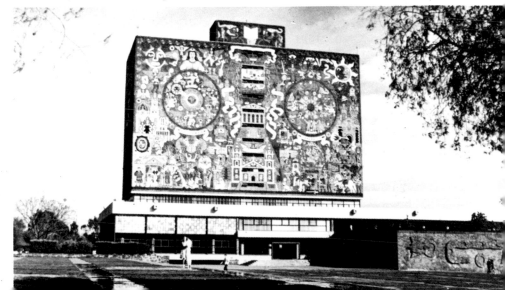

In the School of Engineering, functional problems of lighting—both screening and admitting it—were solved by the use of glass tiles to form hemispherical domes.

Despite the contrasts arising from the free rein permitted each of its architects—José Villagrán García, Alfonso Liceaga, and Xavier García Lascuraín—the School of Architecture and Museum of Art has a striking clarity of design and lack of adornment.

"Toltecism," the heaviness that pervaded much pre-Columbian architecture, is apparent throughout the University City, not only in some of the buildings, but also in the ornamentation and murals (including the polychrome stone relief by Diego Rivera for the Olympic Stadium). It is most extreme, however, in the *frontones* (courts for games), designed by Alberto T. Arai, in the form of truncated pre-Cortesian pyramids.

In spite of the critical controversy the University City aroused, and the fact that it represents a closed cycle in style, the complex as a whole must be considered a genuine monument in the history of Latin American architecture.

There is no point in extending the preceding enumeration to include the recent buildings for offices and government departments and public services that give the tone of a great city to Mexico City today and are reflected in the lesser cities of the country. Outside of the University City, Mexican architecture has proved that it has learned some lessons from that great training ground. And with prosperity, building—for private, industrial, and public purposes—has boomed. It is most notable today for a number of maverick figures.

The case of Juan O'Gorman represents this attitude. The tenacious partisan of a stark functionalism during the heroic epoch of the 1930's, he turned to an extremely elaborate Maya and Mexican baroque style for his own home (1956) in the Pedregal Gardens, an area between the university and Mexico City proper containing luxurious and avant-garde homes.

The most recent examples of Mexican architecture follow two quite different roads. On the one hand, there is the harmony between form and function, obvious in the new museum buildings in Chapúltepec Park, designed by Pedro Ramírez Vázquez. This intent is only moderately successful in the Museum of Anthropology, where the enormous sunshade nearly covering the patio threatens to collapse of its own weight. In the nearby pair of buildings constituting the Gallery and Museum of Modern Art (*Ill. III-55*), done in cooperation with Rafael Mijares, Ramírez has used the International Style to great effect.

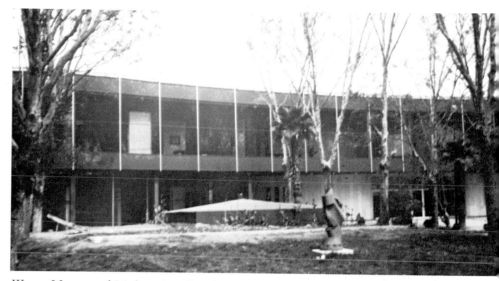

III-55. Museum of Modern Art, Chapúltepec Park, Mexico City (1964). The curvilinear plan facilitates the play of natural light admitted through the unbroken window expanses that make up the façades.

On the other hand, there is the crystallization of a particular form —Félix Candela's hyperbolic paraboloids. Candela's personality faithfully mirrors his work, his attitude toward contemporary architecture, and the importance of his achievements. He does not claim to have invented or discovered anything, except the fallacy of the supposed infallibility of science, and the inexactness of mathematics for architectural calculus. His concept of space in architecture derives from the absolute dominance of a structural form that he has brought to its fullest expression—the *cascarón,* or shell—and that has brought him deserved and universal fame.

Candela is Spanish in training and spirit, but he left the Iberian Peninsula at the end of the Civil War and has never returned, even for a visit. He has become a Mexican by voluntarily involving himself in the country's great awakening, and he has been favored by external conditions (despite some local opposition) that made his work possible.

Some critics have tried to relate Candela's aesthetic conception to the effects, in design, of Gaudí, and in technical aspects, of Eduardo Torroja, a Madrid-born architect, who was one of the great formal innovators of this century. There have also been attempts to associate his delight in curving forms and in the spatial integration of mass and

273

spectator with the prevailing baroque feeling in both Spain and Latin America. If such influences and attitudes play a role in Candela's outlook, they must operate in an unusual way. For in addition to being an architect, Candela is an engineer and a master of the slide rule. His point of departure is a detached, economic, and functional position. For him, the prime necessity is to construct shells that are cheap, useful, and adapted to Mexican conditions; that means avoiding expensive steel structures and utilizing the abundant supply of excellent, low-paid craftsmen.

His most recent works, in addition to the plans for different kinds of "umbrellas" in warehouses and markets, include the churches of Santa Mónica, in the Satellite City (*Ill. III-56*), and of the Miraculous Virgin. Here, the architectural design is Candela's own. In others, generally more spectacular in form, he has acted as builder for the

III-56. Lantern of the Church of Santa Mónica, Mexico City (1966). In this building, which he both designed and built, Félix Candela employs hyperbolic paraboloids on two different planes, with their proportions modulated in keeping with the suspension and the crest.

architects, most often Enrique de la Mora and Fernando López Carmona. His work on the Sports Palace, built for the 1968 Olympics in Mexico City, illustrates his grasp of varied outlooks. In his spatial concepts, he outstrips Nervi at his most audacious, and in the Sports Palace, he departs from the parabolic shells that stamped much of his earlier work, and uses reinforced concrete and supports to achieve a light and airy feeling.

Candela prefers to build religious and industrial structures. But whatever the purpose of a project, he always seeks the simplest solution. During an interview, he said: "What is happening today is that painting is created for painters, music for musicians, and architecture for architects, and no one thinks of the people."

Central America and the Caribbean

Recent architecture in Central America, the Antilles, and Colombia shows the clear imprint of U.S. design approaches and construction techniques. In general, the hotels follow the pattern of standardized U.S. hotels, but some public buildings, especially in Cuba, display the contributions of influential native architects, particularly in the adaptations to deal with strong sunlight.

Although much less daring, and certainly smaller than the university cities of Mexico City and Caracas, Panama City's university complex is well integrated into its urban setting. In the building that houses the School of Administration and Commerce (1949–53), designed by Guillermo de Roux, René Brenes, and Ricardo Bermúdez, elements of the "Brazilian style" (see p. 292) have been adopted with intelligence: the tiles, the rational and tasteful arrangement of the *brise-soleil* (sun screen), and the plastic interruptions of the planes throughout.

In the Civic Center in Guatemala City, especially in the Municipal and Social Security buildings (the former the work of Roberto Aycinena and Pelayo Llarena and the latter designed by Aycinena with Jorge Montes), integration has been achieved with the mural by Mérida and the sculptures by Dagoberto Vásquez, Guillermo Grajeda, and Roberto González Goyri (*Ill. III-57*).

Between 1952 and 1954, the Tribunal de Cuentas was built in Havana. It is one of the most felicitous structures in Latin American architecture after the Ministry of Education Building in Rio, to which incidentally, it has many similarities. Its designer, Aquiles Capablanca y Graupera, employed *pilotis* and other elements derived from Le Corbusier. The varied texture of the stone forms an especially inviting

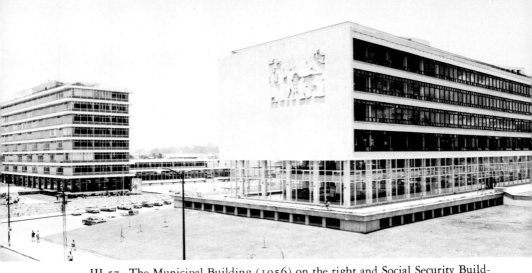

III-57. The Municipal Building (1956) on the right and Social Security Build-
ing (1958) in Guatemala City. Both buildings show the prevailing trend in the
1950's toward integration of art and architecture. The relief mural on the
Municipal Building is by Dagoberto Vásquez.

setting for the exterior mural by Amelia Peláez. In the Tropicana
night club, Harvard-trained Max Borges displayed stunning orig-
inality by incorporating the shell structure with tropical vegetation,
made even more exotic by sculptures by the architect himself.

The high quality of construction that gives U.S. architecture its tone
is also evident in Colombian architecture, which has close links to
that of the United States. In Cartagena, the Caribbean port heavily
fortified by the Spanish in the sixteenth century, Mesa Gabriel Solano,
Jorge Gaitán Cortés, Alvaro Ortega, and Edgar Burbano designed a
baseball stadium (1947) that has won general acclaim.

The Bank of Bogotá (1959), designed by Pablo Lanzetta and
Reinaldo Valencia, with Skidmore, Owings & Merrill as consultants,
follows the Chicago functional concept (*Ill. III-58*), with some integra-
tion of the plastic arts, such as the murals by Eduardo Ramírez in the
interior. The late Juvenal Moya Cadena retained a stylized neo-
Gothic line in his Chapel for the Modern Gymnasium, in Bogotá. The
spatial effect in the interior is more interesting than the sober symmetry
of the exterior. In the Luis Angel Arango Library, in Bogotá (1959),
Rafael Esguerra, Alvaro Sáenz, Rafael Urdaneta, and Daniel Suárez
imaginatively resolved spatial and functional problems, giving the
building's interiors warmth throughout.

Venezuela

The unmistakable hallmarks of a Mexican style or of a Brazilian style are eloquent enough in themselves. The same is not true of architecture in Venezuela, in spite of certain constants that have survived from colonial times and others that have proliferated simultaneously with the economic boom. These are the most noteworthy features: (1) the use of bright colors in the Art Nouveau hues that are currently fashionable in feminine apparel (pale rose, lemon yellow, fuchsia, emerald green); these colors frequently adorn façades, walls, and patios of private homes in the region bordering on the Caribbean and are used very widely in Venezuela; (2) the louver or jalousie, made of cement in our times, much more primitive and heavier than the wooden version of Lima, based on Andalusian antecedents, but similarly open to air currents; (3) the dark-brown roof common in all Spanish-American architecture from colonial times; (4) enclosed gardens with vegetation of staggering color, size, and profusion.

Some of these traditional characteristics (especially the color, the louvers, and a kind of weightiness and solidity) were adapted to the new Venezuelan architecture by its colossus, Carlos Raúl Villanueva. Born in London in 1900, he studied at the Ecole des Beaux-Arts in Paris and graduated in 1928. He returned to Caracas the same year and has remained there ever since, devoting himself systematically to

III-58. Bank of Bogotá (1959). This building, in the tradition of Skidmore, Owings & Merrill's Lever House in New York, is characterized by clean design and fine finishing details. But the volume and importance of the horizontal base is emphasized. Colombia.

creating an architectural school, supervising its instruction, and contributing to the solution of the vast urban and social problems that have been rendered especially critical in Venezuela because of the massive influx of foreigners and peasants to the cities, principally Caracas, in consequence of the oil boom.

In contemporary Venezuelan architecture, adaptations of traditional elements are less important than the characteristic traits of Villanueva's own design, notably: the need to articulate the plastic values of the structure, in accord with the ideas of Auguste Perret. It was Perret who, in the first decade of the twentieth century, pioneered in the use of reinforced concrete not only for its functional value, but also as a decorative element, although he subordinated it to a classical framework. This is the reason for Villanueva's ponderous masses. His work always has a heavy strength, very different from Oscar Niemeyer's sculptural and graceful digressions in Brazil or the lightness of Candela's shells. In Venezuela, cement is employed with abandon. Perhaps that is why Villanueva is obsessed with providing a violent dynamism in the structural contours by the use of unsurfaced concrete.

Among the various attributes of Villanueva's many-sided personality, the most prominent is his ability to conceive urban and other architectural complexes. As in Mexico and Brazil, the public coffers in oil-rich Venezuela were put at the service of city planning, of the latest architecture, and of the integration of visual and spatial components. In Brazil and Mexico, however, the possible excesses (and they were possible) were checked by a democratic official posture, as a result of which the advice of painters, poets, thinkers, and even musicians was sought and obtained. In Venezuela, on the other hand, the beginning of the economic boom, and the attendant construction boom, occurred during the period of dictatorships, frequently guided by whim and by the taste of military men. This explains the incredible projects, such as the useless beehive of the uncompleted Roca Tarpeya, a chaotic mixture of shops and public facilities, or the aesthetic horrors, such as the medical buildings in the University City.

As chief architect and adviser of the Workers' Bank of Venezuela, Villanueva planned and supervised construction of a low-cost housing project, El Silencio, in an unsavory section in the heart of Caracas. Completed between 1941 and 1943, El Silencio was the first urban development to be built in Latin America on such a large scale. Between 1952 and 1954, he directed the El Paraíso project, and between 1955 and 1957, the Twenty-third of January project. It is impossible here to analyze Villanueva's ideas on city planning, but some of his views

will become clear as we examine his crowning achievement—and the most important work in contemporary Venezuelan architecture—the University City in Caracas.

In this complex, Villanueva's genius for urban planning merges with his aesthetic preoccupation—his vision of integrating the visual and spatial arts, in two and three dimensions—and with his desire to make the most vigorous possible exercise of the dynamic concept by employing "floating" structures. His daring use of "floating" concepts almost reaches bravado in the university's Olympic Stadium (1950) and Olympic Swimming Pool (1957). In the stadium, the cantilever span of the grandstand rises gracefully and, with the planes of the seats, forms a huge, elegant V. Twenty-four elements of reinforced concrete, shaped like open pincers, support the cement shells of the roof, 2⅓ inches thick (much thicker than Candela's shells). Despite the fact that the stadium holds only 30,000 spectators, and is thus wholly inadequate for Caracas' mushrooming population, it is redeemed by the airy silhouette of the audacious canopy.

Presumably, Villanueva intended to contrast the airborne freedom of the stadium with the weighty massiveness of the Olympic Pool. The pool was obviously designed as an aquatic symbol, with floating structures that give it the form of a ship. The most ingenious and original element is the prow, whose curved ascending shape is a counterpoint to the louvers and, by contrast, emphasizes the inclination of the rows of seats (*Ill. III-59*).

As in Mexico's university and Brasília, Villanueva's over-all plan

III-59. Prow of the Olympic Pool, University City, Caracas (1957). Carlos Raúl Villanueva gave the stadium the shape of a ship, in which the prow relieves the weight of the whole by means of steplike ascents. Venezuela.

radiates from a central core. But unlike them, the Caracas center came into being a posteriori. The Covered Plaza, the Aula Magna (Large Assembly Hall), and the Library, which constitute the core in Caracas, were built after the equidistant extremes—the medical complex and the sports areas.

The unit consisting of the Aula Magna and the Covered Plaza is Villanueva's most famous work. The plaza serves as a center for all the buildings and is the point where all the circulation roads intersect. Both the plaza and the roads are covered to shield pedestrians from the scorching sun and the driving rains of the tropics. Although the canopies have an ideological unity, their designs are varied.

Seen as a whole from the outside, at the main entrance, the Aula Magna typifies Villanueva's characteristic functionalism in the use of concrete as a volumetric element. The access canopy underlines the heaviness of the design, and the beams that link the transverse walls enhance the building's aspect of utilitarian sobriety. On the other hand, the structural solutions of the roof recall the grace of the canopy of the Olympic Stadium.

Unquestionably, the exterior of the Aula Magna is one of its greatest beauties because of the balance between the inclination of the amphitheater's planes and the radial lines that fan out to define the segments of its roof. In the interior is the crowning achievement: the ceiling covered with stabiles by Alexander Calder, painted in vivid colors— red-orange, green, ocher, yellow. These "flying saucers" have a function beyond the aesthetic; they regulate the acoustics to virtual perfection. Calder himself expressed his enthusiasm about the Aula Magna: "None of my mobiles has met with a more extraordinary environment —more effective or more grandiose. This is a major monument of my art."

Villanueva found that the University City could happily accommodate his obsession with integrating the visual arts and architecture. In keeping with the identification between architecture and music as essentially spatial arts, Villanueva conceived his plan for integration in musical movements, grouped into six visual units.

In the first movement, the spectator faces the Museum, with horizontal plane volumes that are deliberately interrupted by two mosaic murals by Armando Barrios and Oswaldo Vigas. Three mosaic murals, also by Vigas, lead the eye to the second movement, between the entrance and the heart of the cultural area, with the Communications and Administration buildings as background.

The third movement complements the unit formed by the Aula

III-60. Small Concert Hall and Library, University City, Caracas (1953). Designed by Carlos Raúl Villanueva, this group has a bronze *Maternity*, by Balthazar Lobo, and at the rear, Fernand Léger's stained-glass window. Venezuela.

Magna and the Covered Plaza. It is, in addition, the aesthetic axis of the over-all plan. Sculptures by Jean Arp (*Cloud Shepherd*) and Henri Laurens (*Amphion*); murals by Mateo Manaure, Pascual Navarro, Victor Vasarely, and Fernand Léger are skillfully modulated and fused into the architectonic concept. The third movement is completed by the ceiling of the Aula Magna, with its Calder stabiles.

In the fourth movement, the dynamism of sculptures and murals offsets the sternness of the architecture, evident here in the supports of the Small Concert Hall. A construction by Vasarely in black-and-silver aluminum, *Positive-Negative,* intensifies the dynamism, not only through the changes in volume produced as the sun shifts, but also with restless angles that encourage the spectator to move on. The Vasarely links the Covered Walk that leads to the Library with a glass-mosaic mural by Navarro.

Sitting alone before the Small Concert Hall is Balthazar Lobo's *Maternity*. At the entrance of the hall, a glass-mosaic mural by Manaure concludes the plastic integration of this movement (*Ill. III-60*).

As the spectator leaves the Concert Hall, the fifth movement presents him with the contrast between the bronze *Dynamism at 30 Degrees,* by Antoine Pevsner, and another mural by Vasarely, with maddening parallel lines. Next is the Library, a red rectangular block

of floating construction, totally different from the similarly monolithic Library at the University City in Mexico. In the Library lobby, a long mural by Fernand Léger, executed in stained-glass by Jean Barillet, prepares one for the approach to the Exhibit Hall. From the terrace of the Library, a sculpture by Francisco Narváez dominates the panorama of the valley of Caracas.

The sixth movement shifts toward the School of Architecture and the School of Humanities. The Architecture building, considered by most critics Villanueva's supreme work, is covered with polychrome glass mosaics designed by Alejandro Otero.

Peru and Chile

Perhaps more than any other Latin American country, Peru was the victim of the neocolonial style on a grand scale. The results were multiplied by the coefficient of unlimited official support and abundant government coffers. The first neocolonial works, such as the Archbishop's Palace (1916), are now more than a half-century old, but the style reached its peak between 1935 and 1945. Then and since, Lima has neglected its rapidly disappearing authentic colonial sections, while proudly exhibiting artful "reconstructions" to tourists in the Plaza de Armas, the Plaza San Martín, in numerous "California"-style houses, which are actually anachronistic pastiches of the colonial baroque.

In Peru, the new-broom movement comparable to the Semana de Arte Moderna in Brazil or to muralism in Mexico was the Agrupación Espacio (Space Group), formed in 1947 by architects, painters, sculptors, and writers. Strikingly behind the times, the group's manifesto proclaimed the validity of Mies van der Rohe, Le Corbusier, Gropius, and Wright. Within this group, the Wright faction produced a

III-61. San Ignacio School, Santiago (1960). The horizontal lines of this building by Alberto Piwonka are offset by the verticals and diagonals of the geometric mural by Mario Carreño, *Homage to Fra Angelico*. Chile.

III-62. United Nations Building, Santiago (1966), designed by Emilio Duhart. The main façade is echoed in a reflecting pool. Vertical supports stabilize the edifice in the event of earthquakes. To the center right is the spiral tower of the conference hall. Chile.

dynamic, horizontal architecture, employing rusticated stone or unfaced brick, combined with wide glass areas.

Chile also suffered from the neocolonial mania, although it was confined to a single city, La Serena. In general, earthquakes, and modest aims, have circumscribed Chilean architecture to a few outstanding individual efforts. This situation is especially surprising in view of the fact that ever since the middle of the nineteenth century, Chile has had excellent architectural schools. Perhaps it is these circumstances that have limited the achievements of Sergio Larraín, the dean of Chilean architects today. However, he shows a commendable vitality and freshness of spirit in his most recent designs for the projected residential Baquedano Tower, in Santiago, in which he was assisted by Ignacio Covarrubias and Jorge Swinburn.

Alberto Piwonka in his horizontal San Ignacio School (*Ill. III-61*), as well as Jorge Aguirre Silva, Juan Echenique, and Fernando Castillo, in their spatial integrations, alluding to the traditional house, represent leading tendencies of new Chilean architecture. Among the most sweeping works undertaken thus far is the United Nations Building, in Santiago, which Emilio Duhart designed and constructed (*Ill. III-62*). Duhart set himself a demanding task in attempting to weld the edifice to the landscape of the Santiago valley. Further, he conceived his project as both a house and a monument. In rational order, he began with a closed square containing a ring of offices. Within the quadrangle is a central nucleus: a spiral conference hall and a diamond-

shaped meeting hall, with bridges to connect the different branches. A horizontal concept dominates in the planes that gracefully and plastically separate two concentric circular buildings. The complex creates some feeling of claustrophobia, very much in keeping with the Chilean spirit. Despite this, Duhart obtains visual effects in the building, but it remains prevailingly spatial in concept.

The Río de la Plata Region

Architecture in Uruguay centers around three poles: the inevitable influence of Torres García's constructive universalism; the high technical standards preached by Julio Vilamajó, formerly Dean of the School of Architecture in Montevideo; and the contributions of Antonio Bonet, a Spaniard now living in Buenos Aires.

However, several architects operate outside these three prime influences. In Punta del Este, Guillermo Jones Odriozolo developed a style more directly linked to the language of Wright than was the parallel Peruvian Wright movement. Eladio Dieste's work approaches the efficiency of Carlos Raúl Villanueva and Félix Candela more nearly than Niemeyer's sculptural plasticity. In two industrial structures built in 1947 and 1948, Dieste experimented with self-supporting vaults similar to Candela's in Mexico, but less sinuous, less cheap, and less simple. In the parish church of Atlántida (1958), Dieste achieved a felicitous relationship between the rusticated vault and the undulating walls, a structural solution that determines the interior volume and the functional scheme. Although the forms are curvilinear, their feeling is sculptural, rather than conveying the baroque dynamism of the new Brazilian architecture.

Recently, Uruguayan architecture demonstrated its maturity and quality in the building for the Pan American Health Organization and Regional Office of the World Health Organization, in Washington, D.C. (*Ill. III-63*). Unfortunately, because it had to be wedged in between two highways, its volumes and perspectives are somewhat compressed. Moreover, the building had to be limited to an inadequate eleven stories to meet the conventional building regulations of Washington's Fine Arts Commission. The designer, Román Fresnedo Siri, suppressed his sculptural bent to make the design conform to what he sees as "the classic spirit of the city of Washington." Nevertheless, through a graceful interplay of volumes, Fresnedo related the curved façade of the offices to the truncated cylinder of the Council Chamber.

Of all the Latin American countries, Argentina is perhaps the

284

III-63. Pan American Health Organization and Regional Office of the World Health Organization, Washington, D.C. (1965). In Román Fresnędo Siri's plan, the cylinder at the left houses the conference hall. As its backdrop, the curving structure on the right contains administrative offices.

one that has most consistently produced an architecture basically not concerned with aesthetic problems. Chief among the factors that have contributed to this situation is the dominance of a bourgeoisie with traditional European tastes, devoid of the rebelliousness typical of most new countries. Consequently, Argentina has shunned the audacious advances in architecture elsewhere. A constellation of architects rooted in a long contemporary tradition—Jorge Ferrari Hardoy, Mario Roberto Alvarez, Luis Miguel Morea, Alfredo Agostini, Macedonio Oscar Ruiz, Amancio Williams, Antonio Bonet—satisfy the special requirements of Argentine patrons, for example, the commercial arcades in the large cities (especially Buenos Aires), in which the interior architecture is of high quality. In recent years, Argentine architects have campaigned in an effort to attain national solutions in keeping with the revision of the principles based on the four masters of contemporary architecture. And this is why the lectures given in Buenos Aires by Bruno Zevi in 1951 and the courses given later by Pier Luigi Nervi have had vast repercussions.

The rigorous pursuit of sobriety in materials and concepts has

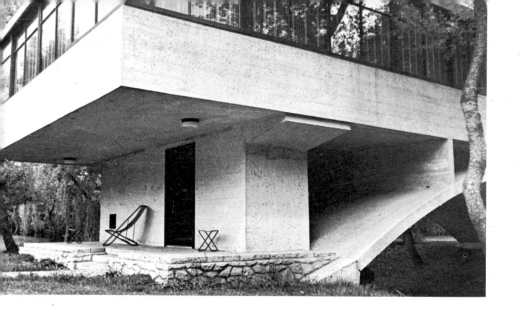

stamped the projects of Santiago Sánchez Elía, Federico Peralta Ramos, and Alfredo Agostini, and it contributes importantly to the masterful Abbott Laboratories building in Buenos Aires Province. Amancio Williams is similarly a perfectionist, and this plays a major role in the simplicity with which he overcame the difficulties in the site of his celebrated house in Mar del Plata (1945–47; *Ill. III-64*). Antonio Bonet is, among Argentine architects, the most persistently experimental, and he reaped the fruits of this preparation most notably in the Cristalplano Pavilion, for the Buenos Aires Sesquicentennial Fair (1960), unfortunately razed at the end of the exposition.

Certain tendencies toward structural plasticity are evident in the Bank of London building designed by Sánchez Elía, Peralta Ramos, Agostini, and Clorindo Testa. The deliberate incorporation of air within the structure produces sculptural façades that justify their visual heaviness. The same thing is true of the cellular exterior screen for the School of Architecture at the University of Mendoza, the work of Enrico Tedeschi, an innovator in spatial concepts in the manner of Aalto and Wright.

Among public buildings in Argentina, there is no doubt that the most outstanding is the San Martín Municipal Theater, in Buenos Aires, designed by Mario Roberto Alvarez and Macedonio Oscar Ruiz (*Ill. III-65*). It is especially remarkable because of the success with which sculpture and painting have been integrated into the architec-

III-64. Residence of Alberto Williams, Pereyra Iraola Park, Mar del Plata (1945–47). This house, designed by Amancio Williams, is almost entirely supported on a concrete bridge over a swamp. Argentina.

III-65. San Martín Municipal Theater, Buenos Aires (1953–1961). The project, designed by Mario Roberto Alvarez and Macedonio Oscar Ruiz, is the most important experiment in integration undertaken in Argentina. In this view of the first-floor lobby, the sculpture is by Pablo Curatella Manes. Argentina.

ture. The whole project consists of a large architectural unit comprising three vertical blocks of descending heights. Between the first and second, there are two theaters. The complex, which was built between 1953 and 1961, utilizes paintings and sculptures by a virtual "Who's Who" of Argentine artists, among them Pablo Curatella Manes, José Antonio Fernández-Muro, and Sarah Grilo.

Brazil

In 1929, Le Corbusier visited Brazil, Uruguay, and Argentina. He was welcomed with unprecedented honors in Rio and São Paulo, and the revolution of 1930, which brought Getúlio Vargas to power, enthusiastically supported the spirit of reform that had been introduced by the Semana de Arte Moderna, eight years before, and by Gregório Warchavchik's issuance, in 1925, of his "Manifesto da Arquitetura Funcional" ("Manifesto on Functional Architecture"), based on Le Corbusier's celebrated axiom: *"La maison est une machine à habiter."*

Spurred by these brilliant precursors, modern Brazilian architecture began with the competition for the construction of the new building for the Ministry of Education and Public Health, in Rio. A group of architects "refusés"—young avant-gardists headed by Lúcio Costa— were denied the award by the dominant academics, but they won the commission to design the building. They obtained the counsel of Le Corbusier, who spent a month in Rio in a productive exchange of

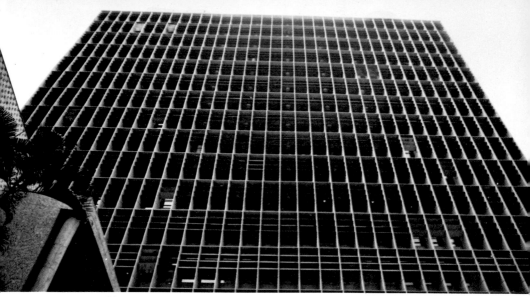

III-66. Ministry of Education and Public Health, Rio de Janeiro (1937–43). The basic work by Lúcio Costa, Oscar Niemeyer, and their associates marks the starting point of the new architecture in Brazil. Here Le Corbusier's ideas were modified and adapted to the existing climatic conditions. Brazil.

ideas. In the final plan, Le Corbusier's initial ideas were modified into adaptations specifically suited to the Brazilian reality (*Ill. III-66*).

Meanwhile, two schools were taking shape, each with its own characteristics. The "Carioca" group, imbued with Lúcio Costa's theories, quickly achieved international acclaim through the work of Oscar Niemeyer. The "Paulista" group centered around the dynamic, experimental School of Architecture in São Paulo, which taught a Brazilian version of Mies van der Rohe and Gropius.

Lúcio Costa represents in Brazil a bridge between the baroque colonial tradition and the extremely free and poetic expressions of contemporary architecture.

Truly the dean of the new architecture in Brazil, Costa, who became Director of the School of Fine Arts in 1931, has trained an entire generation of Brazilians. His basic ideas were summarized in an article written in 1930: "Razões da nova arquitetura" ("Arguments for the New Architecture"). Subsequently, he has supplemented his own work as an architect with definitive studies of baroque colonial architecture. His major historical contribution, however, is his concept of urban planning, which culminated in the over-all scheme for the building of Brasília.

288

Since his early period, Niemeyer's dazzling career has spiraled endlessly forward and upward from his day nursery, Obra do Berço, in Rio, in 1937, to his recent achievements in Brasília or the curvilinear apartment building in Belo Horizonte. His concept of architectonic space as an indivisible whole and his belief in functional planning have not prevented him from employing flowing forms in order to endow his architecture with sculptural values. The Julia Kubitschek School in Diamantina, the Secondary School in Belo Horizonte, the group of buildings in Pampulha, especially the Church of São Francisco de Assis (*Ill. III-67*)—all in Minas Gerais State, inland from Rio; his contributions to the United Nations Building in New York; the South American Hospital in Rio; the plan for the projected Museum of Modern Art in Caracas; and many other works indicate that the plastic sense dominates Niemeyer's thinking.

Another inventive "new" architect, Affonso Eduardo Reidy, arrived at technical and architectural solutions that are absolutely personal, especially in the low-cost Pedregulho housing project (1947–52), the Gavea project (started in 1954), and the Museum of Modern Art (1954), all in Rio de Janeiro. Reidy achieved an essentially spatial architecture with an ingenious play of light and shade created by a combination of natural and artificial light.

Eduardo Kneese de Mello, in São Paulo, has headed a movement that is more international in orientation than that of the "Carioca" architects. His contribution to the Ibirapuéra Park, in São Paulo, employs broad horizontal lines that contrast in feeling with curvilinear ramps for circulation. He has also been highly praised for his dwellings, especially the Japura apartments in São Paulo. Another landmark building was designed for the Associação Brasileira de Imprensa

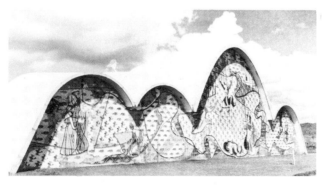

III-67. Church of São Francisco de Assis, Pampulha, Minas Gerais (1943). One of the first Brazilian examples to integrate plastic and architectural forms. The architect was Oscar Niemeyer; the ceramic mural is by Cândido Portinari. Brazil.

289

III-68. Buttresses of Oscar Niemeyer's Palace of the Planalto, Brasília (1957–58). At rear, the towers of the Congressional Administration Building; at right, the truncated sphere of the Senate Building, also designed by Oscar Niemeyer.

(Brazilian Press Association), in 1938, by the Roberto brothers (Marcelo and Milton until 1945 and after that in collaboration with Mauricio). In this building, erected almost simultaneously with the Ministry of Education, the Robertos introduced the use of the *brise-soleil,* soon a standard feature of Brazilian architecture.

Henrique E. Mindlin, an influential architectural critic and historian, made his own name as an architect in 1942, when he won first prize in the competition for an addition to the Ministry of Foreign Affairs (which occupies the nineteenth-century Itamaratí Palace). His most impressive work is the Avenida Central Building (1961), in Rio. This structure is clearly derivative of the work of Skidmore, Owings & Merrill (for instance, Lever House, in New York City); it consists of a broad five-story platform surmounted on one side by the main rectangular block. Nevertheless, Mindlin achieved notable elegance by suspending the massive block on graceful *pilotis.* Together with Giancarlo Palanti, Mindlin also designed the Bank of London building in São Paulo.

Form and function, in accord with the theories that Niemeyer himself summarized in his *Revista Módulo (Modular Review),* in December, 1960, were wholly fulfilled in Brasília, a vision fostered by

290

President Juscelino Kubitschek for a variety of political and personal reasons. In 1956, an international jury approved Lúcio Costa's plan for the construction of the new capital in the highlands of Goiás State, more than 600 miles in the interior of the country. The general scheme follows the contours of an airplane. The wings are formed by residential superblocks; the body is composed of the Avenue of the Ministries, which terminates in the Square of the Three Powers, with the Presidential Palace (executive power), the Supreme Court (judicial power), and the Congress (legislative power). The commercial and entertainment districts surround the intersection of these planes, which are free of ground-level traffic crossings.

As Director of Architecture for the Novacap (Nova, or New, Capital), Niemeyer implemented the architectural-aesthetic aspects of Costa's basic scheme. With a team of more than sixty architects, Niemeyer succeeded in planning and constructing—at least partly—an entire new city in less than two years.

Niemeyer's own principal works are the Palace of the Alvorada (Dawn), the President's residence; the Palace of the Planalto (Plateau), housing the executive offices; the complex of Congress buildings; the cathedral; and the halls for public functions. The Congress buildings rest on a long low base, upon which a calculated contrast is produced by two truncated spheres (one concave, the other convex)— one to seat each chamber of the legislature. Between the spheres emerge two towers, forming an H, which contain the administrative offices (*Ill. III-68*). The cathedral, a flower stretching heavenward, perfectly expresses the sense of verticality and the search for the in-

III-69. The Cathedral of Brasília (begun in 1958). Oscar Niemeyer's sculptural-plastic tendency reaches full expression in this structure. Like an immense flower, it ascends from its petals in a symbolic search for infinitude.

finite that are characteristic of the baroque tradition in Brazil, now as in the past enchanted by the curve (*Ill. III-69*).

The foregoing summary leads to an obvious conclusion: the Brazilian architecture that culminates in Brasília is the result of a fast-moving fermentation process during which a wide variety of ideas and achievements have been poured into a common crucible. Le Corbusier has justly received much of the credit for this development. In Brazilian architecture, he saw the actual application in a tropical medium of his theory that formal and structural elements are a function of light and ventilation needs. But its realization in an actual building depended on the values amassed from a past deeply imbued with baroque traditions.

In addition to adapting decorative tile and the *brise-soleil* from Le Corbusier's aesthetic, Brazil also made very widespread use of the idea, likewise Le Corbusier's, of *pilotis*. Besides supporting the building mass and affording ventilation on the lower floors, *pilotis* enhance the lightness that distinguishes Brazilian architecture. Further, many top-flight artists, especially Cândido Portinari and Roberto Burle Marx, achieved unprecedented splendor by integrating visual and spatial arts.

Other elements—the delight in the curve, the harmonious bending of reality carried to spectacular lengths, the audacity in planning and solutions, an enduring feeling for grandeur, the dynamism of an architecture basically plastic and lyrical—all these justify Reyner Banham's lavish claim that the Brazilians have created the first national style in modern architecture.

When a style has been found, there is delight in the encounter with the soul itself and, at the same time, anguish at the awareness of its transitoriness. In Latin America, this experience ranges between the poles of Venezuela and Brazil. In the former, works of architecture lack a local Venezuelan flavor; in the latter, one can truly speak of a genuine Brazilian style. The midpoint is occupied by Mexico, where, after the brilliant creative awakening in the University City, architects have developed a strict professional outlook. Now they consider the University City stage past and have sought a broader concept.

The concepts, schools, styles, and figures discussed raise the question: Is there a Latin American art? Some artists try to utilize American sources and themes while participating within the framework of contemporary movements. However, the keynote of Latin American art today is the wish to attain an aesthetic purity unfettered by localisms and traditions.

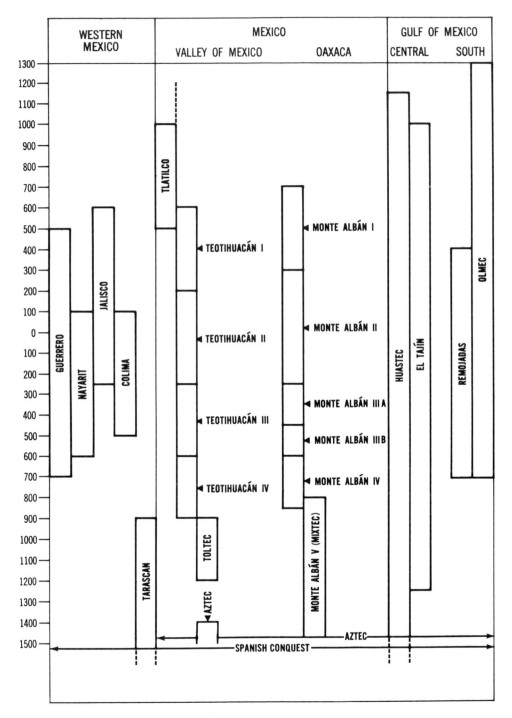

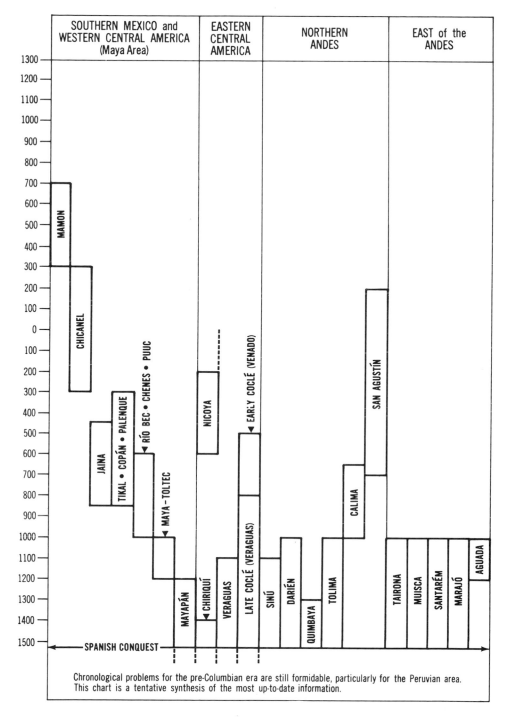

Chronological problems for the pre-Columbian era are still formidable, particularly for the Peruvian area. This chart is a tentative synthesis of the most up-to-date information.

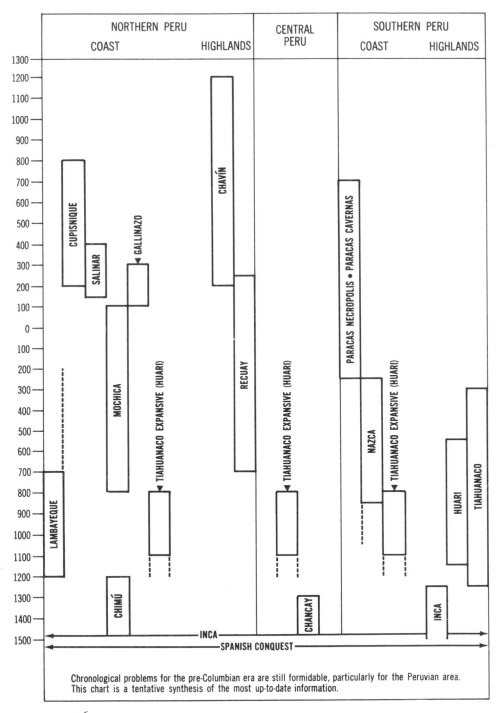

| NORTHERN PERU | | CENTRAL PERU | SOUTHERN PERU | |
| COAST | HIGHLANDS | | COAST | HIGHLANDS |

1300
1200
1100
1000
900
800
700
600
500
400
300
200
100
0
100
200
300
400
500
600
700
800
900
1000
1100
1200
1300
1400
1500

CUPISNIQUE

SALINAR

GALLINAZO

MOCHICA

LAMBAYEQUE

CHIMÚ

CHAVÍN

RECUAY

TIAHUANACO EXPANSIVE (HUARI)

TIAHUANACO EXPANSIVE (HUARI)

CHANCAY

PARACAS NECROPOLIS • PARACAS CAVERNAS

NAZCA

TIAHUANACO EXPANSIVE (HUARI)

HUARI

TIAHUANACO

INCA

INCA

SPANISH CONQUEST

Chronological problems for the pre-Columbian era are still formidable, particularly for the Peruvian area. This chart is a tentative synthesis of the most up-to-date information.

Selected Bibliography

There is no single bibliography that encompasses the entire panorama of Latin American art from pre-Columbian times to the present. The only general listing is the compilation by Robert C. Smith and Elizabeth Wilder (*A Guide to the Art of Latin America,* Washington, D.C., 1948), but this is based solely on the entries in the *Handbook of Latin American Studies* and the earlier works by Mario J. Buschiazzo. This bibliography was continued by Harold Wethey until 1952. Ignacio Bernal's bibliography on pre-colonial Middle American art is exhaustive.

For the colonial period, the major study is that of Diego Angulo Iñiguez, Mario J. Buschiazzo, and Enrique Marco Dorta; for nineteenth-century and contemporary art, in addition to the works devoted to specific nations (e.g., Justino Fernández' on Mexico), the catalogue of the exhibition *Art of Latin America since Independence,* edited by Stanton L. Catlin and Terence Grieder (New Haven, Conn. and Austin, Tex., 1966; New York, 1967) is especially useful. Other valuable material has been published over the past twenty years by the Division of Visual Arts of the Pan American Union: bulletins, catalogues, and monographs, as well as the series "Art in Latin America Today."

The bibliography below constitutes an extremely brief selection of basic works.

The Pre-Columbian Period

BUSHNELL, G. H. S. *Ancient Arts of the Americas.* New York, 1965.

CASO, ALFONSO. *The Aztecs: People of the Sun.* Norman, Okla., 1958.

COVARRUBIAS, MIGUEL. *Indian Art of Mexico and Central America.* New York, 1957.

DISSELHOFF, HANS D., and LINNÉ, SIGVALD. *The Art of Ancient America: Civilizations of Central and South America.* Translated by ANN KEEP. New York, 1961.

Instituto Panamericano de Geografía e Historia. "Monumentos históricos y arqueológicos de América": *Argentina* (1959), *Brasil* (1952), *Chile* (1952), *Colombia* (1955), *Costa Rica* (1959), *Ecuador* (1953), *El Salvador* (1959), *Guatemala* (1953), *Haiti* (1952), *Honduras* (1953), *México* (1953), *Panamá* (1950), *Venezuela* (1959). Mexico, 1950–59.

KELEMEN, PÁL. *Medieval American Art.* Rev. ed. New York, 1956.

KUBLER, GEORGE. *The Art and Architecture of Ancient America: The Mexican, Maya, and Andean Peoples.* Baltimore, 1962.

LOTHROP, S. K. *Treasures of Ancient America: The Arts of the Pre-Columbian Civilizations from Mexico to Peru*. Geneva, 1964.

MARQUINA, IGNACIO. *Arquitectura prehispánica*. Mexico, 1951.

MORLEY, SYLVANUS G. *The Ancient Maya*. 3d ed., revised by GEORGE W. BRAINERD. Stanford, Calif., 1956.

PÉREZ DE BARRADAS, JOSÉ. *La orfebrería prehispánica de Colombia: Estilo Calima*. 2 vols. Madrid, 1954.

ROBERTSON, DONALD. *Pre-Columbian Architecture*. New York, 1963.

SPINDEN, HERBERT J. *Ancient Civilizations of Mexico and Central America*. 3d. rev. ed. New York, 1928.

STIERLIN, HENRI. *Maya: Guatemala, Honduras et Yucatan*. Fribourg, 1964.

TELLO, JULIO C. *Origen y desarrollo de las civilizaciones prehistóricas andinas*. Lima, 1942.

TOSCANO, SALVADOR. *Arte precolombino de México y de la América Central*. Rev. ed. Mexico, 1952.

UBBELOHDE-DOERING, HEINRICH. *The Art of Ancient Peru*. London and New York, 1952.

WESTHEIM, PAUL. *The Art of Ancient Mexico*. Translated by URSULA BERNARD. New York, 1965.

————. *The Sculpture of Ancient Mexico*. Translated by URSULA BERNARD. New York, 1963.

The Colonial Period

ANGULO IÑIGUEZ, DIEGO, MARCO DORTA, ENRIQUE, and BUSCHIAZZO, MARIO J. *Historia del arte hispano-americano*. 3 vols. Barcelona, 1945–56.

BAZIN, GERMAIN. *Aleijadinho et la sculpture baroque au Brésil*. Paris, 1963.

————. *L'architecture religieuse baroque au Brésil*. 2 vols. Paris and São Paulo, 1956–58.

BUSCHIAZZO, MARIO J. *Historia de la arquitectura colonial en Iberoamérica*. Buenos Aires, 1961.

CASTEDO, LEOPOLDO. *The Baroque Prevalence in Brazilian Art*. New York, 1964.

FALCÃO, E. DE CERQUEIRA. *Relíquias da Bahia*. São Paulo, 1940.

————. *Relíquias da Terra do Ouro*. São Paulo, 1946.

GASPARINI, GRAZIANO. *Templos coloniales de Venezuela*. Caracas, 1959.

KELEMEN, PÁL. *Baroque and Rococo in Latin America*. New York, 1951.

KUBLER, GEORGE. *Mexican Architecture of the Sixteenth Century*. 2 vols. New Haven, 1948.

———— and SORIA, MARTIN. *Art and Architecture in Spain and Portugal and Their American Dominions: 1500–1800*. Baltimore, 1959.

MARKMAN, SIDNEY D. *Colonial Architecture of Antigua Guatemala*. Philadelphia, 1966.

MESA, JOSÉ DE, and GISBERT, TERESA. *Holguín y la pintura altoperuana del virreinato*. La Paz, 1956.

NAVARRO, JOSÉ G. *Religious Architecture in Quito*. New York, 1945.

PALM, ERWIN W. *Los monumentos arquitectónicos de la Española*. 2 vols. Ciudad Trujillo, 1955.

ROJAS, PEDRO. *Historia general del arte mexicano: Epoca colonial.* Mexico, 1963.

SMITH, ROBERT C. *Baroque Architecture in Brazil.* Oxford, 1963.

TOUSSAINT, MANUEL. *Arte colonial en México.* 2d ed. Mexico, 1962.

WETHEY, HAROLD. *Colonial Architecture and Sculpture in Peru.* Cambridge, Mass., 1949.

WILDER, ELIZABETH. *Mexico in Sculpture: 1521–1821.* Cambridge, Mass., 1950.

The Modern Period

BULLRICH, FRANCISCO. *Arquitectura argentina contemporánea.* Buenos Aires, 1963.

CETTO, MAX. *Modern Architecture in Mexico.* New York, 1961.

DAMAZ, PAUL F. *Art in Latin American Architecture.* New York, 1963.

Exposición de homenaje nacional. *Diego Rivera: 50 años de labor artística* (exhibition catalogue). Mexico, 1951.

FABER, COLIN. *Candela: The Shell Builder.* New York, 1963.

FERNÁNDEZ, JUSTINO. *Arte moderno y contemporáneo de México.* Mexico, 1952.

GÓMEZ-SICRE, JOSÉ. *4 Artists of the Americas: Burle-Marx, Calder, Peláez, Tamayo.* Washington, D.C., 1957.

HITCHCOCK, HENRY-RUSSELL. *Latin American Architectures Since 1945.* New York, 1955.

MINDLIN, HENRIQUE E. *Modern Architecture in Brazil.* New York, 1956.

MOHOLY-NAGY, SIBYL. *Carlos Raúl Villanueva and the Architecture of Venezuela.* New York, 1964.

MORALES, ADOLFO. *Grandjean de Montigny e a evolução da arte brasileira.* Rio de Janeiro, 1941.

MYERS, BERNARD S. *Mexican Painting in Our Time.* New York and London, 1956.

OSUNA, RAMÓN G. *Naïve Painters of Latin America.* Durham, N.C., n.d.

Pan American Union. "Art in Latin America Today": *Argentina* (1961), *Bolivia* (1963), *Brazil* (1960), *Chile* (1963), *Colombia* (1959), *Guatemala* (1964), *Haiti* (1959), *Peru* (1961), *Venezuela* (1962). Washington, D.C., 1959–64.

PAPADAKI, STAMO. *Oscar Niemeyer.* New York, 1960.

REED, ALMA. *Orozco.* New York, 1956.

RODMAN, SELDEN. *Renaissance in Haiti: Popular Painters in the Black Republic.* New York, 1948.

ROMERA, ANTONIO. *Historia de la pintura chilena.* Santiago de Chile, 1960.

ROMERO BREST, JORGE. *Pintores y grabadores rioplatenses.* Buenos Aires, 1951.

TIBOL, RAQUEL. *Historia general del arte mexicano: Epoca moderna y contemporánea.* Mexico, 1964.

TRABA, MARTA, and DÍAZ, HERNÁN. *Seis artistas contemporáneos colombianos.* Bogotá, 1963.

List of Illustrations

Measurements are given in the following sequence: height, width, depth. Abbreviations: *h.* height, *w.* width, *d.* depth.

AK—Albright-Knox Art Gallery, Buffalo, New York; AMNH—American Museum of Natural History, New York City; DO—Dumbarton Oaks, Washington, D.C.; INAH—Instituto Nacional de Antropología e Historia (National Institute of Anthropology and History), Mexico City; INBA—Instituto Nacional de Bellas Artes (National Institute of Fine Arts), Mexico City; MAEG—Museo de Arqueología y Etnografía de Guatemala (Guatemalan Museum of Archaeology and Ethnography), Guatemala City; MBA—Museo de Bellas Artes (Museum of Fine Arts), Caracas, Venezuela; MNA—Museo Nacional de Antropología (National Museum of Anthropology), Mexico City; MNAC—Museo Nacional de Arte Colonial (National Museum of Colonial Art), Quito, Ecuador; MPA—Museum of Primitive Art, New York City; PAU—Pan American Union, Permanent Collection, Washington, D.C.

All dates are A.D. unless otherwise indicated.

Part I: In the Beginning

I- 1. Monte Albán, Oaxaca, Mexico. View of southwest group from the north platform. Monte Albán I, II, and III. 500 B.C.(?)–600(?).

I- 2. Chichén-Itzá, Yucatán, Mexico. Annex of the Nunnery. Maya culture, Puuc and Chenes styles. Ca. 700–800.

I- 3. Mask in serpentine. Tabasco (?), Mexico. Olmec culture. B.C. *h.* 5¾ in. MPA

I- 4. Clay and paint figure. Tlatilco, Valley of Mexico. Before 500 B.C. *h.* 4¼ in. MPA

I- 5. Stone head. Tlatilco, Valley of Mexico. Before 500 B.C. *h.* 5⅜ in. MPA

I- 6. Clay effigy vessel. Colima, Mexico. Western cultures. 200–500. *h.* 14⅜ in. MPA

I- 7. Teotihuacán, Mexico View from the Citadel. Valley of Mexico. Teotihuacán II and III. Before 500. Photo taken in 1965, during restoration.

I- 8. Teotihuacán, Mexico. Pyramid of Quetzalcóatl. Valley of Mexico. Teotihuacán II. Before 500. Photo taken in 1955, during restoration.

I- 9. Figure of a "dancer" in bas-relief. Monte Albán, Oaxaca, Mexico. Monte Albán I. Olmec culture. Ca. 500 B.C. *h.* 67½ in.

I-10. Terra-cotta urn. Monte Albán III. Zapotec culture. Ca. 500. *h.* 20½ in. Oaxaca Museum.
I-11. Mitla, Oaxaca, Mexico. Wall of main courtyard of the Palace of the Columns. Mixtec culture. 800 (?).
I-12. Gray basalt head. Veracruz, Mexico. El Tajín culture. Ca. 700–800. *h.* 17 in. Jalapa Archaeological Museum.
I-13. Diorite-porphyry "yoke." Veracruz, Mexico. El Tajín culture. Ca. 500–600. 17 x 15 in. DO
I-14. Marble "ax." Tecamalucan (?), Mexico. El Tajín culture. Ca. 300–400. *h.* 11⅘ in., *d.* 2 in. DO
I-15. Stone "palm." Veracruz, Mexico. El Tajín culture. 700–800 (?). *h.* 20⅛ in. MPA
I-16. Clay head. Veracruz, Mexico. Remojadas style. Ca. 400–500. *h.* 8⅜ in. MPA
I-17. Fired clay *techichi* dogs. Colima, Mexico. Western cultures. 200–500. *h.* 13¼ in. MNA
I-18. Clay monkey-head jar. Monte Albán, Oaxaca, Mexico. Mixtec culture. After 800. *h.* 8½ in. MPA
I-19. Ceramic tripod vase. Zaachila, Mexico. Mixtec culture. After 1000. *h.* 11 in. MNA
I-20. Pectoral of gold and turquoise. Yanhuitlán, Mexico. Mixtec culture. Ca. 1000–1100. MNA
I-21. Mask of Xipe-Tótec. Tomb 7, Monte Albán, Oaxaca, Mexico. Mixtec culture. Ca. 1000–1100. *h.* 2¾ in. Oaxaca Museum.
I-22. Mask of bird god in fired clay. Mexico. Mixtec-Puebla culture (?). After 1100. *h.* 4⅝ in. MPA
I-23. Goddess Coatlicue (an engraving after Karl Nebel, in *Viaje pintoresco y arqueológico sobre la parte más interesante de la República Mexicana, en los años transcurridos desde 1824 hasta 1831,* a travel volume published in Paris and Mexico City in 1840). Aztec culture. 1450–1500. MNA
I-24. Calendar stone (an engraving after Karl Nebel; *see Ill. I*-23). Aztec culture. After 1502. MNA
I-25. Stone figure of plumed serpent. Mexico City. Aztec culture. Ca. 1500. *h.* 22½ in. MPA
I-26. Clay and paint figure of Xipe-Tótec. Puebla, Mexico. Aztec culture. Ca. 1500. *h.* 56¾ in. MPA
I-27. Goddess Tlazoltéotl, in aplite with inclusions of garnets. Mexico City (?) Aztec culture. Ca. 1500. 8 x 4¾ in. DO
I-28. Copán, Honduras. General view of the ball court. Maya culture. 514–775.
I-29. Copán, Honduras. Altar G. Maya culture. 800.
I-30. Palenque, Chiapas, Mexico. The Palace. Maya culture. 600–800.
I-31. Jade statuette. Uaxactún, Guatemala. Maya culture, with Olmec influences. Ca. 100–1 B.C. (?). *h.* 10 in. MAEG
I-32. Seated wooden figure with paint and hematite bits. Tabasco, Mexico. Maya culture. Ca. 540. *h.* 14¹³⁄₁₆ in. MPA
I-33. Pottery figurine. Campeche, Mexico. Maya culture, Jaina style. 500 (?). 10 x 5⅓ in. DO

I-34. Jade mosaic mortuary mask found in the crypt of the Temple of the Inscriptions, Palenque, Chiapas, Mexico. Maya culture. Ca. 650–750. Life size. MNA

I-35. Uxmal, Yucatán, Mexico. Pyramid of the Magician and Nunnery Quadrangle. Maya culture, Puuc and Chenes styles. After 950. Photo taken in 1965.

I-36. Uxmal, Yucatán, Mexico. Detail of northern building of Nunnery Quadrangle. Maya culture, Puuc style. After 950. Photo taken in 1965.

I-37. Chichén-Itzá, Yucatán, Mexico. View from the Thousand Columns. Maya-Toltec culture. Ca. 1100. Photo taken in 1965.

I-38. Chichén-Itzá, Yucatán, Mexico. Temple of the Warriors. Maya-Toltec culture. Ca. 1100. Photo taken in 1965.

I-39. Carved seashell. Mayapán culture. After 1300(?). $h.$ 3½ in. Mérida Museum, Yucatán, Mexico.

I-40. Room 1, north wall (detail). Bonampak, Mexico. Maya culture. After 800. Drawing by Agustín Villagra.

I-41. Cast-gold eagle pendant. Panama. Veraguas culture (after 1100). 6 x 5¾ in. DO

I-42. Gold and pyrite pectoral. Costa Rica. Chiriquí culture (1400–1500[?]). $h.$ 6 in. MPA

I-43. Stone figure. Costa Rica. Reventazón culture. After 1200. $h.$ 34¾ in. MPA

I-44. Stone ceremonial metate. Costa Rica. Reventazón culture. After 1200. $w.$ 29 in. MPA

I-45. Gold owl. Colombia. Sinú style (after 1100). $h.$ 4¾ in. MPA

I-46. Gold cup. Colombia. Quimbaya style (after 1300). $h.$ 5⅜ in. MPA

I-47. Gold pectoral found in the Shrine of the Dragon. Caldas, Colombia. Tolima style. After 1000. $h.$ 9¼ in. Gold Museum, Bogotá.

I-48. Gold pectoral. Colombia. Calima style. 700–1000. 10 x 11 in. Gold Museum, Bogotá.

I-49. Stone figure. Colombia. San Agustín culture. Before 700. $h.$ 44 in.

I-50. Ceramic jar. Brazil. Marajó style (1000–1500). $h.$ 7½ in. AMNH

I-51. Cast-bronze plaque. Argentina. Aguada culture (?) (1000–1200). $h.$ 4¾ in. MPA

I-52. Steatite cup. Peru. Cupisnique culture (Coastal Chavín). Ca. 500–400 B.C. $h.$ 3⅓ in. DO

I-53. Anthropomorphic pottery mask with post-fired resin paint. Peru. Paracas Cavernas style. Ca. 600–300 B.C. $h.$ 10 in. DO

I-54. Textile (detail). Peru. Paracas Necropolis style. Ca. 200–100 B.C. National Museum of Anthropology and Archaeology, Lima.

I-55. Stirrup-spout jar in black clay. Peru. Cupisnique culture (Coastal Chavín) (800–200 B.C.). $h.$ 9⅝ in. MPA

I-56. Painted clay vessel. Peru. Recuay style (250 B.C.–700). $h.$ 8¼ in. MPA

I-57. Nose ornament of sheet gold, cut and decorated with gold threads. Peru. Vicú culture. 400–300 B.C.(?). 1⅕ x 1⅘ in. DO

I-58. Clay and paint effigy vessel. Peru. Mochica culture. After 400. $h.$ 4⅝ in. MPA

I-59. Clay and paint effigy jar. Peru. Mochica culture. After 400. *h.* 4⅝ in. MPA

I-60. Painted ceramic funerary vase. Peru. Mochica culture. Ca. 600–700. *h.* 4¾ in. Coll. Norbert Mayrock, Santiago, Chile.

I-61. Clay and paint effigy vessel. Peru. Nazca style. 500–700. *h.* 8⅛ in. MPA

I-62. Sheet-gold ornament for headdress. Peru. Nazca style. 500–700. *h.* 13¾ in. MPA

I-63. Gate of the Sun. Tiahuanaco, Bolivia. Ca. 500. 10 x 12½ ft.

I-64. Stone head (detail of a figure measuring 12½ ft. in all). Tiahuanaco, Bolivia. Ca. 300.

I-65. Stone figure. Tiahuanaco, Bolivia. Ca. 800–900(?). *h.* 18⅜ in. MPA

I-66. Clay and paint incense vessel. Tiahuanaco, Bolivia. Ca. 300–1100. *h.* 10⅛ in. MPA

I-67. Snail-shell vessel with head of a jaguar. Ocucaje, Peru. Tiahuanaco Expansive style (ca. 800–1100). *h.* 2¾ in. Coll. Norbert Mayrock, Santiago, Chile.

I-68. Molded mud and plaster bas-relief (detail). Chanchán, Peru. Chimú culture (1300–ca. 1450).

I-69. Gold-funerary mask. Peru. Chimú culture (1300–ca. 1450). *w.* 28¾ in. MPA

I-70. Gold ear spool. Peru. Chimú culture (1300–ca. 1450). *diameter* 4⅛ in. MPA

I-71. Clay and paint figure. Chancay, Peru. Ca. 1400. *h.* 25 in. MPA

I-72. Wood and paint *kero.* Peru. Inca culture. Ca. 1450. *h.* 8½ in. MPA

I-73. Silver effigy beaker. Peru. Inca culture. Ca. 1450. *h.* 9¾ in. MPA

I-74. Cuzco, Peru. Alley, retaining Inca masonry. Inca section ca. 1500. Photo taken in 1953.

I-75. Sacsahuaman, Peru. Cyclopean wall. Inca culture. After 1440. Photo taken in 1956.

I-76. Machu Picchu, Peru. General view. Inca culture. Ca. 1500. Photo taken in 1956.

Part II: The Encounter with Europe

II- 1. Cathedral of Santo Domingo, 1512–41: main façade, ca. 1540. Dominican Republic. Plan and elevation attributed to Juan de Herrera, Ortuño de Bretendón, and/or Rodrigo Gil de Liendo. Main façade attributed to Rodrigo Gil de Liendo.

II- 2. Church of the Third Order of San Francisco, 1547–66: transept and apse. Santo Domingo, Dominican Republic. Church by Rodrigo Gil de Liendo.

II- 3. Church of San Agustín Actopan, ca. 1540: cloister. Mexico. Church attributed to Friar Andrés de Mata.

II- 4. Church of San Agustín Acolman, 1539–60: façade, 1560. Mexico. Façade attributed to Pedro de Toro.

II- 5. Cathedral of Mexico City: façade, completed ca. 1790, with Sagrario Chapel at right. Cathedral begun in 1563 by Juan Miguel de Agüero, continued in 1584 by Claudio de Arciniega. Façade completed by José Damián Ortiz de Castro.

II- 6. Cathedral of Puebla, ca. 1575–1649: façade, completed in 1664. Mexico. Cathedral attributed to Claudio de Arciniega and Francisco Becerra.

II- 7. Cathedral of Lima: façade, 1626–1722. Peru. Design of the cathedral by Alonso Beltrán (ca. 1572), modified by Francisco Becerra (ca. 1584). Façade begun according to a plan by Juan Martínez de Arrona.

II- 8. The Descent from the Cross: ca. 1575. Polychrome bas-relief, stone, life size. Sagrario Chapel, Yanhuitlán, Mexico.

II- 9. Calvary: ca. 1559. Fresco painting, 96 x 112 in. Church of San Agustín Acolman (main cloister), Mexico.

II-10. Church of San Sebastián y Santa Prisca, 1751–58: façade, ca. 1756. Taxco, Mexico. Church by Diego Durán Berruecos and Juan Caballero.

II-11. Church of La Valenciana, 1765–88: side altar, ca. 1780. Guanajuato, Mexico. Carved wood covered with gold leaf.

II-12. Cathedral of Zacatecas, 1718(?)–61: upper part of the pediment, ca. 1754. Mexico.

II-13. Sagrario Chapel of the Cathedral of Mexico City: façade, ca. 1760. Lorenzo Rodríguez.

II-14. Church of San Martín Tepotzotlán, 1670–82: façade and tower, 1760–62. Mexico.

II-15. Church of Santa Clara: nave seen from the main altar. Querétaro, Mexico. Interior decorations attributed to Mariano de las Casas, 1765-92.

II-16. Collegiate Church of Ocotlán: façade, ca. 1745. Mexico. Church completed ca. 1745, modified in the mid-nineteenth century and in the 1940's. Façade attributed to Francisco Miguel.

II-17. Church of Santa María Jolalpan: façade, ca. 1760. Mexico.

II-18. Church of Santo Domingo, 1575–1675(?): vault of the dome of the Rosary Chapel, completed in 1729 and dedicated in 1731. Oaxaca, Mexico.

II-19. Church of San Martín Tepotzotlán, 1670–82: vault of the *camarín* of the Santa Casa de Loreto, 1679–80, probably modified ca. 1740. Mexico.

II-20. Church of San Martín Texmelucan, ca. 1776–82: façade and lantern, ca. 1782. Mexico.

II-21. Church of the Third Order of San Francisco: facade (detail), second half of the eighteenth century. Atlixco, Mexico.

II-22. Church of San Francisco Acatepec, late seventeenth century to ca. 1760; tiled façade (detail), ca. 1750. Mexico.

II-23. Church of Santa María Tonantzintla: vault of the dome, probably after 1700 (with modifications up to 1897). Mexico. Polychromed plaster.

II-24. *Retable of the Kings:* Jerónimo Balbás, 1737. Carved and gilded wood. Cathedral of Mexico City.

II-25. Christ at the Column: date unknown. Carved and painted wood, life size. Church of San Sebastián y Santa Prisca, Taxco, Mexico.

II-26. *Adam and Eve Before the Cross:* Cristóbal de Villalpando, 1706. Oil on canvas, 102 x 61 in. Monastery of Guadalupe, Zacatecas, Mexico.

II-27. Church of Santa Clara, 1723–34: façade (detail), 1734. Antigua, Guatemala.

II-28. Church of San Francisco, 1675–1703: façade, ca. 1680. Antigua, Guatemala.

II-29. University of Antigua, ca. 1763; view from the courtyard. Guatemala. José Manuel Ramírez.

II-30. Cathedral of Tegucigalpa, 1756–82: façade, 1756(?)–68. Honduras. Façade by Gregorio Nacianceno Quiroz.

II-31. Cathedral of Panama City, 1690–1796: arcading of the five naves, ca. 1749.

II-32. Cathedral of Havana, 1748 to early nineteenth century: façade, 1777. Cuba. Façade attributed to Pedro de Medina and Antonio Fernández Trevejos.

II-33. Church of Cumanacoa: façade, end of the eighteenth century, modified late nineteenth century. Venezuela.

II-34. Palace of the Inquisition, completed in the early eighteenth century: portal, 1770. Cartagena, Colombia.

II-35. Fortress of San Cristóbal, 1765–72. San Juan, Puerto Rico. Tomás O'Daly.

II-36. Guardian Angel: anonymous Guatemalan popular imagery, mid-eighteenth century. Carved wood with *encarnadura* and *estofado, h.* 38 in. Antigua Museum, Guatemala.

II-37. Church of San Francisco, ca. 1564–ca. 1575 (towers recent): façade, after 1580. Quito, Ecuador.

II-38. Monastery of San Agustín, ca. 1581 to late seventeenth century: lower cloister, ca. 1660. Quito, Ecuador. Monastery attributed to Francisco Becerra.

II-39. Church of Santo Domingo, Rosary Chapel, ca. 1680–90: main retable, ca. 1689. Tunja, Colombia. Gilded wood. Reliefs by José de Sandoval and Lorenzo de Lugo.

II-40. Church of Santo Domingo, ca. 1568–ca. 1600: jamb of the chancel arch (detail), early seventeenth century. Tunja, Colombia.

II-41. Church of San Francisco, ca. 1570–ca. 1625: main altar, 1620 (central part rebuilt in 1789). Bogotá, Colombia. Altar by Ignacio García de Ascucha.

II-42. *Virgin Mary:* Bernardo Legarda (?), ca. 1760. Carved wood with *encarnadura* and paint, *h.* 26½ in. MNAC

II-43. *The Christ Child:* Caspicara, mid-eighteenth century. Carved wood with *encarnadura* and *estofado, h.* 20 in. MNAC

II-44. *Virgin Mary:* Caspicara, late eighteenth century. Carved wood painted with flesh tones and garments of cloth, *h.* 34½ in. MNAC

II-45. Church of San Francisco, 1775–95: stairway to the pulpit, late eighteenth century. Popayán, Colombia.

II-46. Christ (detail.): anonymous popular imagery in the New Granada style, mid-eighteenth century. Carved and painted wood, life size. Church of San José, Popayán, Colombia.

II-47. *Winter:* Miguel de Santiago, ca. 1655. Oil on canvas, 62 x 94½ in. MNAC

II-48. Torre Tagle Palace, completed in 1735: main courtyard, seen through the grillwork of a hall, ca. 1735. Lima, Peru.

II-49. Church of La Merced, 1697–1794; façade (detail), ca. 1700, restored 1939–41. Lima, Peru.

II-50. Church of San Agustín, mid-seventeenth to early eighteenth century: façade (detail), 1720. Lima, Peru. Façade attributed to Diego de Aguirre or José de la Sida.

II-51. Church of La Merced, ca. 1653–69: side entrance, ca. 1668, and tower, ca. 1675. Cuzco, Peru.

II-52. Cuzco, Peru: main square. At the left, the Cathedral, 1582–1654; façade, 1651–54. At the right, the Jesuit Church, 1651–68; façade, ca. 1668. Far right, the former Jesuit University. Cathedral by Francisco Becerra. Façade of the Jesuit Church by Diego Martínez de Oviedo.

II-53. Jesuit Church, mid-seventeenth century to ca. 1738: façade (detail), 1698. Arequipa, Peru.

II-54. Church of Santiago, ca. 1720–ca. 1794: vault of the dome, ca. 1726. Pomata, Peru.

II-55. Church of San Lorenzo, 1728–44: central doorway of façade, ca. 1740. Potosí, Bolivia.

II-56. St. Jerome: anonymous Altoperuvian popular imagery, probably late eighteenth century. Carved wood with painted flesh tones, life size. Church of Sicasica, Bolivia.

II-57. St. Isidore the Farmer: anonymous Altoperuvian popular imagery, probably late eighteenth century. Carved and painted wood, garments of cloth, life size. Church of Andahuaylillas, Peru.

II-58. The Virgin with the Infant Jesus: anonymous Altoperuvian popular imagery, mid-eighteenth century. Carved wood with *encarnadura* and *estofado, h.* 20¾ in. Cathedral of Sucre, Bolivia.

II-59. *St. Luke the Evangelist* (detail): Melchor Pérez Holguín, 1724. Oil on canvas, 53¼ x 41½ in. Museum of the Mint, Potosí, Bolivia.

II-60. The Holy Family: anonymous painting of the Cuzco School, mid-eighteenth century (?). Oil on canvas, 58 x 34 in. Private coll., Cuzco, Peru.

II-61. The Virgin of Potosí: anonymous Altoperuvian popular painting, late eighteenth century. Oil on canvas, 78 x 46 in. Museum of the Mint, Potosí, Bolivia.

II-62. Cathedral of Córdoba, ca. 1687–1758: tower and dome, ca. 1740. Argentina. Dome by Friar Vicente Muñoz. Façade and towers by Andrés Blanqui.

II-63. Church of São Pedro dos Clérigos, 1728–82: nave with presbytery at the rear, ca. 1758. Recife, Brazil. Manuel Ferreira Jácome.

II-64. Church of Nossa Senhora da Conceição da Praia, 1739–65. Bahia, Brazil. Manuel Cardoso de Saldanha.

II-65. Church of the Third Order of São Francisco da Penitência, ca. 1697–1703: façade, 1703 (frontispiece modified in 1874). Bahia, Brazil. Façade by Manuel Gabriel Ribeiro.

Part III: The Modern Synthesis

III- 5. *Portrait of Bolívar:* José Gil de Castro, 1823. Oil on canvas, 25½ x 20¾ in. Coll. Alfredo Boulton, Caracas, Venezuela.

III- 6. *Juanita Breña:* Pancho Fierro, mid-nineteenth century. Watercolor on paper, 8⅔ x 6⅔ in. Coll. Fernando Berckemeyer y Pazos, Bullfighting Museum, Lima, Peru.

III- 7. Untitled: Melchor María Mercado, 1868. Watercolor on paper, 7¾ x 13½ in. National Archives, Sucre, Bolivia.

III- 8. *San Isidro:* Prilidiano Pueyrredón, 1867. Oil on canvas, 45¼ x 91¾ in. National Museum of Fine Arts, Buenos Aires, Argentina.

III- 9. *Knucklebones:* Juan Manuel Blanes, ca. 1885. Oil on canvas, 11¾ x 15⅓ in. Coll. Octavio Assunção, Montevideo, Uruguay.

III-10. *Flowers:* Juan Francisco González, ca. 1900. Oil on canvas, 11¾ x 18 in. Private coll., Santiago, Chile.

III-11. *Sharp Tongue:* Pedro Figari, ca. 1934. Oil on cardboard, 27½ x 37½ in. National Historical Museum, Montevideo, Uruguay.

III-12. *The Boy Jesús Miguel Arochi y Baeza:* José María Estrada, ca. 1840. Oil on canvas, 31¼ x 20½ in. INBA

III-13. *Rafaela Herrera Defends the Castle Against the Pirates:* Asilia Guillén, ca. 1960. Oil on canvas, 33½ x 45¼ in. PAU

III-14. *A Sunday:* José Antonio Velásquez, 1957. Oil on canvas, 43⅓ x 55 in. Coll. Ramón G. Osuna, Washington, D.C.

III-15. *Plaza Bulnes, Santiago:* Luis Herrera Guevara, 1941. Oil on canvas, 25 x 28 in. Private coll., Santiago, Chile.

III-16. *Voodoo Personage:* Hector Hyppolite, ca. 1946. Oil on cardboard, 28 x 21 in. Coll. Ramón G. Osuna, Washington, D.C.

III-17. *Don Quixote:* José Guadelupe Posada, ca. 1905. Lead-cut engraving, 5⅞ x 11 in. INBA.

III-18. *Market in Tenochtitlán* (detail): Diego Rivera, 1929–45. Fresco mural. National Palace, Mexico City.

III-19. *Siqueiros by "The Great Colonel":* David Alfaro Siqueiros, 1945. Pyroxylin on Masonite, 39⅓ x 48 in. INBA

III-20. *Crucifixion:* José Clemente Orozco, 1942. Oil on canvas, 76¾ x 43⅓ in. Coll. Charles Bolles Rogers, New York City.

III-21. *Landscape:* Armando Reverón, 1929. Oil on canvas, 36 x 41¾ in. MBA

III-22. *Piety:* Manuel Rodríguez Lozano, 1945. Fresco mural in a private house, Mexico City. Max. *w.* 39 ft.

III-23. *The Fountain:* Rufino Tamayo, 1951. Oil on canvas, 31¾ x 39½ in. MBA

III-24. *The Mestizo Race of Guatemala* (detail): Carlos Mérida, 1956. Byzantine-type mosaic. Total size 3,800 sq. ft. Municipal Building, Guatemala City.

III-25. *Love:* Mario Carreño, 1964. Conté crayon on paper, 17⁵⁄₁₆ x 13½ in. Coll. Mr. and Mrs. Stanton L. Catlin, Riverside, Conn.

III-26. *Figures in Black and White:* Wifredo Lam, 1954. Oil on canvas, 41⅞ x 35¼ in. MBA

III-27. *Colorhythm No. 10:* Alejandro Otero, 1956. Duco on cardboard, 78 x 18 in. Coll. Alonso Palacios, Caracas, Venezuela.

III-28. *The Wake:* Alejandro Obregón, 1956. Oil on canvas, 55¼ x 69 in. PAU

III-29. Model for *Column:* Eduardo Ramírez, 1966. Wood painted white. *h.* 87 in., max. *w.* 23 in. Coll. Damaz & Weigel, Architects, New York City.

III-30. *The Cry:* Oswaldo Guayasamín, 1951. Oil on canvas, 37½ x 27½ in. Luis Angel Arango Library, Bogotá, Colombia.

III-31. *The Myth of Inkarri:* Fernando de Szyszlo, 1968. Acrylic on plywood, 59 x 59 in. Coll. Manuel Cisneros, Lima, Peru.

III-32. *Totem:* María Luisa Pacheco, 1967. Mixed mediums on canvas, 60 x 50 in. Coll. the artist, New York City.

III-33. *The Birth of America:* Roberto Matta, 1957. Oil on canvas, 82 x 115½ in. Museum of Contemporary Art, Santiago, Chile.

III-34. *Beachcomber III:* Enrique Zañartu, 1955. Oil on canvas, 76¾ x 51 in. Private coll., Paris, France.

III-35. *The Heart of the Andes:* Nemesio Antúnez, 1966. Mural, oil on canvas, 78¾ x 236 in. United Nations Building, New York City.

III-36. *Constructive City with Universal Man:* Joaquín Torres García, 1942. Oil on cardboard, 31⁹⁄₁₀ x 40 in. Coll. Manolita Piña de Torres García, Montevideo, Uruguay.

III-37. *Pears and Apples:* Emilio Pettoruti, 1932. Oil on canvas, 28¾ x 39⅓ in. Private coll., Buenos Aires, Argentina.

III-38. *Moon Landing on Mount Taurus:* Raquel Forner, 1964. Oil on canvas, 63 x 51 in. Coll. the artist, Buenos Aires, Argentina.

III-39. *Ramona's Kiss:* Antonio Berni, 1964. Xylo-collage relief, 13¾ x 9¾ in. Private coll., Buenos Aires, Argentina.

III-40. Untitled: Emiliano Di Cavalcanti, 1953. Lithograph, 12½ x 8½ in. Museum of Contemporary Art, São Paulo, Brazil. Reproduction from *Mestres do Desenho. Di Cavalcanti.* Com uma balada introdutória de Vinicius de Moraes. Editôra Cultrix. São Paulo, Brazil, 1963.

III-41. *The Teaching of the Indians:* Cândido Portinari, 1941. Tempera on dry plaster, 189 x 183 in. Hall of the Hispanic Foundation of the Library of Congress, Washington, D.C.

III-42. Tile Mural: Roberto Burle Marx, 1953. Garden of the Arnaldo Aizin residence, Rio de Janeiro, Brazil.

III-43. *Towers Without Function:* Mathias Goeritz, 1957–58. *h.* 121⅓ to 187 ft. Satellite City, Mexico City.

III-44. *Equinoctial Storm:* Edgar Negret, 1959. Aluminum and wood, 39½ x 34 x 10½ in. Coll. the artist, New York City.

III-45. *José Remón Cantera Monument:* Joaquín Roca Rey, 1956. Bronze frieze, life size. Panama City. Architects: Juan Pardo de Zela and Cortés Jara.

III-46. *Lap:* Marina Núñez del Prado, 1943. Lignum vitae, 61⅜ x 41½ in. Private coll., La Paz, Bolivia.

III-47. *Gate of the Sun:* Marta Colvin, 1964. Sulfuric stone. *h.* 10½ ft., *w.* at base 7¾ ft. Coll. the artist, Santiago, Chile.

III-48. *Sign I:* Lily Garáfulic, 1966. Bronze, 27½ x 27½ in. Coll. the artist, Santiago, Chile.

III-49. *Chrysalide:* Alicia Penalba, 1961. Bronze, 16⅛ x 30¾ x 18⅞ in. AK

III-50. *Pastoral:* Bruno Giorgi, 1959. Bronze, *h.* 38 in. Present whereabouts unknown.

III-51. *Boto:* Maria Martins, 1960. Bronze, *h.* 27 in. AK

III-52. Ministry of Hydraulic Resources, 1950. Mexico City. Architects: Mario Pani and Enrique del Moral.

III-53. University City, begun 1950: Central Administration Building, 1952–53. Mexico City. Chief architects of the Central Administration Building: Mario Pani, Enrique del Moral, and Salvador Ortega Flores. At the right, part of a mural by David Alfaro Siqueiros, 1953. At rear, the Central Library.

III-54. University City: Central Library, 1952–53. Mexico City. Architects: Juan O'Gorman, Gustavo Saavedra, and Juan Martínez de Velasco. Mosaic murals of polychrome stones by Juan O'Gorman, 1953.

III-55. Museum of Modern Art, 1964. Chapúltepec Park, Mexico City. Architects: Pedro Ramírez Vázquez and Rafael Mijares.

III-56. Church of Santa Mónica, 1966: lantern. Satellite City, Mexico City. Architect: Félix Candela.

III-57. Municipal Building, 1956. Guatemala City. Architects: Pelayo Llarena and Roberto Aycinena. At the left, Social Security Building, 1958. Architects: Roberto Aycineña and Jorge Montes.

III-58. Bank of Bogotá, 1959. Bogotá, Colombia. Architects: Pablo Lanzetta and Reinaldo Valencia. Consultants: Skidmore, Owings & Merrill.

III-59. University City: Olympic Pool (prow), 1957. Caracas, Venezuela. Architect: Carlos Raúl Villanueva.

III-60. University City: Small Concert Hall and Library, 1953. Caracas, Venezuela. Architect: Carlos Raúl Villanueva. At the right, a bronze sculpture, *Maternity,* by Balthazar Lobo (1953).

III-61. San Ignacio School, 1960. Santiago, Chile. Architect: Alberto Piwonka. Mosaic mural, *Homage to Fra Angelico,* by Mario Carreño (13½ x 47⅓ ft., 1960).

III-62. United Nations Building, 1966. Santiago, Chile. Architect: Emilio Duhart.

III-63. Pan American Health Organization and Regional Office of the World Health Organization, 1965. Washington, D.C. Architect: Román Fresnedo Siri.

III-64. Alberto Williams residence, 1945–47. Pereya Iraola Park, Mar del Plata, Argentina. Architect: Amancio Williams.

III-65. San Martín Municipal Theater, 1953–61. Buenos Aires, Argentina. Architects: Mario Roberto Alvarez and Macedonio Oscar Ruiz. Untitled stone sculpture by Pablo Curatella Manes, 1961.

III-66. Ministry of Education and Public Health, 1937–43. Rio de Janeiro, Brazil. Architects: Lúcio Costa, Oscar Niemeyer, Carlos Acevedo Leão, Jorge Moreira, Affonso Eduardo Reidy, and Ernani Vasconcellos.

III-67. Church of São Francisco de Assis, 1943. Pampulha, Minas Gerais, Brazil. Architect: Oscar Niemeyer. Fresco and ceramic murals by Cândido Portinari, 1943.

III-68. Palace of the Planalto, 1957–58. Brasília. Architect: Oscar Niemeyer.

III-69. Cathedral of Brasília, begun 1958. Architect: Oscar Niemeyer.

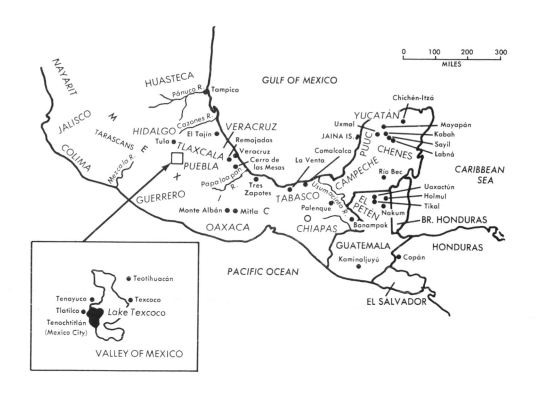

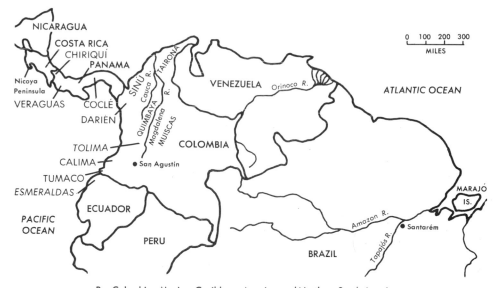

Pre-Columbian Mexico, Caribbean America, and Northern South America

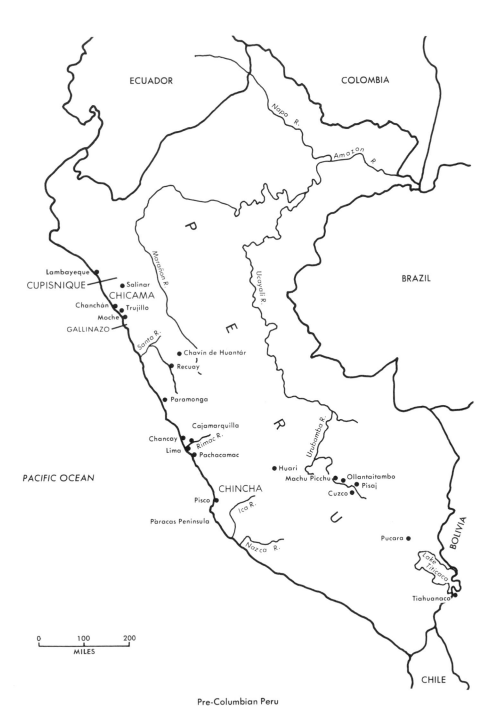

ECUADOR

COLOMBIA

Napo R.

Amazon R.

BRAZIL

P

Lambayeque
CUPISNIQUE
Salinar
CHICAMA
Chanchán • Trujillo
Moche
GALLINAZO

Marañón R.

Ucayali R.

E

Chavín de Huantár
Recuay

Santa R.

Paramonga

R

PACIFIC OCEAN

Cajamarquilla
Chancay
Lima
Pachacamac

Rimac R.

Huari
Machu Picchu • Ollantaitambo
Pisaj
Cuzco

Urubamba R.

CHINCHA

U

Pisco

Ica R.

Paracas Peninsula

Pucara

Nazca R.

BOLIVIA

Lake
Titicaca

Tiahuanaco

| 0 | 100 | 200 |
MILES

CHILE

Pre-Columbian Peru

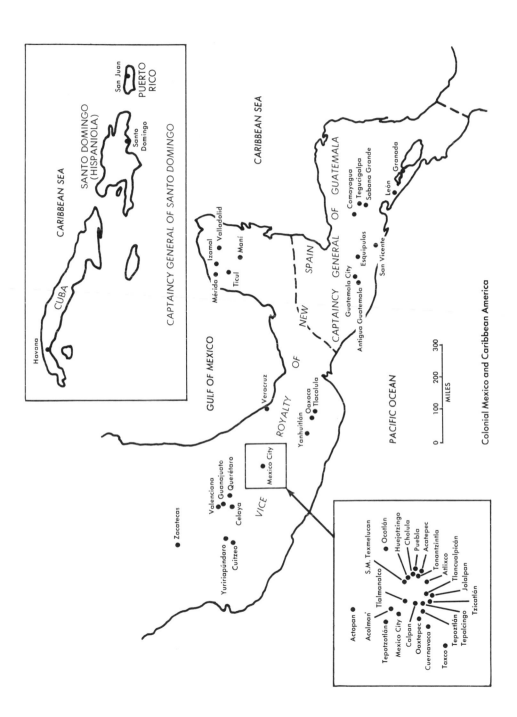

CARIBBEAN SEA

San Juan
PUERTO
RICO

SANTO DOMINGO
(HISPANIOLA)

Santo
Domingo

CAPTAINCY GENERAL OF SANTO DOMINGO

CARIBBEAN SEA

CUBA

Havana

GULF OF MEXICO

Valladolid
Izamal
Mérida
Ticul
Maní

Veracruz

CAPTAINCY GENERAL OF GUATEMALA

Comayagua
Tegucigalpa
Sabana Grande
León
Granada

Esquipulas
Guatemala City
San Vicente
Antigua Guatemala

NEW
SPAIN
OF
ROYALTY
VICE

Yanhuitlán
Oaxaca
Tlacolula

Mexico City

Valenciana
Guanajuato
Querétaro
Celaya

Zacatecas

Yuririapúndaro
Cuitzeo

PACIFIC OCEAN

MILES

0 100 200 300

Colonial Mexico and Caribbean America

Actopan
Acolman
Tepotzotlán
Mexico City
Colpan
Cuernavaca
Oaxtepec
Taxco
Tepoztlán
Tepalcingo
Tzicatlán

Tlalmanalco
S.M. Texmelucan
Ocotlán
Huejotzingo
Cholula
Puebla
Acatepec
Tonantzintla
Atlixco
Tlancualpicán
Jolalpan

Colonial South America about 1790

314

Index

São Paulo Biennials, 232, 250, 253, 257, 261
Savaín, Pétion (n.d.), 220
Sayil, 50
Schenherr, Simon (fl. late 18th cent.), 157
Segall, Lasar (1891–1957), 250
Semana de Arte Moderna, São Paulo, Brazil, 222, 251, 264, 287
Sepúlveda, João de Deus (fl. ca. 1760), 190
Seuphor, Michel (b. 1901), 247
Sibellino, Antonio (b. 1891), 262
Sicasica, Church of, 174
Sicre, Juan José (1861–1929), 257
Sinú style, 62
Solano, Mesa Gabriel (b. 1916), 276
Somarriva, Pascual de (fl. mid. 18th cent.), 142
Soto, Jesús Rafael (b. 1923), 239
Souza Freitas, Verisimo de (fl. ca. 1750), 190
Spilimbergo, Lino Eneas (1896–1964), 223, 249
Stonecutters' School, Chile, 261
Suárez, Daniel (b. 1919), 276
Sucre (Chuquisaca), 152, 176
Swinburn Pereira, Jorge (b. 1934), 283
Szyszlo, Fernando de (b. 1925), 243

Taironas, 59, 62
Tamayo, Rufino (b. 1899), 234, 235–36
Tarascans, 20, 21
Taunay, Nicolas-Antoine (1755–1830), 213
Taxco, San Sebastián y Santa Prisca, 118, 134
Tedeschi, Enrico (b. 1910), 286
Tegucigalpa: Cathedral, 141, 142; Comayagüela, 142; Los Dolores, 142
Tejeda, Juan de (fl. ca. 1586–ca. 1608), 149
Tenochtitlán, 38, 39, 91
Tepalcingo style, 125, 126
Tepeaca, 114
Tepotzotlán, 106; San Martín, 122, 128, 129
Testa, Clorindo (b. 1923), 286
Texcoco, 24, 38
Texmelucan, San Martín, 129
Third Mexican Church Council (1585), 112
Ticul, 148
Titu Yupanqui, Francisco (fl. ca. 1576), 115
Tlacolula, Holy Christ Chapel, 125
Tlalmanalco, San Luis Obispo, 113
Tlancualpicán, Santa María, 125
Tlatilco, 19, 20
Toesca, Joaquín (ca. 1745–99), 178, 205, 206
Tolima, 63, 64
Tolsá, Manuel (1757–1816), 108, 202
Tomasello, Luis (b. 1915), 250
Tonantzintla, 101; Santa María, 130–32
Torres García, Joaquín (1874–1949), 222, 247–48, 261, 284
Torres Méndez, Ramón (1809–85), 209–10
Torroja, Eduardo (1899–1961), 273
Totonacs, 30

Tovar y Tovar, Martín (1828–1902), 209
Tresguerras, Francisco Eduardo (1759–1833), 202
Troya, Rafael (1845–1921), 211
Tula, 25, 39, 53
Tunja, 115, 152; Cathedral, 108; Santo Domingo, 155–56
Tzicatlán, San Lucas, 125

Uaxactún, 42, 43, 46, 56
Urdaneta Holguín, Rafael (b. 1921), 276
Uxmal, 49, 50

Valdés Leal, Juan (1622–90), 114
Valencia, Reinaldo (b. 1922), 276
Valentin (n.d.), 257
Valenzuela Llanos, Alberto (1869–1925), 212
Valenzuela Puelma, Alfredo (1855–1908), 212
Valladolid, 148
Vandelvira, Andrés de (1509–75), 109
Vargas Rosas, Luis (b. 1897), 243
Vasconcelos, Constantino de (d. ca. 1670), 164
Vásquez, Julio Antonio (b. 1900), 261
Vásquez Castañeda, Dagoberto (b. 1922), 275, 276
Vázquez, Alonzo (ca. 1565–1608), 114
Vázquez de Arce y Ceballos, Gregorio (1638–1711), 163, 176
Velasco, José María (1840–1912), 208, 213
Velásquez, José Antonio (b. 1906), 218–19
Venturelli, José (b. 1918), 230
Veraguas culture, 58, 59, 60
Vicú culture, 75
Vicuña Mackenna, Benjamín, 206
Vigas, Oswaldo (b. 1926), 280
Vilamajó, Julio (1894–1948), 284
Villagrán García José (b. 1901), 268–69, 272
Villalpando, Cristóbal de (ca. 1652–1714), 135, 136
Villanueva, Carlos Raúl (b. 1900), 222, 224, 257, 277–82
Vincent, René (b. 1911), 220
Vitullo, Sosostris (1899–1953), 262
Volpi, Alfredo (b. 1896), 253

Warchavchik, Gregório (b. 1896), 287
Will and Action movement, 223
Williams, Amancio (b. 1913), 285, 286, 287

Yáñez, Enrique (b. 1908), 269
Yanhuitlán, 106
Yucatán, 16, 26, 43, 49, 50, 51, 52, 53, 54, 57, 148

Zacatecas, 100, 135; Cathedral, 120–21
Zacatenco culture, 19
Zalce, Alfredo (b. 1910), 234
Zañartu, Enrique (b. 1921), 244–45, 246
Zapotecs, 27
Zepita, 172
Zúñiga, Francisco (b. 1913), 256